To Peter Weibel

ANALIVIA CORDEIRO
FROM BODY TO CODE

ANALIVIA CORDEIRO
FROM BODY TO CODE

Edited by
Claudia Giannetti

//////// KIII center for art and media karlsruhe

HIRMER

Contents

9 Peter Weibel
Acknowledgements

10 Peter Weibel
Analivia Cordeiro: From Choreography to Code

18 Claudia Giannetti
Dance ⇔ *Graphein*. On Nexus and Body Movements

34 Analivia Cordeiro and Claudia Giannetti
Conversation

I · TEXTS BY ANALIVIA CORDEIRO

48 *A Language for the Dance*, 1973

54 *The Programming Choreographer*, 1977

60 *Nota-Anna: An Expression Visualization System of the Human Body Movements*, 1998

65 *Looking for Cyber-Harmony: A Dialogue Between Body Awareness and Electronic Media* – A Summary, 2004

71 *Joy of Reading* – A Summary, 2010

82 *Manuara* – Exhibition of Photos, Sculptures, and Video from 1975, 2014

85 *A Little Description of the Cycle and Ritual of Kwarup -Kamaiurá Indians, Upper Xingú* (Mato Grosso), 2014

87 *The Architecture of Human Movement* A Summary, 2018

II · TEXTS ABOUT ANALIVIA CORDEIRO'S WORK

96 Maria Duschenes
Analivia Cordeiro – *Chamada*, 1980

98 Marcelo Leite
An Accuracy of Issue, 1984

102 Luiz Velho
Nota-Anna Presentation, 1998

104 Arlindo Machado
Body as a Concept of the World, 2010

107 Arlindo Machado
A Reflective Look at Indigenous Culture, 2014

109 Mariola V. Alvarez
Machine Bodies: Performing Abstraction and Brazilian Art, 2020

III · HISTORICAL DOCUMENTS

122 Folder *INTERACT Machine: Man: Society* Computer Arts Society, Edinburgh Conference and Exhibiton, 1973

126 *ICCH/2* – Thirteenth Annual Computer Art Exposition, 1975

128 Grace Hertlein – A Letter, 1975

129 Folder Goethe-Institut de São Paulo, 1975

130 Jeanne Beaman – A Letter, 1976

132 Herbert W. Franke – A Letter, 1976

134 John Lansdown, *The Computer in Choreography* (excerpt), 1978

IV · WORKS

138 1959-1971

152 1973-1977

208 1978-1984

244 1985-1999

270 2000-2014

308 2015-2022
Analivia Cordeiro, *Unforgettable Kicks,* 2016

364 Photographs by Bob Wolfenson
Bob Wolfenson, *Encounter,* 2022

V · APPENDIX

378 Brief Biography

384 Curriculum Vitae

393 Bibliography

397 Authors's Biographies

Peter Weibel

Acknowledgements

As an artist, dancer, and choreographer, Analivia Cordeiro is one of the internationally recognized pioneers of video and computer art. This comprehensive publication presents in an impressive way the great achievements of her work. It was published on the occasion of the exhibition *Analivia Cordeiro – From Body to Code* shown at ZKM | Center for Art and Media Karlsruhe from January 28 to May 7, 2023.

I want to express our deepest thanks to Claudia Giannetti, curator of the show, editor of this volume, and longtime expert on Analivia Cordeiro's work, for her exceptional work on the exhibition and book as well as to the artist Analivia Cordeiro herself. We are really delighted to be able to present her works here at ZKM | Karlsruhe. Many thanks also to Nilton Lobo, the electronic engineer with whom Analivia Cordeiro has collaborated for many years, and photographer Bob Wolfenson, whose works are also part of the exhibition.

We would also like to express our wholehearted thanks to Hanna Jurisch and Philipp Ziegler, the project leaders of the exhibition. Our thanks also go to Anne Däuper for the technical project management, to Leonie Rök for taking care of the conservation supervision, as well as to the construction team and the conservators of the ZKM for their, as always, exceptional work. Further, we want to thank Marc Schütze from the ZKM's museum and exhibition technical services for his support, Janine Burger and Alexandra Hermann who planned a great outreach concept for the exhibition, as well as Natascha Daher, who, as registrar, took care perfectly of all the loan issues. Our grateful thanks to Demian Bern for the graphic design of the exhibition and the great poster motif, and to Laura Meseguer and Lia Araújo for the wonderful design of the book. We would also like to thank Jens Lutz and Miriam Stürner from the ZKM's Publications Department for their unsparing collaboration, as well as Kerstin Ludolph from Hirmer Verlag, who has included the publication in their reknown publishing program. And naturally, we thank all the authors, translators, editors, image editors, and photographers involved in the publication for their commitment.

We would also like to express our very special thanks to Margit Rosen and Felix Mittelberger from ZKM's Wissen – Collections, Archives, and Research Department. They made a great find when they unearthed a very well-preserved copy of Analivia Cordeiro's work *M3×3* from 1973 in the archive of Vladimair Bonačić, that belongs to ZKM. This means that for the first time, this work can be shown in high resolution in our exhibition. They also found the original manuscript of *A Language for the Dance* from 1973 that was thought lost in the archive of Manfred Mohr which is also housed at the ZKM.

Our sincere thanks for supporting the exhibition go to Galerie Anita Beckers in Frankfurt am Main. And last but by no means least we want to take this opportunity to express our profound gratitude to the founders and sponsors of the ZKM: The City of Karlsruhe, the State of Baden-Württemberg, and the EnBW Energie Baden-Württemberg AG.

Peter Weibel
CEO and Chairman ZKM | Karlsruhe

General views of the exhibition *Analivia Cordeiro - From Body to Code* at the ZKM | Center for Art and Media Karlsruhe, 2023. Photographer: Felix Grünschloß. © ZKM | Karlsruhe.

Peter Weibel

Analivia Cordeiro: From Choreography to Code

Analivia Cordeiro's unique and outstanding pioneering achievement, as the title of the accompanying exhibition indicates, is the transition from body-centered to code-centered choreography. This transition originates from the problem of choreography as a generative schema and notation, as a medium of storage and instruction. For language, there is writing and for music, there is notation for passing on information. For dance, this *ars memoria*—art of memory—hardly exists. Letters are the written symbols of the thoughts. Letters or written symbols of movement barely existed at all. Only today, with the advent of computer-aided motion capture technology, is there a "script of movement," which since 1700 has been designated "choreography."

The word choreography is a combination of the Greek words *choreía* (dance) and *grá-phein* (writing): dance-writing. The function of notations is to document and create something that can be passed on. Thus choreography, from Raoul-Auger Feuillet to Rudolf von Laban, was originally about the possibility of reproducing the dance, about prescribing and rewriting the actual movements. Today it is about the analysis and design of movements of the body in space and time.

Dance posed a special problem because of its complexity as a language of body movement in space and time. It requires a notation that is multidimensional. From Rudolf von Laban's notations of expressive dance (*Ausdruckstanz*) (fig. 1) to the Eshkol-Wachman *Movement System* (1968) (figs. 2, 3) to William Forsythe's *Improvisation Technologies* (1999/2003)[1], there has been a series of astonishing attempts to document graphically, to notate the movements of head, arms, legs, pelvis, and torso in the four-dimensional coordination system of space and time on a two-dimensional surface in such a way that they can be replayed, retrieved, and enacted.

Fig. 1
Dance according to the Laban notation, before 1929.

Fig. 2
Noa Eshkol, Eshkol-Wachman Movement Notation (EWMN) for *Promenade*, 1958. © The Noa Eshkol Archive.

Fig. 3
Noa Eshkol, Diagram for "conical movement" of the upper body. Published in Noa Eshkol et al., *Moving, Writing, Reading* (The Movement Notation Society & Tel Aviv University, 1973). © The Noa Eshkol Archive.

1 William Forsythe, *Improvisation Technologies: A Tool for the Analytic Dance Eye*, ZKM | Karlsruhe, Deutsches Tanzarchiv Köln (Ostfildern: Hatje Cantz, 1999/2012), CD-ROM with booklet.

Various ideas about the forms of presentation of dance and performance have inevitably led to the issue of how the movements of the body can be encoded in a notation. Dance is thus not only a question of choreography, but also of code. How can the movements of the body be encoded in space and time? This central question, however, not only results unilaterally from the history of dance and performance, but also from the recent history of art itself. For the visual arts of the 20th century tended toward leaving the sphere of the panel painting and seeking to "exit from the image" [2] (Laszlo Glotzer) in new forms of art such as Happening, Fluxus, actions, and performance. The classic two and three-dimensional space-based arts, such as painting and sculpture, have been pushing forward into four-dimensionality since the 1960s, and the classic four-dimensional time-based arts such as dance, on the other hand, into three-dimensionality. The expansion of the arts has been multidirectional. To this day painting leans toward spatial and object arts, and sculpture toward action arts. Action arts tend diametrically toward the object world, toward visible real or invisible virtual objects, from William Forsythe to Sasha Waltz, and in the world of media, toward film and video and computers. Yvonne Rainer pushed the expansion of dance into film very early and radically by directly producing films (*Lives of Performers*, 1972; *Trio A.*, 1978).

Music as the primary medium of time-based art has played a central role in transforming visual art from an art of space (painting, sculpture) into an art of time (action, event, dance). The impetus was an authentic musical issue; namely, the role of the performer. The New Music of the late 1950s (Pierre Boulez, John Cage, et cetera) sought to emancipate the performer, to grant her or him new freedom within the framework of an "open work of art" (Umberto Eco, *Opera operta*, 1962; in English: *The Open Work*, 1989). Against the horizon of an incipient culture of the recipient, the freedom of the interpreter became central. The composer usually writes a score, for example, for piano, but it is only the musician who knows how to interpret and play that score who actually brings the work into being. Composers write music, the score: it is an instruction manual.

Performers implement these instructions for use and create the music.[3] The score is a set of instructions for creating a specific event, a performance. The concept of the score has been expanded, from instructions for how to use musical instruments to instructions for how to use objects and people. George Brecht, who attended John Cage's courses at the New School for Social Research in New York in the late 1950s, expanded the idea of a score into the term *event scores*, instructions for everyday and simple actions (*No Smoking Event*, 1961). Yoko Ono, who was also part of the circle around John Cage, also created instructions for the audience, her *Instructions*. Allan Kaprow's concept-establishing *18 Happenings in 6 Parts* (1959) also lists "Instructions" for "a cast of participants."

The performative turn in the space-based visual arts brought about a convergence with the performance forms of theater, music, and dance. The result was acts, actions, and performances. Conversely, the performative turn in the time-based arts, from film to music and dance, led to convergence with performative forms of sculpture, installation, and painting. An immobile piano could be the setting for an infinite concert (La Monte Young, *Composition 1960 #7*, 1959/1960). Performances and exhibitions came together.

Thus the performative turn of art around 1960 began principally with extending the notion of the score in music, and with new experiments in dance that expanded into the worlds of objects and media—it also posed afresh the question of notation. In the 1960s, however, actions, performance, dance, and media art were marginalized by the art establishment. Those artists who, against all odds, took the risk of developing these new art forms represent the "heroic" phase of performance art—it was only the following generation of artists who achieved recognition for their art in the world's art museums at the beginning of the 21st century.

Until a few decades ago, classical ballet was the dominant form of dance. Classical ballet was primarily body-centered. But costume and set design also played an important role—think of the collaboration of Serge Diaghilev's Ballets Russes with Pablo Picasso in 1917 for the play *Parade* by Jean Cocteau with music by Eric Satie.

2 Lazlo Glotzer, *Westkunst: Zeitgenössische Kunst seit 1939* (Cologne: DuMont, 1981), 234.

3 In 1960, composer La Monte Young wrote *Composition 1960 #10*: "Draw a straight line and follow it." In 1962, Nam June Paik wrote *Read-Music-Do it yourself-Answers to La Monte Young*: "See your right eye with your left eye." The graphic aspects of the score took on a life of their own around 1950: Morton Feldman, *Projection 3 for Two Pianos*, 1951; Earle Brown, *December*, 1952; Iannis Xenakis, *Metastasis*, 1954, and *4 Systems*, 1954. The score of *Metastasis* in fact became the original sketch for the stunning architecture of Xenakis's Philips Pavilion for Expo'58 in Brussels.

Fig. 4
Jannis Kounellis, *Da inventare sul posto* (To invent on the spot), 1972. Performance. © VG Bild-Kunst, Bonn 2023.

Fig. 5
Joseph Beuys, *Wie man dem toten Hasen die Bilder erklärt* (How to Explain Pictures to a Dead Hare), Nov. 26, 1965. Video still. © Joseph Beuys Estate / VG Bild-Kunst, Bonn 2023.

More important, however, than the visual elements of sets and costumes was the music. From Pyotr Ilyich Tchaikovsky's *The Nutcracker Suite* (1892) and *Swan Lake* (1895) to Eric Satie's music for *Parade* (1917), it is clear that the musicians and the choreographer were equal partners.

In modern times, these components took on a life of their own and resembled more a sandwich. The music was relatively autonomous, as was the visual presentation. There were also ballets without music, precisely in order to emphasize the autonomy of the two components. An absolute master of such independent elements of performative productions is Robert Wilson, who stages the lighting, the stage design, and the movements of the singers independently of the music. We can state that the ballet was a triad of music, visual art, and dance, in which the primary factor was the choreography of the body in space and time.

After the expansion of the arts, this triad changed. Recognizable in exemplary form in the trio of John Cage, Merce Cunningham, and Robert Rauschenberg: musician, dancer, choreographer and visual artist working as equals. Music and dance exist independently, just sharing the same space and time. The dancers' movements are not tied to the music. The exit from the image made the exit from sculpture possible; the transformation of two and three-dimensional art genres into forms of action, that is, into four-dimensional actions of the body in space and time: from Jannis Kounellis (fig. 4) to Joseph Beuys (fig. 5). The collaboration between Robert Morris and his then partner Simone Forti exemplified these

Fig. 6
Simone Fort, *See Saw*, 1960.
Performance. Left: Robert Morris,
right: Yvonne Rainer © J. Paul Getty
Trust, photo © Getty Research
Institute, Los Angeles (2014.M.7).
Photo: Robert R. McElroy.

Fig. 7
Robert Morris,
BodySpaceMotionThings, 1971.
An installation in Tate, April 1971.
Photo © Tate Images /
© VG Bild-Kunst, Bonn 2023.

two contrary directions of expansion. Namely, sculpture tending to expand into time, into action, and action tending to expand into space, into sculpture. One example is Simone Forti's "Dance Constructions," which she started creating in 1960. For example, in one of these, *See Saw* (1960) (fig. 6), she combined ordinary movements such as walking, sliding, and climbing with everyday objects such as ropes and sheets of plywood. In the original version of the performance, Yvonne Rainer and Robert Morris moved up and down a long board, balancing their bodies in relation to each other. Taking a cue from this, Morris set up a kind of choreography for visitors (fig. 7) at the Tate Gallery in London in 1971.Choreographers such as Yvonne Rainer and Trisha Brown (*Accumulation*, 1971) explored this field of action that is extended by objects. All the above mentioned artists, however, remained within the realm of analog objects.

In the 1960s, Michael Noll of Bell Labs in New York was one of the first advocates of the combination of computers and dance. In his book *Changes: Notes on Choreography* (1968) Merce Cunningham speculated with foresight on the possibility of creating dancing stick figures on a computer screen. Using electronic notation, the figures would move in space, so that you could observe the details of the dance: stop it or slow it down, play with the timing, see where in space each virtual dancer would be, and also observe the shape of the movement.

In the 1970s and into the 1980s there were developments in computer dance and notation besides those of Analivia Cordeiro, including Rhonda Ryman's development of an editor for Benesh Notation. From the late 1980s and 1990s, Merce Cunningham worked with Tom Calvert and his team from Simon Fraser University in Burnaby, Canada, developing a new computer

dance software program called *Life Forms* in 1989. Together with interface designer Thecla Schiphorst, he continued to develop the software, which later was renamed *DanceForms*. One of Cunningham's landmark dances, *BIPED* (1999), which he developed with visual artists Paul Kaiser and Shelley Eshkar, encompasses not only human movement conceived using *DanceForms* but also abstract images and dance figures created from motion captured dance sequences reimaged and resequenced on the computer. [4]

Today, it is noticeable that more and more dance performances use VR and AR applications, or operate with video projections and sensor-supported digital image worlds. In other words, after classic visual art, media art has now conquered dance as well. The body is no longer the dominant focus; this decentered dance form has expanded to include further expressive possibilities; for example, from the body to the code. With this expansion, dance has freed itself from its historical shackles of being purely body art and has pushed forward into new dimensions of anthropology.

A great and innovative pioneer of this extension of dance into media art and anthropology is Analivia Cordeiro. For the artist, the role of notation is significant. Her work on choreographic notation is comparable to G. W. F. Hegel's work on the Concept. It forces the choreographer to make rational decisions that go far beyond pure expressiveness. A master of this technique is William Forsythe (fig. 8). He composes a digital technology of notation using sculptural objects, but the objects, which were visible in the previous generation of artists, are now invisible. He thus works in the abstract space of code.

Analivia Cordeiro's abstract notations are an exact demonstration of the path from expressive body choreography to the coded movement of the body in space and time. In this, she has even in a way anticipated the motion capture system. Her notation not only attempts to capture the movement, to store the choreography for subsequent choreographers, but her notation is generative. It designs, almost algorithmically, the sequence of movements in space and time,

Fig. 8
William Forsythe: Improvisation Technologies. A Tool for the Analytical Dance Eye, 1999. CD-ROM and booklet. Screenshots. © ZKM | Karlsruhe.

much as *analysis situs* transformed geometry into mathematics. For in *analysis situs*, each body in space is assigned points in the XYZ coordinate system and the points are marked by three digits. In this way, Cordeiro has also mathematized the space for choreography to some extent with her notations. Her concern is *analysis situs*, the analysis of space, and not the expansion of the body. If her performances nevertheless possess immensely expressive value, then it is because she teaches us a secret code, which consists of the fact that the more complex the geometry (i.e., the movements, positions of the body in space), the greater and more intense the expressiveness.

Out of this Cordeiro created the "expressive visualization system," Nota-Anna (1983/94). This achievement in abstraction opened up two optional paths for Cordeiro. On the one hand, to transform abstract sketches of movement into sculptures; and on the other, to mathematize movement. Thus, it remains only to quote her fellow South American Comte de Lautréamont, who was born in Montevideo, Uruguay: "O austere mathematics! I have not forgotten you since your learned teachings, sweeter than honey, distilled themselves through my heart like refreshing waves...." [5] The new "Language of Dance"[6] (1963) was written by a "programmer as

4 See Janet Randell, "Dance and the Computer–Merce Cunningham," Cedar Dance Animations Limited, 2019. https://cedardance.com/dance-the-computer-merce-cunningham/.

5 Comte de Lautréamont, *Les Chants de Maldoror* [1868], second chant, tenth verse (New York: New Directions, 1965), 86.

6 See Mary Wigman, *The Language of Dance*, trans. Walter Sorell (Middletown, CT: Wesleyan University Press, 1966). First published in German as *Die Sprache des Tanzes* (Stuttgart: Ernst Battenberg, 1963).

choreographer"[7] (1977)—by Analivia Cordeiro. Her computer-based video dance of 1973 is thus an incunabulum of the history of media art as well as the art of the dance. It was presented at the important Computer Art Society festival *INTERACT. Machine: Man: Society* in 1973 in Edinburgh, Scotland, in the context of other important pioneers such as Vladimir Bonačić, Vera Molnár, John Whitney, and John Lifton. Cordeiro's cybernetic models of dance, based on the media of film and video, structured and programmed with the aid of computers, have opened the door to the 21st century: Today's most advanced choreographers all work with sensors as interfaces and computer-based media and codes.

The importance of a code instead of a choreography can perhaps be explained by a reference to Derrida's event. For Derrida, "[t]he trace is the erasure of selfhood, of one's own presence, and is constituted by the threat or anguish of its irremediable disappearance, of the disappearance of its disappearance. An unerasable trace is not a trace, it is a full presence [...]."[8] The trace is a component directly related to what is perceived through it; that is, what is made visible. The dance is visible for a while, replete with presence, but it is precisely through its movement that it erases all trace of movement. Each new phase of movement of a dance becomes presence at the cost of erasing the previous phase of movement of the dance. Dance, in this sense, is the art of the trace, a trace that only becomes visible by constantly erasing itself. The drawing is the trace of a movement of the hand. The hand leaves a material trace on the paper which remains. In this respect, we cannot agree with Paul Valéry, who in 1936 using the example of Degas, stated that there is an analogy between drawing and dance,[9] because while the dance will pass, it is the drawing that remains and persists. The score is therefore less the act, and more the event in the sense of Alain Badiou.[10]

The code, however, is not the dance, any more than the score is the music. Strictly speaking, the great composers, from Bach to Mozart, did not leave us music; they left *mousikē* graphs. They left us visual scores; that is, writings for producing music. Thus music as a trace is comparable to the dance. Movements erase themselves like the sounds do. Music and dance are special cases of presence. Without a trace, presence, which lasts only a moment, is not verifiable. If presence is understood as presence and present, it needs witnesses. The event, the music or the dance, literally testifies that presence is a property of witnessing. To transform the trace back into an event with the aid of witnesses, people or documents like texts, photos, and films, is the real problem of dance.

What is great and innovative about Analivia Cordeiro's achievement is that she went beyond this conception. For her, trace does not only mean recording system, storage. No, she uses the technology of the "trace" (film, video, computer) to construct, to create, to choreograph the dance. This makes her one of the first to introduce video and computer into dance, or into the performing arts like theater, music, and performance. Her seminal 1973 work *M3×3* is considered the first video artwork to come out of South America, and internationally as one of the first dance choreographies created specifically for video, using computer image processing to notate the dance movements. This invention, to use media and code for choreography, also distinguishes her work from other dance and performance productions in the 1970s, which remain in the realm of the body like the work of Ulay and Marina Abramović.

Within the frame of the program of the expanding arts during the 1960s, dance also expanded in three directions: in the utilization of objects (visible and nonvisible); in the utilization of media; and expansion into space. Analivia Cordeiro was the earliest and most radical artist to transfer dance into space. She did not make use of media to document dance performances; instead, she choreographed for the media of video and film, similar to how the best art photographers staged and constructed their subjects. "Dance for video like performance for photography" was her motto.

Likewise she recognized that space is a medium of the dance, similar to modern sculpture. Until 1960, sculptures—depictions of human or animal-like bodies—stood around in space but did not thematize the space itself. It was only after 1900 that modern sculptors

7 Analivia Cordeiro, "The Programming Choreographer," *Computer Graphics and Art 2*, No. 1 (1977): 27–31.
8 Jacques Derrida, *Writing and Difference* [1967], trans. Alan Bass [1978] (London: Routledge, 2001), 289.
9 See Paul Valéry, *Degas, Dance, Drawing* (New York: Lear Publishers, 1948).
10 See Alain Badiou, *L'être et l'événement* [1988]; *Being and Event*, trans. O. Feltham (London: Bloomsbury Publishing, 2013).

focused on space and polemicized against volume, mass, and gravity. One notices from Analivia Cordeiro's mathematical exercises of the body that she perceives gravity as a prison. For Cordeiro, dance is an arithmetic exercise in the space of the mind that is unconscious of its activity. The extremities of her body extend the three coordinates of the space, depict them, play with them. Just like Oskar Schlemmer's dances with poles in his "Bauhaustänze" (Bauhaus dances) (1926–1929) were nothing other than games with spatial coordinates. The arms and legs and torso were extended with rods because the body was defined as part of space and its coordinate system (fig. 9). The body represented the space and the space represented the body. Usually, the body supposedly reflects internal states which the movements of the body externalize, express. This is why it's called *Ausdruckstanz*—expressive dance. Schlemmer and his followers, especially Analivia Cordeiro, who acknowledges him as her role model, articulate the space inhabited by the body. For every movement takes place in space and time, including the movements of the body. Yes, movement creates space and time. In this respect, the home of the body is not the body itself, but space.

This paradigm shift from expression (expressive dance) to space (spatial dance) was already a decisive step that Analivia Cordeiro took. But there was also a second step: the turn to the media. Namely, she had experienced that video and film, as media of notation, enabled the body to be choreographed in space. She has converted every position of a movement, every analysis of a spatial position, every *analysis situs* into the three digits of the spatial coordinates and through this she has mathematized dance and transformed it into a special case of analytical geometry. On this basis of the calculability of movement, she then used computers to control, generate, and program the choreography: "Programmer as Choreographer"[11] (1977). An incredible achievement! The computer community recognized this earlier than most and has therefore invited Analivia Cordeiro to important computer festivals since 1973. Her computer-based choreography of the 1970s is certainly in the great tradition of Brazilian Constructivism and Concrete Art, to which her father, Waldemar Cordeiro, belonged

Fig. 9
Stäbetanz (Staves Dance), 1928/1929. Costume by Oskar Schlemmer, performed by Manda von Kreibig at Bauhausbühne Dessau. Photo © bpk / Kunstbibliothek, SMB / Charlotte Rudolph / © VG Bild-Kunst, Bonn 2022 for Charlotte Rudolph.

and to which the information aesthetician Max Bense paid tribute.[12] Yet Analivia Cordeiro's achievement of encoded choreography is unique.

Only today, when the extension of dance into the media has reached the mainstream, do we understand the artistic achievement of Analivia Cordeiro—with what tremendous imagination and mathematical rigor she has conquered and shaped terra incognita.

Translated from the German by Gloria Custance.

11 See Cordeiro, "The Programming Choreographer."
12 See Max Bense, *Brasilianische Intelligenz: Eine cartesianische Reflexion* (Wiesbaden: Limes Verlag, 1965). The first English edition of this book will be published by Spector Books, Leipzig, in Spring 2023.

Claudia Giannetti

Dance ⇔ *Graphein*
On Nexus and Body Movements
An Introduction

This book was born with the aim of systematizing and offering to researchers and the public at large a broad textual description and photographic documentation of Analivia Cordeiro's production from 1973 to 2022. As such, it can be considered a sort of catalogue raisonnné. Her first large solo show in Europe, at ZKM | Center for Art and Media Karsruhe (Germany), to be followed by her exhibition *Bodygraphies* at the Centro Atlántico de Arte Moderno (CAAM) in Las Palmas de Gran Canaria (Spain), both under my curatorship, provided the great incentive and opportunity to make this ambitious project a reality.

Analivia Cordeiro is recognized internationally above all for her first computer-based video dances created between 1973 and 1976, and also for having developed the computer movement notation system Nota-Anna, programmed together with Nilton Lobo from 1983 onward, on which basis she innovatively deployed a 3D visuality, as well as various spatial-temporal functions. Her production from the 1990s onward, however, has not yet been sufficiently disseminated. Raising awareness about her work of these last phases was another purpose of this book.

This volume is divided into three main parts. The first introduces the artist's work, with a preface by the director of ZKM, the media artist, professor and theoretician Peter Weibel; this is followed by this prologue and an interview I conducted with Analivia Cordeiro over the course of several months in 2022, in which we address various complementary topics of interest not previously covered in the other texts.

The second part is organized in three subgroups: the first presents a selection of Analivia Cordeiro's main writings between 1973 and 2018; the second is dedicated to the selection of texts by various authors concerning her work, about which I shall write further along. A set of relevant historical documents and correspondence, mainly from the beginning of her career, is reproduced in the third subgroup.

Throughout her trajectory, Analivia Cordeiro has felt the need to document her works and her reflections about them in texts. The first subgroup of the second part comprises articles by the artist of historical interest today—such as her paper "A Language for Dance" presented at the international conference and festival INTERACT Machine: Man: Society, in Edinburgh, 1973; and her article "The Programming Choreographer," published in 1977 in the *Computer Graphics and Art* magazine—as well as academic essays, in which she treats on questions relevant to her projects, such as: the software Nota-Anna ("Nota-Anna: An Expression Visualization System of the Human Body Movements," 1998); the video course DuCorpo, created with the aim of democratizing access to body training through dance ("Looking for Cyber-Harmony: A Dialogue Between the Body Awareness and Electronic Media," 2004); the videographic contents for cell phones and other portable devices called *A alegria de ler* (Joy of Reading), conceived to make free literacy courses available to the public ("Learning to Read and Write Through an Application for Mobile Devices," 2010); as well as her text "The Architecture of Human Movement" (2018), which concerns a series of computer designed sculptures produced from 2015 onward, lending continuity to her investigations into the tridimensional and spatial-temporal recording of human movements, specifically the bicycle and the volley kick executed by Pelé in 1958, and the martial art yoko geri kekomi sidekick performed by Bruce Lee in the 1960s. Also reproduced here are her writings about

an experience of great personal relevance to Analivia: her stay for several months in 1975, at the age of 21, among members of the Kamaiurá indigenous people, in the Upper Xingú region, state of Mato Grosso. This sojourn deep in the forest was motivated by her curiosity to study primordial dances and body rituals, which she documented in photographs and Super-8 films. This documentary material was exhibited nearly four decades later in the exhibition *Manuara* ("remembrance" in the Tupi-Guarani language) at the Museu Brasileiro de Escultura (MUBE), São Paulo; and concerning it we include two texts by her from 2014: "Manuara Research, Film and Photographs - Living with the Kamaiurá Indians," and "A Brief Description of the Cycle and Ritual of Kwarup." We are also reproducing the introductory texts of that show written by Arlindo Machado.

 Some of these essays of hers reveal another socio-pedagogical facet of Analivia Cordeiro's production, an outgrowth of her concern to bring culture to the needier social segments while breaking down the educational barriers so characteristic of societies with a high degree of economic inequality. Such obstacles are manifested in the dominant elitism and in the disparities in regard to access to education that still exist in the world today, regardless of a country's level of development. It is important to underscore that, parallel to her artistic production, Analivia developed an intense pedagogical activity in the field of dance, having maintained her own dance school Danças Analivia in São Paulo (1980–1985), and having taught in other schools and colleges for 17 years, lending continuity to the legacy of her first dance teacher, the Hungarian-born Maria Duschenes. Having come from England in 1940, in the midst of World War II, Maria Duschenes introduced into Brazil a theory of movement devised by Rudolf von Laban and the Labanotation system, as well as the Dalcroze Eurhythmics method (both methods were fundamental to Analivia's training in dance). In many of her projects, especially those in videographic format, such as the DuCorpo course, this didactic and/or participative approach forcefully emerges.

 The second set of texts, in the second part of this book, consists of articles and essays published by theoreticians and specialists about Analivia Cordeiro's work. A brief text by Duschenes summarizes the enormous potential that she detected in that 26-year-old dancer: "She does not seek to symbolize anything specific, just using movement itself as a communication channel... Analivia is an artist who seeks to give a new direction to choreographic art, exploring choreography in computer, video and film, as well as movements drawn from everyday life" (Maria Duschenes, *Analivia Cordeiro - Chamada* [Call], October 25-28, 1980).

 Marcelo Leite, in his article published in the magazine *Iris* (1984), underscored the artist's analytic capacity coupled with her sensibility to forms and innovation, also emphasizing the support from electronic engineer Nilton Lobo in the programming of the Nota-Anna software.

 In his text written as an introduction to Analivia Cordeiro's book *Nota-Anna — Electronic Notation of Human Body Movements Based on the Laban Method*, published in 1998, computer scientist Luis Velho emphasized "how ambitious Analivia Cordeiro's proposition is, and the considerable challenge it represents, which has been faced by many others with a relative degree of success."

 The text written in 2010 by Arlindo Machado—one of the theoreticians of media art and communication most representative of Latin America—completes this survey of Analivia's production up to that year. In his text *Body as a Concept of the World*, Machado masterfully summarized the main lines of Analivia's artistic research that she laid down throughout her nearly four decades of work. He mentions an essential aspect little noted previously: that although she is the daughter of an important 20th-century visual artist, Waldemar Cordeiro—one of the pioneers of computer art in the international context—Analivia has developed, since the outset, a very distinct and personal trajectory centered on the idea of *embodiment*. And, without a doubt, Machado was right in noting that her works signified "the first Brazilian attempt to think about the language of video and how the body issue interacts with electronic art."

 Another text by Arlindo Machado, written as an introduction to the above-mentioned exhibition *Manuara*, discusses how Analivia has worked in ways akin to visual anthropology when she documented the rituals and choreography of the Xingú indigenous people during their Kwarup ritual, at a time when the tribes did not willingly allow outsiders to photograph and film their activities, and long before the "media invasion (television, in particular)" in their territories.

 Lastly, we include an essay by Mariola V. Alvarez, a researcher from the United States

specialized in Latin American art from the 20th and 21st centuries and, particularly, in the history of abstract art in Brazil. In *Machine Bodies* she offers a contextualization of the artist's first works in relation to the preceding and coetaneous international scene. She focuses mainly on the analysis of *M3×3*, which, in her words, "proposes a world in which human physical and conceptual effort re-shape themselves in relation to machines."

The third part of this book is dedicated to Analivia's artistic production. The decision to order her works chronologically seeks to situate the reader within the dialectics of her creative process. It is up to the reader to mentally establish the interesting formal, conceptual and aesthetic nexuses that link her works from different stages, which can connect, for example, a study of movement by computer carried out in 1982 with a sculpture produced in 2020.

A brief biography, her resume, and a bibliography conclude the publication.

Analivia Cordeiro's fluency in the production of nexuses between a diversity of elements is something she has possessed since a very young age. A family photo taken when she was a baby shows her crib, with a mobile hanging above it—actually, a replic of a kinetic sculpture by Alexander Calder (fig. 1). According to Analivia, this dance of elements metaphorically influenced her worldview from the outset.

Her two childhood drawings reproduced on page 141 were made at the age of five and six. The tangled lines are like the notation of the paths of the movements of butterflies in flight, configuring a sort of aerial dance. Lending visibility to the intrinsic relationship between space, body movement and writing was to become transversal to all her future artistic work. For example, in her video *Ar* (Air, 1985), she explores gesturalities—arms and legs create visual images in space—and since 2017, her gestural paintings probe the space of the paper in the series *Dancing on the Paper*.

The nexus between gesturality and the visuality of the tracing of movement in space is evident in another drawing made in 1960, in which she depicts a spiral in space, defined by lines that circulate in parallel, fractionated into elements of different colors. Constant transformation and the cyclical nature of the rhythms are fundamental to understand any dance, including the dance of the universe. This would be reflected in future works, as in the choreography of her video dance *E* (which for visual reasons could perhaps be better written as a lowercase e), 1979, which is based on the spiraling circulation of bodies, as shown by the graphic notation of the movement of dancers in the space (see figure on p. 211).

Another suggestive connection can be established between her experiments involving dances performed with lights and Labanian movements, captured by a photographer in 1966, probably by chance, and their materialization in future choreographies, in which the dance of lights in a completely dark scenario is central, as it is, for example, in *Trajetórias* (1984), performed by 10- and 11-year-old schoolgirls, or *Micron Virtues* (1992), in which microswitches are attached to the dancers, which they turn on and off during the performance. These are only a few examples of how the notion of nexus became, from very early on, part and parcel to her way of thinking, practicing and feeling.

As a transdisciplinary and experimental artist par excellence, Analivia Cordeiro's intense and constant research into the movement of the human body was and continues to be decisive for her work in a wide range of areas: dance, movement notation, choreography and computer-designed choreography, performance, photography, sculpture and painting, as well as in the field

Fig. 1
Analivia Newborn, 1954. Photograph, 20 × 15 cm.
Unknown photographer

of media art—video art (video dance, computer-based video dance), multimedia, telematics and mobile art—as well as participative and interactive art installations. The nexus she established, linking techniques and styles of contemporary dance with the visual and audiovisual arts, has permitted her to develop a hybrid language of a very singular quality.

Since the 1970s, her projects, investigations and works have made use of a wide range of different technologies, involving both computers and telecommunication (including Internet and mobile platforms) in step with her inventions. In 1987, years before the emergence of Internet in daily life, she produced *Slow Billie Scan*, a telepresence dance transmitted by slow scan television between a city in Brazil and one in the United States. Although a normal occurrence in the low-tech SSTV system of that time, the interferences in the images during the slow-scan transmission (8–12 seconds per image) provided aesthetic qualities of cuts, distortions and superpositions of images during the transfer of data, which were documented in video. Analivia's choreography considered these effects on the bodies of the two performers—Lali Krotoszynski and herself—while it also played with the randomness inherent to this sort of remote data transmission.

From 2015 onward, she applied her knowledge acquired with Nota-Anna to the creation of computer-designed sculptures. Today her software is being used in the programming of projects with artificial intelligence and mobile systems, as in the recent BodyWay Nota-Anna app, 2022, an optical motion capture application conceived together with Nilton Lobo over the course of two years and slated for release during the exhibition at ZKM Karlsruhe (fig. 7). With this AI algorithm, they provide users around the world with the possibility to capture, visualize and analyze the movements of their entire body based on videographic images that are prerecorded or made at the moment with their cell phone. The images are transformed nearly in real time into stick figures, without the need of using tracing sensors, body markers, detectors, exoskeletons or special clothing. The playful and communicative aspect—for example in sharing the results on the social networks or using them in games—is one of the project's components.

Despite her exploration of different media, Analivia has never considered them an end in themselves. Even while recognizing that the instruments and supports used in the production process are never neutral in their effect, Analivia has always considered them tools for her investigations into the potentials of artistic manifestation of the body and of its movements, as well as channels for the dissemination of interhuman communication. For example, her computer-based video dance *M3×3* (1973) situated her as a forerunner of video art in Brazil and Latin America, and as one of the pioneers in the programming of a computerized notation system to be used in choreography designed specifically for the camera and for creating the instructions to guide the film crew in shooting the performance. Nevertheless, her main aim was not limited to the use of a computer tool; she went much further, introducing random elements in the notations and conceiving an effective method for defining the compositional convergence between the choreography of the movements of the bodies and the instructions for their filming by the video cameras; she consequently focused her research on questions of an aesthetic-conceptual nature. (I will return to this theme later in this text.)

From a conceptual point of view it is relevant to introduce a brief historical overview. The first experiments with computer-designed choreography were made and put into practice beginning in 1964 by Jeanne Beaman, Paul LeVasseur,[1] A. Michael Noll, and Francisco Sagasti. In 1965, Paul LeVasseur published in *Impulse Magazine* the article "Computer Dance – The Role of the Computer," followed by a text by Beaman, a dancer, choreographer and student of Martha Graham, titled "Implications of the Dance," both of which are widely cited in the related literature.[2] They argued that the introduction of randomness in the arts had awakened interest for the use of the computer in choreographies, and stated that, "Instead of tossing coins we have used the computer to the same effect because it can quickly juggle a great complexity

1 See "Computer-programmed choreography," in Jasia Reichardt (ed.), *Cybernetic Serendipidity – The Computer and the Arts* (London: Studio International, 1968), 33.

2 Paul LeVasseur, "Computer Dance – The Role of the Computer," and Jeanne Beaman, "Implications of the Dance," *Impulse - Dance and Education Now*, Annual of Contemporary Dance (San Francisco: Impulse Publications, 1965), 25-28.

of variables."[3] They recognized, however, that in the generation of the "random dances" the computer was "neither discerning nor creative," although the quickness of computer processing was a factor to consider in the use of this tool. In 1967, Sagasti together with William Page began to develop a computer program for composing choreographies for various dancers.[4] A model of choreography generated by this system was applied in a dance workshop in early 1968 by the experimental dance group of Pennsylvania State University. Also in 1967, Noll published the article "Choreography and Computers."[5] In that three-page text, the engineer and computer artist referred to the difficulties inherent to handwritten choreography notations and considered the resource of film recordings (actually, a computer-animated film with stick figures), which, although it preserved the general conception, presented problems in determining the individual positions of the dancers and in the bidimensional representation on the plane.

As mentioned above, in 1977 Analivia published her text *The Programming Choreographer* in the North American magazine *Computer Graphics and Arts*, in which she discusses her researches and works made since 1973. The year 1978 saw the publication of the article "The Computer in Choreography," by John Lansdown, one of the pioneers of computer graphics, who had presented and watched *M3×3* during the Edinburgh Conference and Festival of 1973, which he organized (see the reproduction on p. 135). In that article he indicated that "computer-aided choreography illustrates some basic relationships between the computer artist and the computer procedures he employs to achieve certain artistic outcomes," and mentioned that "more recently Brazilian choreographer Analivia Cordeiro has used programs to generate dances and their television coverage."[6]

In general, they all share the opinion that the use of algorithmic resources allowed for the introduction of new processes, but that the creation of innovative dance forms based on technology would involve another sort of challenge. Precisely in this sense, the approaches to technology based on the world of dance made by Jeanne Beaman and by Analivia Cordeiro differed from the proposals by Sagasti and Noll. As dancers, they were informed by their practical experience in dance, they were familiar with the real needs and concerns of the body expressions and languages, of performance and improvisation, as well as with the aesthetic exploration of compositional and scenic aspects. Analivia went a step further, insofar as she designed the computer-assisted choreography not for the stage, but for performing in front of the video camera. In contrast, Noll, according to what he clearly expressed in his article, was absorbed by the solution of graphic and representational problems, which he called "choreographic programming languages," and his attention was limited to the solution of techno-functional questions of the tool used in the process of choreographic notation.

Another relevant historical question regards the relationship between film and dance—called dance-on-film, dance for the camera, cine-dance, choreo-cinema, screendance—and, especially beginning in the 1970s, between video and dance. The first ones had as their main predecessors the experimental historical productions of the 1920s, for example those by Germaine Dulac, René Clair, Fernand Léger and Dudley Murphy. The pedagogical film documentary *Wege zu Kraft und Schönheit* (1925), by Wilhelm Prager and with screenplay by Nicholas Kaufmann, took body health as its central theme and included scenes dedicated to the studies of movement and of dance, which enjoyed the participation of Rudolf von Laban and his dance group. Laban found in cinema an ally for the visualization and dissemination of his dance method and notation system he had been developing since the 1910s. He believed that his *kinetography* could also be used in the elaboration of screenplays of movements by actors for cinematographic productions, avoiding the ambiguities inherent to oral communication. In 1928, a conversation between him and cinema critic Lotte Eisner was published in the magazine *Der Film-Kurier* with the programmatic title "Film und Tanz gehören zusammen"

3 Ibid, 25.
4 Francisco Sagasti and William Page, "Computer Choreography: An Experiment on the Interaction Between Dance and the Computer", *Computer Studies in the Humanities and Verbal Behavior* (Vol. III, Nr. 1, January 1970), 46-49.
5 A. Michael Noll, "Choreography and Computers" (*Dance Magazine*, Mouton, January 1967), 41, 43-45.
6 John Lansdown, *The Computer in Choreography* (London: *Computer Magazine*, August, 1978), 19-26 (page 19 is reproduced in this book).

(Film and Dance Belong Together),[7] in which he referred to his experiences in the field of cinema, most of which have unfortunately disappeared. In 1929, he collaborated with Wilhelm Prager in the film *Drachentöter* (The Dragonslayer) and wrote scripts for didactic dance films, such as *Das lebende Bild* (The Living Image).

Most likely influenced by the ideas of her teacher, in the 1940s Maria Duschenes—Analivia's dance teacher who, as mentioned above, introduced her to the Laban Method and to Dalcroze Eurhythmics, and conveyed to her the fundamentals of contemporary dance—produced dance-for-the-camera films together with her husband Herbert Duschenes, and subsequently disseminated those pieces to her students. The aesthetic and visual solutions of these experimental films corroborate the creation of choreographies especially conceived for the camera, concentrating on details of movements, for example, on hand movements in the foreground.[8]

Although there are many examples, few artists and/or filmmaking choreographers actually managed to abandon the visual manner of filmed dance and to develop processes for the integration of both languages. In order to create a new "object" of art on an audiovisual support, both cine-dance and video dance needed to go beyond the mere recording of the choreographic experience in situ (which approximated it more to documentation). It is understood that, beyond the movements (choreography), the music/audio and the scenery, the camera takes played a fundamental role, and the film editing and postproduction interfered directly on the work's concept and final aesthetics.

This concern was not new. It was present in the first film experiments of visual music—some with the character of visual dance—in the in the 1920s and 1930s (Hans Richter, Viking Eggeling, Walther Ruttman, Norman McLaren, etc.), that managed to break away from the typical narrativity of commercial cinema to enter into the world of time-based visual art. In 1930, in his book *Film als Kunst* (Film as Art) and, later, in a 1938 text written in Italy, "Nuovo Laocoonte" (A New Laocoön: Artistic Composites and the Talking Film), Rudolf Arnheim had posed the question of whether film would only reach the status of art once it had abandoned the need of reproducing objective reality and the aim of capturing the de facto world. However, few people involved with dance for the camera understood the difference between the *Weltbild* (image of the world) and the *Filmbild* (filmic image) and were thus able to move beyond the mere plane of registering the choreographic performance.

This set of challenges is what Analivia Cordeiro faced at that time.

Her first experiment with dance for the camera took place together with the Clyde Morgan company, in the piece *Improvisação estruturada* (1972), filmed in the studio of TV Cultura de São Paulo. Analivia was 18 years old and noticed the lack of synchronization between the dancers' performance and what the camera operators were filming. Disappointed with the final result, this is what prompted her to start looking for a method to establish a nexus between the two.

The most important precedent she found in her family environment: through her close contact with her father's works, she was attentive to the potential of technology used in computer art. Another previous experience had taken place in 1968 during her first trip to Europe with her family. Together with her father, she had visited an exhibition which is emblematic today, *Cybernetic Serendipity*, curated by Jasia Reichardt, at the Institute of Contemporary Arts of London. It should be remembered that the exhibition included computer graphic pieces, computer-generated pictures, machines and environments, computer poems and texts, but also computer dance, computer programmed choreography (Jeanne Beaman) and computer-animated movies. For Analivia, a 14-year-old youth, it was a special experience that she still remembers today. Thus, from a young age, her relationship with technology developed in a natural way.

In this context of seeking new languages for dance, Analivia's attention was especially called to *Triadisches Ballett* by Oskar Schlemmer together with Albert Burger and Elsa Hötzel, in which they applied vanguard Bauhaus ideas

7 Lotte Eisner (interview with Rudolf von Laban), "Film und Tanz gehören zusammen" - Aus Anlaß des Tänzerkongresses, Essen, 21-26 Juni (*Film-Kurier* 143, 16 June 1928), n.p.

8 I refrain from mentioning other historical references related to the field of dance for the camera from the 1940s onward (Maya Deren and Talley Beatty, Norman McLaren, etc.), and of video dance mainly from the 1970s onward (Nam June Paik, Charles Atlas, etc.) considering that these are already discussed in another text in this book.

of confronting the natural and organic with the mechanical, technical and designed, and of overcoming realism through abstraction and geometric shapes. The configuration of the costumes and the scenographic space (*Raumtanz*) through the combination of colors, sounds, lights and shapes (*Formentanz*) was accompanied by the choreography and the movements (*Gestentanz*).[9] In Analivia Cordeiro's own words, "Duschenes showed me the film of a ballet performance by Schlemmer, which was available for consultation at Goethe-Institute in São Paulo. I later returned to watch it various times, until I memorized the movements. As I was alone in the projection room, I stood up and began to imitate the movements of the dancers of the *Triadic Ballet*."[10] A great deal of caution, however, is needed when pointing to him as the main influence in the conception of Analivia's first video dances. Differences in the conception, aesthetics, choreography, scenography (especially the configuration of the space), and costume design between the two proposals are more than evident. Undoubtedly she shares with the *Triadic Ballet* the importance given to the number three—*trias*, from late Latin— especially in the $M_{3\times 3}$ matrix conception (fig. 2). Three implies the overcoming of duality, refers to the three mathematical coordinates of space, as well as to the three movements and the three colors of the ballet. The prominence of the relationship between numbers and choreographic and scenographic creation has remained, since then until today, a fundamental principle of some of Analivia's work. Moreover, the application of essential geometric shapes, such as the square, the triangle and the circle, to the movements and spaces of Cordeiro's first video dances had as antecedents—besides concrete art—the proposals of both Laban and Schlemmer. Another common point was the inventiveness of the nonorganic movements as an antithesis of the mimic gestures and virtuosic technique of classical ballet, which in the choreography by Burger and Hötzel was also due to the limitation of performance imposed by the volumes and design of the sculptural costumes. (However, other artists had already conceived proposals regarding these mechanized movements, such as those of the dadaist Hugo Ball in 1916, which were doubtlessly much more groundbreaking in the formulation of the human-machine problematics.) Nonetheless in the case of Analivia's first video dances, more than mechanization or automation, the dance style in tandem with the type of video editing convey the feeling of a *programming* of bodies. The initial input and the information generated in the output coincided for the (con)formation of languages (computational and corporal). The artist specified in her paper "A Language for Dance" written in 1973 and sent to the *INTERACT* event in Edinburgh: "The timing of each shooting gives the spectator the sense of programmed rhythm. The shooting times are measured according to a G. P. (geometrical progression), ordered at random."[11]

In other words, Analivia's programmatic proposal succeeded in developing new methods of artistic work based on two precedents: first, from the perspective of choreographic notation, she started from Laban and tried to systematize his method through computer programming. Thus, she created a codification of movement in space for a multidimensional and multidirectional "technical gaze" (the "eye" of the video camera(s)—that is, of the cameraman or TV director—in union with the dancer's "reading" technique translated to body movements). Second, while Schlemmer's ideas of "tänzerische Mathematik" (Mathematics of Dance, 1926) conceived the body as a "Mechanismus aus Zahl und Maß" (mechanism of number and measure), for Analivia the elements that contribute to the staging of the dance for the camera—bodies, movements, costumes, set—are approached as "artifacts" that construct and at the same time are part of the space.

Analivia Cordeiro faced various challenges in the conception and realization of $M_{3\times 3}$,[12] $0º\Leftrightarrow 45º$ (the first two versions), *Gestos* and *Cambiantes*—computer-based video dances produced between 1973 in 1976. She tried to

9 Schlemmer was interested in the proposals for new dance by Émile Jaques-Dalcroze, who with his "Rhythmischen Gymnastik" aimed to renovate the language of dance. With students of this choreographer, the dancers Burger and Hötzel, Schlemmer began to work in 1913 on the first ideas that led to *Triadisches Ballett*, which premiered nearly a decade later, in 1922 in Stuttgart.

10 Correspondence between the author and Analivia Cordeiro, 2022.

11 Analivia Cordeiro, *A Language for the Dance,* 1973, 4 (see her paper reproduced in this book; the original is deposited in the ZKM Karlsruhe archives).

12 For a more detailed description of *M3×3*, see the text in this book dedicated to this piece in the *Works* section.

Fig. 2
M3×3, 1973. Computer-based video dance. Mono-channel video 4:3 (black and white, sound). Video still frame.

harness the three elements that the above-mentioned investigators and artists had separately approached: the audiovisual language linked to dance, or to video dance with computer-designed choreography, and with computerized screenplay for the camera. Therefore, a production with these characteristics was not only limited to the programming of a notation system for generating guide notes for the choreography based on a clear concept, but was also aimed at resolving a series of other relevant questions to reach a satisfactory audiovisual result.

From a conceptual and formal perspective, her clear choice of anti-narrativity was manifested in the linear discontinuity, a way of preventing the choreography's subjection to a sequential expressive structure of movements or scenes. This is also due to the factor of randomness implemented in the algorithm that defined the dance's notation. Besides the work's conceptual and formal design, to mention the main points (which I will letter for easier reading), she aimed to: (a) develop a method that would be empirically applicable to a symbolic language; (b) explore the spatial-temporal configuration from the cameras' point of view to avoid the typical front-on view of the observer in regard to what is happening on the stage (in this sense, diagonals and orthogonals assume special relevance in the pieces, as does also the use of various cameras situated at different angles) or, in the case of *Cambiantes*, simulating a rupture of the format's characteristic rectangular frame; (c) establish a parallel between the geometry of the dance dynamic and the spatial and scenographic design, in the case of *M3×3* for example, the clear delimiting of a matrix on the floor with nine spaces measuring 1.5 × 1.5 meters each, and with two vertical separating lines centered on the walls; (d) conceive the visual elements of the scenography and of the costume design in a way that goes beyond mere analogy and manages to fuse or blend shape, figure and plane; through the artifice of contrasts coupled with gestaltic inclusivity she sought to go beyond the background/figure antimony; (e) interweave the audio aspects with the body gesturalities; (f) link the random selection of movements, made by the program, with the real dance and the human creativity proper to the moments of the dancers' improvisation; (g) perhaps the most innovative of all, as mentioned above: link the visual aesthetic solutions with the new choreographic conceptions based on the use of computerized notation to define not only the choreography of the movements but also the cameras' positioning and framing in regard to the dancers' movements. As Analivia Cordeiro argued in her paper "A Language for Dance," her programming method for coding dance took into account: "1. the camera as [spectator dynamics]; 2. the movements of the dancer; and 3. the output as the members of the team performance program, including dancers and technicians, software and hardware."[13] Last but not least, the film editing and postproduction came into play. All of these aspects were planned, created and

13 Ibid. 4.

Fig. 3
Analivia Cordeiro at the Bat-Sheva Seminar on the Interaction of Art and Science, Jerusalem, 1974. © Vladimir Bonačić Archive, ZKM | Karlsruhe.

solved by Analivia Cordeiro in her first five video dances.

Two other impasses are worthy of mention: in São Paulo, due to the limited access to videographic technology, the only possibility for producing videos at that time was in television studios. However, this required a great deal of persuasive effort to make the technicians and director at the studio of TV2 Cultura understand the importance of following the instructions in computerized notation for the cameras and, furthermore, the aesthetic relevance of the accentuated black-and-white contrast she wanted to achieve. Furthermore, an additional effort was also required from the dancers themselves to internalize the choreographic proposals, to admit that it had been a "machine" that created the guide notes to follow, and to "decipher" the computer-generated choreography printouts. A keen observer will be able to note certain signs of incredulity of some dancers during the recordings in 1973.

From an aesthetic point of view, the works of that first stage were materialized from concrete bases. Analivia Cordeiro was incisive in the defense of the contemporary dance style and needed to face a very limited and conservative cultural context in Brazil. This demanded a much sharper capacity for imagination, coupled with firm perseverance. Her great curiosity and her restless and resolute spirit operated in her favor.

From the outset, her aesthetic approach in her choreographies and video dances included the suppression of the typical pathos of the plots of ballets. The artist balanced the planned unfolding of the dance through the computerized notations with the controlled improvisation of performance without letting herself be carried away by theatricality of the gesture, though while also preserving the moments of intensity. The attention she gave to the designated space evinced a clear intention to deconstruct the traditional notion of stage. In some cases, the visual elements that composed the scenarios tended to create close parities with the dancers' bodies. In other cases, the formal solutions of the (video) choreographies showed more daring motivations: to make the space and the bodies of the action completely disappear, placing the dancers' bodies in utter darkness, so that the dance of lights takes on a leading role, as in *Micron Virtues*; or transforming the very surface of the body, the skin, into a space over which the dance of the camera glides, as in the video choreographies of the *Carne* (Flesh) series. In her video dance *Gestos* (Gestures), there is no scenario; the artist eliminated the stage—the *Zwischenraum*, the intermediate space that usually separates the public from the place of the performance. She thus situated the camera operators within the visual field of the recording at the same level as the performers, something rarely seen in the 1970s, especially in art pieces. By dehierarchizing their roles, she integrated the cinematographer into the work. The space was emptied of any accessory except the TV monitor, which emitted in a closed circuit, in real time, what one of the cameras was recording. The absence of a conventional stage thus allowed more proximity for the observer while also opening two possible layers

of reading. In the late 1960s, investigations by international artists with closed-circuit systems in audiovisual installations were incipient and locally restricted—as was the case of Frank Gillete, Les Levine, Bruce Nauman, Peter Campus or Peter Weibel, concerning which Analivia had no news in Brazil. The way she used closed-circuit video in the context of video dance was, therefore, truly innovative.

It should be remembered that all of her first computer-generated video dances were carried out before her stay for studies in New York beginning in 1976 and, therefore, predate her direct contact with the contemporaneous aesthetics of Cunningham, Alwin Nikolais, Viola Farber, Jeanette Stoner and Gus Solomons Jr. in New York. Her only previous experiences with more cutting-edge contemporary dance had been in 1968, when she watched a presentation by the Cunningham Dance Company in Rio de Janeiro (which she mentions in our interview), and in 1971, when she was taking a course taught by Albert Reid in São Paulo in Cunningham's dance technique.[14] In 1976, still in São Paulo, she attended the dance course given by Kelly Hogan, a disciple of Martha Graham.

Here it is fitting to make a second parenthetical remark about a question that involves a certain paradox. On the occasion of Cunningham's retrospective at Walker Art Center and at the MCA of Chicago, in 2017, it was clearly stated that he was the first choreographer in the world to use a computerized system of movement notation in the creation of choreographies. The same affirmation was made in a documentary about Cunningham directed by Alla Kovgan, produced in 2019 to coincide with the 100th anniversary of the dancer's birth, and various dance theoreticians have reiterated this assertion. It has been documented that his first choreography in which he used a dance notation software, called LifeForms, was *Trackers*, in 1991. However, among his students at his Dance Studio in New York between 1977 in 1978 he had an artist—Analivia Cordeiro—who had already been using computer-designed choreographies since 1973 and had already produced various computer-based video dance works, years before she participated in the video dance workshop with Charles Atlas and Merce Cunningham Dance Studio in 1978. Since 1973, Analivia's pieces had been shown in important international events that brought together personalities active in the arts at that time, for example, in the international conference *INTERACT Machine: Man: Society*, in Edinburgh (1973), at the Bat-Sheva Seminar on Interaction of Art and Science, in Jerusalem, Israel (1974) (fig. 3), at René Berger's seminars at Université de Lausanne, Switzerland (1974), at an exhibition at the Institute of Contemporary Arts of London (1974), at the International Conference Computer & Humanities/2, University of Southern California, Los Angeles (1975), at the 20th American Dance Guild Conference, introduced by Jeanne Beaman, at the Massachusetts Institute of Technology (MIT) in Cambridge (1976), and at the WGBH TV Public Station, in Boston, which in 1976 broadcasted a television program in which *M3×3*, *Gestos*, and $0^o\Leftrightarrow 45^o$ were shown, to cite only a few examples of the channels of that time in which her video dances appeared (fig. 4).

Needless to say, the history of art should also be rewritten in a way that avoids the mere reconfirmation of preconceptions that still exist today, consistent with geocultural power strategies. Or perhaps they are due to unawareness (which is another form of disinterest typical of hegemonic thought) concerning the artistic production in other countries outside the axis of those who dominate the art market. With his characteristic keen insight, Waldemar Cordeiro observed that "every image is a problem of art criticism. Criticism knows next to nothing about this subject."[15]

Getting back to the previous theme: besides her training in various dance styles and techniques—from Laban, passing through Graham, up to the more contemporary ones of the time already mentioned—from the standpoint of the visual arts, Analivia Cordeiro had absorbed various notions developed by Waldemar Cordeiro in his theories and works, and also by the group of artists and intellectuals around Brazilian

14 Dancer Albert Redi was part of the Merce Cunningham Dance Company between 1964 and 1968, and traveled with it on an international tour in 1964, together with John Cage, David Tudor and Robert Rauschenberg.

15 Waldemar Cordeiro, "Transcription of Waldemar Cordeiro's Speech" at the NT5, Zagreb *Tendencies 5* Symposium, The Rational and the Irrational in Contemporary Art, June 1973 (*Waldemar Cordeiro Fantasia Exata*, São Paulo: Itaú Cultural, 2014), 530.

concrete art. This circle defended the notion that art had nothing to do with the reproduction or expression of forms (*Gestalten*) that were preexisting and independent of artistic activity, but rather that art's starting point and end purpose were situated in the creation of forms ("die Schaffung der Gestalten," according to Conrad Fiedler). Most likely, in the revisionist process of the more radical and somewhat inconsistent statements focused on the intended objectivity of his first phase, Waldemar Cordeiro, beginning in 1964, redefined his stand concerning what he denominated as "arte concreta semântica" (semantic concrete art), as well as other questions raised around what he called *arteônica*—beginning in 1968, his last artistic stage—dominated by investigations into computer art.

The notions of Gestalt were as important for the visual arts of that environment and time as they were for dance, and Analivia drank from the two fountains, filtered and leveraged by the concretist thought. Just remember that the first frames of the two faces painted black in *M3×3* are a discreet "homage" to the Gestalt principles, which belies any attempt to explain them in relation to the current identity theories, so much in vogue.

Elements of pop art, of performance art, and even combinatorial techniques emerge especially in *Gestos* (1975). In other words, Analivia demonstrates that she had interiorized and become confident of this "resemanticizing" path of concretism (as Augusto de Campos would say), to avoid falling into a purely formalist abstraction (which would invalidate some theoretic interpretations in this sense of her work) while working in keeping with the tenets of "nonfiguration," to use one of Waldemar Cordeiro's terms.

She was also aware at that time of the concern of the socio-scientific thought in relation to the second Industrial Revolution and to the beginnings of the postindustrial stage, whose forms of production, work and mass communication were modifying the social and individual behaviors, as well as the forms of consciousness (and of the unconscious). Cybernetic theory and the human-machine relationship were still being pondered in various sectors, and at that time found expression and ample debate in the arts and in new discourses of the Franco-Germanic informational, communicational and cybernetic aesthetics, with recognized impact on the circle of artists and intellectuals in São Paulo and Rio de Janeiro.[16]

Analivia, however, introduced into her investigation a new reflection focused on the implications for the human body of the effects deriving from that moment of sociocultural transition, a theme that was very much relegated by the intellectual circuit of concretism and also that of computer art and of informational aesthetics. It is also necessary here to relativize some interpretations that have ventured into projecting politicized discourses on the work she produced in her first artistic stage, attributing meanings related to the military regime that then reigned in Brazil. One does not have to be a specialist in the theory of the image; a good observer will perceive that her central artistic focus was not precisely to convey any sort of moralist criticism in the sense of what today is encoded under the mandate (if not the mantle) of the politically correct, which is, beyond being anachronistic, parasitic. Or, as her father used to say: "Art does not express, it is."[17]

The choreography of the above-mentioned *Gestos* (1975), also recorded in the studio of TV2 Cultura de São Paulo, can be considered a case apart, marking an experimental turning point in relation to the geometricism of the previous video dances. The bases for generating the choreographic elements were selected from printed mass communication sources, such as magazines of fashion and current events. The clippings of human figures or from news articles, brought

[16] It is worth mentioning the close relationship that the theorist of information aesthetics Max Bense had with Brazil and the circle of concretists from São Paulo and Rio de Janeiro. Concerning Bense's relationship with Brazilian art and intelligentsia, see Claudia Giannetti, "Tropisches Bewusstsein: Zwischen cartesianischem Projekt und Schöpfungsintelligenz" in Elke Uhl / Claus Zittel (eds.), Max Bense – *Weltprogrammierung* (Berlin: Springer Verlag, 2018), 169–180. It should also be borne in mind that Analivia Cordeiro personally knew other key thinkers of cybernetic and informational aesthetics, such as Herbert W. Franke, Manfred Mohr and Abraham A. Moles, as well as artists like John Whitney, Frieder Nake and Michael Noll, attending together with them the Bat-Sheva Seminar on the Interaction of Art and Science in Jerusalem (1974) and later events. For information on informational aesthetics, see: Claudia Giannetti, *Estética digital – Sintopía del arte, la ciencia y la tecnología* (Barcelona: ACC L'Angelot, 2002), German transl.: *Ästhetik des Digitalen. Ein intermediärer Beitrag zu Wissenschaft, Medien- und Kunstsystemen* (Vienna/New York, 2004); summary in English in: Aesthetics of the Digital (Karlsruhe: ZKM Center for Art and Media Karlsruhe & Goethe Institut, Germany, 2005): http://www.medienkunstnetz.de/themes/aesthetics_of_the_digital/.

[17] Waldemar Cordeiro, "Concretismo" (*Revista Módulo*, Rio de Janeiro: Avenir, 1959).

Fig. 4
Thirteenth Annual Computer Art Exposition, 13th Annual Art Issue for *Computers and People*, Vol. 24, No. 8. Newtonville: Berkeley Enterprises, August 1975, 8–9. © Archive ZKM | Karlsruhe.

together randomly and numbered, served as a substrate for the notation program. With this input, the algorithm generated, also randomly, the notations for the dancers' motions and their movement through the space. According to the artist, even though the types of gestures mimicked everyday, trivial movements, nothing was improvised during the execution of the dance. The conscious choice for the artificial and circumstantial ran against the grain of dramatic eloquence. The music by John Cage used in this piece, *Variations IV* (1963), was juxtaposed without any dialoguing intention. Originally used in the piece *Field Dances* choreographed by Merce Cunningham—which Analivia had seen in Rio de Janeiro in 1968—the musical score was also based on random spatial interplays. There was no aesthetic or dynamic of collage in either the notations or the choreographic fragments used by Analivia, just as the piece by John Cage had no aim of being a sound collage. Body and sound gestures are dissimilar and yet coexist in the space of the recording studio creating, harmonies within disharmonies.

Besides the world of dance and arts, her interest in spatial relationships and the dialogues between the human being and his or her various environments derived from her studies in architecture, which she made in parallel with those in dance. This becomes more evident in *Cambiantes* (1976), a piece that evinces greater choreographic, scenographic and videographic maturity, produced before her study trip to New York. The various planes of the recordings on a slight diagonal and at 45° accompany the movements of the dancers, who for their part play with the geometricism in right angles and diagonals of their gestures, contrasting in some sequences with contracted or distended body movements. Here, the contact of the bodies with the floor, which in $M3\times3$ had already been the object of the choreography, plays a more central role: some gestures are impelled upward from the floor, others collide against the floor or are developed on it. The architecture of the space is transformed through the scenographic design, based on irregular black polygons situated in the corners and in the frontal part, and in black segments arranged diagonally on the white background of walls and floor, reinforcing the sensation of continuity between the two. The intention to dilute the typical frontal view of the stage is reinforced by the costume design, also in black with white stripes and polygons on the legs, arms and backs, uniquely different on each of the four dancers. Both of these designs were planned to create effects of juxtaposition, superposition, and blending in the viewpoint of the cameras and, during the projection, the spectator's visual perception of the environment/space where the dance takes place. In this sense, the conceptual proposal was to visually interfere in the typical rectangular delimitation of the videographic frame. Here, once again, she goes beyond the limits of the background/figure antimony. According to the artist herself, the makeup on the faces bears a link with the geometric body paintings of the Xingu indigenous people, with whom she had stayed the previous year. The dynamics of the video editing accompanies the

transition elements foreseen in the composition of the dance and of the music of the same title composed by Raul do Valle.

With these bases, which are simultaneously diverse and surprisingly solid for a young artist, Analivia Cordeiro carried out an experimental work without allowing herself to be completely absorbed by any of the previous tendencies, while seeking for her own artistic conception. Considering the enormous financial limitations that artists with such innovative projects and ideas faced at that time, in hindsight it is admirable what she managed to produce in the span of a few years with such little resources and support.

Working on the frontiers requires the development of methods of communication between different parts, whether they are "instrumental"—devices and bodies—conceptual, or aesthetic. Achieving success in this dialogue means intertwining the languages, inventing nexuses.

On the occasion of my first direct contact with her work, still recognizing the importance of her technological research, it was precisely this transdisciplinary treatment of languages, her experimental independence, and her aesthetic approach which most caught my attention.

The strong nexus among choreographic and scenographic aspects allows us to see, since the first video dances, the importance of the aesthetics of visual arts in her production. Feeling the need to go beyond the specific world of dance and the spatial-temporal limitations, Analivia resorted to the new languages provided by technologies to bring about an expansion of the body's domains, its movements, and forms of communication.

In *Ar* (Air), a video dance from 1985, she worked with visual and spatial tension through the interplay between the actions in the field and off-screen. Part of the dance was executed by her outside the fixed frame of the camera, at its borders. Although the quality of the recording could be better, due to obvious issues of access to professional technological resources at that time, I consider it one of the key works, together with *Cambiantes*, for understanding Analivia Cordeiro's artistic attitude: using poetic resources to work along the borders of styles, constantly questioning them. Exploring the limits of the visual field to enter the world of the imagination; questioning the supposed perfections and the certain imperfections of human gestuality. The same off-screen resource was used in *Dance on the Paper*: a large part of the body is absent from the video frame and the final result is a dance of traces left on the spatial cutout (the paper), within which the body disappears although it is implicit.

Her scenographies and choreographies tension not only the physical space (for example the cube in her first works), but also the intimate space of the body explored with and for the camera—as she did in her video art pieces (which she calls *videochoreographies*) from her second phase, such as *Striptease* (1997), *Carne I*, *Carne II* and *Carne III* (Flesh I, II and III, between 2005 and 2009). In these works, the body is transformed into scenario and content, place and object simultaneously. Her images link the sensorial with the sensual through a nearly haptic perception of parts of her body or the dancer's recorded in extreme close-up. The synesthetic effects suggest a caressing gaze on a sensitive surface. Music, poems, urban and human sounds (with a highlight on breathing and exhalations) create interpolated associations. This organic imagery, counterposed to the aesthetics of her first phase, implies relationships between inner and outer, feminine sensibilities that go beyond the physical object to the point where the technical image is relegated to a second plane.

Starting in 2015, Analivia Cordeiro opened a new path in her research and work, based on the expansion of her single-channel videos in the physical exhibition space through multichannel video installation formats. She recovered the notion of the scene, the place where the actions take place, to once again go beyond it and make it accessible to the public. Facilitating the direct dialogue of people with the projected images became her guiding idea. *M3×3* and *Cambiantes* in installation format, both from 2015, reconstruct the cubic structure of the original scenario, now using three projections—two on the sidewalls and another on the floor—which invite the spectator to enter the imagistic space of the audiovisual projection and to dialogue with the work. With the interactive Nota-Anna-based audiovisual installation *Mutatio: Impossible to Control Just Contribute*, Analivia takes a step further, to integrate the movements of the audience within the computer-generated image. Shown in Paris for the first time in 2019, it offers the spectator the possibility to observe his or her own movements transformed into fields of color and shapes.

In the various facets of her work, the artist has prioritized human contact and, with these

installations, through a somewhat ludic aesthetics, fosters the direct contact between work and public. I would like to mention a statement by Waldemar Cordeiro, which I have cited in previous books of my authorship and which I've always seen as visionary for the time in which it was written, 1972: "The variables of the contemporary art crisis are the unsuitability of the communication media as conveyors of information, and the inefficiency of information as language, thought and action... The obsolescence of the communication system of traditional art lies in the limitation of consumption implicit in the nature of the transmission medium. The limited number of possible appreciators... is less than the quantitative and qualitative culture demand of modern society... Increasing the number of appreciators, the situation of culture becomes more diversified and the feedback more complex."[18] In the different stages of her production, Analivia Cordeiro has remained faithful to the need to develop processes and methods to respond to these concerns with the communication between artwork and the public. Questions that range beyond considerations about materials, techniques and forms and deal with the suitability of the projects to new languages (at the semantic and syntactic level) and to broader understandings (at the consciousness and ideas level). For reasons of consistency, such cares are also part of an artist's ethical responsibilities.

Another fundamental aspect of her artistic work centered on scenic dance and performance should be mentioned: that its preservation is complex due to its ephemeral natur. Except for the choreographic notation of *E*, the artist did not conserve other materials or notations of her scenic dances and performances, many of them based on improvisational processes. There is unfortunately little photographic documentation, which was recovered and reproduced in this book, although we are aware of the deficient qualities due to the loss of original media or materials. Likewise, no historical text from that time exhaustively treats on this facet of her creation, which requires not only specialized knowledge, but also the first-hand witnessing of those events. For having resided in Europe since 1982, I have not had the opportunity to keep tabs on that part of her work developed mainly in Brazil. Arlindo Machado mentions in his text the performances and/or choreographies that he personally attended: *VideoVivo* (1989), together with Otavio Donasci, *Unsquare Dance* (2007) and *Toca* (2007), together with João Penoni. I invite the reader to consult his text reproduced here. More recently she has been developing a performative work in collaboration with young artists and with urban dance, as she does in *Small Talks* (2022).

This vast listing of works is capped off by her artistic photographs, her works in visual arts and the above-mentioned series of computer-design sculptures based on Nota-Anna (2015–2018), concerning which two texts by Analivia reproduced in this book—*The Architecture of Human Movement* (2018) and the text about the *Unforgettable Kicks* series—provide ample information (figs. 5, 6).

The observation, interpretation, and perception of Analivia Cordeiro's work require a approach to the notion of gesture.

In his phenomenology of gesture, the Czech philosopher who lived for more than 30 years in São Paulo, Vilém Flusser, states that every human gesture implies a symbolic movement. Their complexity of meanings is so vast, there is no theory for the decoding or universal causal interpretation of gestures. Therefore, their sphere of action and communication has been defined by cultural conventions and is based on intuition. Conventions and intuitions, for their part, are subjective and simplified. This does not diminish the importance of gestures and the power they have on our bodies and thoughts.

Flusser did not write about the gesture of dance, one of the most important facets of interhuman communication in the configuration of cultures. The gesture of dance can be expressive and poetic, without necessarily being emotional. The contrary is also true: an emotional gesture is not necessarily significant or sublime. There exist precise gestures, also everyday and trivial ones—which contemporary dance has been exploring—but we cannot state that pure or objective gestures can exist. This does not prevent us from apprehending them or feeling them, usually without completely understanding them. The movements of dance can be energetic, crude and constricted, or smooth and harmonic, which involve eloquent, harsh, voluptuous or pleasant, and relaxed, mild or symmetric

[18] Waldemar Cordeiro (ed.). *Arteônica – O uso criativo de meios eletrônicos nas artes* (São Paulo: Editora da Universidade de São Paulo, 1972), 3 (free translation).

Fig. 5
Poetics of Movement, 2018. Alumide, 23.45 × 19.88 × 11.73 cm
Photographer: Edouard Fraipont

Fig. 6
Poetics of Movement, 2018. Sculpture digital sketch side view.

gestures, respectively. Communication by way of the alphabet uses an ordering of precise letters that can be repeated with preciseness, something which Analivia Cordeiro explored in *Alegria de Ler* (Joy of Reading), 2010. On the contrary, in dance, the gestures can be analogous or similar, never identical and invariable. They are always interpretive and individual movements, which therefore play with imperfection, randomness and subjective improvisation. The movements of dance imply technical mastery and physical preparation, however even though the dancers master them, their gestures do not have the same aesthetic qualities and they have differing capacities to execute them. Imagination stands above technique. Moreover, in communication through dance the vision of the gesture implies a hermeneutic observation for its assimilation, which adds a degree of complexity, since the mind thinks in images and interprets them according to individual experiences and knowledge.

The gesture, perhaps more than any other form of human communication, involves time and space; the spatial-temporal relationship of the body movement is its quintessence.

Her performances are concomitant to the spaces they occupy and simultaneously transform. Analivia is an artist of compact spaces and times. Those of us who work with music and literature know that the shorter a work is, the denser and more difficult it is to produce. Each note, each word assumes a specific weight. It is no different in her video dances, some of them a few minutes long: each movement, each corporal rhythm, each gesticulation lends the piece a particular character.

In this sense, when a dance manages to transmit new knowledge or awaken certain sensations or sensibilities through the set of movements foreseen in the choreography—as in the case of Analivia Cordeiro's video dances—these enter into the sphere of arts: the gestures of creation.

How far the algorithms can reach in regard to these and many other parameters that are beyond our scope to discuss here, without a doubt was and continues to be a question that drives artist-dancers, like Analivia. In her many years of creative experience, it is clearly perceptible that the ways Analivia has used technologies has always been suited to the intervention, dialogue

or collaboration with the body, with the gestures of the body, rather than the inverse.

Each human gesture implies the use of existing codes or the creation of new ones. This means that the body's movements are developed through codes and, at the same time, embody them. Analivia wrote: "The individual freedom has a meaning when, through a loop feedback, it modifies the program itself."[19]

Analivia Cordeiro starts from the body to go further into the world of codes, not to restrict herself to their formalising rules, but rather to expand them and, once modified, to re-embody them in art.

For that reason, the book title should necessarily imply the inverse action: from code to body.

Translation from Portuguese: John Norman

Fig. 7
Photograph of the audience interacting with *BodyWay Nota-Anna* app in the exhibition *Analivia Cordeiro – From Body to Code*, ZKM | Center for Art and Media Karlsruhe, 2023. Photographer: Felix Grünschloß. © ZKM | Karlsruhe.

19 Analivia Cordeiro, 1973, op. cit., 2.

Analivia, 2020.
Photographer: Bob Wolfenson.

Analivia Cordeiro and Claudia Giannetti
Conversation

Claudia Giannetti. Besides important photographic documentation of a large part of your oeuvre, in this book the readers will find a representative compilation of historical and contemporary texts about your first videographic works. Also texts written by you, which are essential for understanding your works as well as your investigations. On the international scene, your historical work from the 1970s and 1980s is garnering increasing recognition. Your more recent production, however, is less known. To offset this lack of information I would like to begin our dialogue by focusing attention on your works created in the 21st century. What motivated you to create the series *Dancing on the Paper* begun in 2017, which unites the movement of the body with painting on paper?

Analivia Cordeiro. The excessive dependence that technology has created in people made me ask what would happen if, one day, technology were to fail. The answer was that the people would have only their own body left. So I made *Dancing on the Paper*, which are paintings created with the body without using any electronic or mechanical instrument. There is a fundamental question in this creative experience, which has some antecedents in 20th-century art, and from even before that. Actually, since the time that humans lived in caves they have used their own body for printing and creating art. In my case, recovering this form of expression requires a re-evaluation of the gaze and of human comprehension in relation to the shapes drawn by the body, which are very imprecise. The line drawn by the body is never a perfect line from the geometric viewpoint. For me it was very challenging to show the public something that could be considered visually imperfect. At that moment I began to understand that, even though perfection does not exist, there does exist clarity of message, insofar as people see the geometric shape even when it is imperfect.

2.

CG. These works allow us to visualize the process of painting through the movement of fingers, arms and the body in general. Something that may at first sight appear trivial acquires a visual poetics that can surprise the spectator. Is this a way to bring the public closer to the pictorial potentials of movement?

AC. I seek to promote the public's identification with the result, a personal identification, open to anyone. Everyone can draw a circle with their arm—it's just a matter of holding one's shoulder steady while extending one's arm, using the shoulder as a compass point and the hand as the compass tip. This is something very important for me, because I have always believed that people can create admirable things, even if they are not professional artists.

Furthermore, it stimulates young people to look at their own body as a tool of free experimentation, far from the prototypes of beauty and aesthetics spread by the mass media. This is a questioning which, in the future, can bring positive results for people as well as for technology itself. After all, we are still made of flesh and bones.

3.

CG. A common denominator in a large part of your work is the investigation of movement. In your first works, computer systems played an important role in the systematization of notations of the body's movement, which were then used by the dancers during the production of the video. There was a certain virtuality in the process of the work's conception. Now, with this series, physicality prevails together with freedom of movement. How did you arrive at this exercise of translating the body's dynamism into a pictorial language?

Body Prints Black (*Dancing on the Paper* Series), 2018.
Gouache on paper, 96 × 66 cm
Photographer: Edouard Fraipont

AC. I explored the possibilities that exist in different methods of registering movement using paper and paint. I perceived that the various ways of moving the body generate different paintings, which can be classified according to the various artistic trends.

I can make a constructivist or concrete work with the parts of my body if I trace out a nearly perfect circle using my arm as though it were a compass and the tips of my fingers like pencils. That is what I did. If I use my body to create splotches on the paper, I make an informal art. If I put the paint on the end of my hair tied in a ponytail and begin to make movements with my head on the paper, the result looks like a work by Pollock or a tachist artist.

It was very interesting to perceive that, through the body's movement, we can create works close to the various trends of painting. In the future I want to explore this in greater depth.

4.

CG. What is the role of video in the context of that series? Does it function as a documentary record or is it conceived as an independent audiovisual production?

AC. The videos that accompany those paintings establish an audiovisual dialogue between the painting and the body, and they record the process through which the drawing becomes independent from the body's movement. The recording captures specific details of the body painting and the gesturality, for example, of the fingers and toes, each with different pictorial results. The control of the hand's movement is much more exact than what can be done with the outer edge of the foot, even in my case, trained as a dancer to move my legs with a certain precision.

The soundtrack of each of the videos is another element that conveys a poetic message according to the type of body movement and the resulting painting. For example, when I produced splotches in one of the paintings, in its respective video I chose sounds of animals in the forest; when I created a perfect circle, I used electronic sounds.

5.

CG. Two years before your work on this series *Dancing on the Paper* you researched and created sculptures based on the identification and later segmentation of the lines of body movement, to achieve compact three-dimensional forms that represent them. Were those a result of your research with the software for making notations that represent the human body's movement, Nota-Anna, which you conceived and programmed together with Nilton Lobo starting in 1983?

AC. Yes, the sculptures signify a synthesis of decades of research related to the process of writing down movement. I investigated the development of a technique to facilitate the reading of the graphic result, to allow the user to reproduce or analyze the movements. That comprehension should be as simple as writing a word, a skill that any person could easily make part of his or life. That's what our research into Nota-Anna was about. In 1983, when I met Nilton, I invited him to be my trainee and researcher in the technological development part, which would have been very hard for me to do alone. It was so pleasant to work together that we ended up getting married and starting a family. Actually, Nota-Anna is one of our "children."

The idea of transforming that writing—that is, the traces of the lines of movement in space generated by a computer—into sculptures is an old proposal that I had twenty years ago. But back then, techniques for tridimensional manufacture were still not sufficient for creating a precise result. When the 3D printers appeared I was able to materialize my idea.

The shapes of the sculptures arise from the computerized and segmented notation of the movement, that is, of the writing of the movement, that I interpreted in various ways. It is important to underscore that each one of these segments of movement corresponds to a frame of the video of the original movement. For this process, since 1983 video has become a tool for conducting my research, more than a means of expression.

This way of understanding human movement is actually an age-old idea: the ancient Greeks used to say that to dance is to draw in space. The very concept of choreography means the art of representing a dance through signs, just as music is represented through notes. Science has proved the existence of retinal persistence, which allows us to see a series of still images as a continuous movement through time, for example in film, where we see a sequence and not a succession of separate frames. Nota-Anna is based on this notion. The evolution of the available technology allowed us to transform these notations into material, tridimensional objects.

6.

CG. Could you explain your *modus operandi* for working with these sculptures?

AC. We use the Nota-Anna to transform a set of graphic plans in the computer into a physical object. This requires mathematical calculations that convert the tridimensional forms of the movement into instructions for the modeling of the sculpture in the 3D printer.

From an aesthetic point of view, the conception of the sculptures conserves the movements' organic plasticity. In this sense, I do not begin with a "classical" drawing, that is to say, with defined circular, parallel or straight lines. The materialization of the movements is directly related with their reality, while also bearing in mind the possible geometric imperfections of the gestures of a real body. For example, I segmented a circular line into polygons without deforming it mathematically; the drawing of

Body Prints White (*Dancing on the Paper* Series), 2018
Gouache on paper, 96 × 66 cm
Photographer: Edouard Fraipont

a circle is not totally perfect; a line can appear parallel even if geometrically it is not. In the 3D plans, the internal lines correspond with the center of the body; the movements of the feet and hands are external lines. All the adjustments are made mathematically.

The choice of making the sculptures on a small scale was made with the aim of encouraging the public to physically approach the pieces, to observe them up close. This sort of intimacy does not arise with a large sculpture. On the other hand, people are already being so overwhelmed by the media blizzard that it is necessary to work in the opposite direction: the small dimension.

7.

CG. Could we say that your sculptural work is based on a need or desire to visualize, to materialize the invisible?

AC. In 2016, after making the sculptures that describe the movement, I was very much impressed with the formal similarity that exists

I Saw It, 2016.
Black polyamide, 24.80 × 13.98 × 25.20 cm
Photographer: Edouard Fraipont

I Saw It, 2016.
Sculpture sketch. Digital drawing.

between the abstract forms of nature and the sculptures that I created. I did some research and found images of cells and bacteria made by the new electron microscopes. I saw that those images, which showed human tissue extremely close up, often bore great similarity to the works of abstract and concrete artists from the 1920s onward.

Based on that observation, I began to think that those images obtained by the electronic instruments or sensors that capture movement show a real shape, although it is invisible to the human eye. That is to say, visible only to us today, with the advance of technology. A question is raised: how did the artists from the first half of the 20th century create images so similar to the images of the current electron microscopes? Was it by chance? Or, as some mathematicians suppose: has this reality always existed, and we are discovering it more and more over time?

This makes me wonder if technology helps us to unveil what we are at the deepest level, to see what we perceive indirectly and to advance beyond the evident visual-auditive reality of our body's sensory apparatus. And whether technology helps us to capture a more introspective and profound visualization. The greatest evidence is when we meditate, we can "see" abstract images that are not part of reality. Are they akin to abstract art or to the images made by electron microscopes? Or to both, only separated by history?

8.

CG. Where did the name Nota-Anna come from?

AC. "Nota" [note] comes from the notation that is related with writing, in a certain sense. Anna is the name of my grandmother, who played a key role in my upbringing; she transmitted confidence to me and gave all her support, attention and love. To her I owe all my willpower to dedicate myself to what I wanted, and to take on the many challenges.

9.

CG. Could we establish a relationship between this process of abstraction and the method you developed for the symbolic formalization of movement using a computer?

AC. The Nota-Anna computer outputs show the lines traced by the body's articulations in space. This corresponds to an abstraction, which visually reveals the ephemeral movement. I was very impressed by these images and discovered that, to advance this research, I would need to delve more deeply into the study of the sensorial perception of the human body; I needed to learn about the subtleties of not only the visible movements, but also the internal ones within the body. For various years I practiced the Feldenkrais Method as well as Eutonia, which is a very complex technique for corporal harmonization. I still practice these methods today. At that time, these techniques opened new perspectives for me to feel my body as a single mental and sensorial whole: what you feel affects your mind, and what you think affects your sensory perceptions. This knowledge exerted an important influence on the creation of my video dances from then on—I am talking about the years around 1985. I began to integrate processes that were more intuitive and introspective than before. Good examples are my works *Striptease* and *Flesh I, II* and *III*.

10.

CG. You say that there is a corporal intelligence that should be listened to, used and improved. In our bone structure, the role of the spinal column is essential. It's what allows us to maintain our body erect. Throughout your career as a dancer you perfected techniques centered on this architecture of the body. Was this one of the pillars of your activities as a teacher? Speaking metaphorically, what would the "spinal column" of your artistic work be?

AC. I like to cite a poem that Walter Franco wisely put into his song: "Tudo é uma questão de manter a mente quieta, a espinha ereta e o coração tranquilo." (Everything is a question of keeping your mind quiet, your spinal column erect and your heart calm.) He correctly uses the term *ereta* [erect] rather than *reta* [straight], as most people do when referring to the spinal column. Straight denotes a line that connects two points without curves, an incorrect idea for our body or our spinal column. Erect presupposes a line with curves linking two points. Thus, the erect spine is a line of mobile bones with natural curvatures that link two points, the head and the hips. The spine's mobility is essential for the preservation of health and for emotional free expression.

Responding to your question about the "spinal column" of my work, all of my production is related to the human body and the body language. The use I make of technology—often the cutting-edge technologies of the moment—is focused on the investigation of body language, seeking to reveal unknown facets. The digital instruments help me to visualize what is impossible for the naked eye to capture, even though our perception registers it. In my researches I therefore relate body language with technology, always respecting our physiology. Physiology in the sense of the body's functioning, well as the emotions that are expressed through movement. As a biological manifestation, our form of "expression" is related to our experiences in the world. The current technological instruments can be an ally to the body, and help us to refine our auditory and visual perceptions. The sense of smell, the sense of touch, and the sense of taste are still little explored.

11.

CG. How are your studies in architecture and the notions of the planning and design of constructions related to your interest in the body?

AC. That is a very interesting question. The body's relationship with space is not produced from the inside out, nor from the outside in. It is a relationship of belonging. Each person relates with space in a very personal way. A professional classical ballet dancer, with good training, can expand his or her personal space all around, 360°, while in the case of expressive dance, the personal space can configure a very intimate smaller space. The use of video allowed these corporal spaces to be recorded, and this gave rise to a true evolution for the analysis of expression.

In architecture, space is created for the person. For example: when one wishes to convey the corporal sensation of a fresh and well-ventilated space, it is necessary to plan for large windows that allow for direct lighting as well as air circulation. To design a kitchen in a house it is essential to know whether the residents will use it as a place of shared life and encounter (which is how it was in my Italian family) or simply for the storage and preparation of food.

We thus see that the body, its needs and conditioning factors directly influence the architectural planning. When I design the architecture

of a house, I pay a lot of attention to how the residents want to feel within those spaces, and I intuitively deduce the ways their bodies will behave as they inhabit those spaces.

12.

CG. Unlike architectural construction, dance and performance art are transitory and hard to make precise insofar as they involve countless variables. One of the possibilities for systematizing them is through their codification, which involves the understanding of their meanings as well as their interpretation. With Nota-Anna you created an instrument for the schematic recording and visual description of movements to be applied in various areas, especially in choreography. Did your concerns include the need to control the body and the invention of a way to deal with the potentialities of "loss of control," as for example, improvisations or random choices, also made by the software itself?

AC. The question of control is a subject that has permeated human existence since its outset. It is an extremely complex subject. Control and, at the same time, individual liberty are some of the most serious themes of our current society from a behavioral point of view. People are surrounded by technology. Without a doubt, technology interferes in human behavior, in our perceptions, and especially in our forms of expression. When a person types a text on the keyboard of a computer or cell phone, or when one takes a photograph, one is in the presence of a frame that is always rectangular and the image has to fit within that rectangular space. The person has to follow the rules imposed by the technology, and at the same time, to find his or her personal and individual expression within those rules. This is the true current challenge. I have often dealt with this subject and it was also considered in the programming of my computer-dance notation software.

13.

CG. Every process of encoding requires, for the observer, a work of decoding. On the one hand, the program controls the formalization of the movement and, on the other, the dancer has freedom to translate the graphics or the notation according to his or her understanding, his or her feeling and creativity. How do you understand this relationship between control and creative freedom?

AC. I never intended to create a system, a writing, or a communication of movement that would put the dancer into the position of a simple reproducer of the movement proposed by the computer. Rather, I furnished the information which, at the time, was technically possible. I also made the purposeful decision to leave other information open for the performer to add something, create his or her own personal style during the execution of the movement. Therefore, I defined certain positions that his or her body should adopt at a certain moment and place. In moving from one position to another, the dancer had total creative freedom. So the same notation can give rise to different dances. And that is what happened. For example, I used the notation from $0°{\Leftrightarrow}45°$—which was a solo—in a performance. Other people also use it to produce dances with different results. In one of them, a dancer, who was also an athlete and surfer, transformed the choreography of $0°{\Leftrightarrow}45°$ into a very fluid dance probably due to his corporal experience with the sea.

Individual expression finds itself restricted to a series of rules and it is a true creative challenge to achieve personal styles based on the indications proposed by the software. The proposal of this computer-assisted choreography still exists and is meaningful until today, but it can be interpretated by the spectators in different ways. For example, in my video-dance work *M3×3*, some people who have watched the video have thought that it was made recently. Indeed my historical works are couched in questions that are still very present in our current society.

14.

CG. It is as though you were seeking more than a dialogue, a true symbiosis between freedom and control.

AC. The freedom/planning dyad has permeated my entire career, as it has permeated all of our society until today. Technology is essential for human life. This reality challenges people to assume a position that is suitable and emotionally fitting in relation to the rules imposed by technology, leading them to create behavioral alternatives. I therefore understand the meaning of my work far beyond art and aesthetics.

15.

CG. In fact we can consider your works from the 1970s and 1980s as portraits of a very important moment of transition in industrialized societies, which evidently also affected the aesthetic conception. How did you consider the impact of the electronic and informatics technologies in the cultural field and also in your own artistic background?

AC. In artistic terms, adopting a new system of creation requires the proposal of a new form, a new visual result, in my case, dance. I should mention that, before beginning my own artistic production, I decided to study what had taken place with dance up till then. I saw that both painters and sculptors had offered a transformative response to the new reality of industrial society. But in terms of dance, the artists who meant a lot to me, like Oskar Schlemmer, although they made a significant contribution, had never reached the point of proposing a radical change in the language of dance, as had occurred in the other arts.

I understood that, to use the computer or an electronic means as a partner in my artistic creation, I would have to modify the body's language. I thought it was a little pretentious and to a certain point questionable to re-create what already existed, as many artists and scientists were aiming to do when they tried to simulate reality at that time. For me, a re-creation of reality could only be a verification of the effectiveness of the software, of the effectiveness of the electronic medium through the algorithms created by humans.

So I decided to adopt a system based on geometric lines that would work on the movements of the parts of the body to translate them into computerized information. It was, in essence, the visuality of industrial society itself. The straight lines, the squares, the triangles seen in constructivist art, for example, did not exist as an aesthetic formulation before industrial society. Fifty years ago, the individual/mass binomial was a hotly debated issue: what sort of stand should the individual take in relation to the process of massification. My work is in strict relation to these questions.

My idea was to create an expression of the body that would correspond to the strong intervention of electronics in society. I did this fifty years ago. I was radical. I did not want to simply reproduce the movements linked to dance that already existed.

My choice was to use video as a medium or mediator between the vision of the spectator and the dancer. It meant working with a medium that would be generating, coordinating, defining, formatting the expression of the future.

Currently our society and information systems are largely based on audiovisual communication. When I observe the dance of young people today, for example, breakdancing or pop dance, I identify elements that I used fifty years ago: discontinuous stop-motion movements, precise movements which to a certain point were nearly robotic. Without implying any comparison with the robots that have limited and poor movements.

16.

CG. Between 2005 and 2009 it seems that you went to another aesthetic extreme when you made the videographic works *Carne I* (Flesh I), *Carne II* (Flesh II) and *Carne III* (Flesh III), which you mentioned before. You thus got away from the predefined, nearly programmatic choreography of the computerized notations to enter the territory of the sensual, of maximum corporeality, informality and improvisation with the camera.

AC. With the three *Flesh* videos I sought to communicate something that I had always felt when I danced, since I was a child, but which was impossible to transmit on stage. I was never a "dramatic" dancer, so my personal emotions were communicated in a very subtle way.

When the new portable video cameras allowed for extreme close-ups using high-definition technology, I understood that it was the moment to experiment with the recording of details of the body. My proposal was for the dancer to film herself in a situation of maximum intimacy. For this to take place in an artistically interesting way, she was situated inside a cube with a totally white interior. It was a small cube built with fabric to create an intimate environment. So that the camera's focus could follow the movements of the dancer's body, she needed to move slowly and the camera needed to focus on small-scale fragments of the body. That intimacy and small scale were what allowed me to achieve a completely unique aesthetic result.

When I saw those videos of the parts of the body, with the different color tones and lighting, I understood that I had managed to capture

0°⇔45° Version I-G, 1974.
Scene and Costume Sketch I – Possibility 1G.
Pencil drawing on paper, 7.4 × 9.0 cm

living, subtle, seemingly abstract, and unrepeatable organic images. The soundtrack was made in strict syntony with the visual experience: it was concentrated basically on the breathing.

The most interesting thing is that the public, when they watch these videos, have very different reactions: some people feel uneasy or evince a certain opposition. Others, on the contrary, feel comfortable. This means that the video transmits sensations that each observer absorbs or rejects in a highly personal way. For the first time, my videos provoked a clearly emotional reaction in the viewers, which was the aim of these works.

17.

CG. You tell in your biography about how your dance teacher, Maria Duschenes, brought you in 1968 to watch a presentation by Merce Cunningham and John Cage in Rio de Janeiro when you were 14 years old. Much later, in 1977, you were a student of Merce Cunningham in New York. It is well known how this duo of North Americans, a dancer and musician, respectively, were keenly interested in incorporating random methods into dance and into composition—chance occurrences and randomness—and made great strides in strengthening the relationship of music and dance with the visual arts. How did these methods influence your interest in these questions at that time?

AC. At first, what most impressed me about Cunningham was the lack of organicity in his movements: it was a nervous motion that conveyed the neurotic condition of the inhabitants of the big cities. At that time it really impressed me, that discontinuous, interrupted, incisive rhythm, which at times was even "disjointed." That enchanted me. I had come from a more harmonic and very physical background. Although I was still very young to be able to delve more deeply into the intellectual question, I perceived the potential for the radical dance he was proposing. But it is important to remember that, when I studied with him in New York in 1977–1978, I had already created, some years before, my computer-based video dance—*M3×3*, *0°⇔45°*, and *Cambiantes*—which were very advanced for their time.

At his studio in New York the training was very technical. They were arduous physical exercises, very difficult and demanding, which required absolute dedication. His technique is truly painstaking. With my dedication I obtained good results: he chose 18 students to participate in a video dance workshop with Charles Atlas, and I was one of them. This was when I had the greatest personal contact with him. I admired his sense of humor and his playful side: he had a lot of fun. Despite being very demanding, he had an admirably human and open side.

About the question of randomness, it is known how both Cunningham and Cage re-searched the idea of *I Ching* and incorporated

it into the language of dance and music. For me the most interesting thing was how randomness became an inseparable part of their language and, therefore, it was present in the everyday practice of the classes.

18.

CG. Another contribution by Cunningham, together with John Cage in the 1940s, was to liberate dance from the obligation of following the rhythm of the music: they could both co-exist independently. In *M3×3*, in a certain way, you were already putting this into practice, using a metronome—the *sine qua non* instrument for controlling the tempo and marking the rhythm in a musical performance—as a single sound element, whose beats nevertheless do not precisely govern the dancers' movements.

AC. As the computer-based notation was transmitted through static stick figures, the dancers had to create a connection to link their physical dance in real space with the positions defined by those schematic drawings proposed by the software. For this it was necessary to develop and apply creativity to their own movements. This was a positive aspect in this work: it made it possible to integrate the chance of creativity into the rules imposed by the computer and into the rhythm defined by the metronome. Therefore, in *M3×3* we had a certain freedom to act outside the tempo marked by the device.

19.

CG. Another of your great concerns was related to socio-educational questions. Various of your projects that use the online and mobile platforms aim to engage with a broad public and offer educational content free of charge. A good example is your production *Alegria de Ler* (Joy of Reading, 2010), your Portuguese literacy course in video format, which you uploaded to YouTube. Other examples are DJ Mobile, an art app you created together with Nilton Lobo in 2005; and maybe the most ambitious of them all, *DuCorpo*, produced in 2004, which consists of classes recorded on video and made available online to provide body training and education of body movement, which aimed to reach the social segments who could not afford private classes.

AC. For anyone who lives in Brazil and has the opportunity to travel, to visit other countries, the social question becomes evident. An important thing is the attitude that the person takes as a consequence: one either takes a stand or becomes alienated. Moreover, I lived for a time outside the urban environment and, as an architect, I had contact with the construction workers and observed their educational limitations. Such limitations are cruel, they force intelligent and skilled people to live in an unsuitable way, without the possibility to develop their potentials.

In this regard I am a nonconformist. I think that the various technologies and the telecommunication media can aid in dissemination, but dedication is needed. I dedicated my time, for example, producing 242 videos to teach people to read and write, with good results. With my experience as a teacher I was always aware of the need for body training, but the public school system is deficient in this; generally, only expensive schools provide quality teaching. So why not provide this education free of charge to everyone on Internet? I produced *DuCorpo* in 2004 and people are still watching the videos today.

Those works have a clearly social aim and I consider that, in this way, I contribute to the betterment of society not only as an artist, but as a human being.

20.

CG. Since 2019 and up to the current moment, you have been developing, together with Nilton Lobo, a system of social communication based on Nota-Anna, which you call *BodyWay Nota-Anna*. This is your most recent work. Could you explain what that consists of?

AC. My attitude in relation to the art-technology question is that I am against the acrobatics that most of the artists go through to appear up to date with the new products. Although my most recent researches have been related to advanced technologies, such as artificial intelligence (AI), I continue to be concerned about the relationship between communication and the body. *BodyWay Nota-Anna*, as the title says, is concerned with the body's behavior. It is a mobile application that I always imagined, since the beginning of my researches concerning the writing of movement. My final aim was always for Nota-Anna to something that could be used by everyone, as a communication tool. And now, precisely on the occasion of this solo show at ZKM, this goal has been achieved: we are presenting, for the first time, the finalized

M3×3, 1973. Computer-based video dance. Mono-channel video (black and white, sound) transferred, through filming, to 16mm format. Film frame. Vladimir Bonačić Archive – ZKM | Karlsruhe.

BodyWay application. It was developed by Nilton Lobo and the company Obi.tec for various platforms, both cell phones and computers. Using AI systems, Nilton managed to create a system where body movement can be captured without the use of sensors; and through Nota-Anna software, the movement the person records on a cell phone is transformed into visualizations of the capture of those movements with various graphic modes. The user can thus choose between various sounds, different landscapes, and can also include comments in this movement capture. Movement is thus transformed into a form of communication, which the user can send by email, WhatsApp, TikTok, or post on Facebook—in short, publish it on the social networks. The idea is that the person who receives these video shorts can respond with the capture of other movements. In this way a dialogue is created solely through movements, without the use of words. Communication on the social networks in general is based on standardized systems. However, the movement that a person makes is individual. For my part, as mentioned above, I am fulfilling the proposal of transforming Nota-Anna into a communication system. On Nilton's part, as a computer scientist, his aim is to create a system of motion capture based on images, without the use of sensors. Obi.tec implemented the application for smart phones. It is a great leap.

21.

CG. This year, 2023, is the 50th year since the creation of *M3×3*, one half-century of a career dedicated to dance and to art. It is also the year of your first large solo show, which not only presents your historical works, but also others being shown in Europe for the first time, along with documentary materials concerning them and your most recent projects. For me it is a true privilege to be the curator of this exhibition and the editor of this book, as in both I am gaining valuable knowledge about your work and your thought, and about you as a person. At this stage, which we can call the third stage of your career, what does this exhibition project and book mean to you?

AC. Most essentially, they are a learning moment. When a work is finished, it begins to exist in and of itself. The artist, as a person, becomes a spectator of his or her own work. That's how I feel: I look at what I have done as something that I appreciate just as much as any member of the public.

During my work together with you—as you are someone with an art historian's perspective—I learned to see my work from a historical standpoint. I began to see all the time that went by, from the outset of the work till now. And, often, even I myself find it hard to believe that I produced these very radical and profoundly intuitive works.

Studio portrait of Analivia Cordeiro, 1992. BW photograph, gelatin silver print, 19.9 × 29.8 cm.
Analivia Cordeiro Archiv, São Paulo. Unknown photographer.

Another aspect was to understand the value of the restoration and conservation of artworks. Even though the work has by now spanned a very a long time. It changes with time, both physically and conceptually. Its meaning is constantly updated. This is very interesting: it demands objectivity and, at the same time, love and affection. I have learned a lot in this period.

This interview was conducted through videoconferences between Barcelona and São Paulo, through writing, and through audio recordings during the months of September and November, 2022.

Translation from Portuguese: John Norman

TEXTS BY ANALIVIA CORDEIRO

A LANGUAGE FOR THE DANCE

Analívia Cordeiro

In my father's memory

1. Introduction
 1.1. Technical Features of the Program:
 The goal of this dance is to program by artificial means the visual features of human movement. The dance is equated specially for TV set - artificial channel - and the spectator's eye - natural channel. The image to be transmitted is a combination of the changeable elements which form a dance: movement quantity by time unity, dancer's movement in the tri-dimensional space and spectator's point of view. The programming method codifies the dance in three factors: 1. the dancing event; 2. the transmission; and 3. interactive system dancer-TV.
 - to be considered: 1. the camera as dynamic spectator; 2. the movements of the dancer; and 3. the output as the members of the team performance program, including dancers and technicians, software and hardware.
 Summarizing:

From this point of view, the dance doesn't manifest metaphorically the expression of the feelings. The dance communicates objectively by the possibilities of movement of the human body in time and space.

1.2. Operative Features and the Dancer

The practical execution of the program includes the dancer's performance/creation. The human movement is defined by three changeable elements: muscular effort, rhythm and course of movement in space. A dance notation may provide the complete movement, defining the three changeable elements, or leave one or two opened for the dancer's choice. In this case, the rhythm and the positions that the dancer must assume in a given time are defined. The dancer may choose the muscular effort that he wants. The program/operative development relationship is not determinist. The problem is not to make a movie cartoon with real dancer's! To equate a dancer's way of walking is the same as make him an animated character of a movie cartoon. The individual expression is to create inside a dance. This particular feature leads us into general considerations. It comprises a new meaning of the planning/individual freedom relationship. In this proposal, the programming involves greater individual freedom. The individual freedom has a meaning when, through a loop feed-back, modifies the program itself.

Thus, completing:

D1: Did you like the dance?
D2: Did you like to see it?

2. The Program
 2.1. Factor 1 - The Dance Event Program:
 2.1.1. Digital action of the environment-dancer as a matrix:
 2.1.1.1. The row specifies the levels in the space of the movements:

 ☐ erect position

 ⊟ seated position

 ☰ laying-down position

 2.1.1.2. The columns specify the rhythms:

 ☐ 6 movements/minute

 ⊞ 15 movements/minute

 ⫴ 60 movements/minute

 2.1.1.3. Each dancer is a number which level and rhythm are constant, like this notation:

 1 ☐ 2 ⊞ 3 ⫴

 4 ⊟ 5 ⊞ 6 ⊞

 7 ☰ 8 ⊞ 9 ⊞

 2.1.1.4. Matrix level 0 (position + level + rhythm of each dancer)

2.1.2. The dancer displacement by arithmetic operations starting constantly at the end of each operation, from the matrix level 0:

2.1.2.1. A representation in planimetry of the positions:

level 0 level 1.1. level 0 level 2.1.

2.1.2.2. A representation in the planimetry of the displacements:

2.2. Factor 2 - The Transmission (TV)

2.2.1. The timing of each shooting gives the spec tator the sense of programmed rhythm. The The shooting times are measured according to a G.P. (Geometrical Progression), ordered at random.

2.2.2. The three camera focusing for each shooting time are chosen at random, obeying the following probabilities:

camera focusing	probabilitie
front	30%
side	30%
above	40%

2.3. Factor 3 - Interactive System Dancer- TV

 2.3.1. A codification of the position of the human body limbs, according to angles for each camera focusing:

 2.3.2. Random choise of one possible position of the dancer's limb, according to the TV camera focusing.

 2.3.3. Relationship among the chosen positions of the dancer's limbs.

2.4. For instance: Notation of the Output:

 2.4.1. Sequence of the single dancer positions

2.4.2. Drawings of the dancer'groups.

In over view

Another sequence in front view.

3. Operative Experiment
 The dance TV characterizes itself with a high contrast bi-dimensionality. This feature opens in the notation objectivity several movement possibilities for the dancer.
 For instance:

- position notation with a TV camera in over view
- some movement possibilities of the dancer of this position notation

This feature evidences how and why operative experiment is the moment of the individual freedom.

COMPUTER GRAPHICS AND ART

VOL. 2. NO. 1

FEBRUARY. 1977

THE PROGRAMMING CHOREOGRAPHER

by Analivia Cordeiro
905 West End Avenue, #123
New York City, N. Y. 10025

The author, formerly from Sao Paulo, Brazil, is now living in New York City for a year. She describes her experiments in choreography and television at the University of Campinas, Brazil.

Until a short time ago, few people could have imagined that the computer would play any role in the field of the arts. However, its use in the current art scene is an undisputed fact, characterized by a dynamism, manifested through many experiments in the fields of the visual arts, music and dance. For the public, the principal difference in the use of the computer in each of these areas is in the output, which could be an actual work of art or a series of instructions, the interpretations which will permit the production of the work of art.

The use of the computer in the field of dancing is of the second category. The output consists of information for the performance of the dancer, as well as for the technical team producing the show.

The objective of this article is to show how the computer can be used in choreographical programmation for television, a field to which the author has been dedicating herself, in a pioneering fashion, in Brazil for the last few years.

This process, instead of using the dancers as choreographic instruments, allows the choreographer to utilize the computer in the creative act, giving greater potential for new aesthetic results.

THE FAILINGS OF TRADITIONAL CHOREOGRAPHY

As I observed, the choreographer's function, when working in television, is to direct the movements of the dancers and establish an understanding with the television producer and director. They determine how the pre-arranged movements of the dancers will be registered by the television cameras, which transmit the dance. The message received by the spectator is a function of the movements of the dancers, captured by the cameras.

It could be be said that the camera is the eye of a dynamic spectator.

The relationship between the dance-TV-spectator can be represented as follows:

```
choreographer → dancers → TV transmission
                              ↑
      ↓                       |
TV director/ → TV registration → spectators
producer
```

ABOVE: "M3X3" - Camera in overview, from dance experiments by Analivia Cordeiro, from the film, "Computer Dance/TV Dance," 1974.

ABOVE: "M3X3" - Camera in lateral view, from experiments in dance at the Computer Center, State University of Campinas, Campinas, Brazil.

Through practical experience I have observed three basic defects in this process. The choreographer's influence on the television is not direct. His (or her) behavior is determined by the television director and producer, who interpret and subjectively translate the "intentions" of the choreographer. This is a factor of interference of the choreographer's message. On the other hand, the television register -- in this case, the cameras -- act on the dancers without their being conscious of it, because the relationship, dancer -- camera, doesn't exist.

If we consider that the choreographer gives the dancer's a degree of freedom of expression, we will, in this case, have yet another factor of interference of the choreographer's message.

The choreographer communicates with the dancers through metaphors, to induce the dancer to make a movement or a series of movements he utilizes verbal or corporal expression. This relationship is unsatisfactory to the choreographer because "words cannot express the exact degree of the individual neglect or ability in the moving factor," (4) and also for the dancer, who through the imitation of the choreographer's movement, limits his individual expression.

THE COMPUTER

The use of the computer in choreography for television could be of interest in the following areas of human activity:

- To those concerned with the analysis of operational systems. These would observe the decomposition of the language of the dance and of television into their components, the algorithm which relates them, generating the choreography, the communication of the output of the computer to the interpreters.

- To dancers and choreographers seek- new forms of notation and reading/ interpreting human movement.

- To television teams, who would be working in a new context, unique dance, that is a mobile and rhythmic photographic subject.

- To everyone interested in the application of computers in new fields.

THE STAGES OF THE CREATIVE PROCESS - ARTIST-INTERPRETER-SPECTATOR

The objectives of this process can be divided into the following stages:

- To choose from among the components of the language of dance and television, those relevant for the transmission of the message wanted by the choreographer.

- To relate these components in an algorithm which will give the elements indispensable to the transmission of the choreographer's message.

- To communicate these elements to the participants in such a way as to allow the transmission of the artistic message to the spectator.

The aesthetic object will be produced through the actions of the interpreters. This process of production is called computer-assisted art (2) or computer-aided art. The creative process is integrated by the choreographer, the computer, the interpreters (dancers, camers, TV director/producer) and spectators. Its integration can be expressed by the following flow chart:

ABOVE: "0° - 45°" - Experiments in dance and television, Campinas, Brazil.

ABOVE: "M3X3" - Camera in lateral view, television dance, Analivia Cordeiro.

To instruct the computer, the choreographer uses the syntax of the language of dance and television and elements of scenography. "But in dance, analysis of movement is often personal and rarely detailed and scientifically based. We know that the performance of a computer depends entirely on the material fed into it, and so for dance the elements of movement must be clearly defined and the right selection made to describe what is wanted," said Ann Hutchinson (3), in a "A Reply" to the A. Michael Noll article, 1966, "Choreography and Computers," <u>Dance Magazine</u>, January, 1967.

THE COMPONENTS OF DANCE AND TELEVISION

<u>The components of the dance are</u>:

- DISPLACEMENT IN SPACE -- The path of the dancer in space.

- POSITIONS OF THE BODY -- "The trajectory of the movement can delay materially in the change of an object or in a new body's member position." (4)

- MUSCULAR STRENGTH -- The energy expended by the dancer in a given movement.

- FLUENCY OF THE SEQUENCE OF POSITIONS IN THE TEMPORAL DIMENSION -- The relationship between time, the sequence of positions and the muscular effort of the dancer.

<u>The components of television are</u>:

- CAMERA ANGLE -- The cangle of observation of the object.

- PLANES OF FOCUS -- The distance between the observer and object.

- VISUAL EFFECTS -- Visual alterations in the register of the camera.

- CHANGE OF CAMERA -- Passing from the image seen by another.

BELOW: An example of visual effects, in which the dancer moves as a white form with horizontal white lines.

THE ALGORITHM

By selecting components and establishing formal relationships between them, the choreographer structures an interactive dance-TV system. In this way he creates the algorithm which will generate the choreography he imagined. (In the dance-T V system the elements of scenery are explicit.)

An example of the subroutine "camera takes," processed after the subroutine "movement of the dancers" in the M_{3x3} choreography:

"The basis for the incorporation of chance may reside in this: stylistic regularities, as captured in programs, are not sufficient for the clear-cut description of a work of art, and in consequence offer certain degrees of freedom, each style permitting a multitude of realizations. In conventional artistic production, these empty places are filled intuitively." (2)

COMPUTER GRAPHICS and ART for February, 1977

INTERPRETATION AND EXECUTION

The next stage consists of the translation of the algorithm into computer language. After processing the computer furnishes the elements for the interpretation of each of the participants.

The dancer receives instructions like:

time	4s	5s
displacement in space		
camera	over	frontal
postures		

The camera-man and TV director receives:

time		
camera angle angle	over	frontal
planes of focus	medium	close
visual effect	total high-contrast	

The scenographer receives the costume and scene description.

In acting, the interpreters must execute the elements given. The choreographer considers these indispensable for the transmission of his message by television. Those considered dispensable are left open, for the interpreter to create his own character. For example, the information given to the dancer consists of time, position of the body (in accordance with the camera view-point), displacement in space, while muscular effort and fluency of the sequence of positions remain undetermined. The energy used is the component, which to my mind gives greatest expression of individuality. "It gives us the capacity to produce new positions, encounters and percussions, new contacts and possibilities of tactile experiences both within the body itself and in relation to its surroundings." (4)

During the practice the interpreters can criticize the elements which are impracticable, and suggest new ways of expressing these elements, which would assist in the full realization of both the dancers and the choreographer's aims. This justifies this creative process: the programming and its actual verification will compose a dynamic element in the relationship planning/practical application.

In his interpretation, the dancer executes the positions within the determined time.

ABOVE: *The author, Analivia Cordeiro, film-maker, dancer, and choreographer. Miss Cordeiro graduated in Architecture, and began using the computer in dance in 1973.*

Also the transition from position to position is performed according to the given instructions for spatial displacement. The dancer is free to describe the trajectory connecting the positions. However, the choreographer is aware of all possibilities available to the dancer. For example, a dancer following a rapid rhythm has four possibilities of dynamics of movement:

number	time	muscular effort	trajectory
1	fast	light	straight
2	fast	strong	straight
3	fast	light	indirect
4	fast	strong	indirect

In their interpretation, the cameraman and the TV director read the instructions:

camera front - medium plane - vertical line effect - 4 seconds and in this case, choose an image with a medium plane and this type of effect, within the given time.

At the moment all the participants execute their parts simultaneously, the programmed result is transmitted.

THE PUBLIC, CRITICISM AND FEEDBACK

Only a few spectators have the opportunity to express their opinions. At the present, this is done through personal contact with the choreographer. As he and the other interpreters are also spectators, self-criticism is the most common form of criticism.

```
            CREATION
           artist
criticism         work of art
           public
         APPERCEPTION

            CREATION
           artist
          self-
criticism criticism  work of art
           public
         APPERCEPTION
```

"The social communication in art. The feedback process of art incorporates in the production phase a corresponding circular process where the artist, by letting his work set upon him, successively perfects it, in terms of trial and error." (2)

THE ADVANTAGES OF THIS CHOREOGRAPHIC PROCESS

I would like to point out the most relevant characteristics of this process:

- Through the computer output, the choreographer does not communicate metaphorically with the dancers, that is with words or with his own movements.

- The choreographer objectively transmits the possibilities of movement of the body in the space and time given, supplying written and graphically syntatical components of the movement.

- The objective is to program the visual aspects of the movement. In television transmission, the camera is the eye of the spectaor.

- The relationship interpretation/ programmation presupposes both predetermined and undetermined elements. We are not concerned with making an animated film using real dancers.

- The interpreters have a precise awareness of their own interpretations, that is to say, at each moment the camera knows how to focus on the dancers, and the dancer knows how he or she will be seen by the cameras.

- This process does not claim to be the only solution for the problems of production of dancing on television. Its significance is in the way it makes explicit the relationships which occur in any television-dance production. Because of this it can be used in different types of dance production.

- Every choreographer has his or her own personal style. One of the manifestations of this diversity is the degree of freedom given the dancer. This method can be used by other choreographers in different ways. For example, the choreographer may opt for not specifying body-positions.

- In operational terms, a fruitful suggestion would be the use of this process by a creative team composed of the choreographer, musician, producer and director of television, scenographer, computer applications analyst - that is to say, the specialists in the fields involved: dance, television, and computing.

REFERENCES

(1) Cordeiro, Analivia and Zancheti, Silvio, 1974, "Computer Dance TV Dance," Universidade Estadual de Campinas, Campinas.

(2) Franke, Herbert, W. Computer Graphics - Computer Art. New York: Phaidon, 1971.

(3) Hutchinson, Ann, "A Reply," Dance Magazine, January, 1967.

(4) Laban, Rudolf. Choreutics. London: MacDonald and Evans Ltd.

(5) Laban, Rudolf and Lawrence, F. C. Effort. London: MacDonald and Evans Ltd., 1974.

ABOVE: Theater graphics by Otto Beckmann.

Analivia Cordeiro

Nota-Anna
An Expression Visualization System of the Human Body Movements

Nota-Anna is a human body movement notation.[1] It is the result of the union of theoretical and practical experience in two areas of knowledge: computer graphics and nonverbal communication. The computer in this case was a source of inspiration to solve problems, not of limitation. The capacity to generate original ideas produced through "mental gymnastics," as occurs with many data technicians, is not enough; appropriate solutions demand practical experience and a very clear objective. The five points below are this research basis:

1. The contact with contemporary movement notation systems: the Benesh Notation, the Labanotation created by Rudolf von Laban, and the Noa Eshkol Notation. All of them are symbolical languages, which require specialized studies to be used.
2. My experience as a dancer, strongly based on improvisation.
3. Working with my computer-dance system[2] (1973/76): the instructions the dancer receives, according to this system (fig. 1). After three years working with this system, I discovered that for a student/interpreter to see a movement, it is not necessary to have a human or a stick figure in motion. The "drawing" traced in space is enough to reveal the richness of expression and the emotional content of the human movement.
4. The "Art of Movement" teaching experience in classes for children.
5. The nonverbal communication analysis: Nota-Anna is intended for any type of movement; embracing the nonverbal language, of behavior, of the silence that communicates our sentiments. In this sense, the body communicates *per se*.[3] All of its movements and parts, the body shape, its posture, the features of the face, and other details compose a nonverbal message. Nota-Anna supposes the use of computers[4] to read all those movements. This is an instrument invented by man, as many others, to increase the body performance in its interferences in nature, throughout human history.

When a machine or any tool is used for a long time, it shapes the user's body imposing physical behavior or emotional obligations throughout his or her existence. This behavior becomes a part of our daily habits and it is the object of consciousness only when it causes pain and suffering. This is the case of the carpal tunnel syndrome, which is frequent in computer typists.

Besides the biological and genetic heritage, daily habits shape the internal body space, located inside our skin. In other words, daily habits modify the muscles, glands, and body parts as well as human dreams and emotions. So, when a tool is involved in these habits, we can say that it modifies the human body. A common example:

1 Nota-Anna was created by Analivia Cordeiro, with technical development by Nilton Lobo, during the period of 1983/1994.
2 At the time this article was written, most of the devices were wired and the mobile phone had just little use. Today, most of them are wireless. Nota-Anna's motion capture system uses AI algorithm nowadays but the general concept of this text is still valid.
3 In a body communication, the person uses its corporal image or self-image: the mental representation of our body, i.e., the three-dimensional image of the way it appears. This image is formed through sensations we have of our body (heat, pressure, pain, physical muscle movements, and internal sensations) unified by the immediate experience of the corporal unit.
4 Nowadays the computer and the mobile phone are part of our daily life.

The dancer receives instructions like:

time 4s 5s
displacement in space

camera postures over frontal
joint of view over

The camera-man and TV director receives:

time	4s	5s
camera angle	over	frontal
planes of focus	medium	close
visual effects	total high-contrast	

Fig. 1
Example of notation for the dancer and the cameraman.
Analivia Cordeiro, "O coreógrafo programador,"
Dados magazine, Feb/Mar, 1976, 52.

to show happiness, a boy holding a videogame control in his hands, cannot open his arms, imposing stiffness to his trunk.

From this point of view, when the body is connected to a video-game control, computer keyboards, or VR glasses, it is obliged to have an immobility during the time the user is playing, usually for hours. The person's resulting behavior takes on a vicious and obsessive attitude.

On the other hand, the visual and audio environment created in these games, restricted to a tecno-culture, is full of violence and unbalanced desires for competition. The resulting behavior is body immobility and excessive high muscular tonus.

Considering these five points, I formulated the questions:
- Having a computer as a partner, is it possible to perform (act) in a light, loose, and fun way, regarding the body expression movements?
- Is it possible to interact with these machines abandoning, just for a little while, an obsessive behavior, to have just pleasure and trust positive internal feelings, letting out our necessities and curiosities, far from physical and mental obligations or rules?

When a tool is created, it should be tested sufficiently to measure the consequences of its use in human behavior, despite short-term market success or the "eccentric" technological stunts. Then we could be respected as complex beings instead of primary living machines. My posture is to think what can happen today as a contribution to the future.

To answer the questions above, the main conclusion reached in this research was that an efficient movement notation system should necessarily be meaningful and easy to read, involving, and charged with emotion. Nota-Anna has attained these objectives through the visualization of actual movement in a manner analogous to human perception of this movement: its trajectory.

Nota-Anna's most remarkable characteristic: the output shows the student/interpreter the displacement of the body parts, meaning the visualization of the essence of emotional expression of movement in its smallest details.

The Usefulness of Nota-Anna

A fact of our reality: how many hours a day does a child, or an adult, spend in front of a computer or video? How many hours a day do they use the computer or video as a semantic filter in their contact with the real world? Usually, many hours, maybe too many. The main point here is that the child's body movements are very restricted. A child that does not have life experience through its body movements, does not know its own potential to make his or her life full of emotional, mental, or motor abilities. As the psychologist and physician Henri Wallon says: "the happiness begins with the body movements possibilities."[5]

This is the reason I created a tool that besides inducing someone to move their body is easy to use, even by a child. Nota-Anna's use's procedure does not require any symbol memorization.[6] Being iconic[7] and isomorphic to movement, it also helps eliminate the use of symbols and facilitates reading, making special training unnecessary for its use.

To reproduce a movement, only three visual inputs are enough: the speed of each body part displacement, the line, and its directions translated into trajectory in time and space. This is because the person moves and learns how to move using his or her proprioceptive sensibility that registers the motionless positions of the body parts, i.e., the posture[8] and its motion,[9] and also uses the visual persistence that registers the movement trace-forms in the air. On the other hand, a movement notation that uses that visual information can show the movement's intention. That is the reason the notation furnished by the computer should induce the expressiveness of the reader, as the movement transmits a clear message and attains its significance through intentional gestures and interpretative subtleties. The objective of turning real dancers into animated drawings does not exist.

5 Henri Wallon, *As origens do caráter na criança* (São Paulo, Editora Nova Alexandria, 1995), 120.

6 Id., ibid. If the trajectory is short, the person reads it at once, but if it is long, the person moves its eyes along the motion track. So, the eyes movement inducts a head movement and, consequently, all the vertebrae move. The nervous systems receive an information of a whole-body movement.

7 An icon possesses a similarity or analogy with its real reference. Ex.: a photograph, statue, or pictogram.

8 Posture is the body immobility during a short or long time, resulting from the simultaneous contraction of antagonistic muscles or an isolated muscle contraction counterbalanced by load.

9 Motion is the body's parts displacement in space, going from one posture to another.

The easy reading of Nota-Anna pleases the student and requires the use of his or her full expressive capabilities to demonstrate sentiment and instinct, which sometimes must be accompanied by an attitude of mind negation. There is a fable that illustrates why movement notation should demand more than just intellectual capabilities: a cockroach asks a centipede to explain how it manages to move all of its hundred legs with such elegance, ease, and coordination. From that moment on the centipede was never again able to walk.

I remark that movement interpretation as a space trajectory came from long ago. The ancient Greeks defined dance as a drawing in the air. Laban also looked upon movement this way: "Our awareness of space-form actually being shaped can become clearer when we execute the movement and steps with the eyes closed, concentrating on the formal flow of the line."[10]

To the Greeks or Laban, the movement trajectory was perceived only through the human sensitivity but the new technologies brought the real possibility to see a movement trace-form in the air.

We must remember that this new reality present in the art and technology area is only a small part of the human knowledge realm.

How Does Nota-Anna Work?

To use it, we must follow three steps:
1. To capture the image, one video camera, a computer with video input, and a browser installed are used. This is an important detail because usually the 3-D processes use data from two or three video cameras. In our case, we use only data from one video camera.
2. The digitalization/3-D process is used on a human body stick figure, whose parts and joints are numbered, and its dimensions are defined according to the real model proportions, whose motion has been captured by the video.
3. The observation of the resulting images. The notation reading aim is to analyze, imitate, or create movements based on the original movement recorded. As the experience shows, to reproduce the movement by imitation, a person must learn the difference between the project and her or his performance. Many children think when they press a button, they can kill a powerful monster in video games. But when they use the computer to induce their own body movement, they perceive that it is necessary to dedicate time and energy to perform the real body movement. It is important to understand that learning is not a mechanical gesture repetition, but that feelings, emotions, wishes, insecurities, fears, once known, generate courage.[11] I remark that affection participates in this process. What is most important is to attribute meaning to the learning subjects.

Nota-Anna "plays" and preserves the memory of the complexity, richness, and ephemerality of movement, presenting as features:
- Simplicity of its appearance and organization according with state-of-the-art technology allied with low cost (a particularly critical point in countries like Brazil);
- input and 3-D processes using one camera allowing to transpose old films/videos, a basic condition to create a memory and a history of human movement, so necessary to our society. The use of only one stationary camera is the input material to transpose video to the image file. If a person uses adhesives or wires connected to their body, she or he tends to lose spontaneity—the movements of everyday life cannot be studied using artificial laboratory systems; that is why I opted for an input using a frame-by-frame videotape system of movement register, even though this procedure is slower than using sensors attached to the body parts;
- JAVA language running on any computer to allow instant reading of the movement, without any training, allowing an intuitive and/or systematic understanding of the movement language syntax, deeming the integration of varied fields of body movement studies easy. This software intends to open the imaginative capacity of the user, child or adult, demanding, for its use, the sympathy, intuition, and the luck that this system "finds its way into their hands." A cultural manifestation that allows synesthetic communication between

10 Rudolf von Laban, *Choreutics* (London: MacDonald&Evans, 1966), 85.
11 Paulo Freire, *Pedagogia da autonomia - Saberes necessários à prática educativa*, 11th ed. (São Paulo: Editora Paz e Terra, 1999), 50.

different people, groups, or cultures, as this poetic phrase "given to the eyes is the intention of the soul" (Aristotle) conveys.

Conclusion

Observation should precede interpretation or codification of movement. The task of encoding human movement has not yet been accomplished, although there are many propositions that have tried to do so and have failed. It is a mistake to try to code the movement as if it were a word in a dictionary, as if it had only one meaning or message. On the contrary, a movement transmits various meanings simultaneously through the torso, face, hands, feet, and the displacement of the body in the air. Each part of the body accumulates information from past and present experiences, which form a whole that can define the future of the person's body. Any codification system demands a long period of observation and recording. A researcher can only try to establish control over movement after long practice, self-observation, scientific knowledge, and observation of other people. After this complex process, his or her awareness will certainly arise as to how little he or she really knows to attempt to control movement in any degree.

The final Nota-Anna's objective is to open a possibility to the user to exploit the body expression potential in their interaction with technology through the practical experience of recording and reading actual movement. In order to establish any control or reconstruct a real movement, we need to explore much more the relationship between man and new technology, until it becomes "natural" to us. Nota-Anna is a proposal that respects the biological organization of human beings in their relationship with technology.

"Incorporating computer vision and artificial intelligence, Nota-Anna can be a powerful tool for movement analysis and creation. And may be extensively used for those who cultivate this art."[12]

Unpublished text originally presented at the 1999–2000 Sawyer Seminar at the University of Chicago, USA.

12 Luiz Velho, *Nota-Anna Presentation* (Rio de Janeiro: Instituto de Matemática Pura e Aplicada, April 1998), 14.

Analivia Cordeiro

Looking for Cyber-Harmony
A Dialogue Between Body Awareness and Electronic Media
A Summary

Introduction

Millions of people are affected daily by the continuous use of electronic instruments. The preponderance of technology pervades human relationships, and a reflection on the influence of their use on people's behavior is necessary. These instruments dictate physical and emotional behaviors that shape and stress the bodily functions when turned into daily habits. They may cause injury, suffering, and pain (carpal tunnel syndrome, for example). In other words, if we consider the body as a bone structure, covered with skin, containing various types of fabrics, the characteristics of the structures and tissues will change with daily use and abuse. Thus, the tissues naturally resisting mechanical stress to stretch, bend, twist, rip, compress can definitely have structure and functioning compromised if they are in constant demand for repetitive moves.

Within this panorama, this study aims to contribute to the personal balance in terms of body movement. Currently, there are numerous suggestions in this sphere—from medical treatments to religious rituals—but there are no proposals for appropriate action to the new technologies users' body in their own sphere of action. It is here that *DuCorpo* can help, using electronic means for the solution of the problems caused by the electronic means themselves.

DuCorpo proposed body procedures integrated with electronic language, inclined to allow a full body experience, including physical, mental, sensory, and emotional creative and engaging character. Don't try to find the rationale behind this, for it belongs to body practice, not exclusive to the rational field.

Among many aspects that shape the culture of new technology, I note one of them still following the earlier tradition: the body relationship between man and machine, currently defined as the user relationship with the devices of new technology. In this relationship, the value of the individual as unique has never been considered essential for productive work. During most of human history, the inventors were dedicated to devising machinery and instruments aimed only to increase the performance of the human body in the intervention actions in nature and society. These instruments and machines mercilessly dictated physical behaviors and destroyed emotional bonds, shaping your body, the hard way, throughout your life. The overuse of electronic devices has become routine, and most people are not aware of the problems overuse can cause. Injuries, pain, and even death can be caused by the abnormal use of equipment.

In other words, in everyday movements we usually use our hands or focus our eyes on some activity. Such everyday activities tend to be repeated for long periods. Constant repetition implies destabilizing body efforts that the very body seeks to balance other parts of the body not directly involved in the action. These repetitive efforts, which are predominantly made automatically, often cause damages of various types and degrees of intensity for the body.

To understand this situation more scientifically, in this thesis the body is treated as a bone structure, covered by layers of different types of tissues, the outer layer being skin, which changes its functional and emotional characteristics according to its daily use and other factors; and its changes are seen as a functional and expressive shift of this body architecture.

This way we can reframe the thought of the paragraphs above more precisely: despite the body's tissues natural ability to withstand mechanical stress such as stretching, bending, twisting, ripping, and compression, the way its structure is used can profoundly change the ability of these tissues if they are constantly overused in repetitive and stressful positions.

But it is only when excessive use of the body is characterized as a problem that most people become aware of how misused their body is. In general, "dystonia is so incorporated into the body that people are not aware that it exists. If the dystonia caused decreased joint movement, this loss of movement is not perceived as a limitation, it is perceived as that's how it should be because there is no longer the memory of how full movement used to be" (Queiroz 2001, 23).

It is believed that the daily hassle, which can even cause pain or discomfort in the body, can go away or be dissolved with bed rest. This does not happen. The pain may ease but the repetition of movements or the continuation of emotional pressure can turn it into chronic tension.

The situational awareness above belongs to the sphere of body studies researching the body as a whole, including joint health and behavior of the muscles. One of the current revelations of this study area says that every feeling, every thought, every emotion has an immediate muscular response. So, during mental stress situations, there is muscular stress, even if the person is not aware of it. A correct statement is that:

> In mental fatigue, the span of attention is impaired and accuracy in details is lost. In emotional fatigue, irregularities in response and imbalance in rhythm exist… Changes in muscle function are found in prolonged mental and nervous strains, coincident with reaction changes in the neurons.[1]

As noted by Shapiro regarding the current situation of the company: "Sometimes the root of a problem is not a specific traumatic event but the accumulation of stressful situations. This usually happens in large urban centers, and leads to physical illness, problems of memory, or interruption of social performance" (2001, 383). With regard to body movements forging an ideal situation, the philosopher Bachelard says, "How psychology would deepen if we could know the psychology of each muscle? What about the animal being there in man? But our research does not go that far" (1994, 91). Considering the situation above, a key issue is raised: do the current technological tools respect delicate sense organs, the physiological, anatomical, and neurological structure of the body and the unique story of each limb? I don't think so.

On the other hand, with the advancement of technology itself, it can be said that the history of man provided us with enough knowledge so that we can honestly analyze the needs and test the effects of any new instrument from many angles before it is put into action.

In this view, we can say that the current researchers should begin to sincerely consider the consequences of their new inventions, focusing on respect to the proper biological functioning of the human body in detriment of short-term technological and commercial success, thus helping care for our body as a primary machine. Businessmen should approach technology use with a comprehensive sense of human well-being and safety first, so we can work or have fun with the new tools created by them. We could be truly respected as complex individuals. In this way, we might be able to create a day-to-day with more favorable habits for ourselves.

Goals

The practical objective of *DuCorpo*, among others, is to balance the daily life of the user with the integration of two types of activity: interaction with technology and introspective procedures, which could enable a more integrated detection of the world or, at least, richer in mental, sensory, and emotional experiences. We believe that the new generation that knows, even if superficially, meditation practices or "Eastern philosophy" and, on the other hand, lives so close to video games, computers, virtual reality, etc. would have no difficulty in adopting these two practices, providing they are guided properly. In addition, "N-Geners also have a keen interest in body image and in health" (Tapscott 1998, 204). Therefore, this approach may prove to integrate a new universal cultural form, as another step forward in the history of human affection and self-awareness.

Another goal is to go to children, preteens, and teenagers for answers. To justify, we sought

[1] Mabel E. Todd, *The Thinking Body* (New York: Dance Horizons, 1975), 263.

testimonies like that of a sixteen-year-old teenager, Lauren Verity, extracted from Tapscott's book: "I think the net is probably changing the nature of childhood because it opens up the world to everyone. We can get any information, in any area, even those which previously didn't interest us. Now we're getting interested even in these areas" (Tapscott 1998, 292). Or that of Thomas C. Guedes, a boy of eleven, when his mother banned him from playing on the computer: "Mom, you got me everything I have in life." Or that of Patricia, fashion student, commenting on her personal experience: "I need a password to get into another moment of my life." These testimonies, among many others, reveal the critical role of technology in the lives of young people.

From a theoretical point of view, an obvious serious problem in these young people's lives is the lack of movement and exercise. They spend hours playing, researching, dating, or working in front of a monitor where the eyes follow movements of objects (doll, car, information, etc.) on the screen and fingers move buttons triggering this virtual world. The rest of the body is most likely slumped.

For all age groups, we found that virtual culture or information takes away physical mobility. The urban environment, added to the apparatuses of new technology, constantly stimulates vision in detriment of physical mobility and other senses of the body. The consequences of this trend negatively affect adolescents by depriving them of fully moving their bodies and commit their development at all levels of existence.

DuCorpo is a body practice with an educational nature and with a constructive function. Another objective is leisure, opening the possibility of a purely recreational, free, and light activity with an electronic apparatus; letting go of a stubborn attitude of conquest, to be open for pleasure and internal self-confidence, letting our desires, needs, and curiosities flow, regardless of any physical and mental obligations imposed. The stubborn attitude of conquest and/or violence characteristic of the contents of most of the products of new technology, both for professional use and popular consumption, either for work or for fun, is a fundamental tonic in the social attitude of most consumers of these products, for any age group.

Another objective of *DuCorpo* is to mainstream the most advanced modifications of body techniques that are still restricted to an affluent audience.

The tradition of physically shaping the body goes centuries back. Noverre, a 16th-century choreographer, said: "To dance in style, walk with grace, and present oneself nobly, the order of things should be completely reversed, forcing [body] parts to conform, through long and hard dedication, to a new situation totally different from the one they had been introduced to previously" (Monteiro 1998, 321).

This trend is being accentuated in the 21st century. The exaggerated importance given to the appearance of the body is the focus of attention and investment, both by the media and economic power. In large cities, there is the dualism between a lifestyle habit trampled on by often inadequate behavior (sedentary lifestyle, stress, smoking, poor diet, etc.) coupled with technological innovations (which cause greater physical inactivity) and the need to build an acceptable body, which can be attained through artificial practices, such as prostheses implants, hormones consumption, and extreme exercises, like lifting heavy weights.

This unbalanced body work is part of a complete picture. Nuno Cobra, a conscientious and well-prepared personal trainer, says:

> Due to our more and more artificial lifestyle, we break all the natural laws of basic health care (nourishment, motion, sleep, and relaxation), one by one. But the body is resistant; sometimes it takes twenty or thirty years for these negative habits to provoke a disease.[2]

Regular physical exercise promotes elasticity and tones the muscles throughout the body. There are many modalities of exercise, but most important is that it is practiced on a regular basis, avoiding excessive efforts, and the younger the better. Hence, another objective of *DuCorpo* is health.

DuCorpo contributes to a physical/emotional body balanced mind through fun-oriented relaxation practices, elasticity, muscle tone, along with audiovisual instructions via electronic means.

This complex and profound proposal is based on the simplicity and restoration of the universal body movement, which is harmonious and functional. This proposal searches a healthy relationship between the body and the electronic means,

[2] Nuno Cobra, *Separação corpo mente* (Viva magazine, October 2002), 12.

a relationship that is positive and favorable to the human organism. *DuCorpo* proposes corporal practices aimed at everybody, regardless of culture, gender, or age.

Tools

To achieve these goals, it is necessary to access theoretical-practical tools of proven effectiveness. In the field of body awareness, we mention four techniques, which we have studied: the Laban method (explained above), the Feldenkrais method, Eutony and Endobiophilia. From the perspective of new technology, *DuCorpo* uses the movement reading and notation software Nota-Anna.

Endobiophilia

Endobiophilia is a word of Greek origin where Endon = inside, bios = life, philos = friend, thus designating a friendly respect to the inner life, listening to what lives within the body and what it needs to live well.

This technique was created by Odile Vaz-Geringer in Paris. For her, the elasticity of all body tissues—skin, muscles, tendons, ligaments, veins, arteries, connective tissue support, the fascia, and bones—is key to the integrity of the body, for people constantly performing a task as duty gradually lose their flexibility. Another key factor is that people have all the means to reverberate and live. So, on that principle, Endobiophilia works on the entire fibro-elastic body, muscular, osteoarticular, circulation, and lymphatic systems.

As a rule, the higher the capacity of tissue compression, the higher its elasticity in a proportional ratio. Elasticity assumes two opposite and complementary actions: compression and expansion (or relaxation or stretching). Relaxation of the muscles works from inside out. When the tissue of our body is compressed, it reacts with an opposite action. Thus, compressing it opens the possibility for dilation. According to Odile, "the human being is populated with elasticity. When humans become aware that this is the soul of emotion, they bind their own life" (Vaz-Geringer 2001, 109).

Eutony

The Eutony was created by the German Gerda Alexander in Denmark. She developed her work by watching her students and herself. After several years of practice, according to her Eutony (Eu = harmony, tony = tonus) through balanced opening of the joints and the flexibility of tissues throughout the body, enables sensitive contact, pleasurable and intimate with your being, resulting in awareness of its own individuality.

Technically speaking, Eutony advocates the resumption of body awareness as a procedure to dissolve dystonia and tonic fixing. The body perception can be done by stimulating the superficial and deep sensitivity, through the perception of the skin, bones, internal spaces, the volume of the body, and joint movement, i.e., the development of extero and proprioception. This stimulation provides the possibility of conscious control of the muscle tone, which can restore muscle balance and tonus and the neuro-vegetative functions in various parts of the body. The tonus is a fundamental concept for Eutony. "Tissue tone is of great importance in posture and support, and the tone of our muscles moreover largely conditions our body endurance, since muscles do not fatigue so readily when their tone is properly maintained" (Todd 1975, 30).

Within this universe, to relax the neuro-muscular tone, Eutony returns to the muscle's flexibility, "dissolving" the tonic fixings and providing the body with the chance to experience endless tonic variations, i.e., to "break them," the Eutony releases joint movement.

Influencing muscle tone acts on the whole-body tonus, i.e., the neuro-muscular tone, vegetative tone, and the psychological tone. It is important to note that the overall tone, i.e., the set of tones of various body tissues, is the basis on which all the emotions occur. For example, a person with a muscular tonus fixing has no ability for emotional or expressive variations and can be considered ill.

Feldenkrais Method

Moshe Feldenkrais (1904–1984) was born in the Russian city of Baranovitz; he migrated to Palestine in 1918 to work in construction. He also practiced "judo" martial art. His method was founded on the notion of self-image formulated by himself: a person tends to consider

his self-image as something given by nature, though it is the result of his own experience. The appearance, voice, way of thinking, environment, relationships with time and space—to select examples at random—are, in most cases, personal and innate characteristics; but, in fact, each major element in the individual's relationship with others and with society is usually the result of an extensive workout. Walking, reading, recognizing three dimensions in a photograph are skills that the individual accumulates over several years.

In this way, the person acts in the world according to their self-image, which, for Feldenkrais, is conditioned by three factors: heritage, education, and self-education. The hereditary factor is one that concerns the physical structure in anatomy terms. The educational factor is related to the cultural and social conditions in which the individual is inserted. The self-education factor is determined by the inner strength of personality, which leads to individuality and promotes different behavior.

For him, self-image is made up of four components: sensation, feeling, thought, and movement. The sensation component is formed by the five senses—hearing, vision, olfaction, taste, and touch—plus the kinesthetic sense comprising effort, work, orientation in space, the passage of time, and rhythm. In the feeling component, he included, in addition to the family emotions of joy, sorrow, anger, and so on, self-respect, inferiority, the super-sensitivity, and other emotions, conscious or unconscious that color our lives. Thinking encompasses all functions of the intellect, such as right and left positions, good and bad, right and wrong; understanding, knowing what we mean, sorting things, complying with rules, imagining, knowing what is perceived and felt, and, above all, remembering. Movement covers the changes of time and space in the state and body configurations and parts, such as breath, taste, speech, blood circulation, and digestion.

In practice, this method recognizes and uses the interdependence of the four components of the self-image—thought, senses, feelings, and movements—a sophisticated and simple system of sensorimotor instructions based on physics, neuroscience, biomechanics, and motor development.

Briefly: feeling and thought are linked to the movement, their functions are the basis of the creation of self-image through movement. The trend reflects the overall condition of the cortex of the brain that activates muscles. The nervous system is also the basis of awareness because it provides the stimulation of certain cells of the motor system. Feldenkrais Method offers the individual the revival of his or her basic movements: rolling over, sitting, crawling, walking, in order to clarify this process experienced spontaneously during development; and it may provide, in the adult stage, a reorganization of the individual as a whole.

The goal is to improve the ability, that is, expanding the boundaries of the possible: make the impossible possible, make easy what is difficult, and make easy pleasurable. Feldenkrais believed that only easy activities are enjoyable and will be part of normal life and will be useful at any time. Difficult-to-perform actions that require effort and find internal opposition will never be part of everyday life; and, with age, people will lose their ability to perform them.

DuCorpo

Today, we live a two-way nature: one ancestrally inherited planet, and the other, the modern, acquired industrial and urban environment. One can choose to either deny one in favor of the other; the important thing is that these two senses of nature are lived and understood in the integrity of their ontological structure, from the perspective of a universal perceptual awareness embracing the world, making it one; an agreement and harmony between these two kinds of emotion assumed to be the only reality of human language.[3]

Looking around us, the question that arises is when people "work the body." It is not a scientific or temporary question. It has to do with space: in which space people "work the body." It is not limited to the anatomy or physiology. Few people consciously experience space or time with their own bodies in daily life. Most people carry out tasks, filling their schedules on time, day after day. For them, the movement of body practices is transformed exclusively into

[3] Pierre Restany's interview transcript to Sepp-Baendereck and Frans Krajcberg about his sojourn at Upper Negro River, Amazônia. The inverview took place at Fundação Cultural de Curitiba, on August 3, 1978.

Photograph of the audience interacting with *DuCorpo* video in the exhibition *Analivia Cordeiro - From Body to Code*, ZKM | Center for Art and Media Karlsruhe, 2023. Photographer: Felix Grünschloß. © ZKM | Karlsruhe.

mechanical gymnastics. *DuCorpo* is open for people to acquire a new dimension of knowledge of their body.

In theory, the planning of corporal practices had the following intent:
- promote joy and pleasure;
- avoid interpersonal comparison and competitive-ness;
- emphasize individual improvement;
- provide opportunities for self-discovery and decision making;
- encourage acceptance of others;
- stimulate the production of new challenges within everyone's possibilities; promote perceptions of autonomy and choice;
- inform scientific and accurately use.

Participants were also encouraged to:
- choose their favorite activity;
- enhance playfulness;
- value the process (seek gradual improvement in personal performance) and not the end product (results, interpersonal comparisons);
- face the challenge of changing their minds.

In short, you can move your body a little bit differently every day to feel your spirit warm, your feelings and ideas nourished. You will make your days more significant, more fluid, enjoying every minute, leaving the weight behind. Every day, week, month, and every year, register on a daily basis each feeling and idea, so they don't pass without meaning.

Summary of the PhD-Thesis *Buscando a ciber-harmonia. Um diálogo entre a consciência corporal e os meios eletrônicos*, Communication and Semiotics Course. Pontifícia Universidade Católica de São Paulo, advisor Prof. Dr. Arlindo Machado, 2004.

Translated by Helen Andersen

References

- Bachelard, Gaston. *The Poetics of Space*. Boston: Beacon Press, 1994.
- Cobra, Nuno. *Separação corpo mente*. Viva magazine (October 2002): 12.
- Geringer, Odile Vaz. *Quand Le Corps Sera Conte*. Paris: Cahiers Bleue, Bleue, 2001.
- Monteiro, Mariana. *Noverre - Cartas sobre a dança*. São Paulo: EDUSP/FAPESP, 1998.
- Queiroz, Maria Jos Albuquerque. *A eutonia no desbloqueio articular*. São Paulo: Curso de Formação Profissional em Eutonia, 2001.
- Shapiro, Francine. *Eye Movement Desensitization and Reprocessing*. New York/London: The Guilford Press, 2001.
- Tapscott, Don. *Growing Up Digital - The Rise of the Net Generation*. New York: McGraw-Hill, 1998.
- Todd, Mabel E. *The Thinking Body*. New York: Dance Horizons, 1975.

Analivia Cordeiro

Joy of Reading
A Summary

Abstract

This work is intended for the illiterate people, in the broad sense of the word, of any social group and of any age. Illiterate people, in the narrower sense, are those who don't know the letters of the alphabet and don't know how to read and write. The word "illiterate" is seen by most as a pejorative term, a term used to identify part of the population who, by not knowing how to read or write, is taken for being destitute of average intelligence and in a situation of disadvantage.

Then, there are the illiterate people who know how to read and write but don't understand what's written; they are incapable of understanding the meaning of what they read. These are the illiterate in the broader sense of the word and they constitute 74 percent of the students who finish their studies in Brazil, according to statistics presented at the Museum of Portuguese Language in São Paulo. These illiterate people, even that they do know the letters of the alphabet, they are excluded, defined as people who in some way don't have access to forms of self-expression in a social sphere.

How should reading and writing be taught to help them? Writing can be considered either a representation of language or a code of graphic transcription of sound units. Learning it as a transcription code consists in acquiring a skill. Learning it as a system of representation consists in taking on a new knowledge of meanings.

Joy of Reading combines these two concepts in a single learning experience. *Joy of Reading* is based on music lyrics, poems, and other daily manifestations seen as a semantic or syntactic unit, to be learned by parts never separated from the whole. For one student might well know the name of the alphabetic letters and yet not understand the writing system and inversely, another student might make substantial progress in comprehension of the writing system, without having received any particular instruction about the names of the letters of the alphabet. The skill of reading is learned by reading. *Joy of Reading* is a learning system used in a software design for mobile phones and other portable devices.

This project is part of the effort of groups which intend to expand the awareness by means of a great net of solidarity like the Internet or other similar tools, creating possibilities never imagined before to increase and expand human awareness. In other words: "Love is our biologic founding and is the only basis for preserving our human quality as well as our well-being" (Maturana 1999, 227).

Presentation

Joy of Reading is a project for reading-writing teaching and learning of the Brazilian-Portuguese language using wireless devices. Illiteracy prevents individuals from effectively participating in society.

According to statistics, in the state of São Paulo, only 4.5 percent of illiterate youngsters and adults attend any reading and writing course. Countrywide, this percentage is yet smaller: 3.9 percent (*Folha de S.Paulo*, June 14, 2009). Another figure indicates that one in every ten Brazilians at the age of fifteen or over knows neither how to read nor write a simple note (*Folha de S.Paulo*, September 28, 2009). This work proposes bridging that gap in our social and educational system.

In 1996, when the "Law of Directives and Bases of National Education" bill was passed, long-distance education was introduced in the Brazilian educational system. The goal is: "The new technology is intended to generate important innovations in the educational processes, enabling education to be catered for the aspirations and needs of human societies in the new

international scenario, in which knowledge and capacity or ability of learning and creating solutions are essential aspects for the development and well-being of the populations and nations" (Scavazzi 1998, 40). Long-distance education has proved to be very successful. While regular in-class courses for Teaching Education increased 17 percent, the same course in the long-distance modality increased 270 percent in five years. So, there are systems to educate teachers, but none to educate students at the level of learning to read. *Joy of Reading* tries to fill this education void in Brazil: to date, there is no electronically delivered reading course system available.

An electronic reading course system fills a basic social need and in this mode is included in a more sophisticated level of the new culture, which currently faces a period of euphoria and, at the same time, one of challenge.

> Cyber culture presents itself as partial solution of problems of earlier times but it constitutes an immense field of problems and conflicts for which there is no clear configuration of any perspective of a global solution. The relationship with knowledge, work, employment, money, democracy, or with the state must be reinvented, just to cite a few of the most brutally questioned social forms. (Levy 1998)

Joy of Reading's central goal is independent learning and support for school learning, through wireless devices, for anyone of any age and anywhere in the country. To take on this challenge, the type of device must be decided first. We picked mobile or cellular phones as the most adequate device for this. The mobile phone is financially[1] accessible, and the most popular means of communication in Brazil. It is more familiar and tangible to the larger share of Brazilian urban population than school is. Why not use this fact and transform mobile phones into teaching/learning devices? Adapting human knowledge to these new devices is a huge challenge to the current artists, teachers, scientists, and other professionals.

In the teaching field, Paulo Freire, a leading theorist, speaks in defense of "education based on ethics, respect to dignity, and to the autonomy of the student. There is no use of rhetoric if educational activity is impermeable to change … the pedagogic space is a text to be read over and over, and interpreted, written and re-written" (Freire 1999, 12).

Direction

In 2008, it was estimated that there are fifty million functional illiterates in Brazil of which 90 percent do not attend classes; and the remaining 10 percent that are enrolled in schools don't usually finish their studies, constituting the group of illiterates[2] (*Folha de S.Paulo*, September 28, 2009). Yet, many of those who complete elementary education still can neither read nor write at even a basic level. These are illiterate in the sense that they cannot read or write well enough to deal with the everyday requirements of life. An example, with a grocery shopping list written by a domestic maid, who completed the last year of high school in São Paulo: "*azeite, queijo,* **nostra moiveis, bisaquinha**, *bolacha de maizema, biscoito de* **povilho, guaranpo**, *ovos, papel higiênico, ervilha.*" The mistakes denote that the maid does not know the right pronunciation of the words she wrote. Therefore, at first instance, *Joy of Reading* is designed for those who have restricted or no access to teaching systems and for those who have no interest in attending a course or sitting in a classroom at school.

At a second instance, *Joy of Reading* is designed for the followers of the mobile-phone technology regardless of age and social group. In general, they are people who have initiative to search, to learn, and shape their lives. This is why, as authors and articulators of this system of learning, we don't hesitate in focusing on people who are independent and confident.

Illiterate[3] people in one way or another have no access to forms of expression of themselves in the social sphere. To revert this situation, it is necessary to invent ways of social inclusion, as we intend with *Joy of Reading*. We want to build an environment of collaboration and construction, to achieve, through solidarity, a better and a more just society.

1 It is in this direction that technical development is going: it will continue generating cheaper and more sophisticated products, enabling increased access of population to education, commencement, training, qualification.
2 The broader band of illiterate people is people older than sixty years of age, totaling 40 percent.
3 According to the pedagogue Barbara Freitag "people who don't know how to read and write suffer very much. They are ashamed and feel guilty for not having acquired the competency attributed to a seven-year old child. They are foreigners in their own land" (Grossi 1990), 8.

Learning

The acquisition of new information and performance processes provided from learning lead the student in the long run to form "new social abilities" and to the creation of a new subjectivity. All our corporal dynamics participate in this process—gestures, sounds, body positions, emotions, etc.—where what we do shapes our language and vice versa. All this modification is constructed.

> The person tends to consider his or her self-image as something given by nature, though it is, in fact, the result of the person's own experience. One's appearance, way of thinking, how one relates to time and space—to pick random examples—are all taken by innate characteristics, while each important element in the individual's relationship with other people, and with society, is the result of extensive training. To walk, read, recognize three dimensions in a photograph are abilities that an individual amasses over several years. (Feldenkrais 1977, 37)

The acquired knowledge that is experienced and internalized by a person allows this person to reflect about his or her own learning process and the change process that occurred by comparing the before and after.[4] From this, cognition is inseparable from living, shaped by many factors that are not part of school. And it is in this sphere that we discuss learning or knowledge acquisition. The person is not a stagnant or fixed identity. A person is a being in constant change that goes through various stages and ways of thinking. Therefore, a person changes and learns.

What takes a person to change is curiosity, wonder, unease, or necessity. Thus, teaching should consider the construction of a person on all levels of his or her existence, including the whole organism, mental and corporal aspects of that person.

Certain technologies are linked to our body as if they were a prosthetic accessory. Posture of people has changed: the head projecting forward is very noticeable. Personal behavior is drenched in technology, more specifically, with the mobile phones. The relationships have been deeply transformed by mobile technology. The strongest characteristic that the pedagogic-enabling process brought by cellular phones is its plasticity, the freedom of movement, enabling great flexibility in learning and in displacing the body. This is an updating, not a linear or continuous change in the process of learning. *Joy of Reading* considers a simultaneity between the intuitive path—the student reaches out and experiments—and the school path—where the student is guided by a teacher along an established and tested path.

Teaching

The world is not stagnant and set. The world ist in flux and change. Nobody is permanent and still. We are all beings who experience, learn, and change, which means learning and building knowledge.

Individual and social knowledge results whether from a free and open learning experience or from school learning. There are innumerous types of institutional courses and schools on just about any topic or subject.

Historically, it was by social learning that people realized that it was possible to teach. The current known alphabet[5] used for words notation is ancient and the result of a long process of human need to encipher and register facts, ideas, and thoughts. Teaching reading and writing in Ancient Greece and Rome emphasized the mastering of the alphabet to such a degree that learning the alphabet started by calligraphy and by oral sound reconnaissance of each letter assigned by its name. Then, the combination of letters forming syllables, then the combination of the syllables, forming the words, then phrases, until they worked on texts. Later on, in the Middle Ages, the letters were taught by their sounds, and not by their respective names. This was the phonetic method. Only in the 20th century, the phonemic method of teaching where the vowel letters are connected to the consonant letters helping its oral enunciation, as in the Montessori method in Italy.[6] The syllabic method, also taught today, is characterized by the formation of words since the beginning of the process starting from the joining and building of the known

4 It can be said that "ignorance is the presence of intelligence in a mistaken or incomplete way," according to Sara Pain (Grossi 1990), 54.
5 Teaching the alphabet letters coined the Portuguese name to teach and to learn to read and write, "alphabetizer."
6 In Brazil, the method was introduced by the Jesuit priests.

syllables (Rizzo 2005, 14-15). In this brief display, one notices that for centuries, the teaching methods have been renovated and updated.

Joy of Reading, as a plan to renovate teaching of reading and writing, accepts learning from two simultaneous points of view: as a representation of language and as a graphic transcription code of sound units. As a graphic transcription code, learning it is an acquisition of a technique. As a system of representation, learning it is an appropriation of a new knowledge object, conceptual learning. In this way, we diminish or minimize the generation of illiterates in the narrow sense, those who know how to write words, who know the words spelling, that is, they know their graphic transcription code, but do not know what they mean or what they represent in language.

Still, in this renovation effort, the device that we chose to fill this social void in the schooling is the mobile phone and other mobile devices of recent technology. Many Brazilian enthusiasts are willing to follow this trend in this direction. We cite two independent examples. In the city of João Dias, in the northern state of Rio Grande do Norte, when a student succeeds, this student is awarded access to the internet, which is very rare in this remote locality (*Folha de S.Paulo*, October 22, 2009). Glaucia Brito, of the Federal University of Paraná, says: "Paraná is ahead of the other states because they made computer accessibility unlimited. And one still must listen to what the teachers have to say, what they need, beyond offering a consistent pedagogical program, as for the student to make good use of this structure" (Magazine *Carta Capital*, June 3, 2009). Both examples support the idea that people are giving up their isolated and passive attitude in front of the television screen for an active and social attitude on the Internet.

"A new culture is emerging, one which involves much more than just pop culture of music, MTV, and the movies. This is a new culture in the broadest sense, defined as the socially transmitted and shared patterns of behavior, customs, attitudes, and tacit codes, beliefs and values, arts, knowledge, and social forms" (Tapscott 1997, 55). Information becomes culture if we have an attitude characterized by careful evaluation and judgment. This happens with the Internet, when information is criticized and transmitted in a non-passive and non-democratic manner. As a consequence, we are experiencing a reformulation regarding authority and hierarchy.[7]

From pedagogy's stance, this attitude modifies the teacher-student relation leading to important questions. How to deal with students' curiosity? Is this easily met or will it turn into new curiosities? Which sources will be tapped to satisfy this curiosity—books, dictionaries, computers, or questions to other people? Answering these questions, students and teachers will need new forms of teaching.

Renovation implies the use of expressions and content by students to learn to read and write. It is the student's life and his or her reality that become the content for individual or collective creation of stories, using forms of communication available in the new technologies as in SMS, for example.[8]

Another renovation is the use of music and poems, seen as semantic/syntactic units to be learned as a whole. Music and poems not only get young people interested, they are part of the family of histories. As an example, the song *Asa branca* (White Wing) by Luiz Gonzaga is so significant to the northeastern migrants. Music and poetry also contribute to the spirituality, which mostly comes accompanied by happiness, *Joy of Reading*. "There is a relation between the necessary educating activity and hope. Hope that teacher and the students together can learn, teach, become restless, produce, and overcome the hurdles, to our delight" (Freire 1999, 75).

Old form may be traditional but if it is renewed maintaining its identity, it continues to be admired as a current form.

In this new context, what role does the teacher have? The role is to help structure thoughts and devices to communicate them. In this sense, teaching to think properly is not about an isolated experience, but a process while one is living.[9] Thus, to think properly becomes an act

[7] The critical attitude began to consider the individual. "What could have been seen as an inconsequent act in the field of design programing a short while ago is now seen as necessary and welcome boldness. Not exactly for the technical functionality or predictability of the systems but for the fact that subjective elements have been incorporated to the development of products and technology. Less as war strategies and more as consumer strategies, it seems that the things are blending in. The individual has never been such a valuable target" (Mello 2002).

[8] These are activities that *Joy of Reading* will use at a second instant. At the current stage, it intends to teach reading.

[9] Technically, readers in any idiom use the same procedures: they select, forecast, they infer, confirm, and they correct. They also experience the same cycles: optical, perceptive, syntactic, and semantic.

of communication that implies an object and the people who think about this object or with this object.

Learning to read is essentially to think properly, to understand the relation between the spoken word and the writteasan word, which requires students' reasoning. For this, students' rational, intuitive, and creative capacity is engaged.[10] This is why learning is a process where the construction starts from within, where knowledge is not acquired from a teacher but from the student's own construction that comes closer to the few rules of the lecto-written system.

For successful learning, the teacher must, on the one hand, channel without subduing the students efforts and support the students' confidence in their capacity to learn; and, on the other hand, encourage practicing reading and writing, through which the skill and ability will be acquired and consolidated, especially when the subject is of interest to the student.

This way, the most updated didactic position[11] is that of "one learns by solving problems."[12] For this, the student must be considered holistically, the rational aspect connected to the emotional aspect.[13] Reading is a logic operation, while teaching and learning to read is a relation of love. Reading depends on the perceptomotor development, while teaching/learning to read and write depends on organic maturity.

Joy of Reading intends not only to teach reading and writing, but also to participate in a great solidarity network like that one of the Internet, creating possibilities to extend human awareness.

Reading and Writing

Learning to read and write is acquiring the skill and comprehending the meaning.[14] Teaching the skill of reading and writing, traditionally, presumes the following stages: pre-syllabic 1, pre-syllabic 2, syllabic, and alphabetic.

At the first pre-syllabic stage, the expression is through drawings, and then transitions to graphic signs. This transition is not smooth because the student supposes he or she does not yet know how to read or write, then realizes that writing is not drawing. Thus, the pre-syllabic level is characterized by walking along two parallel paths: realizing that alphabetic letters play a role in writing and an understanding or the link between the speech and the written text.

Having dealt with this transition, the pre-syllabic 2 child may be able to represent each sound with any particular letter, so a syllable becomes a letter. The relation of similarity between the sound and the specific letter occurs later. The frustration of knowing how to write and not being able to read what other people write occurs moving from the pre-syllabic level to the syllabic level. This issue inhibits the socialization of writing: the incapacity to read what other people write syllabically and the incapacity to read what the literate people have written. The transition between the pre-syllabic and the syllabic levels is realizing that a word is always written the same way—with the same letters, in the same order.

At the alphabetic level, the student discovers that each syllable does not correspond to a letter and focuses on discovering how the syllables are written. What defines the syllabic level is the quantitative segmentation of the words both in graphic signs and in oral-lip movements when the mouth pronounces it.[15] For the student to master reading and writing, he or she must conquer the stage of seeing the syllables separately and visualize the word as one. Only the comprehension of the syllable gives meaning to the word as an element of a triad: from the letter to the syllable, to the word, and in the opposite direction. Therefore, working these three elements simultaneously is fundamental for any level in teaching and learning how to read and write.

These stages of learning require technical skill, described above, accompanied by

10 According to Jonas Salk, "creativity is on the margin between intuition and reasoning" (Varela 2001), 189. There is no contradiction between intuition and reasoning. Reasoning without intuition is empty and intuition without reasoning is blind.

11 According to Sara Pain, didactic discipline connects knowledge to learning, establishing methodologies that lead to lecto-writing acquisition in accordance with the explicit pedagogic objectives.

12 "Thinking begins only when there is doubt" (Hegel quoted in Rizzo 2005), 11.

13 Piaget: "The building of knowledge is nothing but a problem of accommodation. No one learns in a state of anxiety" (Rizzo 2005), 40.

14 Signifiers are elements, generally words, which represent a meaning. This can be a notion, a relation, a concept, or an algorithm.

15 If you pay attention when you speak, each time your mouth opens a syllable is pronounced.

knowledge of the meaning of words and the broadening or expansion of the student's vocabulary. Vocabulary of related words, referred to in texts, music, and poems. Consistency in writing is achieved by studying many words and not a repetitive vocabulary. Reading is not just deciphering symbols. Reading is extracting the author's thoughts from the written text. A word is not an agglomerate of sounds, it represents an idea. It is important to observe that the acquisition of reading and writing is not simultaneous, nor is it linear.

Therefore, what matters in educational discipline is not the mechanical repetition of the gesture but the understanding of the value of feelings, emotions, hopes and expectations, certainties and uncertainties; fear to err, that with education will be transformed into courage and certainty and assertiveness. For example, when a student chooses the vocabulary, his or her assurance and confidence is strengthened: the student exists as an individual.[16] For this reason the material chosen for this study is very important. It must be of the student's interest, the content must have a meaning that touches the student's life. Hence we chose music, poems, and topics of everyday life as didactic material.

The *Joy of Reading* project should last approximately three years, consisting of twelve themes and four revisions. Each theme is subdivided in various videos. I present half the course in this thesis, because the setup explains points for improving the elaboration of the second half. The themes for the lessons are:

1. Poem *Velocidade* (Speed)
2. Proverb "Água mole, pedra dura, bate, até que fura" (Soft water, hard stone, beats, until it hollows down)
3. Recipe for "pudim de leite" (Recipe for "flan" pudding)
 REVISION 1
4. Music *Asa branca* by Luis Gonzaga
5. Music *O pato* (The duck) by João Gilberto
6. Music *Brasília amarela* (Yellow Brasília) by Mamonas Assassinas (Pop Music Band)
 REVISION 2
7. Artoons
8. News article from paper
9. Instructions from a manual
 REVISION 3
10. Fable
11. International tale
12. Prayer "Our Father"[17]

CONCLUSION

In short: the goals of *Joy of Reading* are:

. teaching reading and writing or supporting school learning;
. refining perception of reality regarding the world of writing;
. relating written word to meaning, battling high rate of functional illiterates in Brazil;
. stimulating creativity;
. enabling learning with no trauma; enabling each student to discover his or her talents and ways he or she can extend his or her personal possibilities, according to their needs;
. ncouraging and nurturing freedom, independence, and motility;
. increasing self-assurance, self-confidence of the students;
. encouraging appreciation of local culture with music and poems;
. nabling deaf people to learn to read by learning to lip read;
. perfecting word pronunciation, speaking correctly;
. constituting a space that is neither of separation, nor of competition, but of construction, transformation, and relation to construct a better world;
. utilizing more popular and lower-cost technology to permit access of target audience.

Devices

In order to reach our goals, in the idealized modes above, we dispose of cellular phones and videos as central pedagogic instruments or devices. Our project does not restrict itself to these modes of communication and is open to new ones such as computers and others.

16 The word that writes the name of the student holds a very special place. This word distinguishes the student from the collective sphere, to the individual.

17 The last edition of the study "Retratos da leitura no Brasil" (Profile of Reading in Brazil) done by the Instituto Pró-Livro in 2007 shows that the Bible is the most widely read genre in Brazil, ahead of the textbooks, that come in second place, and of novels that come in third place, having sold more than five million copies that year of the research.

Mobile Phones

Mobile phones are devices. "Device is an abstract machine, defined by means of functions and shapeless material, it ignores all distinction between content and an expression, between a discursive development and a non-discursive one. Though it is practically deaf and dumb, it is a device that makes us see and talk" (Deleuze 1990, 153).

A device may be a means communication. The mobile phone is the most important, most popular, and most numerous device of mass media[18] today, throughout the world.[19] The mobile phone reaches most inhabited areas of the planet and the numbers of users increase daily at breakneck speed. Hence it is the mass media with most powerful social penetration. It reaches all social classes and all age groups.

The cell phone language, videos, SMSs, e-mails, photos is familiar to all its users. Young people are the ones who most use the communication of mobile phones' resources. According to Tapscott: "Today's kids are so bathed in bits that they think it's all part of the natural landscape" (Tapscott 1997, 1). Mobile phones are such a big part of today's living that it is nearly impossible to be without one. Whilst Internet is also available through mobile phones, it is the major device for accessing current knowledge, principally among young people. "Time spent on the Internet is not passive. It is active time. It is reading time. It is investigation time. It is time for developing abilities and systems to solve problems. It is time of analysis and evaluation. It is time to compose thoughts. It is writing time" (Tapscott 1997, 8). The mobile-phone user considers access to information and personal expression as a fundamental right. This is essential for those who wish to learn.

On the other hand, acquiring knowledge via a mobile phone and Internet is crucial when we refer to more popular classes, where there is a lack of experience with reading material within the family setting, which hinders the alphabet learning by traditional means.

So this proposal of teaching and learning how to read and write via the mobile phone has all the chances or reaching its goals both in quality and range. A final observation: the beginning of this system is the hearing of the young people, the future users. "People, companies, and nations that will reap economic success are those who listen to their children. Listen to their view of the world. We can learn how they can mysteriously use the new devices with least effort. Listening and answering to their frustrations, we can project devices and attitudes for a new era" (Tapscott 1997, 20). And the new era is the era of the mobile phones and other mobile devices.

Video

Video is supported by images. Images in the broad sense of the term are described:

> Images signify two closely related things. We have images when we use the sense of vision. We physically see objects, as objets d'art, sculptures, paintings. And we also talk about images in a universal sense. Our thoughts, inventions, and fantasies are sensory images, that come without the physical presence of the image. Images can as well be still, like stones or they can be action full like living bodies. (Arnheim 2000, 167)

Based on this concept of image, in *Joy of Reading*, learning through videos is holistic. It transmits the visual image of the study object, how to read it and how to pronounce it (the mouth saying the name of the image), its spelling and the final result of the written word. It reaches the object and its meaning. It is dynamic and appealing. It is challenging and captivating. It speaks the language of the young people of our society.

The words are chosen according to their appearing in the music, poems, or other topics being studied at that time. This way we establish a rich meaning connected to the students personal life, cultural origin, and his or her emotions. The association between the object and its name is a very enriching activity used in teaching and

18 "In a great moment of the history of telecommunications, the mobile phones made a significant change in the life of the people, much faster than any prior technology. They were a blowout and were much easier and cheaper to embrace. The long process of connecting everyone on Earth through a global telecommunication network, which started with the invention of the telegraph in 1791, is about to be concluded. Mobile phones will have contributed more than any other technology to the advance in democratization" (*The Economist*, October 7, 2009).

19 How long will it take before everyone on Earth has a mobile phone? "It seems like that mobile phone global teledensity will surpass 100 percent in the next decade," says Hamadoun Touré, secretary-general of União Internacional das Telecomunicações, established in 1965 to control international telecommunications (*The Economist*, October 7, 2009).

learning to read and write. It must not be repetitive and limited to just a few objects. Repetition does not produce learning. It is the establishing of multiple relations that generate knowledge in learning to read and in life.

The video we produced tries to establish a conversation[20] with the student, then supplemented by our site. For this, the finalizing and the presentation of the images is homely, fostering our approximation with the student and a familiar tone in the teaching-learning process.

Important: deaf people also can learn from lip-reading all the material to be studied.

Testimonies

Looking around, those who don't know how to read are limited. Currently, working with construction workers as an architect, we witness on a daily basis that not knowing how to read the instructions of a product or of a machine jeopardizes their life and can put the workers' health on the line. And we realized that only by knowing how to read and understanding that which is read, they can overcome this situation and even progress professionally.

We also learn much from those who don't know how to read. Many times, they know some natural secrets, for example, about herbal cures—and they die without passing this knowledge on. Much of the popular culture is lost with the event of migrants, especially younger generations heading to the great urban centers. They leave behind their elders and sages, and are no longer exposed to the valuable information and culture, and, in their new urban surroundings, they dismiss the "folk" knowledge as if it were worthless. They quickly pick up on the local big-city consuming habits, easily forgetting the traditional folk remedies. An example with medications, they take pharmacy-prescription medications and disregard the natural remedies' efficacy. They suffer more, we all lose, and the native culture is lost.

To consolidate the lecto-writing project for learning reading and writing—*Joy of Reading*—Eleonora Sampaio Caselato, a friend and professional woman who was invited to participate wrote:

> Collaborating with Analivia in this teaching learning to read and write project gives me the opportunity to complement my twenty-year work with children in public and in private schools. The greatest challenge has been to prepare lessons for people I don't know, of different ages, and with an array of interests. The students must be given the certainty that learning to read and write is an individual process which depends on their effort, under good guidance. The expectation of reaching out to these people, to interact with them, to give them that certainty, encourages me to invest more and more time, disposition, and experience into the *Joy of Reading* project.

Renovation

We consider at present that a renovation in the way of teaching is legitimate; and an updated analysis is necessary. The teachers' role is not to supply instant answers, but to foster the atmosphere where the structuring of knowledge comes as a result of the students' own actions.

To offer these conditions, one should know something about how the human body works. The body interacts intensely with the brain, and both interact with the surroundings. The relation body/mind is mediated by the movements of the body and by the activity of its perception senses. Internal or external movement of the body is perceived when positions of parts of the body are changed in relation to space. This change results in muscular activity, which happens when conscious effort is directed[21] to that movement, being that whatever movement done alters not only the part of the body that moved, but the body's entire complete organization.

Without awareness, a baby would not develop and stand upright and would perhaps not survive. The organization of standing upright and walking are considered as the most complex activities the brain executes in a lifetime. Learning to read and write also demands a complete mobilization of the body, requires integration between the conscious and unconscious mind.

20 The roots of the verb "converse" are two Latin words: "cum," which means "with," and "versare," which means "bind, wrap around." This indicates the involvement of those who converse, not only with speech but actions and emotions.

21 The concept of consciousness or awareness is very ample and is defined by several authors with different approaches. In this case, we will use the definition by Damasio (1999, 147): Awareness is the rite that allows an organism able to regulate its own metabolism, with its innate reflexes, and a way of learning called conditioning to become a mentalized organism, a type of organism whose answers are carefully formatted by the interest of its life.

Integration, coordination, interconnection are interrelations that require a non-linear form of thinking, analyzing, and understanding.[22] The memory is one of the results of these interrelations indispensable in learning to read and write. No one knows exactly how the memory works, but we all know that if a fact can be described is because it was experienced. Experience is constituted of the integration, coordination, interconnection of sensory (sight, hearing, taste, smell, touch, and kinesthetic) perception of space, of body movement, of surrounding objects, amongst other elements. The result, one can say, is in the memory. The memory works through images, in the ample sense of the term. Bachelard puts it best when he describes a type of image: "The poetic image is not the subject of an internal truth. It is not an echo of the past. Through the brilliance of an image, the distant past resounds, and it is hard to know how deep these echoes will reverberate and die. Due to its novelty and action, the poetic image has its own dynamics" (Bachelard 1994, 17). When one remembers, one relives the experience in the mind and in the body, adding to it. Memorizing is not a passive process of saving or storing, but an active process or re-categorizing and valuating founded on previous categories, in which thoughts, images, emotions, and stored sensations are related and connected. We intuitively know the importance of the memory for teaching and learning.

The memory is the combination of several elements, among which emotion. Morphologically, emotion signifies "outward movement." The essence of emotion is the body changes induced by the chemical and nervous system, under the control of the brain, which corresponds to the content of a thought regarding an event or particular entity; which should be taken into consideration in any educational project.

The complexity of our organism must be considered as teaching takes place, when the teacher is supplying material to structure the students' learning. Using mobile phones as the device, the content is assimilated by hearing and by seeing, thus *Joy of Reading* will cast knowledge in visual and audio images. Sight occupies such a large part of intelligence, it takes up nearly half of our cortex. Our visual intelligence interacts profusely with our rational and emotional intelligence, and in some cases it even precedes or directs the intelligence. Understanding our intelligence is understanding ourselves. Hoffman says, "Sight[23] is not a passive perception, it is a process of active construction ... the main difference is that scientific construction is conscious, whereas that of the visual intelligence is, by large, unconscious" (Hoffman 1998, 12).

Active construction, active perceiving of the surroundings is adjusting the body willingly to assimilate signals. The body actively changes: perceiving is in the domain of activity over surroundings, it is more than just receiving these signals passively. It is in this realm that learning, in its broader meaning, has its significance. In other words, our development from early days, the design of our cerebral circuits that represent our body and its interaction with the environment depend on the activities we perform and of action of the innate bioregulatory circuits and how they react to these activities. That is why in learning matters is **how one does it**, and not what one does.

This is how we can conceptualize learning: complex organisms put in complex surroundings require a great repertoire of knowledge, the multitude of choices for answers, the ability to construct complex combinations of answers, and the ability to plan in advance to avoid situations that are disvantageous and to promote favorable situations, including for survival.

Summarizing using an Asian saying:
I listen and I forget
I see and I remember
I do and I understand.
Complementarily, we reproduce this text by Fabricio Marques published by FAPESP in November 2009:

Learning to read is not a difficult task, and it is not for nothing that adults have more difficulty than children, whose brains are still developing. Researchers from Spain, Colombia, and England recently unveiled what happens in the brain when learning to read. The contend of this study is intriguing: it is the exam of images of twenty Colombian guerrillas, who were trained to read when leaving their arms, and reintegrating in society. According to a *Nature* article, as these guerrillas had never received any form of education, their brains were intact in terms of any training process and ideal for the study. Compared to other twenty-two illiterate individuals, the literate adults have more grey matter

22 This concern is fundamental for organizing.
23 Sight starts its process with its sense of perception, that is, through the eyes, vision.

in areas associated to visual, speech, and semantic processing; they also have more white matter in a region associated to reading. It is not only the structure that differs: reading increases the connections between the right and the left side of the brain. And while reading aloud, the angular gyrus modulates the functional interactions between processing images and discourse. Now it will be possible to re-evaluate the image of people with dyslexia: until then, it was impossible to know whether the alterations observed were cause or consequence of the difficulty in reading.[24]

Conclusion

"In pondering the future we are tempted to limit our attention to the curiosity about the inventions and discoveries awaiting us. This, however, would be narrow-minded. What is needed is a wider view encompassing the coming rewards in the context of the treasures left us by past experiences, possessions, and insights" (Arnheim 2000, 168). This way, despite utilizing new inventions, we respect all the teaching tradition. To think properly is not to be overly certain of our certainties. We are between the existing knowledge and the knowledge yet to be constructed. For example, one of the questions not yet answered is the system which we will use to evaluate the knowledge assimilated by the students who will utilize *Joy of Reading*.

To finalize: "Love is our biological foundation and only base for conserving our human quality as well as our well-being" (Maturana 1999, 127).

Summary of the post-PhD dissertation of the same title, advisor Prof. Dr. Katia Maciel, defended at the Federal University of Rio de Janeiro, 2010.

Translated by Helen Andersen

[24] Fabricio Marques, *Laboratorio Mundo* (São Paulo: FAPESP, 2009), 40 .

References

- Arnheim, Rudolf. "The Coming and Going of Images." In Leonardo-*Journal of the International Society for the Arts, Sciences and Technology* 33, no. 3, 2000, 167-168
- Bachelard, Gaston. *The Poetics of Space – The Classical Look at How We Experience Intimate Places*. Boston: Beacon Press, 1994.
- Damasio, Antonio. *The Feeling of What Happens – Body and Emotion in The Making of Consciousness*. San Diego CA: A Harvest Book Harcourt Inc., 1999.
- Damasio, Antonio. *The Descartes Error – Emotion, Reason, and the Human Brain*. New York: An Avon Book, 1995.
- Deleuze, G. *O que es un dispositivo*. Barcelona: Gedisa, 1990.
- Feldenkrais, Moshe. *Consicência pelo Movimento*. São Paulo: Summus Editorial, 1977.
- Freire, Paulo. *Pedagogia da autonomia – Saberes necessários à prática educativa*. 11th ed. São Paulo: Editora Paz e Terra, 1999.
- Grossi, Ester Pillar. *Didática do nível pré-silábico*. 10th ed. São Paulo: Editora Paz e Terra, 1990.
- Grossi, Ester Pillar. *Didática do alfabético*. 10th ed. São Paulo: Editora Paz e Terra, 1990.
- Havelock, Eric A. *Origins of Western Literacy*. Ontario: Ontario Institute for Studies in Education, 1976.
- Hoffman, Donald D. *Visual Intelligence – How We Create What We See*. London, New York: W. W. Norton&Company, 1998.
- Levy, Pierre. Revolução virtual. *Folha de S.Paulo*, Caderno *Mais*, August 16, 1998.
- Maturana, Humberto. *Transformaciones*. Santiago: Dolmen, 1999.
- Pellanda, Nize Maria Campos, Elisa Tomoe Moriya Schlunzen, and Klaus Schlunzen Jr. (eds.). *Inclusão digital tecendo redes afetivas/cognitivas*. Rio de Janeiro: DP&A Editora, 2005.
- Rizzo, Gilda. *Alfabetização natural*. Rio de Janeiro: Bertrand Brasil, 2005.
- Scavazzi, M. Proceedings from the Simpósio Internacional Universidade e Novas Tecnologias, *Impactos e implicações*. Rede Macunaíma do Projeto Alfa, support FAPESP, São Paulo, 1998, 40.
- Searly, John. *O mistério da consciência*. 1st ed. São Paulo: Editora Paz e Terra.
- Shapiro, Francine. *Eye Movement Desensitization and Reprocessing*. New York, London: The Guilford Press, 2001.
- Tapscott, Don. *Growing Up Digital – The Rise of the Net Generation*. New York: McGraw-Hill, 1997.
- Varela, Francisco and Shear, Jonathan. "The View from Within: First Approaches to the Study of Consciousness." In Francisco Varela and Jonathan Shear (eds.). *The View from Within: First-Person Methodologies*. London: Imprint Academic, 1999.
- Varela, Francisco. "A science of consciousness as if experience mattered." In: S. Hameroff, A. Kazniak, and A. Scott (eds.). *Towards the Science of Consciousness: The Second Tucson Discussions and Debates*, Cambridge, MA: MIT Press, 1977, 31-44.

Kwarup Dance, 1975. Kamaiurá tribe in the Upper Xingu River region. Slide, color. Photographer: Analivia Cordeiro

Analivia Cordeiro

Manuara
Exhibition of Photos, Sculptures, and Video from 1975

Living for a few months in a preserved Indian village and communicating through gestures with a tribe in which only three individuals spoke a few words of Portuguese was an unforgettable experience for me. For thirty-nine years, I have kept records of this visit, waiting for an opportunity to display them properly. Far from an intellectual experience about which I could write extensively, that was a sensory immersion. I had the opportunity to meet a group of people who actually knew what harmony was, who knew what respect was about, who knew how to listen, observe, wait for their turn to speak up, and were concerned with making themselves understood.

Now I am showing these images publicly so people can see what those native men, women, and children looked like, and what their everyday life in the village was like. I also want to show their facial expressions, the equilibrium of their body muscles, and the harmonious movements that I captured on camera. This is all the product of their existence, their everyday life, and their way of living. Unfortunately, I regret to say, this all belongs in the past, it dwells only in memory because I have no doubt that the children and grandchildren of these native Indians no longer retain the same physical strength, self-confidence, personal dignity, and preservation of their culture. At this point, a couple of questions come to mind: Who are we to judge or assess their civilization? Given all our social issues, do we know any better than them? Are we superior to them in any way? I honestly have never experienced anything so profound. They were so sensitive, gentle, perceptive, considerate, friendly, and generous! I am saying this after thirty-nine years, virtually a lifetime. Thus I have named the exhibition *Manuara*, which means "remembrance" in the Tupi-Guarani language.

In 1975, I began to study the body language of the native peoples of Brazil. I was a dancer and researcher of the human movement who, notwithstanding my young age, had a sound knowledge basis in that field. Bodywork is something we start very early in life. Having started my studies at age seven, by the time I turned eleven I was already dancing. As regards my repertoire, I thought I had to incorporate a deeper understanding of the Brazilian Indian body language into it. To this end, I worked on a project to record a native ritual that lasts approximately two months: the Kwarup. I submitted the project design to the anthropologist Lux Vidal at the University of São Paulo and obtained her approval. Then, thanks to the Brazilian Air Force, I managed to reach the remote Kamaiurá tribe in the Upper Xingu River region. I invited a friend, Silvio Mendes Zancheti, to accompany me on this mission, from which we returned with plenty of photographs and super-8 footage. At the time, I sent the University of São Paulo an analytical report on my observations and the body language of this tribe, together with an edited film. That is how far I went with the subject; my life then turned in another direction as a video artist, computer dance researcher, and designer of a software for dance notation. I took a path toward understanding the significance of technology in today's society. This is how this material ended up being stored for many years until I decided to show it this year.

To this end, I reedited the footage and restored the photos, not knowing which of us took which picture. I have turned this into a personal project that involves manipulating these images, printing them on tree trunks and dried leaves, and using natural materials from Brazil such as iron, sand, earth of different colors, stone, water, tree bark, seeds, wasp hives, and live

plants. In the composition of these pieces, I used my hands as a working tool. I also used shards of mirrors that so fascinated the Kamaiurá in our first encounter. I have used shards because they convey a symbolic meaning of what our civilization has done to the culture of Brazilian natives. It is cruel to ignore this people's contribution—which is more of a human contribution, actually, than a historical one—and to disregard the knowledge they detained until recent times. It is preposterous, a crime!

For me, this exhibition is an act of pure and true love that by far transcends the aesthetic experiment.

 May 2014

This text was originally written for Analivia Cordeiro's exhibition *Manuara* at the MUBE - Museu Brasileiro de Escultura, São Paulo, September 2014.

Translated by John Norman

Analivia Cordeiro

The Cycle and Ritual of Kwarup
Kamaiurá Indians, Upper Xingú (Mato Grosso) A Little Description

The Kwarup ritual is considered the most important ritual of the Upper Xingu culture. This culture is composed of the tribes Kamaiurá, Aweti, Waurá, Yawalapiti, Mehinako, Karib, Kuikuro, Kalapalo and Nahukwa-Matipu. Most of them have inhabited this region for a very long time, having been first contacted by white men in 1884.

To understand the meaning of this ritual, we must know a little about the mythology of the Upper Xingu culture. The mythic events concerning Kwarup take place in Murená, considered the center of the world by the Kamaiurá tribe. Mavutsinin is an anthropomorphic mythical being, who has existed since the primordial times. At the beginning of the myth, Mavutsinin goes in search of a string to make a bow. The owner of the string is a jaguar named Yayat, who is Mavutsinin's nephew, but nonetheless potentially dangerous to him. When they meet, Mavutsinin is trying to steal the string, and Yayat tries to kill him. But in return Yayat receives a proposal of marriage with Mavutsinin's daughters, who are cross-cousins of Yayat and thus preferable as wives in Upper Xingu culture. By offering his daughters, Mavutsinin reverses the situation, thus transforming antagonism into alliance.

Aware of the danger of this marriage, Mavutsinin's daughters refuse to marry the jaguar. Mavutsinin decides to create two new daughters: he cuts two trunks of a tree species called kwarup, stands them up sings to them until they come to life. Then, he gives these two new daughters in marriage to the jaguar. The youngest daughter gives birth to Kwat and Yaí (the Sun and the Moon). And the oldest daughter gives birth to the twins considered the cultural heroes of the Upper Xingu tribe. They are responsible for the zoologic and geographic organization of the Upper Xingu, while Mavutsinin is responsible for the social structure of this culture.

Mavutsinin continued making people from trunks, until a man had sex with a woman, leading to the birth of a child, who would then grow up to become a man or woman.

From then on, Mavutsinin no longer made people from tree trunks. But left the tradition of the Kwarup ritual, carried out for members of the tribal chief's family when they die. The aim of this ritual is to remember the person who died and to continue the cycle of life, and at the end of this celebration the girls of marriageable age are presented.

Kwarup cycles are the commemorations that are carried out between two Kwarup rituals. After the burial of the deceased person from the chief's family, it is forbidden to say his or her name. Three days after the burial, the *apenap* is built, which is a low fence of trunks upon the sepulture.

This moment marks the beginning of the Kwarup cycle, which can last from six months to one and a half years. During this period, the Kwarup dances are performed every day, as are also the *urua* flute dances, and huka-huka fight training sessions are held.

During the dry season, the head of the tribe meets together with other chiefs to set a date for the collective fishing expedition. At this point the preparations for the Kwarup ritual begin. The *apenap* is destroyed to prepare the site for the Kwarup ritual.

Following this, they go into the forest, where the logs for the *kwarups* [ceremonial totem logs] are cut and hidden from the women. Each dead

person from the chief's family will have a trunk transformed into a *kwarup*.

Meanwhile in the village, the *urua* flute dance is performed during the whole day, and the Kwarup dance is held in the late afternoon.

To provide food to the invited tribes, the men go fishing. They go far away from the village and sleep for three days in hammocks in the forest. For fishing they make a net of bark woven with vines. Before throwing the nets into the water, they pray to it using the *tevere*—a magical formula to attract the fish. At the end of the day, they throw the net into the river, and they place heavy sticks on the bottom of the net and bamboo poles at its top, to keep it vertical. At night, they perform a ritual against injuries by alligators or stingrays, which involves placing a floating prayer bowl on the water's surface.

The next day, they remove the prayer bowl, early in the morning. Around 50 people pull the net all day long until reaching a dry river branch, to better catch the fish in the shallow water at its mouth. Before they start killing the fish, the shaman—the spiritual leader—immerses a *timbó* root in the water. This makes the fish dizzy, which then rise to the surface where they are killed with spears. The fish are smoked in the forest before being taken to the village.

Depending on how successful the fishing has been, the *pariat*s—messengers—invite one or more of the tribes Waurá, Yalapiti, Kalapalo and Kuikuro. Meanwhile, in the village, they keep dancing the *urua* flute dance and the Kwarup dance.

Two or three days after the *pariat*s return, they dig a hole for each *kwarup*, into which the trunk is placed upright and then painted as a totem representing the dead person to be honored. They call the *maraka'ip* who play and sing and are paid with food and cotton thread. When the painting of the *kwarup* is finished, they perform the Kwarup dance exceptionally in the morning as the *maraka'ip* sing and play. On this day of the *kwarup* painting, women are forbidden to leave home, so the boys and men have to cook.

After the painting, they put the *kwarups* in the center of the village where the *apenap* was before. The women are called to decorate the *kwarups*. Throughout the night, the women cry in a ritualistic way, to prevent the dead from being reborn.

When the invited tribes arrive, the *pareat*s receive them, offering food and a place to sleep outside the village.

The day after the painting, the visiting tribes enter the village, where they stay separately, and the chief of each one sits on a stool called an *apikawayat*. Then the Ho-at dance is performed twice, first by the invited tribes and then by the Kamaiurá tribe. After this, the huka-huka fight competition is held between the tribes. Following this, they dance the *urua* flute dance and the Kwarup dance.

At the end, the invited tribal chief receives a girl, who was in reclusion, as a wife and as a future mother representing the continuation of the cycle of life.

To finish, the *kwarup* trunks are thrown in the lake near the tribe, for the soul in them to be released, and the tribes exchange goods before returning home. The next day, they return to their daily life and a new Kwarup cycle begins.

This text was originally written for Analivia Cordeiro's exhibition *Manuara* at the MUBE - Museu Brasileiro de Escultura, São Paulo, September 2014.

Translated by John Norman

Analivia Cordeiro
The Architecture of Human Movement
A Summary

Abstract

After decades researching a notation of human-body movement, this postdoctoral project evaluates, practically and theoretically, the results obtained in the last two years: sculptures of the spatial condensation of a body movement, recorded in video and processed by the notation system Nota-Anna.

1. Introduction

> Knowing must therefore be accompanied by an equal capacity to forget knowing. Non-knowing is not a form of ignorance but a difficult transcendence of knowledge. This is the price that must be paid for an oeuvre to be, at all times, a sort of pure beginning, which makes its creation an exercise in freedom.[1]

This postdoctoral thesis is an analysis of the production of sculptures made between 2015 and 2016. The process of creation and production of these sculptures is outside the specific scope of this postdoctoral work. The visual result of these sculptures was surprising from the spatial point of view: the lines and planes that intersect in an unusual and complex way justify an in-depth analysis.

This analysis will mainly address an area I have been active in for decades: human movement. This embraces all human actions anywhere and anytime. In this postdoctoral thesis I will approach the graphic intelligibility of movement, a way of writing movement, as an object that allows for the rereading and reconstitution of movement, besides opening a new possibility of creativity about it: an instrument of human communication that can be used to write, describe, and print human movement for people, in order for them to exchange messages with each other after the movement has already been made in a past act.

In the realm of sound, this proposal has existed for a long time with the musical score, and later with the invention of other types of experimental recording. A qualitative leap occurred when the possibilities for the recording of music appeared, and information theory provided a scientific approach for the study of sound.[2] Its materiality grew to the point where the musical signal could be materialized in an object: the possibility of a physical representation for sound. The musical piece ceased to be music to become a thing, with dimensions in space, measured as a temporal product. With the new technology, the musical signal that circulated through wires and circuits was able to be transmitted, stored, received, and sold. In the universe of human movement, this reality is still a purely theoretical proposition. An effective way of writing human movement is still in the research stage. Some very interesting proposals exist, and in this postdoctoral thesis I will analyze one of these proposals: the condensation of the movement in three-dimensional pieces, which can be called sculptures.

1 Jean Lescure, Lapicque (Paris: Galanis, 1978), 78. (N.T.: Free translation.)
2 The first goal was to develop a method that would allow the sound to be situated independently from the traditional links, as a sonic phenomenon, or sonic object. This approach radically changed the problem of the message. Traditionally, contingencies of immediate perception, with its system of capture that was ingenuous, imprecise and, essentially, of an impressionist or qualitative nature. The difficulty of the traditional focus was rooted in the absence of something that could detect the materiality of the message.

2. Nota-Anna and Sculptures

> It would be especially important for the artist to see how nature uses the basic elements in her independent realm; which elements are to be considered; what characteristics they possess; and in which manner they combine to form structures. Natural laws of composition do not reveal to the artist the possibility of superficial imitation (which he frequently sees as the main purpose of the laws of nature) but, rather, the possibility of contrasting these laws with those of art.[3]

Nota-Anna is a human motion notation software that graphically describes the spatial displacement of twenty-four joints of the body in three dimensions. The data input can be through video frames or sensors.[4]

Nota-Anna, besides writing the movement, allows an analysis and creativity that, without this visualization, would be impossible. It was using this possibility that I began the research on the use of registered movement, in the field of sculpture and drawing.

In plastic terms, Nota-Anna uses as its basis a point that moves in space. The point means the primary element par excellence, according to Kandinsky.

> The geometric point is an invisible thing. Therefore, it must be defined as an incorporeal thing. Considered in terms of substance, it equals zero. ... The geometric point has, therefore, been given its material form, in the first instance, in writing. It belongs to language and signifies silence. In the flow of speech, the point symbolizes interruption, non-existence (negative element), and at the same time it forms a bridge from one existence to another (positive element).[5]

The point in physical reality is the result of a collision of the tool with the work plane, paper, wood, stucco, metal, etc. In the technology field, the point is the pixel, or even the shortest moment of the sensor capture.

In arts, "Point—rest. Line—inwardly animated tension created by movement. The two elements—their intermingling and their combinations develop their own "language" which cannot be attained with words."[6]

In an interpretation of body movements, each articulation corresponds to a point, that moves in three-dimensional space, describing lines. When the lines move, they form planes, which intersect in space. The mathematical concept becomes reality, when after reading Nota-Anna we can reconstitute or execute the body movement again. This fact makes us think about the meaning of numbers in our lives.

> The interest in numerical expression runs in two directions—the theoretical and the practical. In the first, obedience to law plays the greater role; in the second, utility. Law is subordinated here to purpose whereby the work of art attains the highest quality—genuineness.[7]

The relationship between numbers and life is present in this thought of Kandinsky:

> Thus meet here: 1. the roots of two numerical systems, and 2. the roots of the forms of art. ... Today, especially, the necessity of finding this common root appears inevitable to us. These necessities are of an intuitive nature. The road to fulfillment is also chosen intuitively. The rest is a harmonious combination of intuition and calculation—in the long run neither the one nor the other alone suffices.[8]

2.1 Nota-Anna and Researches Concerning Human Perception

> The use of line in nature is an exceedingly frequent one. This subject, which merits special investigation, could be mastered only by a synthesizing natural scientist. It would be especially important for the artist to see how nature uses the basic elements in her independent realm; which elements are to be considered; what characteristics they possess; and in which manner they combine to form structures.[9]

Art, which has been part of human existence since its inception, has accompanied human life for millennia. Its discourse has recently changed

3 Wassily Kandinsky, *Point and Line to Plane* (New York: Cranbrook Press, 1947), 103.
4 A video of Nota-Anna: https://www.youtube.com/watch?v=zTNSh01TmBQ or https://vimeo.com/47377980.
5 Kandinsky, op. cit., 25.
6 Ibid., 112.
7 Ibid., 93.
8 Ibid., 143.
9 Ibid., 103.

with the now-surpassed art & technology trend, which presented a differentiation of other tendencies when it opened a dialogue of art with studies of perception, and also with biological, neurological,[10] and psychological[11] studies. This dialogue provoked a change in social behavior so profound that we have come to change even our organic, biological, neurological, and psychological reality. This social change leads us to the notion of evolution.

From the biological point of view, evolution means directed change, a process of adaptation.

> Adaptation is the property of an organism, whether it be a structure, a physiological trait, or a behavior the organism possesses, which has been favored by natural selection in relation to alternative properties. In each generation, all individuals who survive the elimination process are "adapted" and the properties that allowed them to survive are called adaptations, after a large number of interactions. When one studies the lifestyle of a particular group of organisms (both biologically and anthropologically), specific adaptations are impressive, without which a lifestyle would be impossible.[12]

Art is part of the adaptation and consciousness to "perpetuate" man on earth and allow his long survival. This is because adaptability and its maintenance can be translated into new creations, present in cultural and geographical plurality. In both biology and the arts, man adapts to new conditioning, changes, and creates constantly. Art plays an essential role in human life on earth.

It is curious that there is a term shared by the field of the visual arts and that of biology/neurology: plasticity, which touches on man's adaptation. The morphological meaning of this word is interesting. Plasticity, a noun; in the arts: a quality of materials that can be molded; in biology/neurology: the subject's ability to adapt to environmental conditions.

The dynamic relation of man to the environment is highly present in recent studies on perception. Initially perception was considered independent of one's cultural context. Today we know that life profoundly influences how we capture and store information. The most recent strategy in the research of consciousness has studied how conscious and unconscious perceptive processes influence thoughts, actions, and feelings. Perception is a process that occurs only when the body initiates interaction with its environment.

There are works of art that provoke a real change of human behavior and a new apprehension of the world. Nota-Anna can be one case: try to imagine how much our reality can change if we can broadly share written movements in social and private communication.

When we study adaptation and plasticity, both neural and artistic, we can think about human history both on the scale of humankind as well as on that of the individual's growth and development from birth to death. The understanding of the formation of a person as a whole.

This attempt at understanding leads us to a complex approach. Integration, coordination, and interconnection are difficult to understand, suggesting a nonlinear analysis. Thus, we can, for example, observe the relation between the internal processes and the changes of our body.

10 "During the 1980s, various studies indicated that, due to the influence of the unconscious, people perceive the reasons for how they feel, communicate nonverbally with others, behave and judge other people. In that period, even though the psychologists were trying to diminish the importance of the unconscious, they needed to reconsider its role even though they sometimes denoted it by some other adjective, such as "nonconscious," "automatic," "implicit" or "uncontrolled." Leonard Mlodinow, *Subliminar – Como o inconsciente influencia nossas vidas* (São Paulo: Editora Zahar, 2012), 118. (N.T.: Free translation.) This gave rise to the field of social cognitive neuroscience, or simply social neuroscience. It is a ménage à trois: social psychology, cognitive psychology and neuroscience. (Ibid., 124.)

11 It is interesting to consider how current psychology uses new technologies and bases its conclusions on them, which often have their origin in the traditional masters, such as Freud, for example. "At the end of the 1990s, about 100 years after Freud's book interpretations of dreams, fMRI became widely available. fMRI, or functional magnetic resonance, is an improved version of the MRI device that your doctor uses… With fMRI, scientists can map the consumption of oxygen from outside the brain, through quantic electromagnetic interactions among the atoms in the brain. fMRI thus allows for a noninvasive tridimensional exploration of the human brain during normal functioning. It not only provides a map of the brain's structures but also indicates which of them are active at any given moment, allowing the scientist to see how the active areas change over time. Mental processes can therefore now be associated to specific neural pathways and specific cerebral structures." Ernst Mayr, *O que é evolução* (São Paulo: Editora Rocco, 2005), 119 (N.T.: Free translation.) Note: just as Nota-Anna makes movements made in the air visible, fMRI makes visible the functioning of the brain. This is our current era…

12 Ernst Mayr, *O que é evolução* (São Paulo: Editora Rocco, 2005), 182. (N.T.: Free translation).

The state of the cortex is directly visible on the periphery through the attitude, posture, and muscular configuration in which we are connected. Any change in the nervous system clearly translates through a change of attitude, posture, and muscular configuration.[13]

Recently, this study has deepened in scientific research, reaching our expressive reality: the truthfulness and authenticity of an expression. There are movements that we make for social reasons, and they are very different from those that are true with respect to their expression. An authentic smile, for example, is different from when it is only for social purposes, only to be nice or polite to someone. Both look similar though in the brain they occupy very different positions. "Our facial expressions are also subliminally governed by muscles over which we have no conscious control. Therefore, our true expressions cannot be feigned."[14] Just as in the face, in the rest of the body as well, anything we feign can be detected as such when accurately observed.

The meaning of movement in life is very broad. I point out a fact that touches directly on the subject we are investigating. "The activity of the human mind begins before the crystallization of the verbal symbols, before the development of the logical-discursive way of thinking. Before the verbal symbol, the image is the first vehicle from which human intelligence is served."[15]

The meaning of visual information is so wide that today there is a field of study, Visual Intelligence, dedicated to studying the relationships of our brain, body, and behavior with visual images.

> Vision is such a large intelligence that it occupies almost half of the cortex. Our visual intelligence interacts richly, and in some cases even precedes or directs our rational and emotional intelligence. By understanding our visual intelligence, we understand ourselves.[16]

3. Sculptures Based on Body Movement

> It is said that God took in his hands a little clay and did what everyone already knows. If the artist wants to do a creative work, he can never imitate nature, he must use the elements of nature to create a new element.[17]

According to etymology, plastic art is the art that is expressed by the creation of plastic shapes in volumes or reliefs, either by modeling malleable and/or moldable substances, by cutting solids, or by assembling various materials and/or objects. Sculpture is a noun, while sculpting generally means impressing, chiseling, incising, or carving on some material.

In the process used to make these sculptures with 3-D computerized printing, the material is layered rather than worn away or carved. Even so, respecting these differences, I still use the term *sculpture*.

Historically, sculpture, from the second decade of the 20th century, without the support of the cathedral wall or pompous pedestals, came to apprehend the empty spaces, to incorporate in itself the proliferation of new materials and vehicles of communication. As proposed at that time:

> What is the number one problem in modern sculpture from [Henry] Moore? The answer is to model, sculpt space instead of volume and mass. What is the method to achieve this effect? Movement. This is the value that space represents for us, which causes us to have a phenomenological, even sensory awareness.[18]

The creation of the sculptures studied here is part of this historical approach.

As was the case with visual artists, the composition of these sculptures respected the natural organization of our movement in space. Pictorial elements, in the broad sense of the term, include the materiality of the parts of a three-dimensional piece, such as sculpture.

From a theoretical and universal perspective, the artist aims to provide a new experience for

13 Francisco J. Varela and Jonathan Shear (eds.), *The View from Within—First Approaches to the Study of Consciousness* (Thorverton: Imprint Academic, 1999, and also in *Journal of Consciousness Studies*, 6, no. 2-3, 1999), 82.
14 Leonard Mlodinow, *Subliminar - Como o inconsciente influencia nossas vidas* (São Paulo: Editora Zahar, 2012), 138. (NT.: Free translation.)
15 Ibid., 176.
16 Donald D. Hoffman, *Visual Intelligence: How We Create What We See* (London/New York: W. W. Norton & Company, 1998), XI.
17 Paul Gauguin (1892), *Escritos de un salvaje* (Madrid: Daniel Guérin, 1989). (NT.: Free translation.)
18 Mario Pedrosa, *De la naturaleza afectiva de la forma* (Madrid: Museo Nacional Centro de Arte Reina Sofía, 2017), 279. (NT.: Free translation.)

the public in the broad sense of the word, both syntactically and semantically.

Beauty is always present in these artistic experiments, even when it is an aggressive and violent art. The notion of the beautiful is resignified in each period, and changes according to the social context. In the case of these sculptures, the beautiful is the revelation of a reality that our perception captures but which is still outside the systems of social communication: the written human movement.

Beauty reminds us of the plurality of creativity. Throughout the history of art, there have been various methods and instruments of creation, which resulted in diverse relations of mind/emotion (project/inspiration) with various procedures of production of the artistic objects—methods that we can call creativity. The conception of creation is independent of its verbalization, and it is precisely in the quality of this action wherein lies the quality of the work of art itself.

These sculptures are a product of the symbolic nature of thought above all else. A thought fully integrated with our current technological and social reality.

4. The Production System of the Sculptures

> Como podemos exprimir-nos? Há uma outra classe de beleza, criada, inventada pelo homem para o homem. A beleza visual de um ambiente nos arrebata sem ser a do mar; uma joia que nos extasia, sem ser parecida com uma bela mulher.[19]

Between 2015 and 2017, seventeen sculptures were produced. A project elaborated directly on the Nota-Anna notation of three movements: the bicycle kick executed by Pelé, recorded in video, in 1968; the volley kick performed by Pelé, recorded in video, in 1968; and the yoko geri kekomi hit performed by Bruce Lee, recorded on film in the 1960s. In the *Architecture of Movement* video, one can see the graphical variations of Nota-Anna for Pelé's kicks. Looking at those images together with the sculptures, the close relationship between movement and sculpture becomes clear: these are the material condensation of the movement with great accuracy. These sculptures were made in 3-D printers with diverse materials, always in small size, between 12 and 26 cm in height, as shown in the images [printed in this book] and the video indicated below.[20]

A movement is a drawing in space that outlines an ephemeral form making an impression on people who see it. The movement disappears, but the impression remains.

If the movement is surprising, endowed with beauty and efficiency, the impression that remains is one of admiration. People talk, trying to describe it with emotion, to explain the reason for this admiration. This is how some movements perpetuate themselves in the history of man, as extraordinary deeds. Prime examples of this are found in the bicycle and volley kicks performed by Pelé, remembered in a poetic way, as unforgettable moments. The aim to transform them into materialized memory is what gave rise to these sculptures, faithful to the movement.

Stages of the Creative Process:
- Digitalization of video sequences, recorded in 1968 and in the 1970s.
- Tri-dimensionalization using the Nota-Anna software together with other tools of movement visualization.
- Application of 3-D printing software to each of the geometric interpretations obtained.
- Modeling the sculpture. This is the stage of artistic creation of the sculpture, where we choose the visual option and a visual program may be created for the composition of the sculpture faithfully using the data of the reading of movement.
- Checking technical problems in the modeling.
- Correcting the technical problems and refining the creation of the piece from an artistic point of view, as well as support solutions such as pedestals.
- Choice of the material for the 3-D impression and evaluation of the aesthetics.
- Project of graphical pieces that come along with the sculptures.

19 "How can we express ourselves? There is another kind of beauty, created, invented by men for men. The visual beauty of a setting that washes over us without being that of the ocean; a jewel that enraptures us, without being similar to a beautiful woman." Waldemar Cordeiro, *Arte moderna e naturalismo* (*Folha da Manhã*, São Paulo: Brazil, 1950). (NT.: free translation.)

20 To watch the *Architecture of Movement* video go to https://www.youtube.com/watch?v=XAfV-d8cVFk.

General view with sculptures from the series *Unforgettable Kicks* at the exhibition in ZKM | Center for Art and Media Karlsruhe, 2023. Photographer: Felix Grünschloß.
© ZKM | Karlsruhe.

Technical Options

Video: H.264 format, created with the softwares Nota-Anna, Rhino3D, Final Cut Pro. Sculptures: 3-D printing using copper/brass/gold, polyamide, and alumide.

5. Analysis of the Sculptures

"The soul dreams and thinks, only then imagines."[21]

The visual result of these sculptures was surprising from the spatial point of view. We can observe three points in common to all the sculptures: the complexity of lines and planes that intersect, the lack of a long straight line, and the absence of any parallelism between the lines.

This is new information for the eye because it reveals the movement of the body in space. The fidelity of forms to the real movement of the body in space makes us think and re-watch the movements of people, trying to find these lines in our visual perception of the movement in everyday life. Our eye, which is educated to see, will look differently at the movements of people in the future.

Where exactly is the artist's free creativity in this research? With all the technical data, the artist creates spatial interpretations of the movement described by the trajectories, planes, and points. This creation gives meaning to the condensation of the movement in the form of sculptures. The seventeen sculptures can be grouped into five types of composition, which I will describe without judging or evaluating:

- Lines: there are invisible threads that delineate the trajectories of the movement, and it seems that the straight lines were thrown onto these trajectories, stuck together, and became supported by the trajectory. I called these sculptures *Tribute to Oskar Schlemmer* because they resemble one of his dances in which sticks are tied on the limbs of the body, with a length greater than the member itself, making the dance appear like straight lines in movement. The sculptures of this group are: *Tribute to Oskar Schlemmer I* (2016), *Tribute to Oskar Schlemmer II* (2016), *Tribute to Oskar Schlemmer III* (2016).

- Whole polygons: as if they were folded papers opening as the figure moves. The sculptures of this group are: *Concept of Abstraction I* (2015), *Concept of Abstraction II* (2015), *Ephemerality of Movement* (2016), *Geometry of Movement Materialization* (2017).

- Polygons with cutouts: The zombie version of the entire polygons. A percentage of the polygons is removed at random, without harming the stability of the sculpture. The sculptures

21 Gaston Bachelard, *The Poetics of Space–The Classical Look at How We Experience Intimate Places* (Boston: Beacon Press, 1994).

of this group are: *I Saw It* (2016), *Visible Empty* (2016), *Organic Kaleidoscope* (2017).
- Continuum: these are flexible, dense fabrics that define movement in space. The sculptures of this group are: *Poetics of the Human Movement* (2018), *(in)visible moving I* (2017), *(in)visible moving II* (2017).
- Partial Continuum: some body articulations members have a path in space endowed with great beauty. In these cases, I took these members separately and transformed them into sculptures. The sculptures of this group are: *Gold Kick* (2016), *In-Out* (2017).
- Body: the movement sequence captured by Nota-Anna and transformed into stick figures of the body. The sculptures of this group are: *Materialization of Sight I* (2015), *Materialization of Sight II* (2015).

Conclusion

The points raised in this postdoctoral work are the result of observations I have made over many years—since my childhood in fact, as I grew up surrounded by concrete, constructivist, and abstract art. My background in this area was not academic. And in this thesis, it was impossible to study in depth all the points raised. My intention was just to put them clearly.

I believe in art as a transforming element of people and society. Today we can point to many works and artists that are commercial and run counter to this statement. At the same time, we can see that the art of quality still exists, and it is a field of reflection and understanding of our life.

Experiments have always been in the sense of enlarging, intensifying, or interpenetrating the perceptual thresholds.

"The law of art and life: balance."[22]

This is a summarized version in English of the postdoctoral thesis "Arquitetura do movimento humano" defended at the School of Arts and Communication of the University of São Paulo – ECA USP, São Paulo, Brazil, in October 2018. Responsible professor Dr. Gilbertto Prado.

Translated by John Norman

22 Phrase attributed by Piet Mondrian in unpublished personal notes of Waldemar Cordeiro.

Bibliography

- Annotations of Waldemar Cordeiro from the 1950s, personal unpublished archive of the artist.
- Bachelard, Gaston. *The Poetics of Space – The Classical Look at How We Experience Intimate Places*. Boston: Beacon Press, 1994.
- Cordeiro, Analívia. *Human Motion Im(Ex)pression*. Frankfurt: Anita Beckers Galerie, 2016.
- Cordeiro, Analívia. *Nota-Anna - Uma notação eletrônica dos movimentos do corpo humano baseada no Método Laban*. São Paulo: Editora Annablume, 1999.
- Cordeiro, Waldemar. "Arte moderna e naturalismo." *Folha da Manhã* (São Paulo), 1950. Longo, Edson. Revista Pesquisa. São Paulo: FAPESP, Feb. 2015.
- Freeman, Walter J. and Christine A. Skarda. "Mind/Brainscience: Neuroscience on Phylosophy of Mind." In: Lepore, E. and R. van Gulick (eds.), *John Searly and His Critics*. Oxford: Blackwell, 2010, 115-127.
- Gauguin, Paul. *Escritos de un salvaje*. Madrid: Daniel Guérin, 1989.
- Hoffman, Donald D. *Visual Intelligence - How We Create What We See*. London/New York: W. W. Norton & Company, 1998.
- Kosko, Bart. *Fuzzy Thinking - The New Science of Fuzzy Logic*. New York: Hyperion, 1993.
- Kandinsky, Wassily. *Point and Line to Plane*. New York: Cranbrook Press, 1947.
- Lescure, Jean. *Lapicque*. Paris: Galanis publishing house, 1978.
- Mayr, Ernst. *O que é evolução*. São Paulo: Editora Rocco, 2005.
- Mlodinow, Leonard. *Subliminar - Como o inconsciente influencia nossas vidas*. São Paulo: Editora Zahar, 2012.
- Pedrosa, Mario. *De la naturaleza afectiva de la forma*. Madrid: Museo Nacional Centro de Arte Reina Sofía, 2017.
- Prado, Gilbertto, Monica Tavares and Priscila Arantes, (eds.), *Diálogos transdisciplinares: arte e pesquisa*. São Paulo: ECA USP, 2016.
- Van Doesburg, Theo. 1916. Annotations of Waldemar Cordeiro, personal unpublished archive of the artist.
- Varela, Francisco J. and Jonathan Shear. *The View from Within - First Approaches to the Study of Consciousness*. Thorverton: Imprint Academic, 1999.

TEXTS ABOUT ANA MARIA CORDEIRO'S WORK

I MOSTRA DE DANÇA CONTEMPORANEA DE SÃO PAULO

De 25 a 28 de Outubro - PROGRAMA

I - ANALIVIA CORDEIRO - " CHAMADA "

" Dotada para a dança com aquele dominio do corpo que não limita a imaginação do movimento, mas obedecendo com facilidade a qualquer ideia coreografica que surja , Analivia Cordeiro não procura simbolizar nada especifico, mas usa o movimento em si como canal de comunicação. Para ela " o meio é a mensagem", sendo que no momento, dança , significa mais pensar em movimento, sentir o fluir de formas dinamizadas no espaço do que representar algo.

Usando seu instrumento que é o corpo capaz de transmitir movimentos de dança sem interferencias superfluas, Analivia é uma artista que procura dar novos rumos a arte coreografica, explorando desde coreografias com computador, video e filme , como também movimentos elaborados a partir do cotidiano.

Para assistir ao espetaculo de Analivia , é preciso ter " olhos novos para o novo " .

MARIA DUSCHENES .

" CHAMADA "

Na primeira parte do solo, o publico coloca-se frente ao esqueleto da linguagem da dança: o corpo no tempo e no espaço, puramente. Despido de expressão individual e recursos metafisicos ou simbolicos.
É de fundamental importancia a compreensão de que esta dança resulta de um novo processo de criação. Foi produzida com uso do computador , na UNICAMP. Uma observação interessante foi feita por Jeanne Beaman (precursora mundial da "computer dance "), quando da apresentação deste trabalho no 20th American Dance Guild em Boston;

" Em geral os musicos presentes compreenderam o que você e eu estamos fazendo , mas muitos bailarinos sentiram " por que se preocupar com o computador ? " .

Maria Duschenes
Analivia Cordeiro "Chamada"
Call

First Contemporary Dance Festival of São Paulo
October 25–28 – Program

I – Analivia CORDEIRO – CALL

Analivia is endowed with the qualities and requirements for dance, and with such control over her body, there is no limit to the imagination of movement, it easily conforms to any choreographic idea, she does not seek to symbolize anything specific, just using movement itself as a communication channel. For her "the medium is the message," and dance is being aware of each moment, feeling the flow of forms in space instead of representing something.

Using the body as an instrument capable of transmitting dance moves without superfluous interferences, Analivia is an artist who seeks to give a new direction to choreographic art, exploring choreography in computer, video and film, as well as movements drawn from everyday life.

To watch the spectacle of Analivia, you must have "new eyes to the new."

Maria Duschenes, 1980

Introductory text for the invitation to the presentation of the dance called *Call* with choreography by Analivia Cordeiro.

Translated by John Norman

Brief biography

Maria Duschenes (Budapest, Hungary, 1922 – São Paulo, Brazil, 2014). Maria Duschenes started her dance training in Budapest when she was eleven years old. She studied the method created by the Swiss musician Émile Jaques-Dalcroze called Eurhythmics, which is based on bodily rhythms related to thought and movement. She also was training at the Kurt-Joss-Leeder Scholl of Dance (England) in the Rudolf von Laban system. During World War II, Duschenes went to Brazil and settled in São Paulo in 1940. As an educator and choreographer, she was responsible for introducing Laban's theory and analysis of movement in Brazil. Analivia Cordeiro was her student between 1961 and 1969. Her contribution to the history of dance is recognized both in Brazil and internationally.

Marcelo Leite

An Accuracy of Issue

No one, not even a dancer would see a trace of human movement in the figure 1. Yet this is the representation of the trajectory of points of the body, found in Analivia Cordeiro's studies. She researched precise notation for choreography with the aid of computer graphics. Such an unusual use of the computer, which could only be achieved after years of research and knowledge of the connection between art and technology.

Is it computer art? Not exactly. At best, it is "computer-assisted art," derived from the established applications of computer graphics design/computer-aided manufacturing (computer-aided design/manufacturing, or CAD/CAM). The computer used as a tool and not as a magical object; a multiplying factor of possibilities for creation and research.

In short, it is much more contemporary than what is implied in the pseudo-futuristic marketing imaginary of this equipment.

From a conceptual point of view, the best way to characterize human movement is utilizing trajectory-notation. This was the subject of ongoing research by dancer and choreographer Analivia Cordeiro for thirty-one years, of which at least twelve were dedicated to the study of the possibilities of using computer technology in the context of dance.

At that time, in 1973, researcher Analivia—then a student of architecture—was one of five in the world utilizing computer graphics for dance choreography. Her mentor and model was her father Waldemar Cordeiro (1925-1973), a landscape designer and a pioneer of computer art in Brazil.

Analivia's work was considerably different in that "computerized" or "digital" content was essential in determining the outcome. The result of digital processing is a set of instructions or schemes intended just for dancers and not for spectators. In this case, its access was not clear for the non-professional dancers.

Analytical Potential

Analivia has been researching a manner of notation and recording of dance movements using 3-D features of images by computer processing since 1981, on a CNPq scholarship.

She started at the Computer Center of USP (CCE-USP), where she was introduced to Nilton Lobo, an electronic engineer student (fig. 2). Today, Nilton is her collaborator and founded their graphic terminal business, Intergraph Systems Ltda. Her primary concern is to record dance movements so that they are readable for the dancer. According to Analivia, the more traditional alternative to dance notation is the method known as Labanotation, performed solely by half a dozen specialists worldwide—an expensive resource that only large dance companies can take advantage of. Analivia seeks to capture by computer four basic elements of dance broken down into displacement in space, body position, muscle strength, and fluency.

For this, the computer plots twenty-four points, mostly on the joints of a body image. The next step is to register the positions of each of these points at predetermined time intervals (fractions of a second) in the computer memory through a graphics board. When the sequence of movements is a historical documentation, as in the preservation of a virtually extinct Yemenite dance recorded on 8 mm film, the digitization of points can be made frame by frame by its projection on the working station.

Then each position is displayed on a 3-D program developed by Lobo. From there, the resources of the graphic station Intergraph multiply the analytical potential of this form of incipient notation: modifications or scanning, zoom effect, observation of detail, simultaneous observation of several successive positions and, especially, the turning of the figure and the plane (stage leaning towards any of the three dimensions of space).

Fig. 1
Nota-Anna – Trace Form of Yemenite Dance Step, 1983. Photo of the computer workstation screen, 8.9 × 12.5 cm
Photographer: Nilton Lobo

This last feature would be the main advantage of computer notation compared to other registration processes, such as film or videotape, which display the image in only two dimensions obtained from a single point of view. Thus, many details are lost and parts hidden by other body parts. Finally, Analivia commends the fundamental characteristic of computers—memory—translated into binary code, large amounts of these images can be easily stored on tapes or discs. The many features collected on the graphical platform are key to the best use of technology.

Form and Substance

Analivia has so far mastered "freezing" the three-dimensional positions. The process of reading a movement registered by a dancer—the most important part, according to her—is still in testing phase. It is being tested, at the moment, the possibility of representing dynamically the transition from one position to another by lines representing the trajectory of each of the twenty-four points of the body, resulting in complex images (see fig. 1).

The challenge Analivia takes on is to achieve a factor that recomposes the original emotion besides the pure technical result, trying to include in these formal schemes some movement elements such as fluency and muscle strength, which inevitably are lost in the conversion from analog to digital.

One of Analivia's arguments in defense of her method is its potential for saving time and energy in experimental choreographic composition processes, where the dancer acts "as a mere puppet" under the choreographer's orders. With computer assistance, the choreographer could continue to create, experiment, and select sequences of movements, until two or three would be tested in practice—dispensable only at certain stages and types of choreographic creation, in her opinion.

At this point, the reasoning of the researcher follows the most common line in defense of all types of automation: relinquishing the more mechanical moments of the work in favor of those more pleasurable ones.

Incidentally, during her first experiences with choreography and computer—in the context of choreographic production for TV—her goal was to optimize the relationships between different technical teams. This initial phase of her research—conducted between 1973 and 1976 in the Computer Center of UNICAMP by the invitation of the dean Zeferino Vaz—resulted in the $M_3 \times 3$, *Gestures*, $0° \Leftrightarrow 45°$, and *Cambiantes* videos. These works have been presented in important computational arts shows all over the world. These videos were intended to obtain detailed choreographer instructions for dancers, TV directors, and cameramen. Such instructions generated from programs relating relevant components of the dance and TV languages allowed the dancer to know, for example, from which angle the camera

would be; the TV director and three cameramen, in turn, received precise details of the angle to be adopted (front, side, etc.), and the plane of focus.

All this justified Analivia in her article "The Programming Choreographer" (published in the magazines *Data&Ideas* 4 [Brazil], 1976, and *Computer Graphics & Art* [California], February 1977), to circumvent the effect intended by choreographer's messages.

On the other hand, more precise instructions than the "metaphors" usually employed by choreographers would enable staff to "self-critique" and would be more objective and referenced.

One Among the Other Half

More than to the choreographic creation, however, the computer notation would be important for preserving cultural heritage, in process of being forgotten and then lost, like a traditional dance of Yemen. The film of this dance was entrusted to Analivia. Computer notation should be enhanced with mathematical precision to record the filigree of fine, discrete, and subtle movement. This allows a combination of computer image processing, essentially analytical, and what might be called synthetic media (although, paradoxically, partial) of movement fixation, as in film and videotape.

In lucid design, the computer is put forward as a means among others to study the movement with precision, which unfolds in a series of specific tasks, as well as many others are unfolded by other technological means like videotape. But there is nothing towards making the technology a "battle flag," "brand," or "label." To speak of "art and technology" is to say nothing because technology is something implicit in the day to day. Twenty years ago, the use of computer in art was out of the ordinary; now, after twenty years of experience, there is a whole theory about it.

That's right—a matter of accuracy and memory.

Four Hands

Nilton Lobo Pinto Guedes, fourth-year electronic engineering student from the Polytechnic School and intern at Intergraph, was introduced to Analivia Cordeiro in 1981 by a professor at the Electronic Computer Center (CCE) of USP. "At first, I had no idea what she wanted but did not know how to jump out," he confesses. Obviously, he failed, because the collaboration has lasted nearly four years, having survived the change of institution and equipment.

In CCE-USP, Lobo started researching how to transform the body plan with those twenty-four points into a 3-D image. However, soon the equipment he used—a graphic terminal connected to the PDP-11 computer—ran out of resources and had limitations (fig. 3). The biggest difficulty we partners faced was data entry, which would necessarily have to be done in three dimensions.

It was through Analivia's former partner—collaborator in the times of UNICAMP Computer Center, Guillermo Barrera Fierro, now digital's software manager—they came into contact with Intergraph.

Two years ago, before the explosion of the CAD/CAM market, they met in Intergraph—like other artists (see the January/February issue of *Iris*)—room for experiments with the company's sophisticated graphics resource computer.

Nilton Lobo then had to learn how to master the Intergraph stations, each with two high-resolution monitors (somewhere around 1.3 million dots on the screen, four times more than a standard TV). These stations are connected to Intergraph 11/751, a VAX computer of Digital, and some plotters (tracer machines charts and drawings) Hewlett-Packard.

Within a month, he knew enough to complete a program to transform the scanned two-dimensional figures into three-dimensional ones. Sometime later, in August 1983, Lobo was invited to be an intern at the company, just in his area of professional interest: design, simulation, and implementation of electronic circuits, one of the largest CAD/CAM application areas.

Analivia continued her growing work in the field of technology with the constant support of Lobo and the company. The work division became more flexible in terms of functions, programming, and choreography. "It should be a work in professional bases," complains Analivia, denouncing the lack of local research of its kind in Brazil.

Article published in *Iris* Magazine, São Paulo: 1984, 52.

Translated by John Norman

Fig. 2
Analivia Cordeiro working at Intergraph InterAct Workstation, São Paulo, 1984.

Fig. 3
Nilton Lobo working at Intergraph InterAct Workstation, São Paulo, 1984.

Brief biography

A former Nieman Fellow at Harvard University (1998) and Knight-Wallace Fellow at the University of Michigan (2012), Marcelo Leite is a science and environment columnist with *Folha de São Paulo*, leading Brazilian daily newspaper. Marcelo Leite studied journalism at the State University of São Paulo (USP). He holds a PhD in Social Sciences from the State University of Campinas (UNICAMP). His major field is science and environment journalism, which led him to internships in Germany (1989) as a fellow of the Krupp Stiftung. He worked as an intern at the magazines *Bild der Wissenschaft* and *Kosmos*, as well as at the *Stuttgarter Zeitung*, and covered the reunification of Germany for *Folha de São Paulo* in Berlin (1990). He writes the blog "Virada psicodélica" (Psychedelic turnaround) for *Folha*. Psychedelics are the subject of his most recent book, *Psiconautas - Viagens com a ciência psicodélica brasileira* (Psychonauts - Trips with Brazilian Psychedelic Science), published in 2021 by Fósforo Editora.

Luiz Velho
Nota-Anna Presentation

Nota-Anna is a system for recording movements, developed by a dancer and choreographer who dedicated herself to thinking about the significance of this form of art/communication.

As Analivia Cordeiro says in the introduction to her dissertation, the task of proposing a new notation for dance is certainly very ambitious.

In fact, a notation formalizes the registration information whatever its nature. Writing is closely associated with language, and consequently with communication between human beings. Thus, it takes on an instrumentalized role in the storage and conveying of knowledge/feelings.

For this reason, the great milestones of human history are almost always linked to qualitative changes in the registration information.

The technology of writing has evolved greatly, starting with the drawings on the wall of caves, through manuscript scrolls, continuing until the invention of the printing press, to the era of computerization technology. At the same time, languages also evolved, potentialized by the technical facilities of production and dissemination of content.

Given this historical perspective, it is surprising that even today the language of movement does not have an effective writing system, unlike virtually all other forms of human expressions, such as verbal, musical, and visual language.

From this fact, one can see how ambitious Cordeiro's proposition is, and the considerable challenge it represents, which has been faced by many others with a relative degree of success.

To better understand the difficulty of the problem, note that information registration is intrinsically linked to the physical nature of such information. For example, the physical quantity of sound information corresponds to the air pressure produced by a vibration (or exerted by other force). In mathematical terms, we can describe sound as a continuous function of a scalar variable—pressure—over time. So to register a sound we only need to "record" this function in some way.

However, what we perceive in sound are the changes in pressure that are mathematically characterized by frequency components of the function. Ultimately, these components are the perceptual units that are the signifiers of language. That is, they are phonemes in speech and musical notes in a melody.

The task of writing consists in codifying these units using symbols that can be easily registered and interpreted. On this basis, lexical elements are built and syntactic structures that define the relationships between these elements are created.

Comparing sound with movement, we can note two significant differences: the first is linked to the emission/capture; the second is linked to the size of the space of its parameters.

The sound emission/capture is symmetrical and direct. That is, humans have mechanisms that make it possible for them to produce and perceive sound waves directly, respectively through the vocal cords and ears. In contrast, the emission/capture of the movement is asymmetric and indirect. This is because the movement is produced throughout the body, while its perception is made indirectly by the sense of sight.

Note that singers hear the music they are singing exactly in the same way as the others around them. On the contrary, a dancer perceives his or her movements quite differently from those who are watching him/her.

In terms of their parameters, whatever the approach used in the comparison, sound is much simpler than movement. As mentioned before, in terms of production, sound is associated with the variation of pressure; it depends on one parameter only. Movement, on the contrary, is associated with the variation of the human body joints, i.e., something between fifteen and thirty different parameters, depending on which joints are relevant to the movement. In terms of perception, sound is once again associated with one parameter. Mathematically it is a scalar function of one variable and therefore has dimension 1.

Given that movement is perceived through images that varies with time, it involves more parameters. Mathematically it is a vector function—color (black and white)—of two spatial variables in time. Therefore, it is at least dimension 3 (for monochrome images).

Moreover, movement takes place in a three-dimensional space environment and is therefore not visualized in its entirety, but is observed from a single viewpoint.

Still on the sound-movement relation, it is worth remembering that the movement is often closely linked to the sound. This is the case with dance when it follows the beat of the music.

The conclusion drawn from the analysis above is that one way of registering movement is to use the capture of a sequence of images. Indeed, since the invention of cinema, such a format has been used for this purpose.

However, the motion picture registers the movement in raw form. What is needed is a form of registration that allows encoding syntagmatic units of the movement and assembling more complex semantic structures. Some notation proposals have been developed for this purpose, among them Labanotation system, which served as the basis for the Nota-Anna.

Such writing systems run an analysis of the essential characteristics of movement as space, time, force, and creep. These elements are graphically represented by symbols indicating the behavior of each part of the body.

Although such systems enable the register and reading of movement and dance, they are quite complex and do not translate all the expressive variety of the movement.

It can be said that ratings based on graphic symbols constitute the first generation of systems of movement writing. Despite their limitations, these systems fulfill their role as well as possible, given the constraints imposed by the technology available by mid-century, namely, the two-dimensional and static graphics allowed by paper and pencil.

With the advent of the computer, the age of digital-information processing systems opens new technical possibilities for the development of the second generation of systems for movement writing or notation.

It is in this context that the work of Cordeiro is inserted by developing the Nota-Anna system. The computer enables the direct registration of movement and, furthermore, the use of dynamic three-dimensional graphics. Nota-Anna chose to apply the technique of digitalization from video images and representing the figures by animated wire forms.

Within this perspective, for this system she chose the simplicity option that is in general the most effective proposition and paradoxically, the most difficult to achieve. The system design takes advantage of all the features of the current state-of-the-art computer graphics, without sacrificing ease of access and low cost. In addition, the system is open for the introduction of new resources from a future evolution in technology. In sum, Nota-Anna, in its current stage, is undoubtedly a tool that allows the registration and visualization of the movement, directly and naturally. With its evolution through the incorporation of computer vision and artificial-intelligence techniques, Nota-Anna will probably become a powerful tool for the analysis and design of movement. Who knows, it may turn out to be widely used by all those who cultivate this art.

This text was originally written as an introduction to the book *Nota-Anna - Notação eletrônica dos movimentos do corpo humano baseada no método Laban* (Nota-Anna - Electronic Notation of Human Body Movements Based on the Laban Method) by Analivia Cordeiro, São Paulo: Annablume & FAPESP Fundação de Amparo à Pesquisa do Estado de São Paulo, 1998, 11-14.

Translation from Portuguese: Isabel Burbridge

Brief biography

Luiz Velho is a full researcher at IMPA - Instituto de Matemática Pura e Aplicada and the leading scientist of VISGRAF Laboratory (Rio de Janeiro, Brazil). He received a BE in industrial design from ESDI/UERJ in 1979; an MS in computer graphics from the MIT Media Lab in 1985; and a Ph.D. in computer science in 1994 from the University of Toronto. His experience in computer graphics spans the fields of modeling, rendering, imaging, and animation. He was a systems engineer at the Fantastic Animation Machine in New York, and a principal engineer at Globo TV Network in Brazil, among others. He was a visiting professor at the Courant Institute of Mathematical Sciences of New York University (1994), and also a visiting scientist at Microsoft Research China (2002).

Arlindo Machado

Body as a Concept of the World

Analivia Cordeiro is a pioneer in Brazil in some areas of electronic arts and performance, specifically in video art, video dance, computer dance, performance, and body art. Unless any other interpretation comes up, *M3×3* is the oldest tape admitted as belonging to the history of Brazilian creative video, stored and accessible for viewing today. The work is actually a choreography for video conceived by this dancer and choreographer for the Edinburgh Festival and recorded with the technological resources of TV Cultura, in São Paulo, in 1973. Therefore, an unorthodox chronology of Brazilian video that begins with this pioneering work has allowed us to celebrate, in 2003, the thirty-year history of the Brazilian video and, in 2013, its fortieth anniversary.

Although she is the daughter of one of the greatest Brazilian visual artists of the twentieth century, Waldemar Cordeiro, and is still responsible for his work, Analivia personally followed a career very different from her father's, more geared towards issues of the body and theatrical performance. Two questions are basic in all of her work as an artist: the relationship of the body with its surroundings and the gesture as a primordial expression of man, which can be summed up in the idea of embodiment. Whereas for much of contemporary science, the cognitive activities of men are inseparable from their body, embodiment relates to the body not only in the physiological sense but also as a presence in the world, which is a precondition of subjectivity and interaction with the surroundings. In other words, embodiment is the body understood as an interface between subject, culture, and nature.

In recent years, several studies in the field of science have shown that the body is not just a wrapper that holds the internal organs. As an interface, it is our contact device with the world; it is through it that we perceive the world we hear, see, and touch, and it is also through it that the world perceives our presence as individuals. For each one of us, it is the device of dialogue between our inner and outer selves, between what we are in our physiology and subjectivity, and what makes us part of the world, with its hardships and graces. In addition, the body is our primary means of communication, even before verbal language. It is a universal language, possibly our first language, which dispenses with any instrument external to it. Just remember that when we do not understand or master the language of a country, the body functions as a language naturally and easily understood by all. The gesture, the waving hands, the expressive movement of the body, writhing, jumping and falling, when performed with intention, are the ways in which the body thinks, "speaks," shapes the feelings, and communicates thoughts and emotions to other bodies that also react to it.

The difference introduced by Analivia Cordeiro in her creative work with the body is the actualization of this possibility and this awareness through the incorporation of contemporary technologies (video, computer, electronic projection, etc.), which enhance the results. *M3×3*, as explained above, is possibly the first Brazilian approach on both video art and video dance (at that stage, still in black and white) and consists of a complex choreography that takes place in a concretist and abstract scenery, where the movements of the dancers are "broken" in quick and stiff gestures, already anticipating break dancing and the intervention of the first groups of electronic music like Kraftwerk and Devo, among others. Everything is of such a rigidity, that it would now be considered "constructivist." Such rigor will be relativized by Analivia in later works, thinking it in a more organic way. But it is the first Brazilian attempt to think about the language of video and how the body issue interacts with electronic art.

In *Unsquare Dance*—a performance and video based on the eponymous song by Dave Brubeck using a software by Luiz Velho—she dances with electronic markers that send information to an infrared camera. That information is processed and interpreted by a specific software that generates lines of movement projected on a screen in real time. The body, almost dancing in the dark, generates computer images that function as mandalas synthesizing the geometry of body movement.

The series *Carne* (Flesh) is composed of dances entirely reinterpreted by the video. Unlike the theatrical performance, in which the dancing body and the background are seen all at once, these videos present the interpretation of what should be seen at each moment, and that video interpretation is decided by the framing of the image and also by the effects assembly (in this case, mergers and/or additions of Cummings's poems through a character generator), all under the music of Rodolpho Grani Jr. or Rachmaninoff with overlays of guttural noises, growls, and voices. The body of the dancer is, in a metaphorical sense, "cut" and at every moment we only see eyes, hair, breasts, fingers, mouth, and other parts unrecognizable due to the extremely closed focus of the camera. The result is extraordinarily poetic because the body expressiveness is in dialogue with the technology that becomes sensitive to it (since the time of Griffith, the basis of all the audiovisual language is the close-up, the detail of the body). The images are of extreme intimacy and the difficulty of seeing (for lack of visual context) often stimulates the viewer's "reading," which ranges between a figurative and an abstract approach. The innovative detail is that the ballerina herself (Christina Brandini in one version or Cordeiro in another) handles the camera, looking for a match between their improvised movements and the camera "reading" of them. Cordeiro calls this way of working *videocoreografia* (video choreography), in which the camera and the body as well as the movement of both form an indivisible unity.

In 1989, during the 20th Bienal de São Paulo, the artist, in collaboration with the designer and director Otavio Donasci, presented the performance *Videovivo* (Alivevideo), in which the audience could see an actor performing live with a image of a woman projected on a big screen. Since the projection screen was made from a very elastic fabric, the dancer who provided the projected image (Analivia Cordeiro) could put herself behind the screen and shape it with her own body without being seen by the audience. The impression the public had was that the image of the woman projected onto the screen became alive and three-dimensional, allowing the "real" actor to hug her and even make love to her on stage. Naturally, given the extreme proximity of the dancer's body to the screen, someone had to guide her in order to drive her body to follow the pre-recorded image. This technique has similarities with puppeteering in that the puppet's body is led by a handler. In cases of utmost professionalism, the result can be so exciting that even an experienced actor or a dancer is not able to perform with equal perfection.

This serves as a brief historical introduction to the project *Toca* (Touch), presented in the series *Zonas de Contato* (Contact Zones), at Paço das Artes, São Paulo, together with the acrobat João Penoni. Here, once again, Analivia is not visible as a dancer; she is hidden in a highly malleable fabric, and her body reacts in a choreographic way each time the acrobat, hanging from a rope, touches her body. It is a virtual dance of sorts open to the imagination, in which the viewer must "guess" the movements of the dancer hidden inside a sort of "bag," reacting, in an improvised way, to the touches of the acrobat. There is no music, just pure dance only suggested. The dance goes beyond the ballet and becomes a reflection on being, thinking about the meaning of life.

Analivia Cordeiro's work goes beyond the boundaries of those few lines of critical reflection. Often she also brushes the field of therapy, when she surpasses the limits of her specialty and seeks ways to help people who have difficulty dealing with their own bodies. Programs to teach people to stand in front of a computer or learn to see/read are some parallel projects that the artist develops with great tenacity. She also developed a software for dance notation, called Nota-Anna, and methods for teaching dance to children. Her doctoral thesis entitled *Buscando a ciber-harmonia - Um diálogo entre a consciência corporal e os meios eletrônicos* (Looking for a Cyber-Harmony: A Dialogue between Body Awareness and Electronic Media), presented in 2004 at PUC-SP - Pontifícia Universidade Católica de São Paulo, was considered by FAPESP - Fundação de Amparo à Pesquisa do Estado de São Paulo—the body in charge of funding this research—one of the best in

M3×3, 1973. Computer-based video dance. Mono-channel video (black and white, sound) transferred, through filming, to 16mm format. Film frame. Vladimir Bonačić Archive – ZKM | Karlsruhe.

the area of communication and arts that year. Having studied the Laban Method under Maria Duschenes (Brazil) and also modern dance in the studios of Alwin Nikolais and Merce Cunningham (USA), she brings a load of talent that is yet to be analyzed.

This text was originally published on the catalog of Analivia Cordeiro and João Penoni's exhibition *Zonas de Contato* (Contact Zones), held at Paço das Artes, São Paulo, in 2010.

Translated by John Norman

Brief biography

Arlindo Machado (Pompeia, Brazil, 1949 – São Paulo, Brazil, 2020), PhD in Communication, was an accurate researcher in the fields of technical image, media, and art and tecnology. He was a professor at the Pontifícia Universidade de São Paulo and at the Cinema, Radio and Television Department of the Escola de Comunicação e Artes da Universidade de São Paulo ECA/USP. He wrote several articles and published important books such as *Pré-cinemas e Pós-cinemas* (Campinas: Papirus, 1997); *Máquina e imaginário - O desafio das poéticas tecnológicas* (São Paulo: EDUSP, 2001) and *Made in Brasil: Três décadas do vídeo brasileiro*, ed. (São Paulo: Itaú Cultural, 2003). He was awarded the National Photography Prize by Funarte in 1995. He has directed short films and multimedia art works in hypertext format. As a curator, he organized media art exhibitions in Brazil and abroad. Together with Fernando Cocchiarale he was curator of the retrospective exhibition *Waldemar Cordeiro: Fantasia exata* (São Paulo, Itaú Cultural, 2013).

Arlindo Machado

A Reflective Look at Indigenous Culture

The relationship between the native Indians of Brazil and photography has never been an easy one. For a long time, the native peoples refused to be photographed, for mystical-religious reasons. They believed that each individual is covered by a number of auratic shrouds, which some tribes call *carom*, and that every time a camera photographs an Indian, it is stealing one of these shrouds, leaving the individual poorer or deprived of soul. In the case of the Kwarup festivity held regularly by various tribes from the Upper Xingu River region since time immemorial, white people were not allowed to attend initially but were later admitted on the condition that they did not take photographs or make films. Much effort in terms of comprehension and trust on both sides was required to overcome these obstacles so that we now have not only images of everyday life but also of the sacred Kwarup festivity. Nowadays, native Indians not only allow photographs to be taken without fear of losing their soul but even appear to pose for cameras, as may be seen in Analivia Cordeiro's photographs.

While not abdicating her manifest artistic purpose, Cordeiro's photographs are also eloquent examples of anthropological research into the life and culture of the Upper Xingu peoples. In 1942, the famous US cultural anthropologist Margaret Mead introduced the idea of a visual anthropology that authorized this science to use images and sounds as research tools for its methodology, which had previously been restricted to written culture alone. Anthropologists soon became photographers and filmmakers; they learned to use cameras and edit images. Even the Indians themselves, from a certain point in time, started to photograph and film their own lives. But Cordeiro's case was slightly different. Coming from an artistic background, yet with solid anthropological knowledge, she cast a different gaze on the issue of working with images and sounds of indigenous peoples. This may be seen in the hybrid exhibition that consists not only of photographs and a video, but also sculpture-installations that the artist created while drawing from Upper Xingu cultural concepts and images. This "heresy," let's say, would never be accepted in the severe academic circles of traditional anthropology.

Photographing and filming the native Indians was not easy. A festivity such as Kwarup involves everybody in the tribe; many things are happening at the same time in different places and everything is equally important. But cameras cut out sections; they can only show one thing at a time within a limited framework in terms of length. Therefore, it takes a certain intelligence to cover it all through a succession of part-images that skilled editing may bring together successfully. Cordeiro realizes that a documentary cannot cover everything about the indigenous peoples' lives or even the sacred festivity, and she says so in one of the comments taped in video format, thus leaving certain gaps and openings for viewers to fill with their own imagination.

One point of view has it that allowing white people to photograph and film may be a conscious political gesture: by posing for the camera to dramatize their culture, the Indians would be asserting their identity—firstly for themselves, and then for the nation and society to which these audiovisual statements are ultimately addressed. Perhaps the media invasion (television, in particular) is being thrown into reverse: as soon as indigenous culture starts to coexist with an alien culture's images and procedures, the contrast may become more noticeable and the Indians may be made aware of their own uniqueness as a necessary condition for subsequent self-defense and self-assertion.

Silvio Mendes Zancheti at Kamaiurá tribe in the Upper Xingu River region, 1975. Slide, color. Photographer: Analivia Cordeiro

These are the issues that arise from Analivia Cordeiro's *Manuara* exhibition, which beckons viewers to admire the native Indians for their own beauty and the exuberance of their surroundings and, at the same time, ponder the meaning of this ontological difference. In the game between those living in the natural wilderness and those living in the big cities' concrete jungle, who ends up winning and who ends up losing?

This text was originally written as an introduction to Analivia Cordeiro's exhibition *Manuara* at the MUBE – Museu Brasileiro de Escultura, São Paulo, September 2014.

Translated from Portuguese by John Norman

Mariola V. Alvarez

Machine Bodies
Performing Abstraction and Brazilian Art

Introduction

With an invitation from the annual performing arts celebration of the Edinburgh Festival in Scotland to show her work, Analivia Cordeiro recorded *M3×3* in 1973 in black and white in the studios of TV Cultura in her hometown of São Paulo, Brazil, based on choreography formatted with a computer. Technology overdetermined *M3×3* in multiple ways: a camera recorded it, a television served as the medium for viewing it, and a computer programmed it. Nine female dancers, dressed in black and white costumes, move across a 3 × 3 meter-gridded stage for over six minutes. The title emerges from this set design. The camera cuts between two points of view—from above and squarely in front of the dancers, making visible the lines of the dancers' positions and their placement within the dotted line matrix. Each dancer moves independently and autonomously, adhering closely but not completely to her assigned square. In the course of the video, the group does not come together or synchronize except in the timing of the whole work. As a result, the viewer's attention remains distracted and dispersed. With the absence of any plot, the dance abruptly ends with the completion of the choreography.

The article does not claim that Cordeiro was the first artist to connect dance and video, though within Brazilian art history, she was a pioneer and *M3×3* is considered to be "the oldest tape admitted as belonging to our [Brazilian] video history" (Machado 2007, p. 277). Cordeiro, unlike most Brazilian video artists who identified as visual artists, came from the world of dance. The inherent interdisciplinarity of her work marks the tape as constitutive of contemporary art and worthy of attention, but unfortunately it has also been the reason for the neglect of her practice.[1] Cordeiro's early videos loop between dance, television, and computers, and this entanglement of bodies in movement, machines, and data is at the heart of this analysis. Given the significant interest in the body in postwar Brazilian art, whether the phenomenology of Neoconcrete art or the body in pieces with art under the dictatorship, dance is uniquely able to visualize the impacts of technology on the body.[2] *M3×3* was produced during an almost decade-long military dictatorship in Brazil, in which citizens lived in a pervasive climate of fear and endured brutal repression. Yet, the military leaders continued the programs of previous administrations to power the economy through national industrialization and production. This essay locates *M3×3* at this intersection of machines and bodies in order to think with Cordeiro about the effects of technology on the physical body, its movements, behaviors, and organization.

Abstraction can be seen throughout the video artwork including in the non-narrative format of the dance and, most importantly, through the fragmentation of the dancers' bodies which the essay elucidates in its discussion of the recording techniques, computer programming process, and costume design. The resistance to the unification of the body challenges the

1 I borrow this idea of video's interdisciplinarity from Ming-Yuen S. Ma and Erika Suderburg, "Another Resolution," in *Resolutions 3: Global Networks of Video*, edited by Ming-Yuen S. Ma and Erika Suderburg (Minneapolis, MN: University of Minnesota Press, 2012), IX-XXX.

2 On phenomenology and Neoconcretism see Mariola V. Alvarez, "The Anti-Dictionary: Ferreira Gullar's Non-Object Poems," *nonsite* 9 (2013). On Brazilian art during the dictatorship see Claudia Calirman, *Brazilian Art under Dictatorship: Antonio Manuel, Artur Barrio, and Cildo Meireles* (Durham, NC: Duke University Press, 2012).

autonomy of the human itself, theorized through the lens of posthumanism, and considered in particular through the historical context of the Brazilian dictatorship at the time of the video's production. I argue that the hybrid form of dance and technology—in its production, choreography, and circulation—underlines the limits of the human. I propose that the video questions the ways in which the body will inhabit new media in its movements and behaviors and how advanced technologies will reshape the category of the human. To perform, or in other words to experiment with the effects of technology on the body and its biomechanics, Cordeiro abstracted the body. Significantly, given Cordeiro's focus on the discipline of dance, the human is defined through its physicality, not just as a rational animal. My essay examines the posthuman body in *M3x3* as embodiment altered by new media.

In order to make my case I address how technology determines the work by organizing the article around the media that produced the work: video, television, and computers. Cordeiro's interweaving of dance and video art proposes a new chapter in the history of "videodance" which I explain in the first part of the article, before turning to the radical decision to format a computer to aid in the choreography of the dance and, thus, its engagement with the discourse of digital embodiment in posthumanism and Brazilian history. Prophetic and revolutionary Cordeiro envisioned a future that has now come to pass in which bodies have been re-shaped by the technologies with which they interact daily.

Videodance

Cordeiro's video operates as an example of videodance which can be defined in one way as the perceptual difference in the experience of live versus recorded dance. The term, attributed to the writings of Jeffrey Bush, Peter Z. Grossman, and Vera Maletic, originally considered the relation of dance to television broadcast and how video would produce a new spatial and temporal performance of dance (Bush and Grossman 1975; Maletic 1987–88).[3] In this way, the development of new media and its application to dance forced the evolution of the field and, simultaneously, the body's capabilities and its perception. Bush and Grossman's article, written only two years after *M3x3*, reminding us of the incipient theorization of the form, challenged videodance to address "both halves of the word" and, therefore, rethink the performance of dance. Videodance does not include a live, in-house audience and instead must rely on "the movement of the dance within the window" of the television monitor (Bush and Grossman 1975, 12–13).

For much of the history of performance, the live act has been privileged as the site of authenticity, originality, and present-ness (Jones and Heathfield 2012). Documentation of the event whether by a still or moving camera only highlighted the gap between the original and the copy and, thus, the viewer's distance from the "missed" event. In contrast, videodance is not a recording of a live performance in front of an audience, but rather the dance is performed for the camera and, thus, the viewer's experience is mediated by the camera. Videodance challenges the categorization of dance as only a live experience, and through its cross-disciplinary promiscuity pushes dance into the visual arts and addresses the corporealization of the body through media. The time or "liveness" of videodance never ceases to exist—its mediation makes every repeated viewing the live act and connects audiences, now potentially at great geographic distances, in radically new ways. The dancers' bodies materialize only through the mechanisms that record them and present them.

Artists such as Len Lye (*Rainbow Dance*, 1936) serve as early precedents of this form, though Maya Deren's film *A Study for Choreography for Camera* (1945) perhaps most famously takes recorded dance as its central preoccupation. The dancer, Talley Beatty, moves in front of the camera, but more radically the camera controls the point of view and through expert editing Deren created movement with the camera. The camera dances, jumps, and glides shifting the viewer from the natural world to inside a domestic space and back again over the course of the short avant-garde film. Videodance offered the potential for surprise location changes, multiple viewpoints of the dancer's body including

[3] Douglas Rosenberg has more recently proposed an expanded concept, "screendance," to include "film or video as well as other screen-based software/hardware configurations." I have decided to use the original term, videodance, to describe Cordeiro's work given its historical context and its specific considerations of dance and television. Douglas Rosenberg, *Screendance: Inscribing the Ephemeral Image* (Oxford: Oxford University Press, 2012), 3.

a focus on only a specific part like the head or leg, temporal dissolution, and a sense of weightlessness. Deren's film concludes with a sense of flight as Beatty jumps and the camera-eye shows us multiple parts of his body through quick editing, holding him suspended in the air before touching down gently onto the ground. The camera extends the spatio-temporal dimension of the dance and transforms the human body into an imaginary potential. Consequently, the body is abstracted; the artist refuses the wholeness of the body visible on the stage. Videodance alters the body in both space and time in order to transcend its physical limits and to reduce it to disjointed body parts.

Like Deren, Cordeiro did not choreograph *M3×3* as a dance intended for the stage, but for the camera. *M3×3* begins with a shot from above, immediately foregrounding the camera-eye and not the frontal positionality of a viewer in a theater. Moreover, this camera position, which alternates throughout the video, contrasts with the desire in classic Hollywood dance sequences to privilege the full frame of the dancer's body and movements, often tracking the horizontality of progress through space and centering the protagonist within that space. Obviously, Busby Berkeley's pioneering camerawork took advantage of the top shot, but Cordeiro's dancers never synchronize their movements into a careful composition, instead remaining discrete units, visually emphasized by the divisions of the grid that separate the dancers and stress their intrusions across the lines.

In fact, no single dancer dominates the frame nor emerges as the central "character." Unlike Hollywood films or classical ballet, *M3×3* lacks any narrative device as the means by which to interpret its "message." Dance scholar Mark Franko centers this "resistance to narrative and character" as a defining quality of abstraction in dance. This "resistance" establishes a genealogy for the video within a history of modern film art, such as Deren's work or more contemporaneously Mexican artist Pola Weiss's own intermedial videodance form (Giunta 2013). Both Deren and Weiss appropriated more radically the ability to move between distinct spaces and settings as a way to communicate the technology of the camera and layer meaning in their work. In the case of Weiss, her video *Ciudad Mujer Ciudad* (City Woman City, 1978) overlays and intercuts between a woman's nude figure and street scenes of Mexico City in order to analogize the city as a gendered body and the erotic liberation of the feminine through media. Cordeiro limited her use of space, relying on a more traditional proscenium set and, therefore, does not require cuts or even camera zooms to direct the viewer's eye. The only two moments when we are transported to different spatial registers are at the beginning and the end of the video, to which I will return later in the article.

An unexplored link thus far in the scholarship between Cordeiro and videodance is her relationship to Austro-Hungarian dancer and choreographer Rudolf von Laban. Her dance teacher in Brazil was Maria Duschenes, a Hungarian exile who studied with Laban at Dartington Hall[4] from 1937 to 1939, when the war forced her to move to South America. Laban, whose career flourished during the Weimar Republic and the early Nazi years in Germany, arrived in Devon, England, in 1937 at the behest of his former student Kurt Jooss, who was living and teaching at Dartington Hall. Duschenes taught Cordeiro Laban's method and Labanotation, a system of writing movement to aid memory, to record dance steps for future iterations, and to serve as a script. Importantly, this latter rationale has been underscored recently by scholars who have begun to research Laban's engagement with film and his early recognition of how the interdisciplinarity of film could advocate for the modernity of dance (Franco 2012, pp. 63–78; Köhler 2017). In particular, Susanne Franco makes a case for how Laban recognized immediately the expressive and, therefore, transformative power of what we now call videodance. Writing in 1928 Laban predicted the challenge dancers working with technologies of reproduction would have to address, "It is not an obvious matter to bring to the screen dances conceived for the stage; choreographed movement has to be transformed in such a way that it responds to the expressive character of film" (Laban quoted in Franco 2012, 67). Labanotation was used to choreograph movement for his own films, but he also envisioned it as a system for feature film production and, therefore, instrumental for the emerging movie industry (Köhler 2017).

4 Dartington Hall was part of a 14th century estate purchased by Dorothy and Leonard Elmhirst in 1925, which they transformed into an arts school, community, and retreat. For more on their history: https://www.dartington.org/

Computer dance

Like Laban and his Kinetography, Cordeiro was thinking expansively of how choreography and its graphic system could be continually innovated. *M3×3* is not just a televisual dance—Cordeiro did not limit the mediation of the body to only its recording. A computer aided in programming the choreography. Within this system Cordeiro imagined the choreographer as a programmer giving instructions to the dancers, TV crew, and the camera simultaneously, but based on a random computer output, freeing "the choreographer to utilize the computer in the creative act, giving greater potential for new aesthetic results" (Analivia Cordeiro 2016, p. 27). She described the "computer dance for TV" as "a system that relates the elements of dance language with elements of TV language through a computer system" (Analivia Cordeiro 2016, p. 10). The Fortran IV programming language, developed by IBM, was used to input information in the computer. With this system in place, all the participants were aware of their engagement with and mediation through technology.

Cordeiro formed part of a growing international community of choreographers and dancers, including Jeanne Beaman in the United States, using this "computer-generated approach" to dance, dating back to the early 1960s (Le Vasseur and Beaman 1965). The history of this early technology, including human modeling, was developed by the U.S. military for defense purposes, and one of the earliest computer-generated ballets from 1967 was designed by a legendary pioneer of computer art, A. Michael Noll, in the AT&T Bell Laboratories, a science and research development company.[5] Not surprisingly the artistic, scientific, and militaristic promise of this technology were always intertwined.[6]

In fact, the invitation for Cordeiro to exhibit at the Edinburgh Festival came from the Computer Arts Society (CAS) for their program of computer in the arts called *INTERACT: Machine: Man: Society*. Along with *M3×3* multiple computer-generated dances were featured as part of *INTERACT: Machine: Man: Society* including a work by CAS co-founder John Lansdown who also experimented with dance notation. CAS was founded in 1968 with the aim of connecting global innovators in the field of computer arts and to encourage the free exchange of ideas. In 1969 they organized their first computer art exhibition and in the same year began publishing their bulletin, *PAGE*, which highlighted activities from members around the world until 1985.[7] CAS formed only one node in an increasingly global network of new media arts.[8]

In order to use the computer as an intermediary for dance, Cordeiro broke the body down into digits. With six as the limit of the computer output, she determined "the first was the right leg position, the second the left leg position, the third was the right arm position, the fourth was the position of the left arm, the fifth of the trunk and the sixth the head position" (Analivia Cordeiro 2016, p. 11). In the absence of a readily-available plotter, she drew stick figures, a common early model, also used by Noll in his computer ballet and by other computer dance pioneers. In a parallel way to Deren's filmic fragmentation of the body, the medium, in this case, the computer and its operational language required the body to be abstracted to lines and code.

Given that Cordeiro continued to work with human performers, the computer-generated approach granted interpretive freedom to the dancers to work within the "rules." The instructions communicated to the dancers concerned the length of time to hold a movement, the position of the body in that movement, the camera angle, and then where to move next also known as displacement in space. The dancers determined their own movements in the transitions, and even within the instructed positions of the body the dancer had a host of potential options. Throughout the recording process the dancer and the camera were in harmony—the dancer

5 After leaving AT&T, A. Michael Noll was on faculty at the University of Southern California since 1984 and then Dean of the Annenberg School from 1992 to 1994. For more on Bell Labs and their intersection with art, in particular Experiments in Art and Technology (E.A.T.), see Michelle Kuo, "Inevitable Fusing of Specializations: Experiments in Art and Technology," in *Robert Rauschenberg* (London and New York: Tate and MoMA, 2016), 260-271.

6 Harun Farocki's video art returned to this subject throughout his career. See Thomas Elsaesser, ed., *Harun Farocki: Working on the Sight-Lines* (Amsterdam: Amsterdam University Press, 2004).

7 All of the issues of PAGE can be found at https://computer-arts-society.com/page.

8 For more on this topic see, María Fernández, "Detached from HiStory: Jasia Reichardt and *Cybernetic Serendipity*," *Art Journal* 67, 3 (2008): 6-23 and Madeline Weisburg, "Finding a Techno-Utopia: *Arte y cibernética*," *Vistas: Critical Approaches to Modern and Contemporary Latin American Art* 1 (2018): 10-19.

knew from which angle the camera perceived her and the camera-eye knew where to look. Cordeiro argued that this computer-generated approach eliminated verbal or mimetic communication with the dancers and film crew, which added objectivity and efficiency to the process and lowered the cost of the production.

This desire to eliminate authorial subjectivity can be traced in many ways to the enormous influence of her father, Waldemar Cordeiro, the founder of the São Paulo Concrete art group (Grupo Ruptura, 1952-1959) and relevant for our discussion, a leader in Brazilian computer art. Analivia Cordeiro remembered long conversations and shared readings with her father through which she "learned to observe the artistic phenomenon according to an objective approach" and that "visual language has a syntax independent of a subjective interpretation" (Analivia Cordeiro 2016, p. 9). Her father and his work with digital imaging taught Analivia how to use the language of the computer as a way to create a feedback loop between the choreographer, dancers, and camera. This "interactive dance-TV system" relied on the random chance and thus objectivity of the computer output, "independent of a subjective interpretation" (Analivia Cordeiro 2016, p. 29, p. 9).

Waldemar Cordeiro throughout his career underscored the intellectual nature of artmaking in which the artist relies on logic and mathematics, and the artwork, as a result, becomes "a product" (Waldemar Cordeiro [1956] 2004, p. 495). In his writings from the early 1950s, as the outspoken leader of the Concrete art group, he railed against the artist as a romantic and expressionist figure in favor of one "endowed with clear and intelligent principles" who would produce art "as a means of knowledge deducible from concepts" (Waldemar Cordeiro [1952] 2004, p. 494). Concrete or geometric abstract art with its simple shapes and pure design provided the exemplary means to communicate these concepts to the viewer. His computer art, or what he called "the art of data processing," begun in 1968, offered another vehicle to work with art as a system of communication that did not hinge on artistic intuition, but rather on technological precision (Waldemar Cordeiro [1973] 2004, p. 495). Yet as Rachel Price has argued, although computer art has the potential to "remove subjectivity from representation," the digital or the processing of information in Waldemar Cordeiro's work remains thoroughly embodied due to the artist's intense manual labor needed to prepare the computer programming and the alteration done by hand of the digitally-produced images (Price 2012). This same argument could be applied to Analivia's videodance since the dancers' bodies first needed to be drawn and assigned a numerical system before feeding the information to the computer.

Posthuman dance

Carrying on this significant legacy into videodance, and ahead of its time, Cordeiro's *M3×3* represents an embodied posthumanism. With its intersection of dance and camera, and dance and computer, the body in *M3×3* is definitively a hybrid body, a mediated body, a machine body, while also a human body. She chose to work with human dancers rather than create an animation. Hence, the video proposes the effects of technology on the body in consistently layered ways: 1. Most literally, television is the medium through which we perceive these mediated bodies, so the bodies exist only as a result of the medium by which we view them. 2. The bodies' movements are the outcome of computer programming, instruction, and information. 3. The movements themselves, "broken in [their] quick and stiff gestures," mimic the rigidity and stutter of the machine (Machado 2016, p. 88). 4. Lastly, the black and white costumes and gridded stage simulate the black and white of the camera and television monitor.

The costumes contribute in a significant way to the abstraction of the figures. This attention to the costumes most likely stems from Cordeiro's early study of Oskar Schlemmer's dance performances during his years as a faculty member at the Bauhaus in Germany.[9] *The Triadic Ballet* (1922), one of his most well-known works, originally presented three dancers in three acts, dressed throughout in sculptural costumes that limited, and often resisted the wearers' movements. The dancers' bodies were turned into geometric abstract shapes and patterns, such as a series of circular wires jutting out from the top of the performer's head and waist. With this drive for abstraction the reviewers described the ballet as machinic and argued that the expressiveness

9 Cordeiro notes that she watched may films by Schlemmer at a young age. Cordeiro, 10.

Fig. 1
M3×3, 1973. Computer-based video dance.
Mono-channel video 4:3 (black and white,
sound). Video still frames.

of the human form had been sacrificed (Elswit 2014). Though Cordeiro's costumes do not inhibit the dancers they become the site of abstraction wherein the body and the grid unite. In flickering moments throughout the video, the dancers and stage appear to fuse together when the black and white costumed bodies shift positions and align with the grid, bringing into existence a symbiosis of the dancers, the architecture, and the media. Body parts seem to disappear; the dancers become an *ur*-form of abstraction—the grid. The extension of the black costume over the hair and the paint that covers the face are central to the operation of the costume as a device for abstracting the dancers. Especially when seen from the top shot, the faces can appear like masks, devoid of facial expression, and therefore contributing to the dehumanization of the performers.

Schlemmer was criticized for the mechanical turn in his ballet since he sought to examine the limits of the human through sculptural costume design and choreography. As I argue, Cordeiro pushed at the bounds of the human and machine not just with the dancers' costume but especially through the use of the camera, computer, and television. *M3×3* does not just image machines in the dancers' appearance and movement, but implements the tools of advanced technology to produce the work. Considering then this fusion and confusion of human and machine in the video-dance, I propose a reading of the work as a presentation of a posthuman world, a world where as Cordeiro noted: "Technology is essential to human life. This reality challenges people to put themselves comfortably, emotionally, with[in] the rules imposed by technology, inducing them to create behavioral alternatives" (Analivia Cordeiro 2016, p. 11). My use of "posthuman" does not reject the human or claim a time after the human but instead argues for how Cordeiro imagines the continual re-formation of the material world in its evolution with new media.

Posthumanism theory has many authors. I follow here the definition of the posthuman put forward by Cary Wolfe in which he "attend[s] to the specificity of the human—its ways of being in the world, its ways of knowing, observing, and describing—by … acknowledging that it is fundamentally a prosthetic creature that has coevolved with various forms of technicity and materiality, forms that are radically 'not-human' and yet nevertheless made the human what it is" (Wolfe 2010, p. xxv). Wolfe does not abandon the human, in some sense of transcendence, but rather posits a historical change in the co-development of the contemporary human and "its imbrication in technical, medical, informatic, and economic networks" (Wolfe 2010, p. xv). My interest in theories of posthumanism stem from Katherine Hayles's landmark book, *How We Became Posthuman: Virtual Bodies in Cybernetics, Literature, and Informatics*, in which she calls attention to the potential problems of the posthuman as conceptualized in its origins by the "fathers" of cybernetics in the late 1940s and early 1950s, since it often conjures "informational pattern over material instantiation," consciousness as transcendence, and the body as a prosthesis and, therefore, able to be subsumed easily and readily into machines (Hayles 1999, pp. 2–3). She argues that embodiment has been theorized falsely as secondary to human life in favor of intelligence, therefore establishing the posthuman as very much part of the lineage of the Enlightenment. Wolfe diverges from these forefathers to reclaim posthumanism as a critique of disembodiment and autonomy, and to describe a historical shift.

Cordeiro, like Wolfe, wants to make a case for the inability to divest the posthuman of its material container. Interestingly, Cordeiro began the video with an introduction to the dancers as gendered bodies, we are shown the women in their individual and "natural selves," before transforming them into a cybernetic system (fig. 1). Should this introduction be considered outside the frame of the dance? Or what about the final image of two heads speaking to each other? I prefer to read them as symbolic for the idea of communication as central to a successful system, and thus intentionally part of the video. In these moments, and in the freedom afforded the dancers within the rules of the computer program, *M3×3* resists the long-standing philosophical division between the mind and body, favoring intellect over flesh, and instead proposes a fully embodied posthuman, or again in the words of the artist, "comfortably, emotionally, with[in] the rules imposed by technology."

Even before the invention of the videodance genre or computer ballets produced in research and development labs, modern dance was engaged with advanced technologies, due in part to their shared interest in movement across space and time and in the control of bodies. Felicia McCarren's book, *Dancing Machines: Choreographies of the Age of Mechanical*

Reproduction, argues that while modern dance can be historicized through its innovation of expressionism it simultaneously demonstrated the machinic motor of bodies (McCarren 2003). In the early twentieth-century dancers, photographers, and filmmakers naturally came together making work that performed the robotic or the effects of the industrialization of labor on the body, transforming dancers and performers into "technobodies" (McCarren 2003, p. 63). Like Hayles's reflection on the binary of body and mind, McCarren asserts that dance and the machine or the robotic are not antithetical but, in fact, constitutive of one another within the history of modern dance. Since Cordeiro's videodance depends on the basic language of translating body parts into computer code, the technobodies stutter, repeat movements, and extend along an orthogonal axis. The videodance should be understood as an extension or contemporary iteration of the history narrated by McCarren, but with the most advanced tools. The computer prescribes the dancers' movement; they embody the rhythm of computer language. The regular and aggressive beat of the single percussive soundtrack underscores the mechanical performance, slow and disaggregated.

Cordeiro's exploration of dance, the posthuman body, and the machinic were not only informed by the experimentations in early twentieth-century Germany but also by her contemporaries in modern dance in the United States, in particular the Merce Cunningham Dance Company (MCDC). Though Cunningham would not choreograph with a computer until 1989, for the more than three decades prior he had incorporated the mechanical in his performances and "de-naturalized" or abstracted the body. Cordeiro had a chance to see MCDC in Rio de Janeiro when she was just a child. We can safely assume the production left an impression on her and her practice since she moved to New York City in 1976 and took classes with Cunningham.[10] In turn, the coincidence or shared time of Cunningham and Cordeiro, though separated by geographic distance, demonstrates the interest of performers to relate the human body to the booming technologies of the postwar world. In both *Aeon* (1961) and *Winterbranch* (1964), the latter performed on the MCDC Rio tour, machines roved the stage and lights blinked on and off, which dance historian Roger Copeland has linked to the larger efforts in this period to integrate art and technology, such as with the human-sized construction of metal and wire, Robot K-456 (1964), by Nam June Paik or E.A.T.'s *9 Evenings: Theatre & Engineering* (1966).[11] Cunningham and Paik collaborated in 1965 on *Variations V*, in which the dancers moved through a field of antennae that would then trigger sounds altered by musicians sharing the stage. In addition, film and video projections by Stan VanDer Beek and Paik also contributed to the viewer's distracted attention.

This sense of dissonance, exemplified by Cunningham's refusal to synchronize the dance with the music, could also be examined through his use of chance operations for the choreography. The roll of a dice or toss of a coin removed authorial subjectivity and, therefore, multiplied the possibilities of how to move the body and its displacement. As a result, Cunningham's choreography was very challenging to perform exactly because it didn't "*come naturally* to the human body," as Copeland emphasizes (Copeland 2004, p. 92). In contrast to one form of modern dance as the expression of emotion or psychological interiority, Cunningham explored the ability of the body to communicate its conceptual nature, and in the contradictions of movement determined by chance operations to show the dancers thinking, changing their mind, and their endless permutations of moving in space. Similarly, Cordeiro by working with the computer to choreograph the dance of *M3×3* abstracted the body from its "natural" rhythm, performing the effects of new technologies on the posthuman body.

The intersection of dance and the abstraction of the body in Brazil has a precursor in the work of the Neoconcretists, a Rio de Janeiro-based group (1959-1961) that in many ways served as the rival to Waldemar Cordeiro's Concretists.[12] The Neoconcretists Lygia Pape (a printmaker) and Reynaldo Jardim (a poet) choreographed

10 Cordeiro states that she saw MCDC at the age of 14. MCDC visited Rio in 1968.

11 Roger Copeland, *Merce Cunningham: The Modernizing of Modern Dance* (NY: Routledge, 2004), 183-84. For more on E.A.T. see Sabine Breitwieser, ed., *E.A.T. Experiments in Art and Technology* (Köln: Verlag der Buchhandlung Walther König, 2015).

12 In my interview with Analivia Cordeiro she explained that she had no knowledge of the Neoconcrete ballets when she made her own videodance. São Paulo, July 17, 2016.

and designed two ballets using abstract shapes "motored" by dancers below or behind them. The first Neoconcrete ballet in 1958 featured eight rectangular blocks and cylinders, all 6½ feet tall, made of wood. The dancers fit inside the geometric costumes and moved the forms around the stage with the aid of wheels at the bottom. Pape and Jardim collaborated again on a second Neoconcrete ballet in 1959, which included two geometric shapes constructed out of movements along orthogonal lines. Instead of cylinders and rectangles, two flat forms also about 6½ feet tall move in and out of perceptual space. Similar to the original iteration, the human body is occluded by the geometric forms; in this case, the dancers are behind the wooden forms. Pushing further than Schlemmer's costume design for *The Triadic Ballet*, the Neoconcrete ballets' costumes, which hinder the viewer from seeing the human body behind or below them, draw attention to the arrangement of the animated composition as if an abstract painting had come to life.

Traditional ballet, as well as modern dance, focus on the movement of the human body and privilege the potentiality of the human form. The Neoconcrete ballets obscure and constrain the body in favor of a rhythmic dance of geometry. In their own writings from the period, the artist and poet struggled with the tension within the ballets between the desire for human expression and a robotic movement, as well as express a fear of cybernetic systems. Jardim in a text written to accompany the first ballet in 1958 set up an opposition between the "human-motor" and "cybernetic motors" that I argue elsewhere exposed the artists' anxieties about the larger national political and economic changes occurring since the end of the Second World War.[13] Brazil committed steadily and rapidly to industrial modernization, which threatened to replace the artwork with the machine, according to the Neoconcretists (Gullar (1959) 2007, 157–160).

By the time Cordeiro was producing her video-dance, Brazil as a country had changed dramatically from the optimistic spirit of the immediate postwar years. In 1964, the military led a coup, supported by the U.S. government, and overthrew the sitting president. The military dictatorship remained in power until 1985. Whereas the Neoconcrete ballets expressed an anxiety about the increasing power of machines in a moment of incredible industrialization, Cordeiro's video-dance reflects on the affective corporealization of the dictatorship's power through its brutal repression of citizens and continuing economic development. While Cordeiro's video has no political content *per se*, it must be read within the context of the political history of Brazil—specifically the years between 1969 and 1974 known as *os anos de chumbo* or the leaden years. These five years were the most repressive and violent of the dictatorship—and technology was central to the disciplining of the body. Elena Shtromberg makes a strong case for how the history of video art closely parallels the use of the television as a tool of control by the dictatorship. As she writes, "television was an effective means to promote the regime's inflated patriotic agenda and also to unite audiences in collective celebrations of national triumph" (Shtromberg 2016, p. 97). The government understood that this new technology could spread their message to a mass audience across a large country.[14]

It also served as a technology of censorship, silencing and making invisible the protests against the government and the violence perpetuated by the military against the Brazilian people through torture, disappearance, and death. In one of the most famous cases from this period, the TV Cultura journalist Vladimir Herzog was arrested, tortured, and killed in 1975, though the government intentionally lied and claimed he died by suicide. Herzog worked for the same broadcast company where Cordeiro filmed her video only two years prior. Within these political conditions *M3×3* makes viewers reflect on how the entanglement of technology and the abstraction of the human body can work in tandem as a form of discipline. This culture of violence co-existed with the regime's consolidation of the link between development and security, in which the modernization and industrialization of the country through technological development was fundamental to its national militarization (Adler 1987).

13 Reynaldo Jardim, "Ballet Concreto," *Suplemento Dominical Jornal do Brasil*, August 3, 1958, 1. I dedicate a chapter to the Neoconcrete Ballets in my forthcoming book, *The Affinity of Neoconcretism: Interdisciplinary Collaborations in Brazilian Modernism, 1954-1964* (Oakland: University of California Press, 2023).

14 Shtromberg details the statistics of television ownership in Brazil and the increase in twenty years is incredible: two hundred televisions in 1950 to three million in 1965 and by the first part of the 1970s six million households had a set. Elena Shtromberg, *Art Systems: Brazil and the 1970s* (Austin, TX: University of Texas Press, 2016), 94.

Conclusion

The experience of living with advancing technologies has shaped the public in new ways, and altered radically artistic practices and potentially the definition of art itself. Cordeiro turned to these new tools to research and visualize their effects on the body. As I have demonstrated, abstraction occurred in this process: in the camera work, the line drawings and computer code necessary for the programming of the choreography, the costume design, and ultimately in the viewing of the dance on a screen. Yet, the sensorial capabilities of the flesh were not surrendered. The posthuman body, examined in this article, does not underscore a binary of body and intellect, but rather their dependent existence on each other and on the development of technical knowledge and processes. Cordeiro worked from the premise that technology has always been a part of human existence; rather than two bounded forms, they are entwined and constitutive of one another. *M3×3* proposes a world in which human physical and conceptual effort re-shape themselves in relation to machines. In particular, the field of dance can spotlight the kinetic body in its own postures and behaviors, and in its interaction with the contemporary world, machines and all.

This text was originally published in *Arts* 9, no. 1, 2020. Special Issue, *Dance and Abstraction*.

Acknowledgments

Thank you to Elise Archias and Juliet Bellow, the editors of the special issue of Arts, *and the anonymous reviewers. The article benefitted from revision comments from Tiffany Barber, Jessica Horton, Leah Modigliani, Erin Pauwels, and Delia Solomons.*

Brief biography

Mariola V. Alvarez is an Assistant Professor of Art History at Tyler School of Art and Architecture at Temple University. Her forthcoming book, *The Affinity of Neoconcretism: Interdisciplinary Collaborations in Brazilian Modernism*, 1954-1964, will be published by the University of California Press in 2023. She is the co-editor, with Ana María Franco, of *New Geographies of Abstract Art in Postwar Latin America* (Routledge, 2019), a collection of essays by leading art historians that advances an expanded study of abstraction in the region. She is currently researching and writing her second book on the art of the Japanese diaspora in Brazil.

References

- Adler, Emanuel. *The Power of Ideology: The Quest for Technological Autonomy in Argentina and Brazil*. Berkeley, CA: University of California Press, 1987.
- Alvarez, Mariola V. The Anti-Dictionary: Ferreira Gullar's Non-Object Poems. *Nonsite* 9, 2013. Available online, https://nonsite.org/feature/the-anti-dictionary-ferreira-gullars-non-object-poems https://nonsite.org/feature/the-anti-dictionary-ferreira-gullars-non-object-poems
- Brown, Paul and Charlie Gere, Nicholas Lambert and Catherine Mason (eds.). *White Heat Cold Logic: British Computer Art 1960-1980.* Cambridge, MA: The MIT Press, 2008.
- Bush, Jeffrey and Peter Z. Grossman. Videodance. *Dance Scope* 9, 1975, 11–17.
- Braga-Pinto, César. From Abolitionism to Blackface: The Vicissitudes of *Uncle Tom* in Brazil. In Tracy C. Davis and Stefka Mihaylova (eds.). *Uncle Tom's Cabin: The Transnational History of America's Most Mutable Book*. Ann Arbor, MI: University of Michigan Press, 2018.
- Breitwieser, Sabine (ed.). *E.A.T. Experiments in Art and Technology.* Cologne: Verlag der Buchhandlung Walther König, 2015.
- Calirman, Claudia. *Brazilian Art under Dictatorship: Antonio Manuel, Artur Barrio, and Cildo Meireles.* Durham, NC: Duke University Press, 2012.
- Cordeiro, Analivia. *Human Motion: Impression, Expression Analivia Cordeiro*. Frankfurt: Galerie Anita Beckers, 2016.
- Cordeiro, Waldemar. The rupture Manifesto (1952). In Mari Carmen Ramírez and Héctor Olea (eds.). *Inverted Utopias: Avant-Garde Art in Latin America*. New Haven: Yale University Press, 2004.
- Cordeiro, Waldemar. The Object (Productive Art). In Mari Carmen Ramírez and Héctor Olea (eds.). *Inverted Utopias: Avant-Garde Art in Latin America*. New Haven: Yale University Press, 2004.
- Cordeiro, Waldemar. Note (1973). In Mari Carmen Ramírez and Héctor Olea (eds.). *Inverted Utopias: Avant-Garde Art in Latin America*. New Haven: Yale University Press, 2004.
- Copeland, Roger. *Merce Cunningham: The Modernizing of Modern Dance*. NY: Routledge, 2004.
- Elsaesser, Thomas (ed.). *Harun Farocki: Working on the Sight-Lines*. Amsterdam: Amsterdam University Press, 2004.
- Elswit, Kate. *Watching Weimar Dance*. Oxford: Oxford University Press, 2014.
- Fernández, María. Detached from HiStory: Jasia Reichardt and *Cybernetic Serendipity*. *Art Journal* 67, 3, 2008, 6-23.
- Franco, Susanne. Rudolf Laban's Dance Film Projects. In *New German Dance Studies*. Edited by Susan Manning and Lucia Ruprecht. Urbana, IL: University of Illinois Press, 2012.
- Ginway, M. Elizabeth. *Brazilian Science Fiction: Cultural Myths and Nationhood in the Land of the Future*. Lewisburg, PA: Bucknell University Press, 2004.
- Giunta, Andrea. Feminist Disruptions in Mexican Art, 1975-1987. *Artelogie* 5, 2013, 14–17.
- Gullar, Ferreira. The Neoconcrete Manifesto (1959). In *Experiência neoconcreta: momento-limite da arte*. São Paulo: Cosac Naify, 2007.
- Hayles, N. Katherine. *How We Became Posthuman: Virtual Bodies in Cybernetics, Literature, and Informatics*. Chicago: University of Chicago Press, 1999.
- Jardim, Reynaldo. Ballet Concreto. *Suplemento Dominical Jornal do Brasil*, 1958, 1.
- Jones, Amelia and Adrian Heathfield (eds.). *Perform, Repeat, Record: Live Art in History*. Chicago, IL: Intellect, 2012.
- Köhler, Kristina. A Dancer on Film: Rudolf Laban's 'film theory'. *The Promise of Cinema*. January 1, 2017. Available online: http://www.thepromiseofcinema.com/index.php/a-dancer-on-film// (accessed on August 23, 2019).
- Kuo, Michelle. Inevitable Fusing of Specializations: Experiments in Art and Technology. In *Robert Rauschenberg*. London and New York: Tate and MoMA, 2016.
- Le Vasseur, Paul and Jeanne Beaman. Computer Dance: The Role of the Computer and Implications of the Dance. *Impulse: Annual of Contemporary Dance*, 1965, 25–28.
- Ma, Ming-Yuen S. and Erika Suderburg (ed.). Another Resolution. In Ming-Yuen S. Ma and Erika Suderburg (eds.). *Resolutions 3: Global Networks of Video*. Minneapolis, MN: University of Minnesota Press, 2012.
- Machado, Arlindo (ed.). The Power Lines of Brazilian Video. In Arlindo Machado (ed.). *Made in Brasil: Três décadas do vídeo brasileiro | Three Decades of Brazilian Video*. São Paulo: Iluminuras and Itaú Cultural, 2007.
- Machado, Arlindo. Body as a Concept of the World. In Analivia Cordeiro, *Human Motion: Impression, Expression Analivia Cordeiro*. Frankfurt: Galerie Anita Beckers, 2016.
- Maletic, Vera. Videodance: Technology: Attitude Shift. *Dance Research Journal* 19, 1987-88, 3–7.
- McCarren, Felicia. *Dancing Machines: Choreographies of the Age of Mechanical Reproduction*. Stanford, CA: Stanford University Press, 2003.
- Price, Rachel. Early Brazilian Digital Culture; or, The Woman Who Was Not B.B. *Grey Room* 47, 2012, 60–79.
- Rosenberg, Douglas. *Screendance: Inscribing the Ephemeral Image*. Oxford: Oxford University Press, 2012.
- Shtromberg, Elena. *Art Systems: Brazil and the 1970s*. Austin, TX: University of Texas Press, 2016.
- Weisburg, Madeline. Finding a Techno-Utopia: *Arte y cibernética*. Vistas: Critical Approaches to Modern and Contemporary Latin American Art 1, 2018, 10-19.
- Wolfe, Cary. *What is Posthumanism?* Minneapolis, MN: University of Minnesota Press, 2010.

HISTORICAL DOCUMENTS

INTERACT Machine: Man: Society

1973

Analivia Cordeiro submitted the paper "A Language for the Dance" (see reproduction of the original in this book); her computer-based video dance *M3×3*, produced this same year in U-Matic, but migrated to a 16 mm film, was projected during the festival.

ADVANCE BOOKING FORM

To: John Lansdown, Computer Arts Society, 50/51 Russell Square, London WC1B 4JX

I plan to attend the CAS Conference on Computers and the Arts:

Costs excluding accommodation:
CAS members and student non-members: £15.00 + £1.50 VAT = £16.50
CAS student members: £12.00 + £1.20 VAT = £13.20
Non-members: £18.00 + £1.80 VAT = £19.80

I shall want accommodation on the University campus. I do not require accommodation.
(Approximate cost for bed and breakfast: 5 days = £15.00) *(Remember the difficulty of obtaining accommodation in Edinburgh during the Festival)*

I enclose the advance booking fee *(deductable from the full fee)*
£14.00 *(if accommodation needed)* £4.00 *(if no accommodation needed)* Cheque Money Order

Name .. CAS member
Profession ..
Address ... Student

The completed form should reach John Lansdown by 20th August 1973
Advance booking fees should be made payable to: COMPUTER ARTS SOCIETY

INTERACT
MACHINE:MAN:SOCIETY

COMPUTER ARTS SOCIETY
CONFERENCE/EVENT/EXHIBITION

APPLETON TOWER : EDINBURGH
27-31 AUGUST 1973

INTERACT Machine: Man: Society - Computer Arts Society
Computers in the Arts Conference/Event/Exhibition, Edinburgh, 27th-31st August 1973. Folder, front and back, 23.0 × 29.7 cm

The Computer Arts Society, the Scottish Arts Council and Edinburgh University are holding an International Conference/Event/Exhibition on Computers in the Arts with the theme INTERACT Machine: Man: Society in Edinburgh during the week commencing 27 August 1973.

The Conference

The Conference will be held in the Appleton Tower of Edinburgh University and each session will be devoted to a particular approach in the uses of computers in the arts under chairmen who are experienced in those fields. These chairmen include Manfred Mohr, Lambert Meertens, Leo Geurts, Knut Wiggen and Frieder Nake. About twenty-five papers on all aspects of computer art will be presented in seven separate sessions.

The Conference is restricted to registered delegates only and presents a unique opportunity for those interested in the latest developments in computer art to meet and discuss their problems, approaches and achievements.

The Eventibition

Associated with the Conference but open to the general public will be a five-day event and exhibition of creative computer works. The emphasis will be on live events in music, dance, theatre, poetry, film and robotics and a number of exciting new works are being created specifically for the event. There will also be a continuous display of computer graphics.

A preliminary list of exhibits and compositions include those by John Whitney (US), John Lifton (UK), Peter Zinovieff (UK), Greta Monach (Holland), Alexandre Vitkine (France), Edward Ihnatowicz (UK), Steve Willats (UK), Jacques Palumbo (Canada), U and D Trustedt (Germany), Pietro Grossi (Italy) and Analivia Cordeiro (Brazil).

The Exhibition will take place in the Appleton Tower whilst the dance, music, theatrical and poetry Events will be held in the nearby Reid Concert Hall on the evenings of 27, 28, 29 August 1973.

The Events culminate in a final performance on the evening of Saturday 1 September 1973.

Potential delegates and visitors are asked to note that INTERACT takes place during the Edinburgh Festival so that early bookings are advisable.

...rs to be presented at the Conference
...de the following:-

...d Cornock (UK)	Art and Cognition
...t Edmonds (UK)	Interfaces for Human Interaction
...b, C B Besant ...A Hayward (UK)	Man-Machine Interaction and the Creative Process
...Hunt (USA)	An Adaptive Controller System for Interactive Composition
...owarth (UK)	Colour Mapping by Computer
...Whitney (USA)	A Humanist Counterforce: Computer Motion Graphics in Art and Music
...nis Smith (USA)	A Cybernetic Model of Conscious Behaviour
...'Beirne (UK)	How to Tune and Play a Computer
...Lifton (UK)	Electronic System for the Production of Music from the Internal Processes of Plants
...Laske ...LAND)	Foundation of a Generative Theory of Music
...askin (USA)	A Guide to FLOW
...Grossi (ITALY)	On Computer Music
...via Cordeiro and ...M Zanchetti ...ZIL)	A Language for the Dance
...y Haynes and ...air Rawsthorne	A Version of Music V In use at University of Southampton
...Lansdown (UK) ...t Friedman	Procedures for Artists
...e Mallen (UK)	Art Technology and Communal Authority
...Sutcliffe (UK)	Wherever Next
...Saunders (UK)	Technical Artists or Artistic Technicians?

ADVANCE BOOKING FORM

To
John Lansdown
Edinburgh Conference
50-51 Russell Square
London WC1 B4JX
England

INTERACT Machine: Man: Society - Computer Arts Society
Computers in the Arts Conference/Event/Exhibition, Edinburgh, 27th-31st August 1973. Folder, front and back, 23.0 × 29.7 cm

ICCH/2
Thirteenth Annual Computer Art Exposition
1975

THIRTEENTH ANNUAL COMPUTER ART EXPOSITION
1975

This is the 13th Annual Art Issue for "Computers and People" (formerly "Computers and Automation"). This is also our largest and most varied issue, featuring the work of 41 artists from 11 countries.

Many of the artists (and illustrations) are from the exhibition of the International Conference of Computers and the Humanities, and are reprinted here with special thanks to Professors Rudolph Hirschmann of the German Department and Robert J. Dilligan, Department of English, University of Southern California, Los Angeles. Many of the photographs were taken by Dr. Joseph Raben, Editor of "Computers and the Humanities", and developed by C&P's Art Editor, Grace Hertlein.

The selection, design, and layout of the Art Issue Section is by Professor Hertlein. Questions, further information on artists may be obtained from the Art Editor.

We hope you enjoy the wide variety of works in this issue, by some of the most well-known computer artists in t\[he\] world, and featuring some very new works not shown in this country before. Student entries are marked with an asterisk to give special attention to them, in the hope of eliciting more student works in the future. One of the stude\[nt\] artists is 14 years old — Kelly Lam, of Annandale, Virginia!

Design for Exterior Mural, Vladimir Bonacic

COMPUTERS and PEOPLE for August, 1975

Computer Dance, Analivia Cordeiro

Designs for Sculpture, J. Alexanco

Computer Icone, V. Molnar

Carres, V. Molnar

Thirteenth Annual Computer Art Exposition, 13th Annual Art Issue for "Computers and People". Berkeley Enterprises, August 1975. ZKM | Karlsruhe Archive.

Grace C. Hertlein
A Letter
1975

July 15, 1975

Dear Analivia,

Under separate cover I am returning your film, for which I thank you very much. In addition to using it in ICCH/2, I used it with a choreography class as a guest lecture.

I think variation in tempo is necessary, and NOT having each dancer do something that conflicts with other dancers--in other words, as in a choral group, there is a dominant voice with related, harmonious subordinate voices. These may change in time, but the viewer has difficulty relating to quite so many patterns. Do you have 3-ring circuses in your country? Do you know what they are? In your dance, there are 12-ring circuses. I am sending also as a second package, a discussion of my ideas of computer dance. Your comments will be most welcome. You are a lovely person, and I appreciate your help in ICCH/2 very much. I am going to print large, some of your illustrations, that are in the August issue of Computers & People -- and I sent some also to Leonardo magazine. Your father's works are most interesting -- since they combine the computer idea and people -- images of people, which are rare in computer art.

I send fond regards and best wishes for joy and happiness.

Your friend in art,

Grace C. Hertlein
Associate Professor
Department of Computer Science

Enclosures

Letter from Grace C. Hertlein (Associate Professor Department of Computer Science [California State University]) to Analivia Cordeiro, July 15, 1975. 15.2 × 21.7 cm

Goethe-Institut de São Paulo
1975

analívia cordeiro: coreografias programadas para computador

19 de novembro
quarta-feira
21 horas
auditório do
instituto goethe
entrada franca

analívia cordeiro, nascida em 1954, desenvolve pesquisas no centro de computação da universidade estadual de campinas. seus filmes foram apresentados no edinburgh international festival — grã-bretanha; na international conference computer & humanities — usa; no circuito da mostra latin america 74 do international cultureal centrum — bélgica; media study of state university new york — usa; centro de arte y comunicación — argentina; institute of contemporary arts — inglaterra; galleria civica d'arte moderna — itália.

coreografias de danças programadas para computador, exclusivamente para tv. através do processamento pelo computador, obtém-se a saída do projeto. esta fornece elementos para a atuação da equipe de intérpretes: dançarinos e pessoal técnico (coreógrafo, cameramen, diretor de tv, operador). com esta proposta, a dança não comunica metaforicamente os sentimentos e sim objetivamente, pelas possibilidades de movimentos do corpo no tempo e no espaço, integrados aos recursos técnico-visuais.

a autora deste sistema coreográfico fará uma apresentação de seus três filmes m 3x3, gestos, 0° = 45° e uma exposição teórica da sua concepção.

concerto do zimbo trio

5 de dezembro
sexta-feira
20,30 horas
auditório do
instituto goethe
entrada franca

por ocasião do encontro de professores dos institutos goethe do brasil, o **zimbo trio dará um concerto de músicas brasileiras.** no programa, músicas de joão bosco, milton nascimento, hermeto paschoal, joão donato, pixinguinha e joão de barro, johny alf, tom jobim e zimbo trio.

formado em 1964, o zimbo trio conta com os mesmos integrantes: amilton teixeira de godoy, luiz chaves e rubens barsotti. interpretando basicamente música popular brasileira do mais alto nível, representou o brasil, em 1965, no festival de cinema em cannes, e no festival folclórico de cosquin, na argentina, juntamente com elizeth cardoso.

em 1970 representou a música brasileira em washington, los angeles e nova york. divulgou a nossa música na américa central e do sul, do méxico ao paraguai.

com 8 lps editados em mais de 20 países, o zimbo trio recebeu duas vezes o prêmio "euterpe" do rio de janeiro, duas vezes o prêmio "roquete pinto" de são paulo, duas vezes o "pinheiro de ouro" do paraná, honra ao mérito concedida pela oea por destaque especial no festival de cosquin e duas vezes prêmio de melhor conjunto, no festival de música popular de mar del plata.

centro cultural brasil - alemanha - dozentur des goethe - instituts münchen
rua augusta, 1470 — telefones 288-9588 - 288-9921 — são paulo

instituto goethe

Activity program flyer of the Goethe-Institut São Paulo, November and December 1975. Public presentation of the three computer-based video dance by Analivia Cordeiro: *M3×3, Gestos* and *0°⇔45°*, and a talk by the artist. November 19, 1975, Goethe-Institut Auditorium.

Jeanne Beaman

A Letter

1976

Jeanne Beaman commented on the presentation of the "film" *0°⇔45°* by Cordeiro at the 20th American Dance Guild Conferente at M.I.T. Computer Science Center. This video dance work was produced in 1974/1975 in U-Matic, but migrated to a 16 mm film.

June 1976

Dear Ms Cordeiro,

Your films and your program were presented last week as part of my presentation for the 20th American Dance Guild Conference at the Massachusetts Institute of Technology. Linda Desmond, computer applications analyst from M.I.T. Computer Science Center commented on your program and Nancy Mason, Dance Coordinator of a public television station in Boston, WGBH, which has done many video dance programs commented on the video aspect of your film.

It is interesting to note that what you were doing was perfectly clear to Linda Desmond, while your text was a complete confusion to Nancy Mason. In general musicians in attendance understood what you and I are doing but many dancers felt, "Why bother with a computer."

Several young people, students at M.I.T. and other universities spoke with me afterwards. Two had done their own programming, one in modern dance with a program similar to mine and one in square (folk) dancing in which the calls were also programmed. Certainly there was a warmer reception to my presentation than when I spoke at the Binational Dance Conference in 1971.

You may be interested to know that Jean Babilée did a TV program in Paris in 1971 of a computer generated ballet called "Time Sharing."

Of your work I found that O - 45 seemed to be liked the best while Gestos caused the most comment. By the time you get this letter these films will be on their way back to you by a slower route. And if I ever get my work-book published with several dances, I'll send a copy of that also. In the meantime I hope you will keep me informed of your progress.

Thank you again for giving me the opportunity to both see and share your work at the ADG Conference. I shall send you any write-ups of the proceedings but such reviews will not be published before next autumn and I shall be out of this country until December so do not expect anything soon.

I am sorry you are not coming to Connecticut. Someday you will and we'll meet at last.

Cordially,

Jeanne Beaman

Bass Harbor, ME 04653 USA

Letter from Jeanne Beaman to Analivia Cordeiro, June 1976, 27.4 × 18.3 cm

Herbert W. Franke
A Letter
1976

Dear Analivia,

Thank you very much for your letter of November 15! I am very pleased that you are coming to Europe, and that there is a possibility to meet you again. Unfortunately, I have several commitments in December. For example, I will be traveling between December 3rd and 6th, on December 7th and 8th I will have TV recordings and then I go to a congress from December 9th to 12th, and from there again to Erlangen for TV recordings until December 14th. From then on, I'll be able to manage my time better again. Maybe your visit to Munich can be postponed until the second half of December!

It's very good news that you've finished a film, and that it uses Brazilian music, which I love very much. Will you take the film with you? I would like to see it. Since I'm in a hurry again and we'll see each other again in person soon, I'll finish [the letter] for today and hope to hear from you from Paris.

Kind regards

Dr. Herbert W. Franke D-8195 Puppting, Haus 40 Telefon 0 81 71/1 83 29

Mlle. Analívia Cordeiro
c/o Raul do Valle
43-45 Rue de L'Amiral Mouchez
75013 Paris / Frankreich

2.12.76.

Liebe Analívia,

vielen herzlichen Dank für Ihren Brief vom 15. November!
Es freut mich sehr, daß Sie nach Europa kommen und die
Aussicht besteht, Sie wiederzusehen. Leider habe ich im
Dezember mehrere Verpflichtungen; so bin ich beispielsweise
vom 3. bis 6. Dezember verreist, habe am 7. und 8. Fernseh-
aufnahmen und fahre dann vom 9. bis 12. auf einen Kongreß,
und von dort wieder zu Fernsehaufnahmen bis 14. Dezember
nach Erlangen. Von da ab kann ich wieder besser über meine
Zeit verfügen - vielleicht läßt sich Ihr Besuch in München
bis zur zweiten Dezemberhälfte verschieben!

Es ist schön, daß Sie einen Film fertiggestellt haben, noch
dazu mit brasilianischer Musik, die ich sehr liebe. Werden
Sie den Film mitnehmen? Ich würde ihn gern sehen. Da ich
wieder einmal in Zeitdruck bin und wir uns ja bald persönlich
wiedersehen, mache ich für heute Schluß und hoffe, aus Paris
von Ihnen zu hören.

Mit freundlichen Grüßen
Ihr

24.11.1976

John Lansdown

The Computer in Choreography

(excerpt)

1978

Computer-aided choreography illustrates some basic relationships between the computer artist and the computer procedures he employs to achieve certain artistic outcomes.

The Computer in Choreography

John Lansdown
System Simulation Ltd.

Although readers of this journal will be aware that few areas of endeavor are untouched by the impact of the computer, it will surely come as a surprise to many that even ballet, perhaps the most human of all arts, is being influenced by computing techniques and concepts.

In dance the human body is the instrument the choreographer plays upon (with the active cooperation of the dancer) to create scenes of the figure in motion over time. There is in dance the creativeness of the choreographer in devising interesting, or exciting, movements; there is the creativeness of the dancer in achieving these movements that sometimes even overshadow the original creation.

My question to myself ten years ago was, is there a place for the computer in this intensely creative, intimately personal art? I was familiar with some of the attempts to utilize the computer to compose poetry or prose, to produce kinetic sculpture, or to create music. I tried to draw common principles from these efforts to apply to ballet.

My first experiments with computer-generated dance produced sequences that were pleasing to both dancers and viewers, but they provided for too little human participation, while running up computer time charges beyond my means. Later experiments, as you will see, struck what I felt to be a better balance between human and computer participation.

Background

As far back as 1964, Jeanne Beaman and Paul Le Vasseur at the University of Pittsburgh used computers to generate simple sets of instructions to be performed by solo dancers.[1] In 1966, Michael Noll produced a computer-animated film showing primitive stick-figures moving about a stage to programmed choreographic instructions.[2] More recently Brazilian choreographer Analivia Cordiero has used programs to generate dances and their television coverage.[3,4] A great deal of work, however, is aimed not at creating dances but at assisting choreographers and others in visualizing body movements.

During the late 1960's Israeli choreographer Noa Eshkol and others at the University of Illinois worked on computer-assisted movement notation and produced programs which allowed a choreographer to see a machine-plotted representation of the movement paths of limbs.[5] At about the same time, Carol Withrow at the University of Utah devised programs to describe limited movements of a stick-figure by relating angular displacements of limbs to curves drawn on a graphic display.[6]

Currently, there is a great deal of work on computer interpretation of dance notation—notably in one scheme known as "Labanotation." Zella Wolofsky at Simon Fraser University wrote a program to output stick-figure interpretations of Labanotation commands,[7] and this work has been enhanced and developed by Barenholtz and others.[8] Smoliar, Weber, and Brown at the University of Pennsylvania have described work for the interactive editing of Labanotated scores.[9,10] Janette Keen at the University of Sydney has developed a high-level computer language compatible with Labanotation and suitable for the graphic display of movement.[11] Savage and Officer at the University of Waterloo have devised an interactive system

IV

WORKS 1959–1971

Teatro de borboletas
Butterfly Theater
1959

Untitled
1960

Teatro de borboletas (Butterfly Theater), 1959.
Gouache drawing on paper, 32 × 50 cm

Untitled, 1960. Crayon drawing on paper, 36 × 39 cm

ANALIVIA CORDEIRO

Experiments with Light
1966

Experiments with Light, 1966. BW photograph.
Photographer: unknown

ANALIVIA CORDEIRO

Costumes para Espetáculo Cinético
Costumes for Kinetic Spectacle
1969

Costume Drawing for Kinetic Spectacle, front view, 1969. Felt pen drawing on paper, 29.7 × 21.0 cm
Costume Drawing for Kinetic Spectacle, side view, 1969. Felt pen drawing on paper, 29.7 × 21.0 cm

Espetáculo Cinético
Concert dance

Kinetic Spectacle

1969

Espetáculo Cinético (Kinetic Spectacle), 1969. Concert dance with Maria Duschenes group, Museu de Arte Moderna de Campinas, São Paulo. BW photographs.
Photographer: Abrão Metri

Probabilidades I

Probabilities I

1971

In this graphic-visual work, Analivia Cordeiro explored the various possibilities of distributing information in space based on line segments in the vertical, horizontal, and two diagonal orientations. Defined on the paper, the drawings delineate the different possibilities of the more probable and less probable occurrences from a visual regularity viewpoint.

 The artist resorted to this sort of quasi-mathematical exercise to develop choreographies, and later used it recurrently as her approach in works leading up to the conception of her video dance works and computer-based video dances.

Probabilidades I (Probabilities I), 1971. Felt pen drawing on paper, 29.7 × 21.0 cm

ANALIVIA CORDEIRO

Probabilidades II

Probabilities II

1971

In this graphic-visual work, Analivia Cordeiro used polychromatic points to describe the interlinking of nodes in the vertical, horizontal or diagonal orientations. The position of the points on the paper was defined according to each node's probability of occurrence. Some visual tracing from one point to another are unexpected, while others appear more common.

Probabilidades II (Probabilities II), 1971. Felt pen drawing on paper, 29.7 × 21.5 cm

ANALIVIA CORDEIRO

'1973–'1977

M3×3
Computer-based video dance
1973

M3×3 is a work of historical importance in the field of video art, computer-based video dance and computer-assisted choreography. It is considered the first video-art work made in Latin America and one of the forerunners worldwide in the use of a system of computerized notation for a choreography conceived specifically for the camera.

In 1973, Analivia Cordeiro was invited by the Computer Arts Society to present a video at the international conference *INTERACT Machine: Man: Society*, in Edinburgh, Scotland, from the 27th to 31st of August. With this motivation, she presented the computer-based video dance project *M3×3* to TV Cultura de São Paulo. In Brazil, at that time, only television studios had professional video equipment, in this case an U-Matic. The television studio accepted the project and the piece was recorded.

Analivia Cordeiro had already been working since 1972 on the programming of dance notation software using the language Fortran IV. She thus combined two essential fields of knowledge: on the one hand, she had studied the system of movement analysis developed by Rudolf von Laban. For the informatics, Cordeiro drew on her researches into the execution of algorithms and the use of block-structured programming language. For this she also received technical support from specialists at the UNICAMP Computer Center.

With the finished programming she processed the choreographic notation for the nine dancers, and the notations that indicated the point of view for the video cameras, innovative aspect at the time. According to the artist, "the drawing of movement that each dancer received corresponded to the exact camera positions as planned by the program itself" (Analivia Cordeiro, interview with Claudia Giannetti, Oct. 31, 2022).

As there was no possibility to produce the computer outputs with a plotter printer, Cordeiro drew by hand the stick figures describing the choreography, and these original drawings were given to the performers—photocopies were made and placed aside for any eventuality. Although all those originals have since disappeared, Cordeiro fortunately preserved some of the photocopies of the notations made in 1973, reproduced in this book.

The notation made by the program in strict relationship with the movements of the dancers —the computer-based choreographic script— determined the takes of the three cameras: one from the front, one from the side, and another focused upward on a mirror located to the ceiling, positioned parallel to the floor of the set. This resource was necessary because the television studio's ceiling was not high enough for situating a camera at the zenithal position, as planned.

Both the stage setting based on the geometry of a half-cube as well as the costume design were created by Analivia Cordeiro. The stage setting and costumes were designed considering the view of each of the cameras, generating visual effects based on the relationships between the white and black color fields. The aesthetics of the setup and result ran counter to the typical realism of recordings made for television.

Cordeiro conceived the space of the recording studio as a quadrangular matrix. It was divided into nine squares marked out by discontinuous black stripes distributed on the white walls and floor; this organization gave rise to the title of the work: 3×3. The dancers' costumes were black from head to foot, and included white stripes situated at strategic parts of the body. The aim was to achieve, through high-contrast recording, an amalgam effect between the bodies, and between them and the surrounding space.

The only sound was that of a metronome —the apparatus designed to rigorously mark the tempo through an audible signal and to define the velocity of execution of a musical piece. In the case of *M3×3*, however, these signals only partly determined the rhythm of the dancers' movements, and their motion around the studio—since, despite having received the notations, they had a certain interpretive freedom in the transitions of the movements. The computer-based choice of the parts of the bodies to compose the dancers' movements introduced a factor of randomness, and from then on, randomness became part of the conception of Analivia's works. This contingency resulted in a relative irregularity in the dancers' movements—an aesthetic result sought by the

artist, in a rupture from the classical idea of a totally organized and synchronized ballet. This individualistic manifestation, proper to the inhabitants of the large metropolises and reflected in the aesthetic conception of the dancers' mechanized and rigid gesturalities corresponded to the artist's aim to portray the effects of automatization and functionalism in people's bodies and in society in the postindustrial era.

The recordings were edited according to the instructions defined by the program in the computerized notation, and therefore without conceptual interferences by the members of the television channel or by the artist herself.

In regard to the format, the original recording was made in ¾-inch U-matic. So that Analivia Cordeiro could show the work at the international conference *INTERACT Machine: Man: Society*, in Edinburgh, and on other occasions, it was transferred, through filming, to 16mm format, which was what the television studios normally used at that time. TV2 Cultura kept in its archive the original copy of the video work. However, over time this original copy was considered lost by the institution. More than a decade later, the 16mm film was migrated to VHS format, which was later digitalized. During this process, part of the initial characteristics and information were lost, including the high contrast of black and white and the definition of the shapes.

Analivia made two copies in 16mm film of *M3×3*, in 1973. Until November 2022, she believed that the only surviving copy was the one that the Victoria & Albert Museum, in London, currently holds in its collection, and that the other was lost. The events leading up to its localization, for being extraordinary, merit a brief historical outline. In November 2022, during the process of preparing her exhibition at the ZKM | Center for Art and Media Karlsruhe, the Collections, Archives & Research department led by Margit Rosen carried out a search to find some photographs from the 1970s where the name of Analivia Cordeiro appeared in the archive of the late Vladimir Bonačić (who had bequeathed his entire legacy to that institution). Bonačić, a computer engineer and computer artist, was founding director of the "Jerusalem Program in Art and Science" at Bezalel Academy of Arts and Design, in Jerusalem between 1972 and 1977. Analivia had met him in São Paulo, when he came there in 1971, invited by Waldemar Cordeiro to the event and exhibition the latter curated, called *Arteônica* (MAB-FAAP and Museu de Arte Contemporânea de Campinas, May 1971). Later, Bonačić invited Analivia to present *M3×3* at the Bat-Sheva seminar on the *Interaction of Art and Science*, organized by him in Jerusalem (3–14 November, 1974), which brought together various key figures of art and science of that time, including Jonathan Benthall, Herbert W. Franke, Frank Joseph Malina, Abraham A. Moles, A. Michael Noll, and John Whitney, among others. Impressed with her video dance, which she projected during the event, he asked her to send him a copy for academic use. In the following year, 1975, she sent him one of the two original copies of *M3×3* in 16mm film format by regular mail. Time passed, he did not return the film, and Analivia ended up forgetting the whereabouts of this copy. Almost fifty years later and to everyone's surprise, the ZKM found it in its own archives, kept in the envelope still intact with the Brazilian stamps and Analivia's return address. That original copy of the video had been kept by Bonačić in his file the whole time.

Digital video versions are found in the collections of the Museum of Modern Art (MoMA) of New York, at the Museo Nacional Centro de Arte Reina Sofia de Madrid, at Itaú Cultural de São Paulo, and at the Museu de Arte Contemporânea (Contemporary Art Museum) of the University of São Paulo. From 2022, a new version corresponding to the digitalization directly from the 16mm format became part of the collection of the Media Museum of the ZKM | Center for Art and Media Karlsruhe.

Claudia Giannetti

Translation from Portuguese into English:
John Norman

M3×3
Computer Program
on Fortran IV Language
1973

M3×3 - Computer Program on Fortran IV Language, 1973. Computer output on paper, 84 × 39 cm

ANALIVIA CORDEIRO

M3×3 Dance Notation V
1973

In 1973, the computer programs that specified the corporal positions of the dancers generated a numeric output. There was no way to generate drawings of the positions of the body, as this technical resource would only arise some years later. Based on the information that the computer outputted concerning the positions of each of the body's members—that is, the position of the right leg, left leg, right arm, left arm, the positions of the torso and head— Analivia Cordeiro manually drew on paper the translation for each vector of the body positions for the dance.
This was a painstaking work demanding great precision, as can be seen in these notations for the choreography of dancer number 3 and for the video dance *M3×3*.

M3×3 Dance Notation V, 1973. Electrography from the original lost drawing, 35.4 × 21.5 cm

M3×3
Computer-based video dance
1973

Mono-channel video 4:3 (black and white, sound), video version: 9:41 min; 16mm film version: 12:11 min.

Performers
 Analivia Cordeiro, Beatriz Maria Luiz, Cybele Cavalcanti, Eliana Pena Moreira, Fabiana Cordeiro, Marina Helou, Nira Chernizon, Silvia Bittencourt, Solange Arruda

Production
 Computer Center of University of Campinas UNICAMP and TV-2 Cultura de São Paulo, Brazil

Choreography costume design and scenography
 Analivia Cordeiro

Computer programming
 Analivia Cordeiro and Computer Center of University of Campinas

TV Direction
 Irineu de Carli

Photography
 Ricardo Delling

Audio
 Metronome sound

Sound
 Laerte Silva

Lightning
 Durvalino Gomes, Antonio Cirino

Editing
 Computer Center of University of Campinas UNICAMP and TV Cultura de São Paulo, Brazil

M3×3, 1973. Mono-channel video 4:3 (black and white, sound), video version: 9:41 min; 16mm film version: 12:11 min.
Video still frames

ANALIVIA CORDEIRO

M3×3, 1973. Mono-channel video 4:3 (black and white, sound), video version: 9:41 min; 16mm film version: 12:11 min.
Video still frames

ANALIVIA CORDEIRO

M3×3

1973

Two photographs taken during the recording of *M3×3* in the studio of TV2 Cultura of São Paulo, at that time considered the most important educational channel in Brazil.
The images document the positions of the dancers in the space of the recording studio and the dimensions of the stage.

M3×3, 1973. Photographs taken during the recording of the performance, 18.0 × 23.5 cm
Photographer: Silvio M. Zancheti

ANALIVIA CORDEIRO

0°⇔45°
Subroutine Enfoque Fortran IV Computer Language

1974

This computer output corresponds to the programming of the choreography and camera position of *0°⇔45°* used in the three versions of the video art work (1974/1975 and 1974/1989). Although the source for the choreography was thesame for the three versions of *0°⇔45°*, each of them differed in terms of recording and editing aesthetics, as well as of stage and costume design.

This programming was written in Fortran IV language that is still used today in scientific and engineering research. The computer used was a Digital PDP 11 of the Computing Center of the Universidade Estadual de Campinas. In 1974, when this program was written, the computer team would generally discard all the prints. This one was saved and is currently a fundamental document for understanding the process of the artist's work process.

For the reader to see the contents better, two separate images of the printout are shown, even though the existing physical form is a continuous group of three unbroken sheets.

```
LPTSPL VERSION 5(211)  RUNNING ON LPT0
*START* USER ARTES  [20001,107] JOB  ENFOQU SEQ. 4322 DATE 09-SEP-74 17:10:56 MONITOR UNICAMP 5068 WITH 2 RJE *START*

*START* USER ARTES  [20001,107] JOB  ENFOQU SEQ. 4322 DATE 09-SEP-74 17:10:56 MONITOR UNICAMP 5068 WITH 2 RJE *START*

*START* USER ARTES  [20001,107] JOB  ENFOQU SEQ. 4322 DATE 09-SEP-74 17:10:56 MONITOR UNICAMP 5068 WITH 2 RJE *START*

*START* USER ARTES  [20001,107] JOB  ENFOQU SEQ. 4322 DATE 09-SEP-74 17:10:56 MONITOR UNICAMP 5068 WITH 2 RJE *START*

*START* USER ARTES  [20001,107] JOB  ENFOQU SEQ. 4322 DATE 09-SEP-74 17:10:56 MONITOR UNICAMP 5068 WITH 2 RJE *START*

*START* USER ARTES  [20001,107] JOB  ENFOQU SEQ. 4322 DATE 09-SEP-74 17:10:56 MONITOR UNICAMP 5068 WITH 2 RJE *START*

*START* USER ARTES  [20001,107] JOB  ENFOQU SEQ. 4322 DATE 09-SEP-74 17:10:56 MONITOR UNICAMP 5068 WITH 2 RJE *START*

*START* USER ARTES  [20001,107] JOB  ENFOQU SEQ. 4322 DATE 09-SEP-74 17:10:56 MONITOR UNICAMP 5068 WITH 2 RJE *START*

*START* USER ARTES  [20001,107] JOB  ENFOQU SEQ. 4322 DATE 09-SEP-74 17:10:56 MONITOR UNICAMP 5068 WITH 2 RJE *START*

*START* USER ARTES  [20001,107] JOB  ENFOQU SEQ. 4322 DATE 09-SEP-74 17:10:56 MONITOR UNICAMP 5068 WITH 2 RJE *START*

*START* USER ARTES  [20001,107] JOB  ENFOQU SEQ. 4322 DATE 09-SEP-74 17:10:56 MONITOR UNICAMP 5068 WITH 2 RJE *START*

*START* USER ARTES  [20001,107] JOB  ENFOQU SEQ. 4322 DATE 09-SEP-74 17:10:56 MONITOR UNICAMP 5068 WITH 2 RJE *START*

*START* USER ARTES  [20001,107] JOB  ENFOQU SEQ. 4322 DATE 09-SEP-74 17:10:56 MONITOR UNICAMP 5068 WITH 2 RJE *START*
```

```
ENFOQU.ART
          DIMENSION NC(600),KI(3),LI(3)
          CALL IFILE(10,'FOR10')
111       FORMAT(1X,I2)
          READ(10,29) (KI(J),J=1,3),(LI(J),J=1,3)
          DO 23 IK=1,6
          READ(10,100) NT
          WRITE(3,101) NT
101       FORMAT(1X,' *',' UNIDADE DE ',I3,' SEGUNDOS')
100       FORMAT(G)
29        FORMAT(6G)
          DO 3 M=1,NT
          GO TO(24,25,26,22,27,25)IK
24        NSORT=RAN(X)*2+1
          KC=KI(NSORT)
          IL=LI(NSORT)
          GO TO 28
25        LSORT=RAN(X)*2+2
          KC=KI(LSORT)
          IL=LI(LSORT)
          GO TO 28
26        KC=KI(1)
          IL=LI(1)
          GO TO 28
22        KC=KI(3)
          IL=LI(3)
          GO TO 28
27        LISORT=RAN(X)*3+1
          KC=KI(LISORT)
          IL=LI(LISORT)
28        NC(M)=RAN(X)*KC+IL
3         CONTINUE
          DO 9 K=1,NT
          WRITE(3,111) (NC(K))
          KSORT=RAN(X)*7+1
          GO TO( 14,14,14,14,15,15,15),KSORT
14        WRITE(3,16)
16        FORMAT('+',4X,' PLANO GERAL')
          GO TO 9
15        WRITE(3,17)
9         CONTINUE
17        FORMAT('+',4X,' DETALHE')
          READ(10,100)KT
          IF(KT-1)23,11,11
11        READ(10,100)NTE
          DO 30 MK=1,NT
          JTSORT=RAN(X)*2+2
          KJ=KI(JSORT)
          IJ=LI(JSORT)
          NTO=RAN(X)*KJ+IJ
          JSORT=RAN(X)*3+1
          GO TO (1,1,2)JSORT
1         WRITE(3,18) NTO
18        FORMAT(1X,I2,' SEM EFEITO')
          GO TO 30
2         IF(NTE-1)60,61,61
60        WRITE(3,40)NTO
40        FORMAT(1X,I2,' EFEITO HOR/VERTICAL')
          GO TO 30
61        WRITE(3,41)NTO
41        FORMAT(1X,I2,' EFEITO DIAGONAL')
```

0°⇔ 45°- *Subroutine Enfoque Fortran IV Computer Language*, 1974. Computer output on paper, 84 × 39 cm (partial reproduction).

0°⇔45° Body Position
Computer Program on Fortran IV Language
1974

The algorithm was written in the computer programming language Fortran IV to specifically define the choreography of the dancer in the recording of the work *0°⇔45°*.

```
                     4   2   5   7   1   1
                    18  12   3   1   2   3
                 PULOS
                 REDONDO
                     6   6   1   1   2   2
                     5   5   1   1   4   6
                     5   1   1   1   3   5
                     1   5   1   1   3   4
                     1   3   1   1   4   5
                 PULOS
                 HORIZONTAL-VERTICAL
                    10  18   3   7   1   2
                     1   1  11   4   1   3
                    18   1   9   2   2   1
                     6  10   9   1   2   4
                     7   5   6   6   1   2
                 PULOS
                 REDONDO
                     1   6   1   1   4   5
                     5   1   1   1   4   3
                     4   5   1   1   4   5
                     3   5   1   1   1   2
                     4   1   1   1   4   2
                 PULOS
                 HORIZONTAL-VERTICAL
                    17  12   6   2   2   3
                     3   6   7   7   1   3
                     3  17   5   6   1   2
                     9  14  12   1   1   4
                    17  18   1   3   1   2
                 PULOS
                 REDONDO
                     2   4   1   1   4   1
                     6   6   1   1   1   4
                     1   2   1   1   1   4
                     6   1   1   1   1   4
                     6   3   1   1   1   2

                 QUEDAS E/OU LENTOS
                 HORIZONTAL-VERTICAL
                    14  12   9   4   4   2
                    12  14  10   1   4   3
                    16   7   8   5   1   2
                     9   2   5   4   1   1
                    12   1   3   7   4   2
                 QUEDAS E/OU LENTOS
                 HORIZONTAL-VERTICAL
                    14   5  12   1   4   1
                    17   7  12   2   3   2
                    17  14   5   6   1   2
                     2  18   3   6   1   2
                     7  10  11   7   1   1
                 QUEDAS E/OU LENTOS
                 HORIZONTAL-VERTICAL
                    18  13   5   4   2   3
                     9   9   6   4   1   1
                    16  14  11   2   2   3
                     1  11   3   7   2   2
                     7   4  12   7   1   3
                 QUEDAS E/OU LENTOS
                 HORIZONTAL-VERTICAL
                    12   5   8   1   3   3
                    12  18  11   1   3   2
                    17  13   9   4   2   2
                    17  11   8   7   3   3
                     3   4   5   5   3   4
                 QUEDAS E/OU LENTOS
```

0°⇔ 45° Body Position - Computer Program on Fortran IV Language, 1974. Computer output on paper, 84 × 39 cm

0°⇔45° Dance Notation
1974/1984

This is the notation that the dancer would read on paper to interpret the choreography planned by the artist for the video *0°⇔45°* and programmed in Fortran IV. When the computer program was written for this work, in 1974, there were no plotter printers in Brazil. This dance notation was printed a decade later on a plotter printer based on the output from 1974.

0°⇔ 45° Dance Notation, 1974/1984. Computer plotter output on paper, 21.5 × 33.2 cm

ANALIVIA CORDEIRO

0°⇔45° Dancer's Costume
1974

0°⇔ 45° Dancer's Costume, 1974. Pen drawing on paper, 32 × 22 cm

ANALIVIA CORDEIRO

0°⇔45°
Version I-E / Version I-C / Version I-A
1974

Sketches for the choreography and costumes of the dancers drawn by hand by the artist for the computer-based video dance *0°⇔45°* version I, 1974/1975. The costumes and stage settings are all part of a single overall design. Various visual possibilities were created and just one was chosen to be adapted during the recording in black-and-white.

0°⇔ 45° Version I-E, 1974. Scene and Costume Sketch I – Possibility 1E. Pencil drawing on paper, 7.1 × 9.5 cm

ANALIVIA CORDEIRO

0°⇔ 45° Version I-C, 1974. Scene and Costume Sketch I – Possibility 1C. Pencil drawing on paper, 7.1 × 9.5 cm
0°⇔ 45° Version I-A, 1974. Scene and Costume Sketch III – Possibility 1A. Pencil drawing on paper, 9.5 × 7.1 cm

ANALIVIA CORDEIRO

0° ⇔ 45°
Version I-3

1974

0°⇔ 45° Version I-3, 1974. Scene and Costume Sketch II – Possibility 3. Pencil drawing on paper, 7.1 × 21.7 cm

0°⇔45° Version I
Computer-based video dance
1974/1975

The first version of *0°⇔45°* is a historical work in computer-based dance. It is a solo dance performed by Cordeiro where the dancer's body blends with the stage design while she makes movements following rounded or diagonal lines. Both the stage setting and the costume design were created with an aesthetic close to concrete art. This work develops a language of dance based on a very contemporary look for that time, which broke away from the then prevailing conventional dance aesthetics that still maintained a clear influence from classical ballet. The body seemed to become a moving sculptural form.

Mono-channel video 4:3 (black and white, sound), 3:23 min.

Performer
 Analivia Cordeiro

Direction and choreography
 Analivia Cordeiro

Production
 Analivia Cordeiro, Computer Center of State University of Campinas – UNICAMP, and Escola de Comunicações e Artes da Universidade de São Paulo

Scenography
 Analivia Cordeiro

Direction of photography
 Pedro Farkas

Computer programming
 Analivia Cordeiro and Guillermo Barrera Fierro

Music
 Fox Trot by William Russell, conducted by John Cage

Editing
 Analivia Cordeiro, Computer Center of State University of Campinas – UNICAMP, and Escola de Comunicações e Artes da Universidade de São Paulo

0°⇔ 45° Version I, 1974/1975. Mono-channel video 4:3 (black and white, sound), 3:23 min. Video still frames.

ANALIVIA CORDEIRO

0°⇔45°
Version II Scene
1974

This sketch was the basis for the stage design of the video *0°⇔45° version II*. The stage setting consisted of black rectangles and lozenges, whose sequence was randomly chosen by computer. The dimensions of these shapes were equivalent to the measurements of the body of the dancer, Analivia Cordeiro. The dancer's body thus blended into the background of the stage setting. The stage design itself became a sculptural work of art.

0°⇔ 45° Version II Scene, 1974. Pen, felt pen drawing on paper, 35.8 × 70.0 cm

ANALIVIA CORDEIRO

0°⇔45° Version II
Computer-based video dance
1974/1975

The second version of *0°⇔45°* also consisted of a solo where the dancer's body blends with the stage design while she makes movements following rounded or diagonal lines. The stage setting was, however, conceived very differently from the proposal of the first version, as it was based on variously sized polygonal shapes randomly sorted according to an aesthetic proper to the first stage of computer art, which researched innovative ways of integrating random systems with the creative act.

Mono-channel video 4:3 (black and white, sound), 4:26 min.

Performer
 Analivia Cordeiro

Direction and choreography
 Analivia Cordeiro

Production
 Analivia Cordeiro, Computer Center of State University of Campinas – UNICAMP, and TV Cultura de São Paulo, Brazil

Scenography
 Analivia Cordeiro

Computer programming
 Analivia Cordeiro

Music
 Fox Trot by William Russell, conducted by John Cage

Editing
 Analivia Cordeiro, Computer Center of State University of Campinas – UNICAMP

0°⇔ 45° Version II, 1974/1975. Mono-channel video 4:3 (black and white, sound), 4:26 min. Video still frames.

ANALIVIA CORDEIRO

0°⇔45° Version III
Computer-based video dance
1974/1989

In version III of the video *0°⇔45°* the human body and its movements are seen as a schematic, symbolic notation of the human figure. In close-ups, the images of the real body are only seen in a fragmented way. The complete real body should be imagined by the spectator, as it never appears in the video. This work studied the degrees of visual intelligibility of corporal movements, in an experiment concerning the human perception of space-time. It can be interpreted as a representation of the fragmented view of the human corporal image as a consequence of the hectic lifestyle in industrialized and computerized societies, coupled with the impact of the various media on the individual's perception.

Mono-channel video 4:3 (color, sound), 1:59 min.

Performer
 Analivia Cordeiro

Direction and choreography
 Analivia Cordeiro

Production
 Analivia Cordeiro, Computer Center of State University of Campinas – UNICAMP, and Escola de Comunicações e Artes da Universidade de São Paulo

Scenography
 Analivia Cordeiro

Direction of photography
 Gil Ribeiro

Music
 Fox Trot by William Russell, conducted by John Cage

Editing
 Analivia Cordeiro, Computer Center of State University of Campinas – UNICAMP, and Escola de Comunicações e Artes da Universidade de São Paulo, Renato L. Pahim

0°⇔ 45° Version III, 1974/1989. Mono-channel video 4:3 (color, sound), 1:59 min. Video still frames.

ANALIVIA CORDEIRO

Gestos
Dance Notation

Gestures
1975

The positions of the dancers' bodies were conceived based on a random selection of photos from newspapers and magazines and their combinations. Analivia Cordeiro thus questioned the traditional narrative and the realist representation, showing that our everyday life can be seen as pieces of a puzzle. Instead of using the conventional and symbolic drawings of the positions of the body, as in the other representations of video dance, in this notation she leaves the possible interpretation of the images up to the performers themselves.

188

Gestos (Gestures) – Dance Notation, 1975. Collages on paper, 22.5 × 15.5 cm (each)

ANALIVIA CORDEIRO

Gestos
Computer-based video dance

Gestures

1975

Gestos is a video dance work whose choreography was planned by computer. The sources of inspiration were photos taken from magazines of that time. The images were numbered and went through a random selection process. The selection defined the movements of the dancers, Analivia and Fabiana, as well as the camera shots in accordance with the choreography. The movements referred to the actions that people normally make in everyday life. This aesthetic was influenced by the concepts of pop art, which brought about a semantic shift in the meaning of everyday life when displaced to other environments or visual supports. The choreographic interpretation did not seek spontaneity, but rather aimed to lend the dance a certain theatrical character.

Mono-channel video 4:3 (black and white, sound), 4:24 min.

Performers
 Analivia Cordeiro and Fabiana Cordeiro

Production
 Gregório Basic; Computer Center of State University of Campinas – UNICAMP and TV2 Cultura de São Paulo, Brazil

TV Direction
 António Carlos Rebesco

Production assistant
 Ella Durst

Filming
 J. Carrari

Ilumination
 Carlos Travaglia, Ronaldo C. Botelho

Sonosplasty
 Marco Aurélio

Music
 Variation IV by John Cage

Editing
 José Luiz Sasso, Computer Center of State University of Campinas – UNICAMP and TV Cultura de São Paulo, Brazil

Gestos (Gestures), 1975. Mono-channel video 4:3 (black and white, sound), 4:24 min. Video still frames.

Manuara – Kwarup Series
Photographs and film

Memory

1975

In 1975, Analivia Cordeiro lived for two and one-half months among the members of the Kamaiurá tribe, of the indigenous culture of the Upper Xingu, in Amazônia, studying and recording the body movements during the Kwarup ritual, as well as the community's everyday life. During that period, Analivia produced extensive photographic documentation in 35mm slide format, along with audiovisual recordings shot by her and Silvio Zancheti of the Kwarup on Super-8 film. She systematized the results of the experiment and the research in a study titled "Análise dos elementos da linguagem corporal no Alto Xingu" [Analysis of Body Language Elements in the Upper Xingu Region], under the orientation of Professor Lux Boelitz Vidal, of the Department of Anthropology of the University of São Paulo, in 1976. The first part of this book contains reproductions of some of the text written by Analivia on this theme, as well as the text by Arlindo Machado written as an introduction to this exhibition. Another result was the production of the film *Kwarup*, in 1980, based on the material recorded in situ. In 2014, those slides were restored and digitalized, and the printed photographs were shown at the exhibition *Manuara*— which means "Memory" in the Tupi-Guarani language—at the Museu da Escultura (MuBE), in São Paulo. On the artist's site the reader can find more information on these projects: http://www.analivia.com.br/anthropology

The Kamaiurá Tribe's Dawn (Kwarup Series), 1975. Photograph, 35 mm color slide.

ANALIVIA CORDEIRO

Cambiantes
Notations for Scene and Dancer 1
1976

Definition of the stage setting for the video *Cambiantes*. In the planning, the artist defines the proportions of the stage setting and formulates observations for its production, for example: "Round the corners so as to not give shadow in the film"; "place some patterns with wood in relief that will visually blend with the entering dancer seen from above." The three rectangles show views from above, from the front, and from the side of the stage setting.

The other document corresponds to the notation for dancer 1, in passage 1.1, where she indicates: "Beginning of improvisation with a 45° diagonal line above in relation to the indicated panel."

Cambiantes Notation for Scene, 1976. Pen drawing on paper, 32.9 × 43.5 cm
Cambiantes Notation for Dancer 1, 1976. Pen drawing on paper, 32.8 × 21.7 cm

Cambiantes
Scene Drawing
1976

This sketch for the stage setting of the video *Cambiantes* shows the importance of the geometric shapes in the aesthetic composition. The position of the plastic elements was randomly chosen by the computer program. Large black triangles were positioned at the edges to simulate an alteration of the regular form of the rectangular videographic frame. Thus, when this video was projected in a cinema projection room of that time, the black of the triangle merged with the darkness of the projection screen. The rectangular form of the video's framing was visually transformed into an irregular polygon, breaking away from the imposition of its typical format.

Cambiantes Scene Drawing, 1976. Pen and gouache drawing on paper, 32.8 × 21.9 cm

Cambiantes
Music Score
Dancers Entrances Graphic
1976

Cambiantes Music Score, 1976. Pen drawing on paper, 21.7 × 33.0 cm
Cambiantes Dancers Entrances Graphic, 1976. Sound and movement analogy table. Pen drawing on paper, 21.7 × 33.0 cm

Cambiantes
Numerical Body Division
Costumer for the Dancer Cybele
1976

In this drawing Analivia Cordeiro made a division of the members of the body and numbered them. The computer program was based on this numerical scheme of the body to generate the diagram of the costumes. The aim in *Cambiantes* was for the body and the stage setting to engage in a visual dialogue: the body was part of the stage setting and vice versa.

Cambiantes Numerical Body Division, 1976. Pencil drawing on paper, 16.0 × 27.5 cm
Cambiantes Costumer for the Dancer Cybele, 1976. Pencil drawing on paper, 27.9 × 21.0 cm

Cambiantes
Space Subrotine in Fortran IV Language
1976

```fortran
       SUBROUTINE ESPACO
       COMMON KOE(5,6,4),P(7,3),II,KT(4),TE(5,251),IRAN2,KN,IRAN(4
      1 ),NDA(2,3),JN,N(4),MES(4),NPES(4)
       REAL T(4),NPT(4),NPID(4)
       INTEGER ND,NP,ID(4),TT,NT(4),NID(4),N(4),M(4),M1(6)
       OPEN(UNIT=2,DEVICE='DSK',FILE='DADOS.ESP',ACCESS='SEQIN')
       READ(2,100)(T(K),K=1,4),(NPT(K),K=1,4),(ID(L),L=1,4),(NP
      1 ID(L),L=1,4),TT
100    FORMAT(17G)
       MN=0
       DO 10 K=1,4
C      CALCULO DO NUMERO DE CADA TEMPO DE ACORDO COM A %
       NT(K)=TT*NPT(K)/T(K)
10     MN=MN+NT(K)
       MN1=0
C      CALCULO DO NUMERO DE CADA DESLOCAMENTO DE ACORDO COM %
       DO 20 L=1,3
       NID(L)=TT*NPID(L)/ID(L)
20     MN1=MN1+NID(L)
       NID(4)=MN+MN1
       DO 30 ND=1,5
       I=1
       WRITE(3,98)ND
98     FORMAT(' DANCARINO',1X,G,/)
       DO 40 K=1,4
40     N(K)=NT(K)
       DO 50 L=1,4
50     M(L)=NID(L)
C      ORDENACAO DOS TEMPOS E DESLOCA/OS CALCULADOS
51     IRAN1=RAN(X)*4+1
       IF(N(1).EQ.0.AND.N(2).EQ.0.AND.N(3).EQ.0.AND.N(4).EQ.0)GOTO 52
       IF (N(IRAN1).EQ.0) GO TO 51
       N(IRAN1)=N(IRAN1)+1
       TE(ND,I)=T(IRAN1)
       I=I+1
       WRITE(3,99)T(IRAN1)
99     FORMAT(' DESLOCA/O',1X,G,1X,' TEMPOS',/)
       GO TO 51
52     IRAN2=RAN(X)*4+1
       IF(M(1).EQ.0.AND.M(2).EQ.0.AND.M(3).EQ.0.AND.M(4).EQ.0)GO TO 30
       IF(M(IRAN2).EQ.0) GO TO 52
       M(IRAN2)=M(IRAN2)+1
       WRITE(3,101)ID(IRAN2)
101    FORMAT(' DESLOCAMENTO',1X,G,1X,' PONTOS',/)
       GO TO 52
30     CONTINUE
C      DISTRIBUICAO DAS LINHAS DE DESLOCA/O P/ CADA DANCARINO
       DO 60 NM=1,5
       WRITE(3,201) NM
201    FORMAT(' GRUPO',1X,G1,1X,' DAS LINHAS DE DESLOCA/O',/)
       M1(1)=0
       DO 60 MN=1,5
72     IRAN3=RAN(X)*5+1
       DO 80 MI=1,MN
80     IF(IRAN3.EQ.M1(MI)) GO TO 72
       M1(MI+1)=IRAN3
60     WRITE(3,103) MN,IRAN3
103    FORMAT(' LINHA DE DESLOCA/O DO DANCARINO',1X,G1,1X,G2,/)
       RETURN
       END
```

Cambiantes - Space Subrotine in Fortran IV Language, 1976. Computer output on paper, 28 × 39 cm

ANALIVIA CORDEIRO

Cambiantes
Camera Takes Drawing
1976

This hand-drawn sketch illustrates the process of the dance in a way akin to a storyboard. The sequence was defined according to the output of the computer program that handled the subroutine of the camera shots.

204

Cambiantes Camera Takes Drawing, 1976. Felt pen and pencil drawing on paper, 21.9 × 32.3 cm

ANALIVIA CORDEIRO

Cambiantes
Computer-based video dance
1976

As in her previous computer-based dances, geometric shapes also take on a special importance in *Cambiantes*. On the one hand, the dancers' free movements and the presence of the color red in the makeup of their faces were inspired in the dances and body paintings of the members of the Kamaiurá tribe on the Xingú indigenous lands, with whom Analivia Cordeiro lived for a time in 1975.

 The choreography is composed of movements based on 45 degrees and right angles performed by the positions of the body members during the dance. The set design and the costumes of the dancers, both in black and white, generate a visual overlay due to the high contrast of the videographic recording. When the video is projected into a dark room, the rectangular image becomes an irregular polygon because of the shapes painted on the walls of the stage set.

Mono-channel video 4:3 (color, sound), 4:58 min.

Performers
 Analivia Cordeiro, Beatriz Maria Luiz, Cybele Cavalcanti, Fabiana Cordeiro

Direction and choreography
 Analivia Cordeiro

Production
 Computer Center of State University of Campinas – UNICAMP City Hall of Campinas, São Paulo, Brazil

Music
 Cambiantes by Raul do Valle

Direction of photography
 Pedro Farkas

Editing
 Computer Center of State University of Campinas – UNICAMP City Hall of Campinas, São Paulo, Brazil

Cambiantes, 1976. Mono-channel video 4:3 (color, sound), 4:58 min. Video still frames.

ANALIVIA CORDEIRO

1978—1984

# E
Displacement in Space Notation
1979

E – Displacement in Space Notation, 1979. Graphic for the dance choreography. Felt pen drawing on paper, 23 × 25 cm

E
Video dance
1979

This choreography was based on a spiral design. The dancers Cybele and Analivia moved in the space along a spiraling path from the outer edge to the center. The theme was a dramatic, dynamic dialogue between two friends. The title refers to the writing of the lower-case letter *e* which can be graphically associated to the spiraling form, as also represented in the previous drawing.

Mono-channel video 4:3 (black and white, sound), 3:50 min.

Performer
 Analivia Cordeiro and Cybele Cavalcanti

Production
 LIMEC, Brazil

E, 1979. Mono-channel video 4:3 (black and white, sound), 3:50 min. Video still frames.

ANALIVIA CORDEIRO

Chamada
Performance

Call

1980

Choreography and performance
Analivia Cordeiro

Place
Casa de Cultura Laura Alvim,
Rio de Janeiro (Brazil)

Chamada (Call), 1980. Photographs taken during the performance.
Photographer: unknown

ANALIVIA CORDEIRO

Relações
Concert Dance

Relations

1980

Choreography
Analivia Cordeiro

Place
Teatro Municipal de Santo André,
São Paulo, Brazil

216

Relações (Relations), 1980. Photographs taken during the performance.
Photographer: unknown

ANALIVIA CORDEIRO

Naturalidade
Concert Dance

Naturality

1980

Performers
 Analivia Cordeiro, Fabiana Cordeiro,
 Silvia Rinaldi, Sylvia Nascimento

Choreography
 Analivia Cordeiro

Place
 Teatro Brasileiro de Comédia, São Paulo (Brazil)

Naturalidade (Naturality), 1980. Photographs taken during the performance of the piece.
Photographer: unknown

ANALIVIA CORDEIRO

Nota-Anna
Relação Poligono Variável
Variable Polygonal Relation
1982

To begin the research for the programming of the Nota-Anna software, the movements of the body were represented in an abbreviated way as polygons. From a mathematical point of view, each movement of the body was symbolized by a polygon of two or three dimensions, depending on the movement. This sketch schematizes the variable relationship of the polygons, as Cordeiro notes in the sketch: "The variations the polygons undergo are in regard to 1. dimension and/or 2. relationship of their Cartesian axes, 3. symmetry. Centered on the dancer's navel. Front (left side)." The drawing delineates the relationships of arm, leg, torso and head.

Nota-Anna – Relação Poligono Variável (Variable Polygonal Relation), 1982.
Ink and felt pen drawing on paper, 28.0 × 19.7 cm

Nota-Anna
Movement Notations
MC3 / MC2r
1982

These initial sketches were the first documents of the movement notation program research called Nota-Anna. They compose a pictogram representation made with a watercolor pen describing the two movements of the arms when opened out to the side.

Nota-Anna MC3, 1982. Sketch of the arm movements for Nota-Anna. Pen drawing on paper, 26.7 × 21.2 cm
Nota-Anna MC2r, 1982. Sketch of the arm movements for Nota-Anna. Felt pen drawing on paper, 27 × 21.3 cm

ANALIVIA CORDEIRO

Nota-Anna
Movement Notations
MC4 / MC2

1982

These two drawings are based on the lines developed in the previous drawings and correspond to the painstaking manual process required for the digitization of these same movements. These drawings are important for marking the beginning of Cordeiro's thought toward formalizing and conceptualizing the work she undertook that culminated in the programming of the Nota-Anna movement notation software.

Nota-Anna MC4, 1982. Sketch for the digitalization of the arm movements for Nota-Anna. Pen drawing on paper, 26.7 × 21.3 cm
Nota-Anna MC2, 1982. Sketch for the digitalization of the arm movements for Nota-Anna. Ink drawing on paper, 26.7 × 21.2 cm

ANALIVIA CORDEIRO

Yemenite Dance
1960/1982

This video of a dance by Yehuda Cohen in the 1960s served as the input for the study and capture of the movements in the first phase of the Nota-Anna research. The Yemenite steps are characteristic of the traditional Hebrew folkloric dance.

The drawing represents the initial and final positions of the steps of the Yemenite dance, as they were traced in the first phase of the research for the Nota-Anna software.

Yemenite Dance, circa 1960. Performer Yehuda Cohen, S-8 film. Film still frame.
Yemenite Dance Step, 1982. Nota-Anna initial and final position. Pen drawing on paper, 32.3 × 12.5 cm

ANALIVIA CORDEIRO

Nota-Anna
Initial Drafts for Digitalization
1982

These drawings are from the studies leading up to the programming process involving the digitalization of the body's movements. They trace out human stick figures using 24 points corresponding to the joints among the body's members. With various sizes, they were made on tracing paper and cut out by hand.

Nota-Anna – *Initial Drafts for Digitalization*, 1982. Pen and tracing paper, approx. 10.2 × 13.9 cm (each)

Nota-Anna – *Initial Drafts for Digitalization*, 1982. Pen and tracing paper, approx. 10.2 × 13.9 cm (each)

Nota-Anna
Intergraph InterAct Workstation
Four Points of View of
Yemenite Dance Step

1983

In doing his work, the Nota-Anna programmer, Nilton Lobo, used the InterAct graphic workstation which has two monitors—one monochromatic and the other in color—with a VAX-11/751 computer from the Digital Equipment Corporation (DEC), at that time considered high resolution (1.3 million pixels), made available by the Integraph company of São Paulo for this project. He also used Hewlett-Packard (HP) plotter printers.

Intergraph InterAct Workstation, 1983. Photo, 8.9 × 12.5 cm
Photographer: Nilton Lobo

Nota-Anna – Four Points of View of Yemenite Dance Step, 1983. Photo of the computer workstation screen, 8.9 × 12.5 cm
Photographer: Nilton Lobo

ANALIVIA CORDEIRO

Nota-Anna Trace Form
Yemenite Dance Jump and Step
1983

One of the most painstaking tasks in the process for digitalizing the human body's movements involved their capture. At that time there were no motion capture systems using optical sensors. Rather, recordings made on Super-8 film were used as an information source for determined movements—in this case a Yemenite dance jump and step. This audiovisual fragment was analyzed frame by frame. For each film frame a hand-made pencil drawing on paper was produced, in which the position of each of the 24 articulation points of the human body were marked on the X and Y axis of the Cartesian coordinate system. Then all the data corresponding to the positions of each of these points, at time intervals of 24 frames per second, were registered in the computer through a list of numeric coordinates for each articulation. Once the process of digitalizing this information was completed, the program could transform these data into an image, which in the case of these images represents a Yemenite dance jump and step.

Nota-Anna – *Trace Form of Yemenite Dance Jump*, 1983. Photo of the computer workstation screen, 8.9 × 12.5 cm
Photographer: Nilton Lobo

Nota-Anna – *Trace Form of Yemenite Dance Step*, 1983. Photo of the computer workstation screen, 8.9 × 12.5 cm
Photographer: Nilton Lobo

ANALIVIA CORDEIRO

Nota-Anna
Menu, Body and Figure Positioning Instructions
1983

After developing the technique and establishing the process for digitalizing the movement of the Yemenite jump and step based on the filmed images, it was necessary to research how the user would have access to the notation. Two menus were developed: one providing access to the instructions for visualizing the body positions, and another with options for reading the movement.

Nota-Anna – *Body Positioning Instructions*, 1983. Photo of the computer workstation screen, 8.9 × 12.5 cm
Photographer: Nilton Lobo

Nota-Anna – *Body Positioning Initial Figure*, 1983. Photo of the computer workstation screen, 8.9 × 12.5 cm
Photographer: Nilton Lobo

Nota-Anna – *Positioning Initial Figure with Menu*, 1983. Photo of the computer workstation screen, 8.9 × 12.5 cm
Photographer: Nilton Lobo

Nota-Anna
Body Positions of Yemenite Dance Step
1983

One of the main goals and challenges of the task of programming the Nota-Anna software was to be able to analytically and tridimensionally identify two basic elements of the dance: the positions of the body and its movement through space. After capturing the motion, digitalizing the movements and creating the menus, a following step was undertaken to achieve something very innovative at that time: the tridimensionalization of each one of the positions. This represented a quantum leap in comparison to the bidimensional representation of the other systems of computerized notation then in use. Nota-Anna's analytic potential allowed for different forms of spatial and temporal observation of the figures—for example, a zoom effect, simultaneous observation of various successive positions, or a rotation of the figure and of the plane in space. These functions were especially useful in the process of conceiving and drawing a choreography, or for the detailed analysis of a determined movement.

Nota-Anna – *Front Perspective of Body Position of Yemenite Dance Step,* 1983. Photo of the computer workstation screen, 8.9 × 12.5 cm
Photographer: Nilton Lobo

Nota-Anna – *Other Front Perspective View of Yemenite Dance Step*, 1983. Photo of the computer workstation screen, 8.9 × 12.5 cm
Photographer: Nilton Lobo

Nota-Anna – *Perspective View of Body Position of Yemenite Dance Step*, 1983. Photo of the computer workstation screen, 8.9 × 12.5 cm
Photographer: Nilton Lobo

ANALIVIA CORDEIRO

Femilino
Concert dance

1983

The title is a play on words between feminine + masculine = *femiline*.
The choreography was created by Analivia Cordeiro, and it was performed by her and by Beto Martins.

Femilino, 1983. Photograph of the stage performance at Teatro São Pedro, São Paulo, Brazil, 24 × 18 cm

ANALIVIA CORDEIRO

Trajectories
Concert dance

1984

With a collective choreography directed by Cordeiro, the dance was executed by children aged 10 and 11. On a completely darkened stage, the children performed the dance with flashlights, creating a dance with luminous effects. The video recording documented the live public performance.

Mono-channel video 4:3 (color, sound), 2:19 min.

Performers
 Carolina Melardi, Caroline Quintella, Juliana Sayão, Luciana Stoiani

Production
 Analivia Cordeiro

Choreography
 Analivia Cordeiro with Performers

Direction of photography
 Analivia Cordeiro

Music
 Waltz Opus 70 No.1 in G Major by Frédéric Chopin

Editing
 Analivia Cordeiro

Trajectories, 1984. Mono-channel video 4:3 (color, sound), 2:19 min. Video still frames.

ANALIVIA CORDEIRO

1985–1999

Ar
Video dance

Air

1985

In *Air*, a video dance from 1985, Analivia Cordeiro gave poetic intent to gestural traces and their relationship with the visual space. Her dance takes place partially outside of the fixed frame of the camera shot, on its edges, emphasizing the play between what is inside and outside the visual field. By exploring visual limits, she incites the viewer to delve more deeply into the realm of the imagination.

Mono-channel video 4:3 (color, sound), 5:58 min.

Performer
　Analivia Cordeiro

Production
　Analivia Cordeiro

Choreography
　Analivia Cordeiro

Scenography
　Takashi Fukushima

Direction of photography
　Takashi Fukushima

Music
　Air on G String, Suite No. 3, BWV 1068 by Johann Sebastian Bach

Editing
　Analivia Cordeiro

Ar (Air), 1985. Mono-channel video 4:3 (color, sound), 5:58 min. Video still frames.

ANALIVIA CORDEIRO

Slow Billie Scan
Telepresence dance using slow scan television

1987

This video dance piece was part of a project of telematics exchange of works in a broadcast of slow scan television (SSTV) between the Museu da Imagem e do Som (MIS) in São Paulo, Brazil—where Analivia Cordeiro and Lali Krotoszynski performed—and Carnegie Mellon University in Pittsburgh, USA. The video signal of the prerecorded dance was broadcast by SSTV using amateur radio signals and received at Carnegie Mellon University, visualized on a Cathodic Ray Tube (CRT).

The work explores the spatio-temporal relationships and possible intersections and symmetries between the bodies of the dancers. The slow scan—12 seconds per image—created effects and distortions in the image and produced simultaneities between two or three figures in the same frame, lending pictorial and nearly abstract effects to the corporal images.

Mono-channel video 4:3 (color, sound), 4:80 min.

Performers
 Analivia Cordeiro and Lali Krotoszynski

Choreography
 Analivia Cordeiro

Production
 Museu da Imagem e do Som – MIS,
 São Paulo (Brazil)

Direction of photography
 Produtora Video Verso

Music
 Don't explain interpreted by Billie Holiday

Editing
 Produtora Video Verso

ow Billie Scan, 1987. Telepresence dance using slow scan television.
ono-channel video 4:3 (color, sound), 4:80 min. Video still frames.

ANALIVIA CORDEIRO

VideoVivo
Audiovisual performance
1989

VideoVivo was a performance held at the Museu de Arte Contemporânea of the Universidade de São Paulo – MAC USP, which used in real-time the video by Otavio Donasci projected on a 1.80-meter-high Lycra screen. Analivia performed behind the screen. When she pressed her body against the flexible fabric, its shape was molded into it, generating a tridimensional effect. The aesthetic aim of this performance was to play with the illusion that the images of people in the video, projected on the screen, were brought to "life" by these effects as Cordeiro precisely followed their movements with her own body.

Conception and Direction
Otavio Donasci

Performers
Analivia Cordeiro, Eduardo Lopes Marlot, Lygia Caselato, Tulio Menezes

Video
approx. 26:00 min. by Otavio Donasci

Choreography
Analivia Cordeiro

Music
Fala da Paixão (1983) by Egberto Gismonti

Scenography
Otavio Donasci

Place
Museu de Arte Contemporânea da Universidade de São Paulo, Brazil

VideoVivo, 1989. Audiovisual performance. Photograph during rehearsal of the performance, 12 × 18 cm
Photographer: Otavio Donasci

ANALIVIA CORDEIRO

Wearables
Video dance
1989

Wearables is a fashion design concept in which the articles are considered art objects. They are exclusive pieces to be shown as works of art. Cordeiro made the choreography for the presentation of these clothing designs at Miriam Mamber Gallery. Some of these designers are currently internationally recognized.

Mono-channel video 4:3 (color, sound), 9:45 min.

Performer
 Analivia Cordeiro

Production
 Miriam Mamber Gallery, São Paulo, Brazil

Choreography
 Analivia Cordeiro

Costume design
 Andrea Kraemer, Carmita Lion, Glaucia Amaral, Liana Bloisi, Fernando Penteado, Maria Teresa Castor, Silvia Mecozzi

Music
 Laurie Anderson (Liana Bloisi), Carlos Saura (Carmita Lion and Silvia Mecozzi), Shadowfax (Heloisa Beldi), Traditional Japanese Music (Glaucia Amaral), Ruidos y Ruiditos (Maria Teresa Castor), Nino Rota (Fernando Penteado)

Editing
 Analivia Cordeiro

Wearables, 1989. Mono-channel video 4:3 (color, sound), 9:45 min. Video still frames.

ANALIVIA CORDEIRO

Modos da Moda
Performance

Fashion Modes

1989

Performer
　Analivia Cordeiro

Conception and Direction
　Liana Bloisi

Place
　SESC Belenzinho, São Paulo, Brazil

Modos da Moda (Fashion Modes), 1989. Color photographs taken during the performance, 12 × 18 and 18 × 12 cm
photographer: Vera Albuquerque

ANALIVIA CORDEIRO

Micron Virtues
Light concert dance and video dance
1992

A dance in which 26 lights were attached to the legs, arms and trunk of four performers. The individual system consisted of an electric circuit with small incandescent light bulbs connected to a microswitch turned on and off by the dancer during the performance, according to the choreography. The precise coordination between the movements of the body and the actions of the lighting circuits was highly complex and required great technical skill from the dancers to interpret the choreography. The performance was executed on a totally dark stage. The visual effect was like a dance of stars in a constellation. The visual aesthetics did not seek geometry but rather organic movements, irregular by nature.

Mono-channel video 4:3 (black and white, sound), 8:51 min.

Performers
 Analivia Cordeiro, Lali Krotoszynski,
 Luciana Gandolpho, Rosa Hércoles

Direction
 Analivia Cordeiro

Production
 Analivia Cordeiro

Choreography
 Analivia Cordeiro, Lali Krotoszynski,
 Luciana Gandolpho, Rosa Hércoles

Music
 7th Symphony, 2nd movement by Gustav Mahler

Editing
 Analivia Cordeiro

Place
 Centro Cultural Vergueiro, São Paulo, Brazil

Micron Virtues, 1992. Mono-channel video 4:3 (black and white, sound), 8:51 min. Video still frames.

ANALIVIA CORDEIRO

Tableaux
Performance
1992

The choreography was based on actions of everyday life. Each scene or tableaux was composed by one of these actions that could involve vigorous or subtle movements, extrapolating the explicit attitude proper to conventional dance. In the words of Analivia Cordeiro: "In this stance, the body is seen as an envelope of skin replete with complex and subtle psychophysiological contents. The corporal expression takes place through the pores, hair, fingernails, and not only by the members of the body as in traditional dance. The subtler and smaller movements are important. Why can't fingernails dance? Why can't a mouth be choreographed? Why can't the free movement of hair be part of the dance?"

Performers
 Analivia Cordeiro, Lali Krotoszinski, Luciana Gandolpho, Rosa Hercoles

Conception and direction
 Analivia Cordeiro

Choreography
 Collaborative creation by the group

Place
 Centro Cultural de São Paulo, Brazil

Tableaux, 1992. Photographs taken during the performance. BW photographs, gelatin silver print, 11.3 × 17.7 cm
Photographer: Bob Wolfenson

ANALIVIA CORDEIRO

Nota-Anna
Body motion capture
Stick figure visualization
1994

Images captured from the screen of a Unix workstation during the work of digitalizing the articulations of the body, necessary for processing the capture of the movement using the Nota-Anna software. As can be seen in the Nota-Anna image "Body motion capture on the screen" the 24 points of the articulations were marked one by one, with the mouse, in each video frame. As observedin the image of the "Trajectories" visualization, when all the points of each articulation in a sequence of frames is joined, the movement's trajectory is obtained. The "Trajectories" image and stick figure visualization provide a schematic basis for accompanying the body's trajectories on a plane.

ota-Anna – Body motion capture on the screen, 1994. Screenshot on Unix workstation.
ota-Anna – Trajectories visualization, 1994. Screenshot on Unix workstation.
ota-Anna – Trajectories and stick figure visualization, 1994. Screenshot on Unix workstation.

ANALIVIA CORDEIRO

Laban Art of Movement
Educational video dance

1996

This video was made as part of Analivia master's degree thesis *Nota-Anna – A notação eletrônica dos movimentos do corpo humano baseada no Método Laban* (Nota-Anna – The electronic notation of the movements of the human body based on the Laban method) under the orientation of Prof. Nelly de Camargo, in the Multimedia Department, Arts Institute of the State University of Campinas, São Paulo. Based on her research into Laban's theory, Cordeiro became aware of the limitation of words for describing or explaining corporal movements. She decided to expound Laban's theory through the format of video, which allows for the recording of a sequence of movements in time and space, thus illustrating the theoretic contents with greater precision.

Mono-channel video 4:3 (color, sound), 25:10 min.

Performers
 Analivia Cordeiro, André Sampaio,
 Bruno Sampaio, Claudia Barnabé,
 Claudio Kozakowski, Cybele Cavalcanti,
 Gilson Kloc, Luciana Stoiani, Mara Cordeiro Kloc,
 Maria Luiza de Lima, Gregoire Cordeiro Belhassen,
 Leonard Cordeiro Belhassen, Nilton Lobo Guedes,
 Thomas Cordeiro Guedes, Thomas de Felipe,
 Tião Carvalho, Zelia Monteiro

Production
 Analivia Cordeiro

Direction of photography
 Analivia Cordeiro and Nilton Lobo

Music
 Untitled by Rodolpho Grani Jr.

Voice
 Afsoon Rabbani

Language
 English

Editing
 Analivia Cordeiro and Tamara Ka

Laban Art of Movement, 1996. Mono-channel video 4:3 (color, sound), 25:10 min. Video still frames.

Nota-Anna and Virtual Reality
1996

In this experiment carried out in the backyard of Analivia Cordeiro's house, she and Nilton Lobo tested the visualization of Nota-Anna through the first virtual reality goggles available on the market.

Nota-Anna and Virtual Reality, 1996. Color photographs, 18 × 12 cm (each photo)
Photographer: Nilton Lobo

ANALIVIA CORDEIRO

Striptease
Video art
1997

In the video recording of *Striptease*, the sequence of takes was decided without a preestablished script, using an experimental introspective method based on meditation, on memory and on subjectivity. According to the artist: "The theme was a stripping, in the sense of 'peeling off' the skin, to arrive at the interior of the body seen as a physical and emotional universe. The slow movements of the body, the sounds of daily life and the poem by Ademir Assunção transformed it into a poetic striptease."

Mono-channel video 4:3 (color, sound), 9:50 min.

Performer
 Analivia Cordeiro

Production
 Analivia Cordeiro

Direction of photography
 Analivia Cordeiro and Nilton Lobo

Music
 Untitled by Rodolpho Grani Jr.

Poem
 Escrito na pele (Written in the Skin) by Ademir Assunção

Voice
 Edvaldo Santana

Language
 Portuguese

Subtitle
 English

Editing
 Analivia Cordeiro

Striptease, 1997. Mono-channel video 4:3 (color, sound), 9:50 min. Video still frames.

Nota-Anna Bycicle by Pelé
Video art

1999

The images show the first version of the process for digitalizing the movement made with the Nota-Anna software—in this case a specific bicycle kick by the famous soccer player Pelé during a game, recorded in 1968. This process signified a substantial technological advance for its time. This was the first study of a kick by Pelé made by Cordeiro, motivated by the perfection of the athlete's movement in space. This movement was used in her research for two decades, culminating with the production of sculptures in 2015/16.

Mono-channel video 4:3 (color, sound), 0:30 min.

Content
 Historical video of Pelé's bicycle kick, 1968, recorded on VHS tape

Conception
 Analivia Cordeiro

Programming of Nota-Anna
 Nilton Lobo

Music
 Untitled by Rodolph Grani Jr. (Composed for this video)

Editing
 Analivia Cordeiro

Nota-Anna Bycicle by Pelé, 1994. Mono-channel video 4:3 (color, sound), 0:30 min. Video still frames.

ANALIVIA CORDEIRO

2000–2014

DuCorpo – Rock'n'Roll
Educational video series
2004

This video is part of a series of classes that constitute the course *DuCorpo* dedicated to body training. The course was conceived for an online platform and taught by Analivia Cordeiro. The content included physical preparation, movement therapy, the reading of complex movement sequences and dance compositions. The aim was to freely disseminate knowledge for the education of corporal movement, in order to reach the largest number of people. In conceiving this project, the artist considered that the vast majority of people in Brazil and other countries could never have access to in-person classes with a professional trained in specialized schools and academies due to the high cost of this sort of training. Her aim was to achieve a democratization of the education of the body for personal well-being.

 The program consisted of 77 classes in three languages: Portuguese, English and Spanish. The average duration of each class was 3:50 minutes. The theoretic approach was based on Cordeiro's PhD thesis, under the orientation of Prof. Arlindo Machado, titled *Procurando a Ciber-harmonia: um diálogo entre a consciência corporal e a mídia eletrônica* (Seeking Cyber-Harmony: A Dialogue Between Corporal Awareness and Electronic Media), 2004. A summary of this thesis is given in the first part of this book.

 In 2007, the videos became part of the *DuCorpo* online channel and can currently be freely accessed on YouTube.

Mono-channel videos 4:3 (color, sound)

Category
 Class documentation

Content
 77 video capsules; film quotation: Richard Thorpe (Director), *Jailhouse Rock*, 1957, with Elvis Presley, Metro-Goldwyn-Mayer Studios, Inc.

Conception
 Analivia Cordeiro

Production
 Analivia Cordeiro

Music
 Untitled by Rodolpho Grani Jr.

Languages
 English, Portuguese and Spanish

Recording
 Nota-Anna Digital Motion Capture

Editing
 Analivia Cordeiro

DuCorpo – Rock'n'Roll, 2004. Class Event 5 option 4 Elvis Presley dance sequence represented by digital stick figure processed by Nota-Anna. Mono-channel video 4:3 (color, sound), 2:15 min. Video still frames.

ANALIVIA CORDEIRO

Carne I
Video choreography

Flesh I

2005

The three videos produced between 2005 and 2009—*Carne I*, *Carne II* and *Carne III*—consisted of video choreographies in which the dancer executes movements coordinated with, and simultaneous to, the motion of the camera. To achieve greater proximity, the dancer records her own movements with portable cameras attached directly to her body—at wrist and ankle—exploring the relationship between body, space and time. The aesthetics of the editing was based on concepts of Brazilian concrete art applied to organic images. The corporal movements and expression were converted into formal abstract elements of great sensibility and subtlety. For Analivia Cordeiro, these works sought to convey messages of harmony against the generalized violence in societies, along with a sensation of calm and pleasure, in accordance with how the spectator's curiosity was stimulated.

Mono-channel video 4:3 (color, sound), 7:13 min.

Performer
　Cristina Brandini

Conception direction and production
　Analivia Cordeiro

Sound composition
　Rodolpho Grani Jr.

Sound-track
　Imaginação Produções

Poem
　You no, at *95 Poems* by Edward E. Cummings, 1958

Audio
　voices by Analivia Cordeiro, Cristina Brandini, Nilton Lobo and Thomas Cordeiro Guedes

Language
　English

Editing
　Analivia Cordeiro

Carne I (Flesh I), 2005. Mono-channel video 4:3 (color, sound), 7:13 min. Video still frames.

ANALIVIA CORDEIRO

Carne II
Video choreography

Flesh II

2005

Analivia Cordeiro considers this video choreography as her self-portrait. First of all, the choice of music was very personal: her favorite instrument is the piano. The capture and editing of the images was done by herself, and is marked by the same dynamism that characterizes her personality.
The parts of the body chosen also indicate a personal preference. In her words: "For a dancer who expresses herself with her body, her self-portrait must represent the entire body."

Mono-channel video 4:3 (color, sound), 3:00 min.

Performer
 Analivia Cordeiro

Conception and production
 Analivia Cordeiro

Music
 Prelude in G-sharp minor, Op. 32 No. 12,
 Sergei Rachmaninoff,
 interpreted by David Helfgott

Poem
 You No by Edward E. Cummings, 1958

Language
 English

Editing
 Analivia Cordeiro

Carne II (Flesh II), 2005. Mono-channel video 4:3 (color, sound), 3:00 min. Video still frames.

ANALIVIA CORDEIRO

Nosotros El Pueblo
Educational video

We the People

2005

During the year 2005, Analivia made a series of eight videos in partnership with children as experimental didactic exercises to attend to their interest in learning the language of video.

This video was made in coauthorship with a five-year-old boy. The partnership included the development of the theme and script, the development of the material, the recording and the editing of the video. The initial work consisted in developing a theme. The method used was the collage of material cut out from magazines, which were glued to a large sheet of paper in front of a video camera. Kloc would choose an image and glue it, Cordeiro would respond by choosing another image and including it. It was a dynamic, quick-paced dialogue.

Mono-channel video 4:3 (color, sound), 0:36 min.

Performers
 Analivia Cordeiro and Alexandre Kloc

Production
 Analivia Cordeiro

Music
 Wonderful Copenhagen by Dave Brubeck Quartet

Editing
 Analivia Cordeiro and Alexandre Kloc

Nosotros El Pueblo (We the People), 2005. Mono-channel video 4:3 (color, sound), 0:36 min. Video still frames.

Save the Nature
Educational video
2005

Video in coauthorship with a 12-year-old boy. The partnership included the development of the theme and script, the preparation of materials, the recording and the editing of the video. The theme chosen by Thomas Guedes, along with the material, was the conflict between monetized society and the preservation of nature.

Mono-channel video 4:3 (color, sound), 0:55 min.

Performers
 Analivia Cordeiro and Thomas Cordeiro Guedes

Production
 Analivia Cordeiro

Music
 Aluja de Xango by Baba Messias

Editing
 Analivia Cordeiro and Thomas C. Guedes

Save the Nature, 2005. Mono-channel video 4:3 (color, sound), 0:55 min. Video still frames.

ANALIVIA CORDEIRO

Guerra e paz
Educational video

War and Peace

2005

Video in coauthorship with a 12-year-old boy. The partnership included the conception of the theme and script, the preparation of materials, the recording and editing of the video. The theme was decided together, questioning the option of war to solve conflicts. In this case, the boy shows a conciliating character, without appealing to violence. The video was structured as a dialogue, where they both drew alternately: a stroke by one followed by a stroke by the other, and thus ending up with two drawings that represented war and peace, respectively.

Mono-channel video 4:3 (color, sound), 0:43 min.

Performers
 Analivia Cordeiro and Thomas Cordeiro Guedes

Production
 Analivia Cordeiro

Audio
 Rainforest by Ken Davis and metronome sound

Editing
 Analivia Cordeiro and Thomas C. Guedes

Guerra e paz (War and Peace), 2005. Mono-channel video 4:3 (color, sound), 0:43 min. Video still frames.

Education
Educational video
2005

Video in coauthorship with a 13-year-old boy. The partnership included the conception of the theme and script, the preparation of materials, the recording and editing of the video. The boy, for being the son of university professors, proposed the theme of education in society. In Brazil, this is a sociopolitical theme in view of the scarcity of schools and universities accessible to everyone. The contents were generated by a simple means: a pencil was used to make drawings in black-and-white, most of them created by Tumkus.

Mono-channel video 4:3 (black and white, sound), 1:70 min.

Performers
 Analivia Cordeiro and Lucas Tumkus

Production
 Analivia Cordeiro

Music
 Education by Modest Mouse

Editing
 Analivia Cordeiro and Lucas Tumkus

Education, 2005. Mono-channel video 4:3 (black and white, sound), 1:70 min. Video still frames.

Understandable Fuzziness
Educational video

2005

Cybele Cavalcanti is a visual artist and dance teacher for children. As Cordeiro's friend, they both developed a dialogue based on the combined composition of a painting made with crayons, with music by Bach in the background. The videographic presentation also included the poem by Mayakovsky, which corresponded to the visual result obtained.

Mono-channel video 4:3 (color, sound), 2:11 min.

Performers
 Analivia Cordeiro and Cybele Cavalcanti

Production
 Analivia Cordeiro

Music
 Air on G String, Suite No. 3, BWV 1068 by Johann Sebastian Bach

Poem
 Picture of Spring by Vladimir Mayakovsky

Language
 English

Editing
 Analivia Cordeiro

Understandable Fuzziness, 2005. Mono-channel video 4:3 (color, sound), 2:11 min. Video still frames.

ANALIVIA CORDEIRO

DJ Mobile
App for Art
2005

When the first smart phones came out on the market, some artists used this new technological support to create artworks. Developed in 2005 by Cordeiro and Nilton Lobo, DJ Mobile was a pioneering art application, at a time when mobile applications were not yet popular, and two years before the first iPhones. With DJ Mobile, the public could create music with sounds produced by construction workers. To compose the music, the user first chooses a rhythmic basis, which can be hip-hop, samba or rock 'n' roll. On top of this rhythm, the user places sounds chosen from a repertoire of audio recordings of construction workers building a house. For example, a hammer hitting a nail works as a percussion sound. This sound is recorded in MP4 format. The images are chosen from a online image databank, in this case, of the body movements of workers constructing a house. The result is a video that combines the images with the audio created by the user. The public composed more than one thousand video clips with DJMobile during the 12 hours of the event Nokia Trends in São Paulo, in 2005, sponsored by Nokia.

Conception
 Analivia Cordeiro

App Programming
 Nilton Lobo

Exhibition
 Nokia Trends, São Paulo, Brazil, 2005

Sponsor
 Nokia

DJ Mobile, 2005. App for Art. Photographs, digital file.
Photographer: unknown

ANALIVIA CORDEIRO

Unsquare Dance I
Video art

2007

The body's movement was recorded in real time in video by sensors distributed on the dancer's body and manipulated by a VJ, also in real time, creating paths in the space with different textures. The result is an abstract animation with a clearly organic temporality. Cordeiro conceptually attributed different visualizations to the movement captures, showing the diversity of human movement. The software programmed by Luiz Velho and Julio Lucio transformed the movement capture into abstract visual effects. The software and video were presented at Siggraph, on August 11–15, 2008, in Los Angeles, California (USA).

Mono-channel video 4:3 (color, sound), 2:34 min.

Concept and Performer
 Analivia Cordeiro

Production
 Instituto de Matemática Pura e Aplicada – IMPA, Rio de Janeiro, Brazil

Programming
 Luiz Velho and Julio Lucio

Music
 Unsquare Dance by Dave Brubeck Quartet

Recording and editing
 Luiz Velho

Unsquare Dance I, 2007. Mono-channel video 4:3 (color, sound), 2:34 min. Video still frames.

ANALIVIA CORDEIRO

Carne III
Video choreography

Flesh III

2009

In *Carne III*, Cordeiro used the sound of a car's motor as a reference to the masculine world, also associated with the realm of technology. In the video editing, fragments from *Carne I* and *Carne II* were combined and manipulated through special effects. As in the first version, the dancer executes movements in coordination with, and simultaneous to, those of the camera. In order to achieve greater proximity, the dancer records her own movements with portable cameras attached directly to her body—at the wrist and ankle—exploring the relationship between body, space and time.

Mono-channel video 4:3 (color, sound), 4:28 min.

Performer
 Analivia Cordeiro and Cristina Brandini

Production
 Analivia Cordeiro

Sound
 Assembly of voice and car engine sounds by Analivia Cordeiro

Poem
 Voce Re, by Edward E. Cummings, 1958

Language
 English

Editing
 Analivia Cordeiro

Carne III (Flesh III), 2009. Mono-channel video 4:3 (color, sound), 4:28 min. Video still frames.

ANALIVIA CORDEIRO

Você
Software

You

2010

Você is the name of the software created by Analivia Cordeiro together with the group Amudi of the Polytechnical School of the University of São Paulo. The software Você used a video camera to record the image of a member of the public and to transform it into discrete lines. The aesthetic result was an image in impressionist style. An infrared blood flow sensor attached to person's index finger was also used to record his or her heartbeat. The data captured by the sensor interfered with and changed the color of the image. The faster the heartbeat, the redder the image became; the slower the heartbeat, the bluer the image. Thus, interactivity was produced according to the body's internal behavior, which normally takes place without the person's conscious control. Only people with specific training, such as yogis for example, can control their heartbeats. The result was a video generated in real time of a person who interacted with the system.

Conception
 Analivia Cordeiro

Interactivity design
 Analivia Cordeiro

Software programming
 Grupo Amudi

Exhibition
 Zonas de Contato, Paço das Artes da Universidade de São Paulo (Brazil), 2010.

Você (You), 2010. Software. Screenshots, digital files.

ANALIVIA CORDEIRO

Alegria de Ler
Educational videos
Joy of Reading
2010

Alegria de Ler (Joy of Reading) is an audiovisual course for teaching people to read and write Brazilian Portuguese, created to be freely accessed on YouTube. It consists of 242 videos whose contents aim to fill a gap in the education of a very needy segment of the population. It is organized in eight modules consisting of various lessons in video format. Each module concerns a determined subject to be studied, focusing on popular Brazilian culture or questions of public interest, while also presenting lessons in Portuguese grammar and writing. The last lesson seeks to teach the student to write his or her own name. The average duration of each class is 2:51 minutes.

The course continues to be offered online, and receives on average 2,900 visits per day, a number that is continuously growing. The project was produced as a practical part of Cordeiro's postdoctoral thesis titled *Alegria de Ler*, which she defended at the Federal University of Rio De Janeiro (UFRJ), in 2010. A summary of this thesis is presented in the text part of this book.

Mono-channel videos 16:9 (color, sound)

Content
 242 Educational videos

Conception
 Analivia Cordeiro

Performer
 Analivia Cordeiro

Language
 Portuguese

Production and edition
 Analivia Cordeiro

Escrita das Palavras Bate Bate (Writing the Words Bate Bate), from *Joy of Reading* Course, 2010. Video 16:9 (color, sound), 1:20 min. Video still frames.

ANALIVIA CORDEIRO

Acrobacia do dinheiro
Photo collages
Money Acrobatics
2010

These three works composed the series *Acrobacia do dinheiro* (Money Acrobatics). They are collages in digital format that deal with the power of capital in the art market and in our society's cultural production.

Breast, from the series *Acrobacia do dinheiro* (Money Acrobatics), 2010. Photograph, 37.7 × 26.0 cm
Lips, from the series *Acrobacia do dinheiro* (Money Acrobatics), 2010. Photograph, 36.8 × 26.0 cm
Luck, from the series *Acrobacia do dinheiro* (Money Acrobatics), 2010. Photograph, 39.0 × 26.0 cm

Architecture of Movement
Video art
2014

Using the Nota-Anna software, film frames of soccer player Pelé making a bicycle kick, and a volley, both from 1968, were transformed into schematic 3D images. These ethereal movements became graphic images that can be observed from different angles in the program.

Video 4:3 (color, sound), 1:20 min.

Performer
Analivia Cordeiro

Production
Analivia Cordeiro

Nota-Anna Programming
Nilton Lobo

Music
Live recording of the Escola de Samba (Samba School) during the Carnival 2012

Edition
Analivia Cordeiro

Architecture of Movement, 2014. Video 4:3 (color, sound), 1:20 min. Video still frames.

ANALIVIA CORDEIRO

M3×3
Computer-based video dance
1973/2015

The three-channel synchronized video installation created in 2015 uses the audiovisual material of *M3×3* from 1973 and recurs to the spatial concept of the video dance work, which is the cube. In this participative installation, the three video projections compose the respective sides at right angles: a lateral face, a frontal face, and a lower face. The videos are projected synchronized and simultaneously. The installation's size was defined according to the human scale, that is, each side measures 1.95 × 2.60 m. The public can enter the projection space of this installation and the shadow projected by each of their bodies creates a dialogue with the figures of the dancers in the video, who wear black clothing.

Three-channel synchronized video installation, 4:3 (black and white, one-channel sound), loop.

Conception of the installation
 Analivia Cordeiro, 2015

Dimensions
 2.60 × 2.60 × 1.95 m

Award
 ARCO-BEEP Electronic Art Awards 2015

Video material 4:3 (black and white, sound, loop), 1973:

Performers
 Analivia Cordeiro, Beatriz Maria Luiz, Cybele Cavalcanti, Eliana Pena Moreira, Fabiana Cordeiro, Marina Helou, Nira Chernizon, Silvia Bittencourt, Solange Arruda

Production
 Computer Center of University of Campinas UNICAMP and TV-2 Cultura de São Paulo, Brazil

Choreography, costume design and scenography
 Analivia Cordeiro

Computer programming
 Analivia Cordeiro and Computer Center of University of Campinas

TV Direction
 Irineu de Carli

Photography
 Ricardo Delling

Audio
 Metronome sound

Sound
 Laerte Silva

Lightning
 Durvalino Gomes, Antonio Cirino

Editing
 Computer Center of University of Campinas UNICAMP and TV Cultura de São Paulo, Brazil

M3×3 Installation, 1973/2015. Three-channel synchronized video installation 4:3 (black and white, sound), loop, 2.60 × 2.60 × 1.95 m
Photo: ARCO Art Fair, Madrid, 2015 Photographer: unknown

ANALIVIA CORDEIRO

Cambiantes
Computer-based video dance installation

1976/2015

The three-channel video installation created in 2015 uses the audiovisual material of *Cambiantes* from 1976 but with a completely new edition. Cordeiro recurs to the spatial concept of the video dance work, which is the cube. In this participative installation, the three video projections compose the respective sides at right angles: a lateral face, a frontal face, and a lower face. The videos are projected simultaneously. The installation's size was defined according to the human scale, that is, each side measures 1.95 × 2.60 m. The public can enter the projection space of this installation and the shadow projected by each of their bodies creates a dialogue with the figures of the dancers in the video, who wear black clothing.

Three-channel video installation 4:3 (black and white, one channel sound), loop.

Conception of the installation
 Analivia Cordeiro, 2015

Dimensions
 2.60 × 2.60 × 1.95 m

Video material 4:3 (black and white, sound, loop), 1976/2015:

Performers
 Analivia Cordeiro, Beatriz Maria Luiz, Cybele Cavalcanti, Fabiana Cordeiro

Choreography and direction
 Analivia Cordeiro

Original production
 Computer Center of State University of Campinas – UNICAMP City Hall of Campinas, São Paulo, Brazil

New production
 Analivia Cordeiro

Music
 Cambiantes by Raul do Valle

New editing
 Analivia Cordeiro

Cambiantes Installation, 1976/2015. Three-channel video installation 4:3 (black and white, sound). Photographs of the the installation in the exhibition *Analivia Cordeiro – From Body to Code* at the ZKM | Center for Art and Media Karlsruhe, 2023. Photographer: Felix Grünschloß. © ZKM | Karlsruhe.

ANALIVIA CORDEIRO

Cambiantes, 1976/2015. Mono-channel video 4:3 (color, sound), 4:58 min. Left video still frames
Cambiantes, 1976/2015. Mono-channel video 4:3 (color, sound), 4:58 min. Right video still frames.
Cambiantes, 1976/2015. Mono-channel video 4:3 (color, sound), 4:58 min. Floor video still frames.

ANALIVIA CORDEIRO

2015—2022

Chutes Inesquecíveis

Unforgettable Kicks

2015–2018

Computer-designed sculptures series based on Nota-Anna by Analivia Cordeiro and Nilton Lobo

Unforgettable Kicks

The sculptures produced between 2015 and 2018 are based on the analysis of the recording of movements of three unforgettable kicks: the bicycle kick performed by Pelé, recorded in video in 1968; a volley performed by Pelé, recorded in video in 1968; and the *yoko geri kekomi* by Bruce Lee, recorded on film in the 1960s. These kicks were transformed into sculptures and drawings.

At a first glance, it is difficult to identify these movements in the works, as these are decoded by a movement notation system called Nota-Anna, developed by me and Nilton Lobo as of 1983.

Nota-Anna is the result of decades of research in choreography and teaching of movement for adults and children, in addition to theoretical studies in the visual arts, video art, anatomy, physiology, neurology, and movement analysis. This search had two stages: first, the computer-generated movement notation (1973–76), which focused on the video-dance area, and the second that expanded the sphere of dance to any form of corporal expression.

This attempt to propose a computer-designed notation occurs at the maturity of a study. A researcher can only try to establish control over the movement after decades of practice and experience, self-observation, scientific knowledge, and observation of others. After this complex and time-consuming study, I certainly became aware of how little it is possible to know about the movement in order to control it to a high degree. The greatest significance of this research is to visualize the subtleties and details of human actions that reveal beauty and its expressive intentions.

The trajectory is an impersonal form of movement recording, which shows the movement itself regardless of the characteristics of the person that is moving (appearance, clothes, gender, etc.). Nota-Anna writes the pure movement, introducing it into a new universe comparable to music.

Nota-Anna is intended to any type of motion, such as dance, everyday movements, sports, and even to other animals.

As an artist, I envisioned that this purely computational resource could turn into real sculptures. A totally unique and genuine design. The result is a series of seventeen computer-assisted sculptures made by 3-D printers called *Unforgettable Kicks*.

The geometry of the body is complex; in the *Unforgettable Kicks*, straight or parallel lines are inexistent.

The point to be observed corresponds to the traces of the body parts in action during the execution of the movement.

The sculptures can be accompanied by computer drawings using the Nota-Anna movement notation system. In total, there are twenty-six drawings to be presented printed on transparent acetate. The labels will clarify which is the movement source and the point of view.

<div style="text-align:right">Analivia Cordeiro</div>

Text originally written as an introduction to the solo exhibition by Analivia Cordeiro in 2018 with the same title, *Chutes Inesquecíveis*, Museu de Arte Moderna, Rio de Janeiro, Brazil.

Tribute to Oskar Schlemmer I, 2016. Computer-assisted sculpture. Red polyamide, 23.36 × 16.74 × 10.31 cm
Photographer: Edouard Fraipont

ANALIVIA CORDEIRO

Materialization of Sight I, 2015. Digital sculpture sketch side view.

Materialization of Sight I, 2015. White polyamide, 24.05 × 16.04 × 7.96 cm
Photographer: Edouard Fraipont

Ephemerality of Movement, 2015. Digital sculpture sketch.

Ephemerality of Movement, 2015. Resin, 24.10 × 20.70 × 19.10 cm
Photographer: Edouard Fraipont

Concept of Abstraction II, 2015. Digital sculpture sketch.

Concept of Abstract II, 2015. White polyamide, 26.70 × 22.35 × 18.52 cm
Photographer: Edouard Fraipont

Empty Visible, 2016. Digital sculpture sketch.

Empty Visible, 2016. Black polyamide, 25.48 × 18.52 × 10.80 cm
Photographer: Edouard Fraipont

Materialization of Sight II, 2015. Digital sculpture sketch.

Materialization of Sight II, 2015. Computer-assisted sculpture. Blue polyamide, 28.43 × 22.42 × 21.38 cm
Photographer: Edouard Fraipont

ANALIVIA CORDEIRO

Gold Kick, 2016. Digital sculpture sketch perspective view.

Gold Kick, 2016. Gold plated brass, 12.50 × 6.29 × 8.46 cm
Photographer: Edouard Fraipont

ANALIVIA CORDEIRO

In Out, 2017. Digital sculpture sketch.

In Out, 2017. Gold plated brass, 12.49 × 5.55 × 3.37 cm (each one)
Photographer: Edouard Fraipont

ANALIVIA CORDEIRO

Materialization of the Geometry of Movement, 2016. Digital sculpture sketch.

Materialization of the Geometry of Movement, 2016. Brass, 12.42 × 4.94 × 6.99 cm
Photographer: Edouard Fraipont

Organic Kaleidoscope, 2016. Digital sculpture sketch.

Organic Kaleidoscope, 2016. Black polyamide, 24.27 × 21.10 × 18.10 cm
Photographer: Edouard Fraipont

ANALIVIA CORDEIRO

(In)visible Moving II, 2017. Digital sculpture sketch.

(In)visible Moving II, 2017. Alumide, 20.43 × 14.73 × 22.81 cm
Photographer: Edouard Fraipont

ANALIVIA CORDEIRO

(In)visible Moving I, 2017. Digital sculpture sketch.

(In)visible Moving I, 2017. Red polyamide, 16.99 × 15.00 × 12.84 cm
Photographer: Edouard Fraipont

ANALIVIA CORDEIRO

Tribute to Oskar Schlemmer II, 2016. Digital sculpture sketch.

Tribute to Oskar Schlemmer II, 2016. Yellow polyamide, 22.94 × 20.61 × 18.28 cm
Photographer: Edouard Fraipont

ANALIVIA CORDEIRO

Tribute to Oskar Schlemmer III, 2016. Digital sculpture sketch.

Tribute to Oskar Schlemmer III, 2016. Dark blue polyamide, 22.95 × 27.69 × 16.15 cm
Photographer: Edouard Fraipont

ANALIVIA CORDEIRO

London Hyde Park
Photography

2016

338

London Hyde Park, 2016. Photograph.

ANALIVIA CORDEIRO

Frankfurt Shopping Center
Photography

2015

Madrid
Photography

2016

Frankfurt Shopping Center, 2015. Photograph.

Madrid, 2016. Photograph.

ANALIVIA CORDEIRO

Dancing on the Paper
Series, Painting on paper

2017

This series of paintings titled *Dancing on the Paper* started in 2017 was conceived using the artist's own body, without any electronic instrument. Analivia Cordeiro draw shapes on a delimited area—the sheet of paper. With her actions she was not seeking perfection—improbable in dynamic improvisations—but rather to reproduce the spontaneity of corporal gestures. In this work, her fingers are used as a sort of brush guided by the circular gesticulations of her arms. In the works reproduced on the following pages, she used other members of her body, including her toes.

Red (*Dancing on the Paper* Series), 2017. Gouache on paper, 170.4 × 90.6 cm
Photographer: Edouard Fraipont

ANALIVIA CORDEIRO

Fingers I (*Dancing on the Paper Series*), 2017. Gouache on paper, 96,5 × 66,5 cm
Photographer: Edouard Fraipont

Fingers II (*Dancing on the Paper Series*), 2017. Gouache on paper, 29,7 × 21 cm (each)

ANALIVIA CORDEIRO

Hair Brush I (*Dancing on the Paper* Series), 2018. Gouache on paper, 46.0 × 104.0 cm
Photographer: Edouard Fraipont

ANALIVIA CORDEIRO

348

Red and Black (*Dancing on the Paper* Series), 2017. Gouache on paper, 180.0 × 100.0 cm
Photographer: Edouard Fraipont

Black Diagonals (*Dancing on the Paper* Series), 2017. Gouache on paper, 180.0 × 100.0 cm
Photographer: Edouard Fraipont

ANALIVIA CORDEIRO

350

Fingertips I (*Dancing on the Paper* Series), 2018. Gouache on paper, 17.0 × 71.0 cm
Photographer: Edouard Fraipont

Fingertips II (*Dancing on the Paper* Series), 2018. Gouache on paper, 17.0 × 71.0 cm
Photographer: Edouard Fraipont

Fingertips III (*Dancing on the Paper* Series), 2018. Gouache on paper, 17.0 × 71.0 cm
Photographer: Edouard Fraipont

Hair Brush II (*Dancing on the Paper* Series), 2018. Gouache on paper, 66.0 × 98.0 cm
Photographer: Edouard Fraipont

ANALIVIA CORDEIRO

Mutatio: Impossible to Control Just Contribute I
Interactive Nota-Anna-based audiovisual installation
2019

Mutatio - Impossible to Control Just Contribute is an interactive installation in which the public can play an active role by making movements that generate combinations of images in real time, which are always distinct and projected in the context of the installation. The motion of the spectator's body is recorded by a Kinect sensor and sent to the computer. The Nota-Anna software processes these images in three different ways: the exclusive selection of the body's points of articulation; the body transformed into a stick figure; and the generation of volumes described in space by the movements of bodies and their limbs. These images are projected alternatingly on a screen and the members of the public can observe their own figures and movements. As a second step, the software randomly selects four of these captures of the public's movement, which are inserted into a constantly changing preestablished structure of images. This result is projected on a second screen in real time and the public can see the transformation of their movements into images, watching how their gestures interfere in the final aesthetic composition.

The visual aesthetics favors the abstraction of the human body's movement and plays with the figuration of the real image. The public is thus offered a moment of freedom and playful spontaneous creation.

The program's aesthetic result is subjected to processes of adaptation and modification depending on the place where the work is shown. Up till now there have been three versions: *Mutatio I* (2019, presented at Renault Garage, Paris); *Mutatio II* (2021, presented at SP-Art Fair, São Paulo); and *Mutatio III* (2023, made specifically for the solo show at ZKM Center for Art and Media Karlsruhe).

Conception of the installation
 Analivia Cordeiro, 2019

Programming
 Nilton Lobo

Dimensions
 approx. 4.4 × 4.4 m, variable according to the exhibition space

Mutatio: Impossible to Control Just Contribute I, 2019. Interactive Nota-Anna-based audiovisual installation.
Computer-generated images based on the movements of the audience interacting with the work *in situ*. Renault Garage, Paris.

Mutatio: Impossible to Control Just Contribute II and III
Interactive Nota-Anna-based audiovisual installation

2021 (II) / 2023 (III)

Mutatio: Impossible to Control Just Contribute II and *III, 2021-2023*. Photographs of the audience interacting with the installation in the exhibition *Analivia Cordeiro – From Body to Code*, ZKM | Center for Art and Media Karlsruhe, 2023. Photographer: Felix Grünschloß. © ZKM | Karlsruhe

Re-constructive
Assemblages on paper
2020

358

Re-constructive, 2020. Natural seeds on paper, 21.5 × 30.0 cm (each)
Photographer: Edouard Fraipont

ANALIVIA CORDEIRO

BodyWay Nota-Anna
Application for mobile platforms
2022

BodyWay Nota-Anna is an application for smartphones and tablets that uses artificial intelligence to capture the movements of the human body. Once the application is installed, the user can use the smartphone's camera or a pre-recorded video showing the movements of his body. The application processes this video through the Nota-Anna software, offering different forms of graphic visualization of this body capture, which can be placed over different background images, as well as adding soundtracks. This result can be complemented with an optional comment written and shared on social networks, or used in games offered within the application itself.

 This application stands out for being an innovative communication tool as it opens the possibility of creating a body capture message to be shared on any social network. It is easy to use, fun, applicable to anyone anywhere in the world, regardless of gender, age, profession or purchasing level.

 Design and conception by Analivia Cordeiro, development of Nota-Anna with AI by Nilton Lobo and application implementation by Obi.tec.

Design and conception
 Analivia Cordeiro

AI development
 Nilton Lobo

Versao
 1.2.0, 2022

Supported systems
 iOS and Android, 40 MB

Development framework
 Flutter

Development languages
 Dart, Java and Swift

Languages
 Portuguese and English

Implementation
 Obi.tec

BodyWay Nota-Anna app can be downloaded to iOS and Android smartphones using the following QR codes. Just open the camera in your smartphone and capture one of the QR codes, according to your device.

BodyWay Nota-Anna, 2022. Photograph of the audience interacting with the application in the exhibition *Analivia Cordeiro – From Body to Code*, ZKM | Center for Art and Media Karlsruhe, 2023. Photographer: Felix Grünschloß. © ZKM | Karlsruhe.

Small Talks
Video performance
2022

In this performance, Analivia Cordeiro establishes a spontaneous and improvised dialogue with Gissauro, a young urban dancer from São Paulo. Each one uses a different dance language according to their respective backgrounds and generational references, as well as sociocultural conditions.

Video 16:9 (color, sound), 3:25 min.

Performers
 Analivia Cordeiro and Gissauro

Production
 Analivia Cordeiro

Music
 La Vie en Rose interpreted by Louis Armstrong

Edition
 Analivia Cordeiro and Gissauro

Small Talks, 2022. Video 16:9 (color, sound), 3:25 min. Video still frames.

ANALIVIA CORDEIRO

PHOTOGRAPHS BY BOB WOLFENSON

1987—2020

Studio Portraits of Analivia Cordeiro

Bob Wolfenson

1987–2020

Encounter

I have known Analivia Cordeiro since we were both ten years old, at Aplicação School in São Paulo, when we were just starting "ginasial" (the word used in Brazil for "junior high" at that time) and, of course, long before we became what we became: she, a performance artist and dancer, I a photographer transiting through various fields of that trade. As in all the friendships of childhood and adolescence, various happenstances interrupted our shared destinies, and our encounters and connections became very scarce for some time.

In adult life we met up again—as luck would have it, in my studio. Those photographic sessions were to serve as a connecting link between us, as a pretext for the reconnection. That work involved a series of documentations about her work, which included movements, choreographies, installations, performances and silences—many of which were constructed in the flow of those same sessions.

And they were like this: she moving freely through the endlessness of my studios and I chasing after her like a hunter in search of his prey, trying to capture something nearly intangible, really abstract, which would only become concrete when we developed the films and were struck by the lightness and power of her apparition. Looking back, I see how artistically radical (I did not have that notion at that time) she was in those blendings of music, dance and visual arts made in the setting of a photography studio, bringing me with her to the paroxysm of her visual discourse. Beyond the impact that this beauty had on me. I am very grateful for those encounters, not only for the affective experience and the result, but above all for the chance I had to document, in an unusual way, the spatial perambulations invented by a dear friend and powerful artist.

When one is heading down paths never tread before, the camera works as a tracker of chance happenings—as in the film *Blow Up* by Michelangelo Antonioni, the unexpected is revealed when the detail is enlarged, the photographer then sees what he did not see with his naked eye. With her it was and is like that, we flowed along with what was happening, immersed in a wealth of ideas, each in his or her own métier, inventing lightings, poses, adding objects, wrapping her body in cellophane, rolling her body in sand for the camouflaging grains to coat her skin and/or, simply, coaxing her to take flight within the infinity of a white background. And with the developed film frames and enlarged images I would come suddenly upon her moving or still body, offered as a work of art. Within the void, within nothingness, within the unsaturation of the blank page that represents the raw infinite background, Analivia fills it with her all, with her body, with her courage and nudity.

And I only record them.

Bob Wolfenson
September 17, 2022

Translated by John Norman

Bob Wolfenson, Studio portrait of Analivia Cordeiro, 1987. BW photograph, gelatin silver print, 13.1 × 19.9 cm. Analivia Cordeiro Archive, São Paulo. © Bob Wolfenson

Bob Wolfenson, Studio portrait of Analivia Cordeiro, 1987. BW photograph, gelatin silver print, 26.0 × 26.0 cm. Analivia Cordeiro Archive, São Paulo. © Bob Wolfenson

ANALIVIA CORDEIRO

Bob Wolfenson, Studio portrait of Analivia Cordeiro, 1987. BW photograph, gelatin silver print, 19.9 × 16.1 cm. Analivia Cordeiro Archive, São Paulo. © Bob Wolfenson

Bob Wolfenson, Studio portrait of Analivia Cordeiro, 1987. BW photograph, gelatin silver print, 19.6 × 12.7 cm. Analivia Cordeiro Archive, São Paulo. © Bob Wolfenson

Bob Wolfenson, Studio portrait of Analivia Cordeiro, 1987. BW photograph, gelatin silver print, 21.2 × 14.3 cm. Analivia Cordeiro Archive, São Paulo. © Bob Wolfenson

Bob Wolfenson, Studio portrait of Analivia Cordeiro, 1987. BW photograph, gelatin silver print, 19.6 × 12.7 cm. Analivia Cordeiro Archive, São Paulo. © Bob Wolfenson

Bob Wolfenson, Studio portrait of Analivia Cordeiro, 1987. BW photograph, gelatin silver print, 28.0 × 19.9 cm. Analivia Cordeiro Archiv, São Paulo. © Bob Wolfenson

Bob Wolfenson, Studio portrait of Analivia Cordeiro, 2020. BW photograph. © Bob Wolfenson

Bob Wolfenson, Studio portrait of Analivia Cordeiro, 2003. BW photograph, gelatin silver print, 18.9 × 25 cm © Bob Wolfenson

Bob Wolfenson, Studio portrait of Analivia Cordeiro, 1987. BW photograph, gelatin silver print, 10.4 × 21 cm. Analivia Cordeiro Archiv, São Paulo. © Bob Wolfenson

Bob Wolfenson, Studio portrait of Analivia Cordeiro, 1987. BW photograph, gelatin silver print, 26.0 × 26.0 cm. Analivia Cordeiro Archiv, São Paulo. © Bob Wolfenson

Bob Wolfenson, Studio portrait of Analivia Cordeiro, 1987. BW photograph.
Analivia Cordeiro Archiv, São Paulo. © Bob Wolfenson

374 Bob Wolfenson, Studio portrait of Analivia Cordeiro, 2020. BW photograph.
© Bob Wolfenson

Bob Wolfenson, Studio portrait of Analivia Cordeiro, 2020. BW photograph.
© Bob Wolfenson

ANALIVIA CORDEIRO

APPENDIX

Analivia and her father, 1954. BW photograph, 20 × 24 cm
Unknown photographer.

Photo with Analivia Cordeiro in the Clube Esperia's playground in São Paulo still under construction, designed by artist and landscape designer Waldemar Cordeiro (1925-1973). Photograph by Elisabeth Walther-Bense, ca. 1964. Collection Max Bense and Elisabeth Walther-Bense. © ZKM | Karlsruhe Archive.

A Brief Biography and Report about the Researches of Analivia Cordeiro

Analivia Cordeiro's first contact with the arts took place when she was still a child, in her family environment. Her father, Waldemar Cordeiro, was an artist, art critic and theorist, a key figure in the concrete art movement in Brazil and one of the pioneers of computer art. Besides her father's production, in her childhood she made contact with the works and thinking of leading artists of the popcrete and kinetic art movements. In this cultural environment she witnessed and absorbed key concepts for the comprehension of artistic creativity.

> In long conversations I had with my father, coupled with readings, I learned to observe artistic phenomena according to an objective approach: the visual language has a syntax independent of a subjective interpretation. In the case of Brazilian concrete art, this syntax followed the principles of visual Gestalt (Kurt Koffka), a 20th-century scientific approach to art. Concrete art opened the possibility for a systemic organization of visual creation, as occurred later with the computer art that introduced algorithms into the processes of artistic creation of various fields—visual arts, dance and others.[1]

Her dance education began at seven years old. Her teacher, Maria Duschenes (Budapest, 1922 – São Paulo, 2014), had been trained in the Rudolf von Laban method. Originally from Hungary, after the outbreak of World War II she came to Brazil, in 1940. Based on her solid knowledge of human body movements and expression, and of how to convey this understanding, she taught this attitude to children and adults. Her classes were special: warmup exercises, sequences to be repeated, and at the end an improvisation. The students always had a moment for free creation, guided by the teacher.

In the first two years of her training at Maria Duschenes's school, Analivia sharpened her ability for observation—an outlook that was to shape many developments in her career. At that time she began to improvise and to become familiar with the expression of movement. At age 14 she was invited by Maria Duschenes to the Merce Cunningham and John Cage dance presentation, in Rio de Janeiro (1968). The vanguard proposal and a certain playful character of that presentation were unforgettable and profoundly marked her life. That same year, she began to work with professionals on stage.

By the time she was 15, already possessing a good basis of aesthetic and expressive knowledge in combination with her evolving physical skills, she started to develop experimental ways of writing choreography to assist the rehearsals in Maria Duschenes's classes. She thus helped out while also shaping her comprehension of the language of dance: the questions of time and space, distribution, composition, rhythm, movement of the dancers and their different individual abilities. Seeing her interest, Maria Duschenes taught her Labanotation and gave her the book *Choreutics* by Laban. She improved her studies by watching Oskar Schlemmer's films over and over and observing Moholy-Nagy's photographic works, both from the Bauhaus, as well as by looking at McLaren's animations.

At 16, she started classes in ballet and other types of dance, which expanded her vocabulary. She was soon invited to participate in *Structured Improvisation* (1972) with the Clyde Morgan Company, which was a group of dancers improvising in front of video cameras. She recorded this work, which caused her great frustration because there was no dialogue between the camera and what she was dancing. In her words, "when I stopped moving, the camera registered

Based on Analivia Cordeiro, *The Architecture of Human Movement* (São Paulo: Escola de Comunicações e Artes da Universidade de São Paulo, 2018), 5–11. (Postdoctoral thesis oriented by Prof. Dr. Gilbertto Prado.)

1 Ibid., 5.

my whole body; and when I gave a wonderful jump, the camera filmed my finger. When I saw the result, I was horrified. And I thought: 'Wow! There must be some way for a better dialogue between the camera and the movements.'"[2]

At that time, recording a dance audiovisual production in the television studio required many hours of preparation and dialogue between the choreographer and the technical team to plan the camera takes. This made the production very expensive. Around that time, she often observed her father working with a computer, and thus got the idea to plan the process with informatics. Her enormous interest in mathematics was therefore joined to her passion for dance, and this is what gave rise to her computer-aided visual dance system: a choreographic coordination between the dancers and the TV studio team through computerized notation.

In 1973, she submitted her first computer-aided video dance process called *M3×3* to the International Edinburgh Festival, Scotland, and on that basis was invited to participate in the festival's event that year, *INTERACT Man: Machine: Society*. This invitation opened the possibility for her to record the video at the studios of TV Cultura, in São Paulo. That same year, she was invited to present *M3×3* at the XII Bienal de São Paulo.

> I ended this production in May of 1973, and I told my father, 'You must see this video.' He answered, 'Wait a little bit, because I'm very busy now.' Three days later, he died unexpectedly in his sleep at the age of 48. He did not see my first work.[3]

During the computer programming, she perceived that there were moments when the computer program offered more than one possibility for defining the movements. Aesthetic decisions thus had to be made for selecting the different possibilities. At that point she decided to introduce elements of randomness into her works. This characteristic was present in many computer art creations at that time, and is still used today.

The computer output used stick figures to define the choreographic notation, which indicated the movements of the dancers' bodies and their movement around the stage. In the following years she used her computer-aided notation method in the video dances, $0°⇔45°$ (1974), *Gestos* (Gestures, 1975), and *Cambiantes* (1976).

For the dancers, however, it was hard to gain an understanding of these movements merely by reading the notation. The dancer's training was based on imitating the teacher or improvising and feeling his or her own body, not from reading schematics and the symbols used by the notations. Moreover, this form of translating movement into writing was not isomorphic with the movement, thus requiring the dancer to engage in an effort of mental decoding. This interfered in the kinesthesis of his or her movement and became an obstacle for the interpretation of the choreography. This critical insight into the system of notation she used in these computer dances, from 1973 up to 1976, is what later gave rise to her research for the development of her own computer-aided dance notation system.

Motivated by this interest in studying the movement of the body in its most primordial forms, in 1975 she lived for two and a half months with the Kamaiurá indigenous tribe in Amazonia. This experience profoundly marked her life and artistic activity. She documented her stay together with the Kamaiurá people through photographs and Super-8 film recordings, which were edited and saved in digital format many years later.

In 1976, she graduated from the College of Architecture and Urbanism of the University of São Paulo. She decided, however, to continue her training in dance outside Brazil. She moved to New York. "For two and a half years, I worked hard and exchanged experiences with other artists; because in Brazil I felt lonely, doing a different art. In New York I felt like a participant of society."[4] In New York she made contact with the generation of postmodern dance: she studied with Merce Cunningham, attended the studio of Alwin Nikolais, she took lessons with Viola Farber and Gus Solomons Jr., with whose company she performed in street performances; she danced in Janette Stoner's company and took part in videos at Merce Cunningham's and Charles Atlas's workshops. She was also able to present her own choreographies in avant-garde dance performances.

2 Ibid., 6.
3 Ibid.
4 Ibid., 9-10.

Analivia Cordeiro with her computer dance notation, 1973.
BW photograph, 23 × 16 cm
Unknown photographer

Returning to Brazil in late 1979, she continued with her research into video dance by addressing the relationship between the act of dancing, the video camera and the method(s) to create choreography. In parallel with this, she began working with children, teaching them the art of movement based on the Laban method, also introducing the video language to them. She furthermore maintained a series of contacts with other countries where she could show and disseminate what she was creating.

In 1982, as mentioned above, she began her research for the development of her dance notation computer software ultimately called Nota-Anna, but initially called Trajectory-Notation. The programming work was carried out in 1983 together with an intern at the Polytechnic School of University of São Paulo named Nilton Lobo. Nota-Anna was designed with the aim of offering a solution for the deficiencies she had detected in the computer-dance notation in her previous work. Her starting point was to find the answer to the question: "What is the best way to communicate movement in a writing mode, in a way that is understandable to both professionals and laymen, that is, with a broad perspective of communication?" She reached the conclusion that the ideal way would be like the eye itself sees the movement, i.e., the trace-forms the movement leaves in the air.

Analivia Cordeiro decided to use video recording that allowed for a frame-by-frame analysis and fragmentation of the movement to obtain the trace-forms of different body parts in the air. In mathematical terms, calculating the angle on the X and Y axes of the Cartesian system, the position of the body on the Z axis is obtained. The system thus allowed for the

transformation of the bidimensional video image into a tridimensional image in the computer. This algorithm was completed in 1994.

> In this search, I ended up marrying Nilton. In 1994, after the birth of our son, Thomas, I started my master's degree program in which I finished the Nota-Anna software and wrote a book called *Nota-Anna: An Electronical Notation of Body Movements based on the Laban Method*. For this same thesis, I put the Laban method in video format, which opened me to the possibility of an excellent relationship with international institutions.[5]

She applied Nota-Anna to capture the movement of Marilyn Monroe's walk, the kick of Bruce Lee, the kick of Pelé and a dance sequence by Elvis Presley. Observing her videos, one can note the extremely meticulous way in which the movements of these iconic figures were recorded in tridimensional trace-forms.

She also realized that the union of sense perception with the visual results of Nota-Anna could be a discovery for the correct use of technology in teaching and creation in the field of nonverbal communication. Envisioning a future use for this notation research, she produced her PhD thesis titled *Cyber-Harmony: A Dialogue Between Sense-Perception and Technology*, which she defended in 2004 under the orientation of a leading specialist and theorist of video art, Arlindo Machado, at the Pontifícia Universidade Católica de São Paulo.

In order to produce that thesis, she put Eutony practices in video format, developed movement sequences using Nota-Anna to be learned by lay people, and created videos for the training of muscle strength. This content was made available free of charge online with the aim of promoting social education, considering that many people never have access to a high-quality work of body training. The goal of this work was to help people maintain good health and to balance their body.

After that thesis, she spent several years dedicating herself to her family. Cordeiro moved to Rio de Janeiro in 2010 to continue her investigations, which she formalized through her postdoctoral thesis at the Federal University of Rio de Janeiro, *Joy of Reading*. Her research focused on the literacy system through 242 short videos for smartphone viewing, made in collaboration with educator Eleonora Sampaio. Her contribution was aimed at training part of the population of Brazilian children who suffer from language learning problems. The videos became popular on Internet, accessed on smartphones, devices which now provide a way to reach people in the most far-flung locations, whether in the countryside or in cities, or in places where Analivia could never go.

Furthermore, since the death of her mother in 1993, she became responsible for the collection of her father, Waldemar Cordeiro's artworks and raising awareness concerning them. "I then took care of everything in the broadest possible way: works, restorations, publications, the archive, documents, contacts with researchers and critics, all with financial acrobatics in order to make it happen."[6] In 2000, Galeria Luciana Brito began to collaborate in raising awareness about Waldemar's works. In early 2012, a retrospective exhibition of her father was held, along with the publication of a book by Itaú Cultural. This exhibition won two awards—best exhibition of the year from the APCA (Association of Art Critics of São Paulo) and from the ABCA (Brazilian Association of Art Critics). The book presented Waldemar Cordeiro in all his fields of activity: as an artist, art critic, art theorist, and landscape designer. A key stage of her mission had been accomplished. During that period, Analivia dedicated herself entirely to this work.

Starting in 2015, she went back to her own artistic oeuvre. Her work began to be represented by the German gallery Anita Beckers. She started a phase of materializing her videos as installations, sculptures and still images. "This is a very elaborate work, which unites all my knowledge since my childhood. This is the last phase of my work."[7] She wrote in 2018:

> In short: for more than 45 years I have researched the area carried out in the field of expression of human movement and media arts that has at its core the manifestation of the human body, as a complex organism. Moving my body, I understood the meaning of the organic/artificial dyad. The organic factor is spontaneity, improvisation, loose emotion, the unpredictable. The artificial factor is planning, interoperability between

5 Ibid., 8.
6 Ibid., 9.
7 Ibid., 9.

Bob Wolfenson, Studio portrait of Analivia Cordeiro, 2020. Photograph © Bob Wolfenson

different medias, the scientific study of the body, the predictable. Those two 'guided or determined' factors have been the core of my artistic researches from 1973 until now.[8]

During her entire artistic career, Analivia Cordeiro was not interested in following trends and fads that often guide paths in the arts. Her aim has always been to use technologies in a humanist way, beyond the mere use of new gadgetry for its own sake. Between 2015 and 2017, in a project of coauthorship, Analivia and Nilton Lobo created the series of 17 sculptures called *Unforgettable Kicks*, based on the soccer kicks of Pelé, decoded by Nota-Anna.

Between the years 2017 and 2019, Cordeiro created a series of paintings called *Dancing on the Paper*, in which she created a stronger link between movement, ink, color and paper. The result was mostly large-format paintings, along with videos documenting the creation and process.

In 2019, Analivia created the interactive audio-visual installation *Mutatio: Impossible to Control Just Contribute*, which on a constantly changing base of rectangles, as in a generative work, lines were superimposed in accordance with the automized capture of the motions of the public. Thus, without ever controlling the result, the movement of people's bodies became an integral part of the final visual result. This installation is presented until now in three different versions adapted to each location.

From 2019 until today, Analivia together with Nilton Lobo have been developing B*odyWay Nota-Anna*, a system of social communication based on Nota-Anna, which is operational as an app from 2022. The smart movement capture was only possible with the advancement of technology. Using the artificial intelligence (AI) approach, this system can capture movement without the use of sensors. *BodyWay Nota-Anna* has the main goal of enhancing communication between people through their gestures, using a graphic and auditory platform.

Translated by John Norman

8 Ibid., 10.

Curriculum Vitae

1954 Born February 8, São Paulo, Brazil
 Father: Waldemar Cordeiro / Mother: Helena Kohn Cordeiro

Educational Background

1965–1971 High school, Colégio de Aplicação, Faculdade de Ciências e Letras, Universidade de São Paulo, Brazil.

1972–1976 Faculdade de Arquitetura e Urbanismo, Universidade de São Paulo, Brazil.

1972 "Trajetórias contínuas e intersecções de sólidos," Faculdade de Arquitetura e Urbanismo, Universidade de São Paulo, Brazil.

1972 "Introdução a Ciência da Computação e Teoria da Informação," Faculdade de Arquitetura e Urbanismo, Universidade de São Paulo, Brazil.

1996 Master's degree, *Nota-Anna – A notação eletrônica dos movimentos do corpo humano baseada no Método Laban*, advisor Prof. Nelly de Camargo, Multimedia, Art Institute, Universidade Estadual de Campinas, São Paulo, Brazil.

2004 PhD *Ciber-Harmonia: um diálogo entre a consciência corporal e os meios eletrônicos*, advisor Prof. Arlindo Machado, Comunication and Semiotics Department, Pontifícia Universidade Católica, São Paulo, Brazil.

2010 Post-Doctorate, *Alegria de ler*, advisor Katia Maciel, Art Department, Universidade Federal do Rio de Janeiro, Brazil.

2018 Post-Doctorate, *The Architecture of Human Movement*, advisor Gilbertto Prado, Visual Arts Department, Universidade de São Paulo, Brazil.

Dance and Fashion Courses

1962–1972 Expressive Dance with Maria Duschenes (graduated at Laban Art of Movement Centre), São Paulo, Brazil.

1971 Merce Cunningham Technique, with Albert Reid, São Paulo, Brazil.

1972 Modern Dance with Clyde Morgan, São Paulo, Brazil.

1976 Classical Ballet with Ismael Guiser, São Paulo, Brazil.

1976 Martha Graham Technique with Kelly Hogan, São Paulo, Brazil.

1977–1978 Daily classes at Merce Cunningham Dance Studio, New York, USA.

1977 Two-semester classes at Nikolais/Louis Dance Theatre Lab, New York, USA.

1978 Video Dance Workshop by Merce Cunningham and Charles Atlas, Merce Cunningham Dance Studio, New York, USA.

1978 Six months of daily classes with Viola Farber, New York, USA.

1978 Daily classes with Jeanette Stoner, New York, USA.

1978 Four months of daily classes with Gus Solomons Jr., New York, USA.

1981 Two months of study at leading Israeli folk dance groups at several cities, kibbutzim, and moshavim, Israel.

1986 Fashion stylist training course, Senac, São Paulo, Brazil.

1986 Workshop with Suzanne Linke, São Paulo, Brazil.

1989 Workshop with Wim Vanderkeybus, São Paulo, Brazil.

1989 Tai-Chi-Chuan classes with Wong, São Paulo, Brazil.

1990 Eutonia intensive course with Berta Vishnivetz, São Paulo, Brazil.

1991 Workshops with Odile Geringer, Paris, France.

1991 Introduction to Eutony, Escola de Eutonia do Brasil, São Paulo, Brazil.

1992 Eutonia I and Eutonia II, Escola de Eutonia do Brasil, São Paulo, Brazil.

1994 Workshop of Cia Fleur de Peau, São Paulo, Brazil.

1995 Análise do movimento para professores e terapeutas pelo Método Laban, workshop with Walli Meyer, CENA, São Paulo, Brazil.

1996 Workshop with Joana Lopes, Encontro Laban 96, Sesc, São Paulo, Brazil.

1996 Eutonia workshop with Jean-Marie Hubert, Sesc Consolação, São Paulo, Brazil.

1997	Modern Dance with Magpie Music Dance Co. – Katie Duck, Estúdio Nova Dança, São Paulo, Brazil.
1997	Improvisation Performance II with Katie Duck, 29th Festival de Inverno, Ouro Preto, Minas Gerais, Brazil.
1998	Introdução ao Curso Profissionalizante de Eutonia, Escola Brasileira de Eutonia, São Paulo, Brazil.
1999	*Dance through Camera* workshop, lectured by Elliot Caplan, Itaú Cultural, São Paulo, Brazil.
1999-2001	Professional Course of Eutony, São Paulo, Brazil.
2002	Eutonia e movimento workshop with Jean-Marie Hubert and Angel Vianna, Fazenda Maristela, São Paulo, Brazil.
2002	*From Laban to Forsythe*, workshop with Valerie Preston-Dunlop, São Paulo, Brazil.
2002	*A elasticidade dos tecidos*, workshop with Odile Vaz-Geringer, Hotel Fazenda São João, São Pedro, São Paulo, Brazil.
2002	Endobiophilia workshop with Odile Vaz-Geringer, Escola Angel Viana, Rio de Janeiro, Brazil.
2002	Endobiophilia workshop with Odile Vaz-Geringer, Senai, São Paulo, Brazil.

Solo Performances

1979	Performance *Chamada*, 3rd Concurso de Dança Contemporânea, Universidade Federal da Bahia, Salvador, Brazil.
1979	Performance *Chamada*, 2nd Ciclo de Dança Contemporânea, Serviço Nacional de Teatro – SNT, Rio de Janeiro, Brazil.
1980	Performance *Chamada*, 1st Mostra de Dança Contemporânea, Teatro Brasileiro de Comédia, São Paulo, Brazil.
1985	Performance *0º⇔45º*, *Arte Novos Meios/Multimeios: Brazil 70/80* exhibition, Fundação Armando Alvares Penteado, São Paulo, Brazil.
1987	Performance *Billie*, Projeto Cunhatã, Sesc Pompeia, São Paulo, Brazil.
1989	Performance *Mágico espaço – Seu corpo,* Miriam Mamber Artwear & Design, São Paulo, Brazil.
1989	Photo model at Wearable Art by Liana Bloisi, São Paulo, Brazil.
1990	Photo model at book by Bob Wolfenson, São Paulo, Brazil.
1992-1997	Painting model to Luiz Paulo Baravelli, São Paulo, Brazil.
1996	Performance *0º⇔45º* (soundtrack by Grupo de Percussão da Universidade do Estado de São Paulo UNESP), opening of the 4th Studio de Tecnologia de Imagens, UNESP/Sesc/SENAI, São Paulo, Brazil.
1996	Performance *Linguagem dos pássaros*, Encontro Laban 96, Sesc, São Paulo, Brazil.
1997	Performances *Striptease* and *0º⇔45º*, *Mediações* exhibition, Itaú Cultural, São Paulo, Brazil.
1997	Performances *Striptease* and *0º⇔45º*, *Precursor e Pioneiros da Arte Contemporânea* exhibition, Paço das Artes, São Paulo, Brazil.
2007	Fashion model at *Fantasia Brasileira*, Sesc Belenzinho, São Paulo, Brazil.
2007	Improvisation *Ângulos retos* and *Da pele ao espaço,* Musicircus, Bienal do Mercosul, Porto Alegre, Brazil.
2009	Performance *Corpo preparado* in RadioVisual, Bienal do Mercosul, Porto Alegre, Brazil.

Choreographies and Group-Dance Performances

1966	Performance with Maria Duchenes Group, Colégio Sion, sponsored by Seminários de Música Pró-Art, São Paulo, Brazil.
1967	Performance with Maria Duchenes Group, Teatro da Universidade Católica – TUCA, São Paulo, Brazil.
1969	*Espetáculo cinético* with Maria Duschenes Group, Semana de Artes, Museu de Arte Moderna de Campinas, São Paulo, Brazil.
1970	Performance with Maria Duchenes Group, 1st Congresso Internacional da Comunidade Terapêutica and 5th Congresso de Psicodrama e Sociodrama, Museu de Arte de São Paulo, São Paulo, Brazil.
1972	*Espetáculo cinético* with Maria Duschenes Group, Museu de Arte de São Paulo, Brazil.
1972	Performance *Grupo Projeto*, Teatro Municipal de Santo André, São Paulo, Brazil.
1972	Performance, Martha Graham Technique with Grupo Projeto, TV Cultura, São Paulo, Brazil.
1972	Performance *Improvisação estruturada,* directed by Clyde Morgan, TV Cultura, São Paulo, Brazil.
1973	Choreography and performance *Métodos de criação em dança*, TV Cultura, São Paulo, Brazil.
1973	Choreography, computer programming, direction and performance, *M3×3*, developed at the Computer Center, Universidade Estadual de Campinas, and produced by TV2 Cultura, São Paulo, Brazil.
1973	Choreography and performance, 2nd Bienal de Artes Plásticas, Santos, Brazil.

1974	Choreography and performance, Pesquisas artísticas na Universidade Estadual de Campinas, TV2 Cultura, São Paulo, Brazil.
1974	Choreography, computer programming, direction and performance, *0º⇔45º*, developed at the Computer Center, Universidade Estadual de Campinas, São Paulo, Brazil.
1974	Choreography and performance *Mutações*, Teatro Municipal de Ribeirão Preto, São Paulo, Brazil.
1975	Choreography, computer programming, direction and performance, *Gestos*, developed at the Computer Center, Universidade Estadual de Campinas, São Paulo, Brazil.
1976	Choreography, computer programming, direction and performance, *Cambiantes*, developed at the Computer Center, Universidade Estadual de Campinas, and sponsored by Prefeitura Municipal de Campinas, São Paulo, Brazil.
1978	Performance with Jeanette Stoner Dance Company, Carl Schurlz Park Hockey Field, New York, USA.
1978	Street performances, *Rits & Runs II*, directed by Gus Solomons Jr., New York, USA.
1978	Choreography *Brazilian Memories*, Brook Theatre, New York, USA.
1979	Choreography and performance *E*, sponsored by Universidade Estadual de Campinas, São Paulo, Brazil.
1979	Choreography and performance *E*, Jardim Popular, sponsored by Movimento Popular de Arte, São Miguel Paulista, São Paulo, Brazil.
1980	Choreography, direction and performance *Relações*, Teatro Municipal de Santo André, São Paulo, Brazil.
1980	Choreography, direction and performance *Naturalidade*, Analivia & Company, Teatro Brasileiro de Comédia (Teatro Galpão), São Paulo, Brazil.
1982	Choreography *SOS Raizes de América*, 2nd Mostra Estadual de Teatro, São Paulo, Brazil.
1981–1983	Choreographer and director of Israeli Dance groups Carmel and Hacotzrim, Associação Brasileira A Hebraica, São Paulo, Brazil.
1983	Choreography and performance *Femilino*, Mostra de Dança Independente, Teatro São Pedro, São Paulo, Brazil.
1984	Choreography *Hora Carmel* and *Hora Aviv*, 4th Festival de Dança e Música Israeli-Carmel, São Paulo, Brazil.
1984	Direction and video dance production *Trajectories*.
1985	Performance *0º⇔45º*, in: Multimedia exhibition, Fundação Armando Alvares Penteado, São Paulo, Brazil.
1985	Choreography and performance *Ar em solos unidos*, Centro Cultural São Paulo, Brazil.
1985	Choreography *Trabalho* and *Schedemati*, performed by Israeli dance groups Carmel and Hacotzrim, Associação Brasileira A Hebraica, São Paulo, Brazil.
1985	Performance *0º⇔45º*, in: *Arte Novos Meios/Multimeios: Brazil 70/80* exhibition, Fundação Armando Alvares Penteado, a São Paulo, Brazil.
1987	Choreography *Slow Billie Scan*, telepresence dance using slow scan television, produced by Museu da Imagem e do Som – MIS, São Paulo, Brazil.

Analivia Cordeiro, travel to Bat-Sheva Seminar on the Interaction of Art and Science, Jerusalem (Israel), 1974. Photo: ZKM | Karlsruhe Archive

1988	Performance and choreography *VideoVivo,* 1st Mostra Internacional da Imagem Científica, Estação Ciência, São Paulo, Brazil.
1989	Performance and choreography *VideoVivo*, directed by Otavio Donasci, Museu de Arte Contemporânea da Universidade de São Paulo, Brazil.
1989	Choreography for the children's play *Guaiu – A ópera das formigas*, Teatro João Caetano de Campos, São Paulo, Brazil.
1989	Direction for the choreography *Jogo*, with Alice K., 4th Semana de Mímica, Sesc Pompeia, São Paulo, Brazil.
1989	Choreography *Wearable*, produced by Miriam Mamber Gallery, São Paulo, Brazil.
1989	Performance *Modos da Moda* (Fashion Modes), SESC Belenzinho, São Paulo, Brazil
1992	Direction and performance *Tableaux,* with the Micronvirtudes Group, Centro Cultural São Paulo, Brazil.
1992	Dancer and model at the workshop *Fábrica da forma e do volume,* Modos da Moda, Sesc/Senac, São Paulo, Brazil.
1992	Direction *Micron Virtues*, a concert dance at Centro Cultural Vergueiro, São Paulo, Brazil.
1994	Choreography for the play *Hagoromo – O manto de plumas*, transcription by Haroldo de Campos of the eponymous play by Zeami (1363–1443), directed by Alice K., Centro Cultural São Paulo, Brazil.
2001	Performance *Pinturas para pisar*, by Aldir Mendes de Souza together with Gícia Amorim, Pinacoteca de São Paulo, Brazil.
2007	Choreography and conception *Unsquare Dance*, software X-Motion and Choreografismo in patnership with Luiz Velho, Instituto de Matemática Pura e Aplicada – IMPA, Rio de Janeiro, Brazil.
2008	Choreography mis-en-scène *O nome científico da formiga*, by Angelo Madureira and Ana Catarina Vieira, Sesc Anchieta, São Paulo, Brazil
2022	Performances *Torre de Babel, Guerrilha artística, Sítio encantado*, together with Gissauro, in: *Ouver* Décio – Hommage to Décio Pignatari's 95th anniversary, Casa das Rosas, São Paulo, Brazil.
2022	Performance *Small Talks*, with Gissauro, in: *Flora, Fauna e Primavera* exhibition, Luciana Brito Galeria, São Paulo, Brazil.

Exhibitions

Solo Exhibitions and Video Screening

1975	*M3×3, Gestos*, and *0º⇔45º*, Goethe-Institut de São Paulo, São Paulo, Brazil.
1976	*M3×3, Gestos*, and *0º⇔45º*, TV Public Station – WGBH, Boston, USA.
1977	*M3×3* and *Cambiantes*, Teatro Galpão, São Paulo, Brazil.
1980	*Kwarup* (film), Oficina de Dança Contemporânea, Universidade Federal da Bahia, Salvador, Brazil.
1983	*E* video, LIMEC, Universidade Estadual de Campinas, Informática 83, São Paulo, Brazil.
1987	*Slow Billie Scan*, slow-scan transmission of the choreography, together with Lali Krotozynski and grupo IPAT, from Museu da Imagem e do Som to the Dax Group, Carnegie Mellon University, Pittsburgh, USA.
2010	*Zonas de Contato*, Paço das Artes, São Paulo, Brazil.
2014	*Manuara*, Museu Brasileiro de Escultura MuBE, São Paulo, Brazil.
2015	*Manuara*, Livraria da Vila, Shopping JK, São Paulo, Brazil.

Analivia Cordeiro at the Bat-Sheva Seminar on the Interaction of Art and Science, Jerusalem (Israel), 1974. Photo: ZKM | Karlsruhe Archive

2015	Analivia Cordeiro –*Videos and Creation Documents* (*M3×3* installation, *M3×3, 0º⇔45º, Cambiantes*), Anita Beckers Galerie, ARCO, Madrid, Spain.	
2016	*A dança como cinema* (*M3×3, 0º⇔45º, Carne I, Ar, Arquitetura do movimento*), CINUSP Paulo Emílio, Universidadede São Paulo, Brazil.	
2018	*Chutes inesquecíveis* (sculptures, *M3×3, Trajetória, Micron Virtudes, Ar, Arquitetura do movimento*, Nota-Anna), Museu de Arte Moderna, Rio de Janeiro, Brazil.	
2019	*Chutes inesquecíveis* (sculptures, *M3×3, Trajetória, Micron Virtudes, Ar, Arquitetura do movimento*, Nota-Anna), UNIBES Cultural, São Paulo, Brazil.	
2019	Analivia Cordeiro – *Obras de 1973 até 2019*, Mestre sector, Galeria Isabel Aninat, SP-Arte, São Paulo, Brazil.	
2023	Analivia Cordeiro – *From Body to Code*, ZKM	Center for Art and Media Karlsruhe, Germany.
2023	Analivia Cordeiro – *Bodygraphies*, Centro Atlántico de Arte Moderno - CAAM, Las Palmas de Gran Canarias, Spain.	

Group Exhibitions and Video Screening (Selection)

1967	*Colagem*, in: Concurso de Arte para Jovens, distinguished by Museu de Arte Contemporânea da Universidade de São Paulo, Brazil.
1973	*M3×3*, in: *INTERACT Machine: Man: Society*, Computer Arts Society Conference/Event/Exhibition, International Festival of Edinburgh, 27-31 August, Scotland.
1973	*M3×3*, in: 12th Bienal de São Paulo, Brazil.
1973	*M3×3*, in: Jovem Arte Contemporânea, Museu de Arte Contemporânea da Universidade de São Paulo, Brazil.
1974	*M3×3*, in: System Art in LatinAmerica, International Cultureel Centrum, Antwerp, Belgium.
1974	*M3×3*, in: Latin American Films and Video Tapes, Media Study of State University of New York, Buffalo, USA.
1974	*M3×3*, in: Festival Experimental, Centro de Arte y Comunicación, Buenos Aires, Argentina.
1974	*M3×3* and *0º⇔45º*, in: Instituto Musical de São Paulo, Brazil.
1974	*M3×3* and *0º⇔45º*, in: The Bat-Sheva Seminar on Interaction of Art and Science, Jerusalem, Israel.
1974	*M3×3* and *0º⇔45º*, in: *LatinAmerica 74* exhibition, Institute of Contemporary Arts, London, England.
1974	*M3×3* and *0º⇔45º*, in: *Esthétique et Mass Media: la Télévision*, course lectured by René Berger, Université de Lausanne, Suisse.
1975	*M3×3* and *0º⇔45º*, in: *LatinAmerica 74* exhibition, Espace Cardin, Paris, France.
1975	*M3×3* and *0º⇔45º*, in: Galleria Civica D'Arte Moderna, Ferrara, Italy.
1975	*M3×3* and *0º⇔45º*, in: International Conference Computer & Humanities/2, University of Southern California, Los Angeles, USA.
1976	*M3×3, Gestos*, and *0º⇔45º*, in: 20th American Dance Guild Conference, introduced by Jeanne Beaman, Massachusetts Institute of Technology, Cambridge, USA.
1978	*Cambiantes*, in: *Art of Space Era*, Von Braun Civic Center of Huntsville Museum of Art, Alabama, USA.
1980	*Chamada* and *Cambiantes,* in: 1st Mostra de Dança Contemporânea, Teatro Brasileiro de Comédia, São Paulo, Brazil.
1981	*Kwarup* film presented at Ginásio Estadual, I Km 23 Raposo Tavares and Escola Infantil Crescer, São Paulo, Brazil.
1983	*Cambiantes* and *M3×3,* in: 1st Exposição de Artes Computacionais da SUCESU, Informática 83, Parque Anhembi, São Paulo, Brazil.
1983	*Kwarup* film presented at the *Quantos índios tinham no Brasil?* exhibition, Biblioteca de São Miguel Paulista, São Paulo, Brazil.
1984	*Cambiantes,* in: Informática 84, Riocentro, Rio de Janeiro, Brazil.
1985	*Ar,* together with Takashi Fukushima, in: *Arte & Tecnologia*, Museu de Arte Contemporânea da Universidade de São Paulo, Brazil.
1988	*Cambiantes,* in: Carlton Dance Festival, Museu da Imagem e do Som, São Paulo, Brazil.
1989	*Dança Criança, Slow Billie Scan,* and *0º⇔45º*, in: Carlton Dance Festival, Museu da Imagem e do Som, São Paulo, and Espaço Laura Alvim, Rio de Janeiro, Brazil.
1996	*M3×3, 0º⇔45º, Cambiantes*, and *Trajetória,* in: 4th Studio de Tecnologia de Imagens, UNESP/Sesc/SENAI, São Paulo, Brazil.
1996	*0º⇔45º, Cambiantes*, and *Trajetória,* in: Encontro Laban 96, Sesc, São Paulo, Brazil.
1997	*M3×3, 0º⇔45º, Cambiantes*, and *Trajetória,* in: *Precursor e Pioneiros da Arte Contemporânea* exhibition, Paço das Artes, São Paulo, Brazil.
1998	*Striptease,* in: 27th Annual Dance on Camera, Walter Reade Theater at Lincoln Center, New York, USA.

1999	*Laban's Concepts of Movement, 0º⇔45º, Slow Billie Scan*, and *Striptease*, in: 9th Festival Internazionale de Videodanza – 2nd Coreografo Elettronico, Institut Français de Naples Grenoble, Italy.
2003–2005	*M3×3*, in: *Made in Brazil* exhibition, Itaú Cultural, São Paulo and Brazilian itinerancy.
2003	*M3×3*, in: *Subversão dos Meios* exhibition, Itaú Cultural, São Paulo, Brazil.
2005	*M3×3, 0º⇔45º, Cambiantes, Ar, Slow Billie Scan, Striptease,* and *Carne I*, in: Mostra Audiovisual da Dança em Pauta, Centro Cultural Banco do Brasil, São Paulo, Brazil.
2005	*DJMobile*, together with Nilton Lobo, Life Goes Mobile, NokiaTrends, Anhembi, São Paulo, Brazil.
2005	*Ex-Image*, together with Nilton Lobo, Life Goes Mobile, NokiaTrends, Cais do Porto, Rio de Janeiro, Brazil.
2006	*Carne I, Carne II*, in: *Dança em Foco*, Festival Internacional de Vídeo&Dança, Rio de Janeiro, Brazil.
2007	*Carne I, Carne II*, in: 6th Mostra do Filme Livre, Centro Cultural Banco do Brazil, Rio de Janeiro, Brazil.
2007	*E/OU*, in: *Panorama da Videocriação no Brasil*, Centro Cultural Banco do Brasil, Brasília, Brazil.
2007	*CarneI/II*, in: Mostravideo *Subjetividades*, Itaú Cultural, São Paulo, Brazil.
2007	*E/OU*, in: 21st Mostra do Audiovisual Paulista, São Paulo, Brazil.
2007	*Unsquare Dance*, in: SIGGRAPH, San Diego, California, USA.
2007	*Unsquare Dance*, in: SIGRAPI, Cuiabá, Brazil.
2007	*M3×3* and *Ver para ler*, Galeria Expandida, Galeria Luciana Brito, São Paulo, Brazil.
2008	*Unsquare Dance*, in: *Art7*, Museu Nacional, Brasília, Brazil.
2008	*Carne II, Carne III, Liberdade é Pouco*, in: *O que desejo não tem Nome* exhibition, Jardim Botânico, Rio de Janeiro, Brazil.
2008	*M3×3*, in: *1969–1974 um dia que ter terminado* exhibition, Museu de Arte Contemporânea da Universidade de São Paulo, Brazil.
2013	*Carne I* stills, in: *Geometria Fragmentada*, Galeria Contemporânea, São Paulo, Brazil.
2013	*M3×3* installation 1, SP-Arte, Anita Beckers Galerie, São Paulo, Brazil.
2015	*M3×3* installation, *M3×3* creation documents, in: *Moving Image Contours: Points for a Surrounding Movement* exhibition, Tabakalera, San Sebastián, Spain.
2015	*Cambiantes* sculpture, *Cambiantes* installation, *Unforgetable Kicks* sculptures, *0º⇔45º*, and *M3×3*, in: 11th Bienal do Mercosul, Porto Alegre, Brazil.
2016	*M3×3* installation, in: *The End of The World* exhibition, Centro Pecci, Italy.
2017	*M3×3* and *Cambiantes*, in: *Radical Women* exhibition, Hammer Museum, Los Angeles, USA.
2017	*M3×3* and *Cambiantes*, in: *Radical Women* exhibition, Brooklyn Museum, New York, USA.
2017	*M3×3* and *Cambiantes*, in: *Radical Women* exhibition, Pinacoteca de São Paulo, Brazil.
2017	*M3×3,* in: LatinAmerican videos, Laxart, Los Angeles, USA.
2018	*M3×3* installation, in: *Algoritmos Suaves* exhibition, Centre del Carme, Consorci de Museus de la Comunitat Valenciana, Valencia, Spain.
2018	*M3×3* and creation documents, in: *Coder Le Monde* exhibition, Centre Georges Pompidou, Paris, France.
2018	*M3×3*, in: *Chance and Control* exhibition, Victoria and Albert Museum, London, England.
2018	*M3×3*, in: 35th Jerusalem International Film Festival, Israel.
2019	*M3×3* installation, in: *Faces* exhibition, Es Baluard Museu d'Art Contemporani de Palma, Spain.
2019	*M3×3*, in: *El Giro Notacional*, Museo de Arte Contemporáneo de Castilla y León, Spain.
2019	*M3×3*, Fairest of the Fair, Bao Out Post, Manilla, Philippines.
2019	*Carne I* and *M3×3*, in: BAM – Bienal de Artes do Movimiento, Madrid, Spain.
2019	*Mutatio Impossible to Control, Just Contribute,* at *Mutatio*, Renault Garage, Paris, France.
2020	*Cambiantes*, Galeria Isabel Aninat, Basel Art Fair, Suisse.
2021	*Carne I*, in: *Dance?* exhibition, CAAM – Centro Atlántico de Arte Moderno, Las Palmas de Gran Canaria, Spain.
2021	*M3×3*, in: *Más allá de lo concreto. Resistencias en América Latina* exhibition, Museo Nacional Centro de Arte Reina Sofía, Madrid, Spain.
2022	*M3×3,* in: *Artistas y máquinas. Diálogos en el desarrollo del arte digital* exhibition, Centre del Carme. Consorci de Museus de la Comunitat Valenciana, Valencia, Spain.
2022	*M3×3* installation, in: *Possibles* exhibition, ISEA 2022, BEEP Collection, Recinte Modernista de Sant Pau, Barcelona, Spain
2022	*M3×3, Re-constructive, Leaves, War and Peace, Small Talks*, in: *Flora, Fauna e Primavera* exhibition, Luciana Brito Galeria, São Paulo, Brazil.

Design and Audiovisual Documentaries

1969	Costume design to *Espetáculo Cinético*, Festival Nacional de Teatro, São Paulo, Brazil.
1973	*Multiambiente*, architectural design proposal representing the Faculdade de Arquitetura e Urbanismo da Universidade de São Paulo at the I Bienal de Arquitetura, São Paulo, Brazil.
1975	*Ritual Kwarup*, S-8 footage of the Kamaiurá tribe, Parque Nacional do Xingú. Edition sponsored by Fundação de Amparo à Pesquisa do Estado de São Paulo – FAPESP, Brazil.
1987	Costume design to *Masculina Idade* by Carlos Martins, Centro Cultural São Paulo, Brazil.
1988	Costume design to *Diva em Dívida* by Bel and Carlos Martins, together with Silvia Mecozzi, Espaço Off, São Paulo, Brazil.
2001	*Waldemar Cordeiro*, CD-Rom conception and direction, launched at the retrospective exhibition, curated together with Givaldo Medeiros, Galeria Brito Cimino, São Paulo, Brazil.
2021	*Waldemar Cordeiro – Fantasia Exata*, video documentary (screenwriter and director), São Paulo, Brazil.

Didactic Activities by Analivia Cordeiro

1972-1973	*Dance for Children*, Seminários de Música Pró-Art, São Paulo, Brazil.
1975	*M3×3* included at the teaching program, Bezalel Academy of Arts, Jerusalem, Israel.
1979	*Modern Dance Technique*, Escola Arte do Movimento, São Paulo, Brazil.
1980	*Modern Dance*, Escola de Dança Ruth Rachou, São Paulo, Brazil.
1980	*Stage Lighting for Dancers and Choreography for Stage Light Technicians* course, Oficina de Dança Contemporânea, Universidade Federal da Bahia, Salvador, Brazil.
1980	*Conception of Dance College for the University of São Paulo*, Brazil.
1980-1981	*Body Expression* classes, Escola de Dança Ismael Guiser, São Paulo, Brazil.
1981-1983	Director and choreographer of Israeli Folcloric Dance Groups Carmel and Hacotzirim, Associação Brasileira A Hebraica, São Paulo, Brazil.
1983-1987	Director and teacher, Escola Danças Analivia, Granja Viana, São Paulo, Brazil.
1989	*Laban Method of Movement Analysis,* Instituto de Psicologia da Universidade de São Paulo, Brazil.
1990	*Laban Method*, Curso de post-graduation de Artes Cênicas, Escola de Comunicações e Artes, Universidade de São Paulo, Brazil.
1990	*Laban Method*, Núcleo de Formação em Dança Contemporânea, Oficina Cultural Oswald de Andrade, São Paulo, Brazil.
1995	Body preparation of actress Mylla Christie for the soap opera *Malhação*, TV Globo, Brazil.
1995	Dance workshop, Pinacoteca Benedicto Calixto, Santos, São Paulo, Brazil.
1996	*Laban Theory*, Jungian psychotherapy specialization course focusing on physio-psychic integration, Instituto Sedes Sapientae, São Paulo, Brazil.
1997	*Laban Theory*, Jungian psychotherapy specialization course focusing on physio-psychic integration, Instituto Sedes Sapientae, São Paulo, Brazil.
1997	*Nota-Anna and Laban Method*, Mediações, Itaú Cultural, São Paulo, Brazil.
1995-97	Classes of *Observation of Body Expression*, Estilismo e Moda College, Faculdades Santa Marcelina, São Paulo, Brazil.
1998	*Graphic Representation of Body Movement*, Escola Superior de Desenho Industrial –ESDI, Rio de Janeiro, Brazil.
1998	*A Dialogue Between Corporal Awareness and Artificial Languages in the Body Language Universe*, City Canibal, Paço das Artes, São Paulo, Brazil.
1998	*Laban Method applied to Teenagers Body Expression*, Fantasia Brasileira, Sesc Belenzinho, São Paulo, Brazil.
1999	*Nota-Anna*, The 1999-2000 Sawyer Seminar at The University of Chicago, USA.
1999	*Nota-Anna*, L'Ombra dei Maestri – Rudolf Laban: gli spazi della danza, Università degli Studi di Bologna, Italy.
2002	*Dance Improvisation Practice*, 2nd Simpósio Internacional de Dança em Cadeiras de Rodas, Universidade Estadual de Campinas – UNICAMP, São Paulo, Brazil.
2003	*A influência do olhar no alinhamento ósseo*, 3rd Jornada Brasileira de Eutonia, Centro de Estudos Musicais Tom Jobim, São Paulo, Brazil.
2004	Advisor for Tarsila Tarantino thesis, visual arts course, Fundação Armando Alves Penteado – FAAP, São Paulo, Brazil.
2005	*Looking for the Cyber-Harmony: a dialogue between body awareness and electronic media*, Cinético-Digital, Itaú Cultural, São Paulo, Brazil.

2005	*Videodance workshop*, Festival Tapias, Rio de Janeiro, Brazil.
2005	*Total Body* workshop, Festival Tapias, Rio de Janeiro, Brazil.
2007	Board of examiners for the academic course of Olvidia Dias, Escola Superior de Artes e Turismo, Universidade do Estado do Amazonas, Manaus, Brazil.
2007	*The Body and The Arts*, Produtos em Processo: O Gesto na Arte, post-graduation course, Faculdade de Arquitetura e Urbanismo da Universidade de São Paulo, Brazil.
2015	*Movement Notation – from Computer Dance to Nota-Anna* workshop, Tabakalera, San Sebastian-Donostia, Spain.
2015	*Movement Notation – from Computer Dance to Nota-Anna* workshop, Bienal do Mercosul, Porto Alegre, Brazil
2016	*Movement Notation – from Computer Dance to Nota-Anna* workshop, Centro Pecci, Prato, Italy.
2017	*Wellness, Therapy, and Technology* workshop, Centro Pecci, Italy.

Lectures

1973	*A Language for Dance Research*, Escola de Comunicações, Faculdade Armando Alvares Penteado – FAAP, São Paulo, Brazil.
1974	*Computer Dance for TV*, Faculdade de Música, Instituto Musical de São Paulo, Brazil.
1974	*Computer Dance for TV – TV/Dance*, The Bat Sheva de Rothschild Seminar on Interaction of Art and Science, Jerusalem, Israel.
1975	*Computer-Dance for TV*, Fundação Armando Alvares Penteado – FAAP, São Paulo, Brazil.
1975	*Computer-Dance for TV*, 13th Bienal de São Paulo, Brazil.
1975	*Computer-Dance for TV*, Goethe-Institut São Paulo, Brazil.
1975	*Computer Dance TV – TV/Dance*, guest lecturer introduced by Grace Hertlein, International Conference on Computers & Humanities/2, Los Angeles, USA.
1979	*A Language for Dance Research*, 3rd Concurso de Dança Contemporânea, Salvador, Bahia.
1984	Simpósio Internacional de História da Arte-Educação, Escola de Comunicações e Artes da Universidade de São Paulo, Brazil.
1984	*Trajectories of Body Expression Notation*, 17th Congresso Nacional de Informática, Riocentro, Rio de Janeiro, Brazil.
1987	*Dance Notation,* Encontro de Dança – Novas Tendências, Oficinas Culturais Três Rios, São Paulo, Brazil
1989	Participation at the 1st Seminário Nacional de Tecnologia para as Artes, Instituto de Artes, Universidade Estadual de Campinas, Brazil.
1994	*Dance and Electronic Media*, Mostra de Dança Arte-Educação, Sesc Santos, Brazil.
1996	*Observation and Movement Analysis*, Encontro Laban 96, Sesc Consolação, São Paulo, Brazil.
1997	*Nota-Anna and the Laban Method*, Pontifícia Universidade Católica, São Paulo, Brazil.
1998	Debate with Ana Francisca Ponzio and Luiz Velho, launch of the book *Nota-Anna: a escrita eletrônica dos movimentos do corpo baseada no Método Laban*. City Canibal, Paço das Artes, São Paulo, Brazil.
1999	*Nota-Anna*, in: *Dramaturgia do Corpo: Laban em Cena*, Goethe-Institut São Paulo, Brazil.
1999	*Nota-Anna*, in: *Invenção: Thinking the Next Millennium*, Itaú Cultural, São Paulo, Brazil.
1999	*Nota-Anna: An Expression Visualization System of the Human Body Movement,* The 1999-2000 Sawyer Seminar, The University of Chicago, USA.
1999	*Nota-Anna: An Expression Visualization System of the Human Body Movement*, L'Ombra dei Maestri meeting – Rudolf Laban: gli spazi della danza, Università degli Studi di Bologna, Italy.
2001	*Analysis of Human Motion Using Java Technology*, JavaOne Conference, Sun's 2001 Worldwide Java Developer Conference, together with Nilton Lobo, Moscone Center, San Francisco, USA.
2001	*My Artworks*, Centro Cultural Banco do Brasil, São Paulo, Brazil.
2003	*Dance and the New Technology*, lecture delivered at dance course held at Universidade Anhembi Morumbi, São Paulo, Brazil.
2003	*Real Time Motion Capture Using Java Technology*, JavaOne Conference, Sun's 2003 Worldwide Java Developer Conference, together with Nilton Lobo, Moscone Center, San Francisco, USA.
2006	*Pocket Art Video Show*, Centro de Cultura Judaica, São Paulo, Brazil.
2007	*Art, Ecology, Design, and Technology Panel in Brazil*, Paralelo Tecnologia e Meio Ambiente, Museu da Imagem e do Som, São Paulo, Brazil.
2008	*Body Language and New Technology*, International Congress #7.ART, Universidade de Brasília, Brazil.
2008	*Looking Inside the Body*, together with the neurologist Valéria Bahia, Paço das Artes, Universidade de São Paulo, Brazil.

2011	*Thinking&Feeling*, with the neurologist Valéria Bahia, "Arte e Cultura na Poli," Escola Politécnica, Universidade de São Paulo, Brazil.
2011	*Thinking&Feeling*, with the neurologist Valéria Bahia, Encontro Internacional de Arte e Tecnologia: modus operandi universal, Museu Nacional, Brasília, Brazil.
2011	*A Linguagem do Corpo,* at the 2nd Fórum Internacional de Biblioteconomia Escolar FIBE 2011, Centro de Estudos Avançados, USP, Brazil.
2012	*The Body Movement and the Digital World*, 8th Encontro Arte e Cultura, UNESP, Bauru, São Paulo, Brazil.
2012	*Waldemar Cordeiro*, 8th Encontro Arte e Cultura, UNESP, Bauru, SP.
2012	*Waldemar Cordeiro*, 30th São Paulo Biennial, Brazil.
2015	*Manuara*, seminar *Índios no Brasil – Vida, Cultura e Morte*, Biblioteca Guita e José Mindlin, Universidade de São Paulo, Brazil.
2015	*Thinking and Writing Movement – Technology Revealing a Hidden Feature of Human Expression*, B3 Moving In Biennial, Frankfurt, Germany.
2017	*My Researches*, LOOP Festival, Barcelona, Spain.
2017	*My Researches*, MACBA - Museo de Arte Contemporáneo de Barcelona, Barcelona, Spain.
2019	*From Computer Dance to Nota-Anna*, BAM – Bienal de Artes del Movimiento, Madrid, Spain.

Awards, Mentions, and Scholarships

1967	*Concurso de Arte para Jovens Prize*, O Estado de S. Paulo newspaper, Brazil.
1974	Acquisiton Prize, *M3×3* movie by the Museu de Arte Contemporânea, Universidade de São Paulo, Brazil.
1975	Scholarship for the *Kwarup* S-8 film edition-8, Fundação de Auxílio a Pesquisa do Estado de São Paulo – FAPESP, São Paulo, Brazil.
1980	Scholarship for the *Trajectory Body Movement Notation Research*, CNPq, São Paulo, Brazil.
1986	Member of Arquivo de Artistas Plásticos Brasileiros, Fundação Armando Alvares Penteado, São Paulo, Brazil.
1989	Nominated for Best Choreography, Prêmio Mambembe, children's show *Guaiu – A ópera das formigas*, São Paulo, Brazil.
1990	Screenplay for *VT – Choreutics*, Bolsa Vitae, together with Maria Duschenes, São Paulo, Brazil.
1996	Master's scholarship, FAPESP – Fundação de Amparo à Pesquisa do Estado de São Paulo.
2000	PhD scholarship, FAPESP – Fundação de Amparo à Pesquisa do Estado de São Paulo.
2009	Member of John Cage Folksonomy, New York, USA.
2015	BEEP Electronic Art Prize for *M3×3* installation, ARCO Art Fair, Madrid, Spain.
2022	Honorable Mention, *Waldemar Cordeiro – Fantasia Exata* video-documentary, Florence Film Awards, Italy.

Main Collections

1974	Museu de Arte Contemporânea da Universidade de São Paulo, Brazil.	
2014	Museum of Concrete Art and Design, Ingolstadt, Germany.	
2015	Collection BEEP Electronic Art, Barcelona, Spain.	
2015	Museo Nacional Centro de Arte Reina Sofía, Madrid, Spain.	
2017	Bühnen Archiv Oskar Schlemmer/The Oskar Schlemmer Theatre Archives – C. Raman Schlemmer.	
2017	Victoria and Albert Museum, London, England.	
2018	The Museum of Modern Art – MoMA, New York, USA.	
2019	Itaú Cultural, São Paulo, Brazil.	
2020	Pinacoteca de São Paulo, Brazil.	
2022	ZKM	Center for Art and Media Karlsruhe, Germany.

Her work is represented by the following galeries: Anita Beckers Contemporary Art & Projects, Frankfurt (Germany); Aninat Galeria de Arte, Santiago (Chile); Luciana Brito Galeria, São Paulo (Brazil)

Bibliography

Bibliography by Analivia Cordeiro
(Papers and publications)

- *A Language for Dance*, paper presented at the *INTERACT Machine: Man: Society*, Computer Arts Society Conference/Event/Exhibition, International Festival of Edinburgh, 27-31 August, Scotland. São Paulo, 1973 (the original document, preserved in the ZKM-Karlsruhe Archive, is published for the first time in this book).
- *Computer Dance TV* – TV/Dance. São Paulo: Centro de Computação da Universidade Estadual de Campinas, 1974.
- "O coreógrafo programador." *Dados e Ideias*, no. 4. Rio de Janeiro: SERPRO, 1976, 48.
- "The Programming Choreographer." *Computer Graphics and Arts Magazine* (California, USA), vol. 2 no. 1, February 1977, 27-31
- "Dança e a Educação." *Jornal D'Aqui*, 1987, 121.
- "O coreógrafo programador," in *Arte/Novos Meios/Multimedia – Brazil '70/80*. São Paulo: Instituto de Pesquisas Setor Arte – Fundação Armando Alvares Penteado, 1988.
- Cordeiro, Analivia, Cybele Cavalcanti, and Claudia Homburguer. *Método Laban – Nível Básico,* Course notes. São Paulo, 1990.
- *Nota-Anna – A notação eletrônica dos movimentos do corpo humano baseada no Método Laban*. Master's thesis, Multimedia Art Institute, São Paulo: Universidade Estadual de Campinas, 1996.
- *Nota-Anna – A escrita eletrônica dos movimentos do corpo baseada no método Laban* (The Electronic Writing of Body Movements Based on the Laban Method). São Paulo: Editora Annablume and FAPESP – Fundação de Amparo à Pesquisa do Estado de São Paulo, 1998.
- *Ciber-Harmonia – Um diálogo entre a consciência corporal e os meios eletrônicos*. PhD diss., São Paulo: Pontifícia Universidade Católica, 2004.
- *Os pés e a saúde*, in: Cotia (July), 2009, 15.
- *Alegria de ler*. Post-PhD diss., Rio de Janeiro: Universidade Federal do Rio de Janeiro, 2010.
- *Waldemar Cordeiro – Fantasia Exata* (ed. and conception), São Paulo: Itaú Cultural, 2014.
- *Arquitetura do movimento*. Post-PhD dissertation, Visual Arts Department, São Paulo: Universidade de São Paulo, 2018.

Bibliography about Analivia Cordeiro

Book cover *Nota-Anna – A escrita eletrônica dos movimentos do corpo baseada no método Laban*. São Paulo: Editora Annablume, 1998. Photographer: Felix Grünschloß. © ZKM | Karlsruhe.

Monographic papers (Selection)

- Alvares, Mariola. "Machine Bodies: Performing Abstraction and Brazilian Art", *Arts 9*, no. 1 Special Issue, Dance and Abstraction, 2020 (indexed within ESCI [Web of Science], and many other databases).
- Eacho, Douglas. "Scripting Control: Computer Choreography and Neoliberal Performance." *Theatre Journal 73*, no. 3 (September), Baltimore: Johns Hopkins University Press, 2021, 339-357.
- Leite, Marcelo. "Uma questão de precisão." *Iris* magazine, São Paulo, 1984.
- Machado, Arlindo. "Corpo como conceito do mundo." *Zonas de Contato*, Paço das Artes, 2010. Exhibition catalogue.
 "Um olhar reflexive sobre a cultura indígena." Introduction to Analivia Cordeiro's exhibition *Manuara* at MUBE – Museu Brasileiro de Escultura, September 2014, São Paulo.
- Shanken, Edward. "Coding Dance and Dance Code: Analivia Cordeiro's *M3×3*", in: *Coded: Art Enters the Computer Age, 1952-1982*. Los Angeles: Los Angeles County Museum of Art and DelMonico Books, 2023, 196-203. Exhibition catalog.
- Tracy, Martin J. "Computer Dance, TV, TV/Dance." *Dance Research Journal 8*, no. 2 (Spring – Summer), 1976, 40. Congress on Research in Dance. Available at: https://www.jstor.org/stable/1478154.
- Velho, Luiz. Introduction to the book *Nota-Anna – Notação eletrônica dos movimentos do corpo humano baseada no método Laban* by Analivia Cordeiro. São Paulo: Annablume & FAPESP, Fundação de Amparo

à Pesquisa do Estado de São Paulo, 1998, 11-14.

Books (Selection)

- Arantes, Priscila. @rte e Midia. São Paulo: Editora Senac, 2005.
- Callia, Marcos Henrique P. *Kuarup – Osíris no Alto Xingu*. São Paulo: Sociedade Brasileira de Psicologia Analítica, 1989.
- Carneiro, Maria Luiza Tucci. *Índios no Brasil – Vida, cultura e morte*. São Paulo: Editora Intermeios, 2019.
- Da Costa, Cacilda Teixeira. *Arte no Brasil 1950-2000*. São Paulo: Editora Alameda, 2009.
- De Silva, Soraia Maria. "O pós-modernismo na dança." In Guinsburg, Jaco, and Ana Mae Barbosa (eds.) *O pós-modernismo*. São Paulo: Editora Perspectiva, 2005.
- Giannetti, Claudia. "Media Sculpture: The Cybernetic Condition." In Ströbele, Ursula, and Mara-Johanna Kölmel (eds.). *The Sculptural in the Post-Digital Age*. Berlin: De Gruyter, 2023.
- Machado, Arlindo (ed.). *Made in Brazil*. São Paulo: Itaú Cultural, 2003.
- Mello, Christine. *Extremidades do vídeo*. São Paulo: Editora SENAC, 2008.
- Rengel, Lenira. *Dicionário Laban*. São Paulo: Editora Annablume, 2003.
- Smith, Andrew. *Jeito Brasileiro*. São Paulo: Editora Saraiva, 2008.
- Spanghero, *Maíra. A dança dos encéfalos acesos*. São Paulo: Itaú Cultural, 2001.
- Velho, Luiz. *Visgraf 21 Anos*. Rio de Janeiro: Editora IMPA, 2010.
- Venturelli, Suzete. *Arte – espaço_tempo_imagem*. Brasília: editora UnB, 2004.
- Wolfenson, Bob. *Collector's Books*. São Paulo: Sver&Boccato Editores, 1990.
- Wolfenson, Bob. *Desnorte*. São Paulo: Editora Galeria Milan, 2021.

Catalogs and Specialized Magazines (Selection)

- Cavalli, Angelo. "Videodança: Território Fértil." idança.net, 2007.
- Coelho, Maria Emilia, Interview with Analivia Cordeiro. *CloseUp* magazine (May), 2005.
- Editorial staff. "Paredes Zas-Tras." *Arquitetura &Construção*, year 18, no. 10, (October) 2002: 80-84.
- Editorial staff. *Cotia e Região*, year 6, no. 38 (Jul/Aug), 2003, 15.
- Editorial staff. *E magazine*, Sesc São Paulo, year 12, no. 3 (September), 2005.
- Editorial staff. "Manuara." Note on *The Art Newspaper* (September), 2014.
- Editorial staff. "Chutes inesquecíveis." *ABNews*. Bimonthly Bulletin, Academia Brasileira de Neurologia (May/Jun), 2019: 19.
- Fajardo-Hill, Cecilia and Andrea Giunta (Ed.). Radical Women: *Latin American Art, 1960-1985*. Los Angeles: Hammer Museum and DelMonico Books/Prestel, 2017.
- Giannetti, Claudia. "Media Sculpture: La condición cibernética," in *H-ART. Revista de historia, teoría y crítica de arte*, no. 12 (December) 2022: 117-136.
- Hertlein, Grace (ed.). *Computers & People*, "Thirteenth Annual Computer Art Exposition 1975", Vol. 24, No. 8, August, 1975, 9 (M3×3), 16 (Computer Dance).
- Hertlein, Grace. *Computers & People*, August 1976, 30.
- ICCH/2 – Second International Conference on Computers and the Humanities, Exhibition of Computer Art, Los Angeles. April 3-6, 1975, 3, 5 (Computer Dance), 18 (M3×3), 19.
- Junior, Gonçalo. "Dança da máquina, do corpo e da mente." *Revista da FAPESP*, no. 130 (December), 2006, 44.
- Lansdown, John. "The Computer in Choreography." *Computer Magazine*, London, 1978, 19.
- Leite, Juliana. "Câmera na mão e sapatilha no pé." *Revista Contemporânea*, year 1, no. 2 (Jul/Aug), 2007, 10.
- Leite, Marcelo. "Uma questão de precisão." *Iris Foto* (São Paulo), April 1985, 52-55.
- Migayrou, Frédéric (dir.). *Coder le monde*. Paris: Editions Centre Pompidou, 2018.
- Neves, Fabíola. *Contato-Conversas sobre Deficiência Visual*, year 5, no. 7 (December), 2001, 119.
- "O coreógrafo programador," republished in *Dados e Ideias* – 10 anos, no. 91, São Paulo, 1985, 48-54.
- *Planeta Dança Sagrada magazine*, special edition, 1988, 40.
- Restany, Pierre. "L'Arte Brasiliana." *Domus*, no. 544, 1975.
- Rodrigues, Ernesto. "Placa de Concreto torna a Casa Mais Economica", *O Estado de S. Paulo*, November 24, 2002.
- Tracy, Martin J. Review in *The Dance Research Journal* (Fall-Winter 75-76): 40.

Other Magazines (Selection – Chronological sequence)

- "Maitre computador." *Veja* (São Paulo), September 12, 1973, 124.
- "Programando os passos da dança." *Visão* (São Paulo), December 6, 1976, 129.
- "A bailarina cibernética." Note on *IstoÉ magazine* (São Paulo), December 5, 1984, 72.
- Note on *IstoÉ magazine* (São Paulo), 1985.
- *Seleções do Reader's Digest* (São Paulo), December 1986, 40.
- "O fascínio dos tecidos rústicos." *Fatos* (São Paulo), March 3, 1986, 28.
- "Artistas da Granja se dão as mãos e os pés." *Jornal D'Aqui* (Cotia, São Paulo), 1992.
- "O pescador que roubou o manto do anjo-pássaro." *Vogue* (Brazil), no. 206, 1994, 37.

- Menconi, Daniela. "Bem-vindo à Era Digital." *IstoÉ Digital* (Dec 1999–Jan 2000), 1999: 11.
- Campos, Rose. "Terapia corporal em alta." *Viver Psicologia*, no. 116 (September), 2002: 14.
- "Placa de concreto torna a casa mais econômica." Revista, *O Estado de S. Paulo* (November), 2002: 1.
- "Primeira obra de videoarte é disponibilizada para download em celular." *Revista Uol* (October), 2006.
- "Impressões digitais." *E* (May), 2010: 16.
- "Lembranças indígenas." *Vila Cultural* (January), 2015: 20–21.
- "Chutes e pontapés." *Veja Rio*, May 23, 2018, 34.

Newspaper
(Selection - Chronological sequence)

- "Balé moderno no Sedes Sapientae," *Folha de S.Paulo*, June 19, 1967.
- "Concertos," *O Estado de S. Paulo*, 1972.
- "Expressão corporal," *O Estado de S. Paulo*, Suplemento Feminino, May 28, 1972.
- "O Brasil em Edinburgo," *Folha de S.Paulo*, August 28, 1973. Jornal de Brasília, September 16, 1973.
- "Notable Suceso de Muestra Argentina," *Clarín* (Buenos Aires, Argentina), May 2, 1974.
- "Trabajos de CAYC en el Exterior," *El Cronista Comercial* (Buenos Aires, Argentina), July 12, 1974.
- *La Opinion* (Buenos Aires, Argentina), July 12, 1974.
- *La Prensa* (Buenos Aires, Argentina), May 21, 1974.
- *Cronica* (Buenos Aires, Argentina), June 16, 1974
- *La Prensa* (Buenos Aires, Argentina), July 12, 1974.
- *El Cronista Comercial* (Buenos Aires, Argentina), August 3, 1974.
- *La Nación* (Buenos Aires, Argentina), July 12, 1974.
- "Dança por computador já é uma realidade". NovaMulher, *Folha de São Paulo*, November, 28, 1974.
- *Jornal da Tarde* (São Paulo), November 12, 1974.
- *La Prensa* (Buenos Aires, Argentina), July 12, 1974.
- *O Estado de S. Paulo*, July 5, 1974.
- "Dança coreografada por computador em exibição no 'Goethe,'" *O Estado de S. Paulo*, November 19, 1975.
- "O drama da santa pela dança," *Jornal da Tarde* (São Paulo), December 13, 1976.
- *O Estado de S. Paulo*, June 18, 1979.
- "A bailarina Analivia Cordeiro e seu trabalho de dança com computador," *Gazeta de Pinheiros* (São Paulo), June 29, 1979.
- Katz, Helena. "Nem cabeças perfeitas garantem um bom balé," *Folha de S.Paulo*, November 3, 1979.
- Katz, Helena. "Nos passos de uma nova dança," *Folha de S.Paulo*, September 10, 1980.
- *Folha de S.Paulo*, March 10, 1981.
- "Em São Miguel, a exposição *Quantos Índios Tinha no Brasil?*," *O São Paulo* (São Miguel Paulista), April 22, 1983.
- Romério, Sonia Maria. "Coreógrafa desenvolve dança em computador," *Folha de S.Paulo*, October 10, 1984.
- "Rumo os pioneiros," *Audio News* (São Paulo), September 1984.
- "Computador já faz marcação de coreografias no Brasil," *Jornal da Tarde* (São Paulo), April 23, 1984.
- "'Bytes' e 'Bits' recriam balé por computador," *Jornal do Brasil*, November 9, 1984
- "Coreografia Analivia Cordeiro," *Meio & Mensagem* (São Paulo), 1988.
- "Entrelinhas," *Folha de S.Paulo*, May 30, 1988.
- Labaki, Amir. "'Diva em dívida' parte do clichê para chegar ao clichê," *Folha de S.Paulo*, April 14, 1988.
- Souza, Edgar Olimpio. "O vídeo pisa no palco e dança," *O Estado de S. Paulo*, June 4, 1988.
- "Entre carruagens e abóboras," *Folha de S. Paulo*, May 8, 1992.
- "Dança tem temporada diversificada em São Paulo," *Folha de S.Paulo*, May 10, 1992.
- "Mostra pode ser acessada pela internet," *Folha de S.Paulo*, September 22, 1996.
- Moraes, Angélica de. "Paço reúne obras nacionais de arte eletrônica," *O Estado de S. Paulo*, October 22, 1997.
- Decia, Patricia. "Mostra revela pioneiros da arte eletrônica," *Folha de S.Paulo*, October 23, 1997.
- Viegas, Camila. "'Canibal' resiste ao massacre urbano," *Folha de S.Paulo*, September 4, 1998.
- *Folha de S.Paulo*, September 7, 1998.
- "Analivia Cordeiro lança livro-video," *Folha de S.Paulo*, September 30, 1999.
- "Lançamentos traduzem butô e explicam 'Computer Dance,'" *Folha de S.Paulo*, October 18, 2005.
- "Entrelinhas," *Correio Braziliense*, March 13, 2007.
- "A arte do vídeo," *Jornal de Brasília*, March 13, 2007.
- "Trinta anos de novos olhares," *Tribuna do Brasil*, March 13, 2007.
- "Marcas registradas," *O Globo*, August 2007.
- Dimenstein, Gilberto. "Ver para ler," *Folha de S.Paulo*, February 17, 2010.
- Cypriano, Fabio. "Desleixo curatorial afeta mostra sobre acervo pioneiro do MAC na ditadura," *Folha de S.Paulo*, January 10, 2011.
- "Laboratório Visgraf, um reduto de designers e matemáticos," *O Globo*, May 20, 2014.
- Ellis, Adrian. "São Paulo Ready for Big-Budget Biennial," *The Art Newspaper Special Report*, September 2014
- Martí, Silas. "Galerias brasileiras apostam na Europa para vencer crise interna," *Folha de S.Paulo*,

Folha Ilustrada, Folha de S.Paulo, February 26, 2015.
- Cabanelas, Lucia. "Los Premios más Latinos," *El Pais* (Madrid), February 28, 2015.
- Bosco, Roberta. "El Arte Electronico se Normaliza," *El Pais* (Madrid), February 28, 2016.
- Andrade, Lucia Dias. "Chutes em forma de esculturas," *O Globo*, May 25, 2018.
- Gobbi, Nelson. "A arte do futebol em clima de Copa," *O Globo*, May 29, 2018.

Video Documentary

- *Passado dentro do presente*, Arte e Artistas project, consultancy Cacilda Teixeira da Costa, Fundação IOCHPE, 1988.
- *Video Art Brasilien 1970*, directed by Karina Medomagova and Daniel Morawitz, 2019, 17m36s, starkingbiker channel.

TV Broadcasting (Selection)

- *Primeiro Plano*. Interviewer: J. Lerner. TV Cultura, São Paulo, 1973.
- Interview with Analivia Cordeiro by J. Lerner, TV Bandeirantes, São Paulo, 1974.
- *M3×3, Gestos,* and *0°⇔45°*, TV Public Station - WGBH, Boston (USA), 1976.
- Panorama. Interview. TV Cultura, São Paulo, 1979.
- Interview TV Record, São Paulo, 1983.
- Interview TV Cultura, São Paulo, 1983.
- *Domingo*. Interviewer: Dina Sfat, TV Manchete, São Paulo, 1985.
- Grupo Danças Analivia on *Jogo de cintura*, TV Cultura, São Paulo, 1988.
- *0° = 45°* on *Metrópolis*, TV Cultura, São Paulo, 1988.
- Interview on *Metrópolis*, TV Cultura, São Paulo, 1992.
- *Zoom*, retrospective of her work, TV Cultura, São Paulo, 1999.
- *Art<e>Tecnologia*, TV Cultura, São Paulo, 2003.
- *Oficina de vídeo*, TV Senac, São Paulo, 2001.
- FoxTV, São Paulo, 2005.
- Statement for UnbTV, Brasília, 2007.
- *Móbile*, TV Cultura, São Paulo, 2006.
- *Espaço Aberto - Ciência Tecnologia - Matemática*, Globo News, Rio de Janeiro, 2006.

Website: www.analivia.com.br
Instagram: analiviacordeirooficial

Author's Biographies

Claudia Giannetti

A researcher specialized in contemporary art, aesthetics, media art and the relation between art, science and technology. She is a theoretician, writer and exhibition curator. Ph.D, from the University of Barcelona in Art History and Aesthetics. For eighteen years she was director and/or artistic director of institutions and art centers including ACC L'Angelot (the pioneer space in Spain dedicated to art and technology), MECAD\Media Centre of Art & Design (Spain), Fundação Eugenio de Almeida (Portugal), and Edith-Russ-Haus for Media Art (Germany). She has curated numerous exhibitions and cultural events in international museums, among other in ZKM | Center for Art and Media Karlsruhe; Centre George Pompidou, Paris; Neue Galerie Graz; MEIAC Badajoz; Centro Multimedia del Centro Nacional de las Artes, México DF; and in Madrid: Casa de América; Museo Nacional Centro de Arte Reina Sofía; Fundación Telefónica; Museo del Romanticismo.

She has been a professor in Spanish and Portuguese universities for the last two decades, and visiting professor and lecturer worldwide. She performs the function of adviser in several international media art projects. Giannetti has published more than 160 articles and several books in various languages, including: *Ars Telematica - Telecomunication, Internet and Cyberspace* (Lisbon, 1998; Barcelona, 1998); *Aesthetics of the Digital - Syntopy of Art, Science and Technology* (Barcelona, 2002; New York/Vienna, 2004; Belo Horizonte, 2006; Lisbon, 2012); *Flusser und Brasilien* (Cologne, 2003); *The Capricious Reason in the 21st Century: The Avatars of the Post-industrial Information Society* (Las Palmas, 2006); *The Discreet Charm of Technology* (Badajoz/Madrid, 2008); *Photo & Media* (Oldenburg, 2013); *AnArchive(s) - A Minimal Encyclopedia on Archaeology and Variantology of the Arts and Media* (Oldenburg, 2014); *WhatsAppropriation* (São Paulo, 2015); *Image and Media Ecology. Art and Technology: Praxis and Aesthetics* (Lisbon, 2017).

Nilton Lobo

An Electronic Engineer with specialization in Visual Computing and Computer Graphics and AI/Deep Learning, and most of his work was dedicated on technology and products development. After a successful career in large software and hardware companies, like Scopus Technology, Sun Microsystems, Intel and NVIDIA, he decided to start his own company, ARTEONIC, developing projects and studies using Artificial Intelligence and Deep Learning in the manufacturing industry. In 2019, his project submission to the GTC Conference in San Jose, CA, one of the most important AI Conferences in the world, was selected as one of the Top 5 best researches presented at the event. He has been working with Analivia Cordeiro in many artistic projects as technical developer since the 1980's. Graduated in Electronic Engineering at Polytechnic School of University of Sao Paulo, he has also postgraduate courses in Computer Graphics and Applied Mathematics at IMPA (Institute of Applied and Pure Mathematics) in Rio de Janeiro, Brazil.

Peter Weibel

Peter Weibel (1944-2023) was Chairman and CEO of ZKM | Karlsruhe, director of the Peter Weibel Research Institute for Digital Cultures at the University of Applied Arts Vienna and professor emeritus of media theory at the University of Applied Arts Vienna. He is considered a central figure in European media art on account of his various activities as artist, theoretician, and curator. He published widely in the intersecting fields of art and science. His career took him from studying literature, medicine, logic, philosophy, and film in Paris and Vienna and working as an artist to head of the digital arts laboratory at the Media Department of New York University in Buffalo (1984-89) and founding director of the Institute of New Media at the Städelschule in Frankfurt/Main, Germany (1989-94). As artistic director he was in charge of Ars Electronica in Linz, Austria (1986-95), Seville Biennial, Spain (BIACS3, 2008), and of Moscow Biennale of Contemporary Art (2011). He commissioned the Austrian pavilions at Venice Biennale (1993-99) and was chief curator of the Neue Galerie Graz, Austria (1993-98).

Bob Wolfenson

Born 1954 in São Paulo, started his work as photographer at the age of sixteen. With a career spanning fifty years, he became one of the best-known portrait and fashion photographers in Brazil. Wolfenson moves freely through different disciplines in the field of photography. He published several photo books of his work, among them *Jardim da Luz, Antifachada, Apreensões, Belvedere*, and *Desnorte*. He also held solo shows such as *Retratos* (Espaço Cultural Porto Seguro 2018), *Apreensões* (Centro Universitário Maria Antonia, USP, 2010), *Nósoutros* (Galeria Milan, 2017), *Cinépolis* (Museu de Arte Moderna da Bahia, 2016), and *Desnorte* (Espaço Cultural da Unimed, 2022). His most prominent works belong to collections of major institutions such as Museu de Arte Contemporânea (MAC USP), Museu da Fotografia Cidade de Curitiba, National Gallery of Art Zacheta (Warsaw), Museu de Fotografia de Fortaleza, Museu de Arte de São Paulo (MASP), Itaú Cultural, in addition to several private collections.

Colophon

This book is published on
the occasion of the exhibition
Analivia Cordeiro
From Body to Code

ZKM | Center for Art and Media
Karlsruhe, Germany
January 28 – May 7, 2023

The Book

Editor
 Claudia Giannetti

Concept and general coordination
 Claudia Giannetti

Project management ZKM | Karlsruhe
 Jens Lutz, Miriam Stürner

Work descriptions
 Claudia Giannetti,
 Analivia Cordeiro

Translations Portuguese to English
 John Norman, Helen Andersen,
 Isabel Burbridge

Translations from German to English
 Gloria Custance

Copy editing
 Regina Stocklen

Photos of works
 Edouard Fraipont,
 Nilton Lobo, UMFotografía

Image editing
 Carlos Fadon Vicente,
 Chris Kehl, Nilton Lobo

Graphic design
 Laura Meseguer, Lia Araújo

Cover design based on the design of
the exhibition poster by Demian Bern

Project management Hirmer
 Kerstin Ludolph,
 Katja Durchholz

Printed and bound
 Sersilito Empresa Gráfica, Lda.

Papers
 Coral book 120 g/m^2
 Condat silk 135 g/m^2

Typefaces
 Forma DJR by
 David Johathan Ross
 Sisters by Type-Ø-Tones

Special thanks to
 Anita Beckers, Luciana Brito,
 Thomas Cordeiro Guedes,
 Marina Goulart, Nilton Lobo,
 Franck-James Marlot,
 Felix Mittelberger, Margit Rosen,
 Carlos Fadon Vicente,
 Peter Weibel, Bob Wolfenson

© 2023 Analivia Cordeiro, ZKM |
Center for Art and Media Karlsruhe,
Hirmer Verlag GmbH, Munich

Unless otherwise indicated, all texts
© by the individual authors and their
legal successors.

Unless otherwise indicated, all
images © Analivia Cordeiro. In the
different specific cases, the copyright
is indicated in the corresponding
caption of the image.

Photographs by Bob Wolfenson
© the author.

All rights reserved. No part of this
book may be reproduced in any form
by any electronic or mechanical
means (including photocopying,
recording, or information storage and
retrieval) without permission in writing
from the copyright holders.

In the absence of documentation,
Analivia Cordeiro is responsible for
all historical data and dates cited in
this book.

The German National Library lists
this publication in the German National
Bibliography. http://www.dnb.de

ISBN: 978-3-7774-4193-1

Printed and bound in Portugal.

Distributed by
Hirmer Verlag GmbH, Munich
www.hirmerverlag.de
www.hirmerpublishers.com

The Exhibition

Curator
 Claudia Giannetti

Head of ZKM | Curatorial Department
 Philipp Ziegler

Curatorial project management
 Hanna Jurisch

Technical project management
 Anne Däuper

Exhibition graphic design
 Demian Bern

Conservation
 Leonie Rök, Cornelia Weik

Registrar
 Natascha Daher

Construction team
 ZKM | Museum and Exhibition
 Technical Services

ZKM | Center for Art and Media Karlsuhe
Lorenzstraße 19, 76135 Karlsruhe
Germany
www.zkm.de

CEO and Chairman
 Peter Weibel

COO
 Helga Huskamp

Head of administration
 Boris Kirchner

Founders of ZKM

Premium partner of ZKM